Capital Sporting Grounds

Capital Sporting Grounds

A History of Stadium and Ballpark Construction in Washington, D.C.

Brett L. Abrams

McFarland & Company, Inc., Publishers
Jefferson, North Carolina, and London

ALSO BY BRETT L. ABRAMS

*Hollywood Bohemians: Transgressive Sexuality
and the Selling of the Movieland Dream*
(McFarland, 2008)

LIBRARY OF CONGRESS CATALOGUING-IN-PUBLICATION DATA

Abrams, Brett L., 1960–
 Capital sporting grounds : a history of stadium and ballpark
construction in Washington, D.C. / Brett L. Abrams.
 p. cm.
 Includes bibliographical references and index.

 ISBN 978-0-7864-3956-0
 softcover : 50# alkaline paper ∞

 1. Nationals Park (Washington, D.C.)—History.
2. Stadiums—Washington (D.C.)—Design and construction—
History. 3. Washington Nationals (Baseball team)—History.
I. Title.
GV416.N38A37 2009
725'.8270975309—dc22 2008044265

British Library cataloguing data are available

On the cover: (top) Stadium seating plan for East Potomac Park
(Library of Congress); (bottom) FedExField (photograph by D.B.
King)

Manufactured in the United States of America

*McFarland & Company, Inc., Publishers
 Box 611, Jefferson, North Carolina 28640
 www.mcfarlandpub.com*

Table of Contents

Preface

Washington, D.C., experienced a tumultuous two years as arguments erupted over whether the city should build a stadium to house a new major league baseball team. Opponents decried the financial burden and the misplaced spending priorities. Proponents advocated for the opportunity to acquire a team after thirty years and the ability for a stadium to generate economic development. The first vote to approve the allocation of the funding to build the stadium proved a prelude to stories of escalating budgets, displacement of businesses, and parking problems.

The economic development rationale for justifying the baseball stadium intrigued me. I thought the stadium necessary because a city needs sports teams to be perceived as a big-league city. I wondered about what other reasons advocates for stadiums used in the past. Since Washington is the nation's capital and a monumental city, I figured there would be a wide variety of fascinating stories behind stadium construction in Washington.

As I searched for books on stadiums I came across many beautiful coffee-table works. They devoted a couple of pages to depicting stadiums of the past. Another voluminous group discussed the economics and fiscal aspects of stadium construction. These books focused on whether the economic development rationale justifies the public financing of stadiums. There were few books that discussed other reasons that proponents of stadium construction made in the past.

The limit to the information made me widen my search. I discovered books that discussed a single stadium in each of three cities: New York, Philadelphia and Chicago. These excellent books each covered one team or a single sport. They provided insight into the first owners' reasons for constructing the stadium, and the activities of the mayoral administrations. They described development issues in that one section of the city where the stadium sat.

I realized that there was no similar book on Washington, D.C. What is

1

more, common knowledge of the city's sporting history stopped with Griffith Stadium. A significant number of the books devoted to the development in the city featured the Mall and the federal buildings and monuments. Another sizeable group documented the development of Washington through photographs or a focus on a specific ethnic group or project.

In early 2008, the issue of stadiums in the District heated up. The new mayor, Adrian Fenty, faced hard choices about offering a development project to the ownership of the District's D.C. United soccer team. His administration also began talking to the Washington Redskins organization about returning to the city.

These stadium deals were tied to land swaps between the federal government and the District. The federal government took control over patches of developed land in exchange for providing the city with public park land in Anacostia and where RFK Stadium sat. The city would then provide to private developers either the building rights or the land itself to build a stadium and a development project. The new tax ratables would allow the federal government to reduce its annual payment of "rent" to the city. The deals represented the increasing drive to privatization, the devaluing of public space which would lead to the loss of such space, and the desire to spend less on public infrastructure, which helps account for our deteriorating bridges, highways, parks, et al.

My research began with the examination of local newspapers. The Washingtoniana Division of the Martin Luther King Jr. District of Columbia Public Library has copies of the *Washington Star*. The index that accompanies the *Star* "morgue" proved invaluable. The Division also maintains vertical files filled with articles from a range of publications that provided more names, activities and plans. I built upon this knowledge base through using the searchable copies of the *Washington Post* and later the *New York Times*.

The District of Columbia has been under the federal government's oversight if not direct control for most of its existence. The agency responsible for maintaining federal records seemed like the most appropriate place to discover insight into the federal portion of the stadium activities. I visited the National Archives and Records Administration (NARA) frequently to examine the files of the various government agencies involved in the District's management. I also examined pertinent legislative documents and court cases.

Several other repositories in the area had additional records of value on organizations, neighborhoods and sports. The Historical Society of Washington, D.C., held maps, photographs and files on a wide range of groups. The George Washington Archives, the Library of Congress's Local History and Prints and Photographs Divisions, and the U.S. Army Corps of Engineers History Office each provided valuable documents.

A number of the people working in archives and libraries provided exceptional assistance in locating documents and photographs. The staff at the Washingtoniana Division helped me a great deal. Brian Kroft, an independent researcher who frequents the Division, always offered important suggestions. The NARA's reference staffs in textual, photograph, and cartographic custodial divisions were top notch, particularly Richard Smith. The Kiplinger Research Library staff of the Historical Society of Washington, D.C., was very willing and able. Michael J. Brodhead, Ph.D., of the U.S. Army Corps of Engineers did yeoman's work. I received many excellent photographs from the Washington-Baltimore 2012 Coalition, HNTB Architecture, Brailsford & Dunlavey and Devrouax and Purnell Architects.

There is always a long list of people who deserve acknowledgment as important people in your life and to a work of this nature. I want to thank my father Al Abrams and stepmother Linda Gagliardi Abrams for their never-ending support. I appreciated the views of contemporaries and scholars that I met at the National Popular Culture Association/American Culture Association conferences and the Washington Studies Conference.

I appreciated all the listening and advice that friends have provided during this project. I'm particularly grateful to: Paul Andresino, David Brown, Thomas Drymon, Daniel Emberley, William Fischer, Deborah Garcia, Peter Hoefer, Willard (Bill) Hillegiest, Theodore (Ted) Hull, Michael Hussey, Michael Kazin, Gregory Lepore, Jon Carl Lewis, William Megevick, Jim O'Laughlin, John Powell, Michael Seto, Tim Tate, and Kyle Wicks. Dearest of all to me is my man, Ira Tattelman.

Introduction

A Contentious Capital City

In the fall of 2004, the District of Columbia under Mayor Anthony Williams won the "lottery" to become the new home to Major League Baseball's (MLB) former Montreal Expos. The component of the deal that sold the thirty owners of the baseball franchises, the public financing of a new stadium in southeast D.C., split citizens and city leaders. Amid much fanfare in the middle of historic Union Station, many celebrated the rechristening of the team as the Washington Nationals. Other crowds gathered at community sites across the city and denounced Mayor Williams's plan to spend taxes to build a baseball stadium, crying out that the city needed schools, jobs, and homes.

After twelve hours of contentious hearings, the City Council's finance and economic development committees each approved the stadium-financing bill by 3-to-2 margins. The financing bill carried an original cost of $395.2 million, but the cost soon rose to $440 million. Council Chairperson Linda Cropp, with an eye to running for mayor, proposed that the District's deal with MLB feature a stadium near the current RFK Stadium site in Anacostia Park or use private funding to construct the stadium. An MLB official replied, "They're going to lose that team." A month later, the City Council almost rejected the team, passing the stadium financing bill by a 7–6 vote.[1]

The vote green-lighted the construction project. The problems then compounded. District Chief Financial Officer Natwar M. Gandhi estimated during his testimony before the District's City Council that infrastructure improvements and unforeseen contingences raised the cost to $486.2 million. Soon, Gandhi requested that the Council remove the $500 million bond issuance cap for the stadium construction. Costs continued to rise; land acquisition, infrastructure improvements, and finding sufficient parking all emerged to present their own special problems. Despite these difficulties,

Mayor Williams remained convinced, as does current Mayor Adrian Fenty. A spokesperson for Mayor Williams promised, "The stadium will be a catalyst for economic development and a better life."[2]

Capital Sporting Grounds: A History of Stadium and Ballpark Construction in Washington, D.C. shows that controversy and political shenanigans always appear in stadium dreams in Washington. What has not always been part was the economic boon rationale former Mayor Williams used to justify the public financing of the stadium. The mayor's reason has been used in other cities to justify construction over the last fifteen to twenty years. Few in the past used that reason to promote the construction of a stadium in the District.

What reasons did advocates for building stadiums in Washington give in the past? What types of financial plans received consideration for the creation of the stadiums in the District? What does an examination of the recent past reveal about the possibility that either of Chairperson Cropp's proposals would have succeeded? With the city's cultural status as the national capital and oversight by the federal government, Washington's stadium stories include an unusual assortment of advocates and reasons for proposing stadiums over the last 125 years. This history has been underpinned by the long-time battles over Washington, D.C., as the location for the nation's federal government, the purpose behind that government and the appropriate amount of finances for operating the city.

Appropriate Location

Neither Congress nor President George Washington and his first cabinet held a single shared vision for the location and type of place that would serve as the federal seat of government. During the years of the Continental Congress and the government under the Articles of Confederation, cities including Philadelphia, Pennsylvania; Trenton, New Jersey; and Annapolis, Maryland, served as the seat of government. After the election of George Washington as the first president of the United States under the Constitution, New York and Philadelphia both served as seat of government. Eleven cities vied during the first Congress to become the new nation's seat of the federal government.

Several individuals attempted to influence the choice of location. Senator Robert Morris, a noted financier of the American Revolution, offered to provide $100,000 if the capital resided within the state of Pennsylvania. The state legislatures of Maryland and Virginia combined to offer $192,000 if the location resided along the Potomac River. Thomas Jefferson and Alexander Hamilton had a dinner meeting where the pair reportedly reached a compro-

mise that placed the seat of the federal government in what would become the District of Columbia. The Residence Bill of 1790 created the District of Columbia from portions of Maryland and Virginia and included a port city from each of these states, Georgetown and Alexandria. Within fifty years, Congress would return Alexandria and other areas back to the jurisdiction of Virginia.[3]

The struggles over the location of the national capital continued even after the compromise. President George Washington worried over the continued existence of the Residence Act. He anxiously avoided providing the numerous groups who opposed the District as capital with any justification for the rescinding of the Act. While Washington achieved success, the first decade of the national government in Washington sparked a movement to relocate the capital back to Philadelphia. In 1808, Representative James Sloan of New Jersey offered such a resolution in the House of Representatives because the District of Columbia was inconvenient in location and the building of the necessary public buildings would be expensive. After a week of debate the District retained its standing.[4]

The struggle for Washington to retain its capital status continued. In the early 1830s, advocates argued for moving the capital to Cincinnati, Ohio. During the secession crisis, months before the beginning of the Civil War, *Harper's Weekly* ran an article that postulated about the need for a new capital for the remaining northern states. The voters of the city fretted over the possibility of a relocation of the capital during their election of a new mayor for Washington.

The movement toward finding a new national capital reached its zenith shortly after the Civil War. The *New York Tribune* drummed up support for the national convention at St. Louis with the express purpose of finding a new capital. Representative John A. Logan, Republican from Illinois, introduced a bill into the House of Representatives to shift the federal seat of government to the Midwest. Another congressman argued that all the necessary records and treasures could be simply packed and shipped west. However, President Ulysses S. Grant supported the city of Washington and his threatened veto helped halt any movement of the relocation bill.[5]

Seat of Government or Capital?

The Constitution of the United States referred to the location of the federal government by the term "seat of government." Throughout most of the nineteenth century many citizens and foreign nationals used the term to describe Washington instead of the word "capital." Throughout Europe and in most nations in history, the capital city represented the foremost location

in a nation for politics, culture, and commerce. During the late eighteenth century, this proved true in nearly every European nation but the Netherlands. Despite the visions George Washington had for commerce on the Potomac, the District of Columbia would have a long way to go to compete with several cities on the East Coast in commerce or culture. Indeed, Washington shared its start with only one capital city, St. Petersburg in Russia, which was also specifically established as the national capital.

The struggle between the two major political parties of the era, the Federalists and the Anti-Federalists, later Democrat-Republicans, then Democrats, influenced the purpose for Washington as the seat of the federal government. The major split between the two parties concerned the ratio of power between the federal and the state governments. After the first two Federalist presidents, the White House and a significant majority in Congress held the Democrat-Republican perspective of limiting federal power. These politicians frequently viewed Washington as a seat of government as opposed to a grand national capital. Since they did not want to give the federal government a great amount of responsibilities, they saw little need to construct buildings for the operations of a federal bureaucracy that they would want to maintain at a limited level. Thus, these politicians limited the physical landscape in Washington, and kept its beauty, size, reputation and comforts of life at a minimum. The perspective of Washington as a seat of government prevailed throughout the culture until after the Civil War. Then, magazines and newspapers, particularly in the former Union states in the northern and western parts of the country, carried articles that referred to the District of Columbia as a "capital."[6]

Contentious Financing

The original funding from the two state legislatures served as initial seed money for the construction of the president's house and the Capitol Building. President Washington appointed Pierre L'Enfant, a military engineer under the French Major General Lafayette, as the chief designer of the city of Washington. The designer came under the control of three commissioners. Their plans depended on the first lot sales to provide a great deal of cash with which to continue. However, the commissioners failed to sell the 10,000 lots slated in that auction, generating significantly less funding than had been planned. Pierre L'Enfant advised that the federal government take out a million-dollar loan to finance the necessary infrastructure. The designer of Washington thought this would make the city look appropriate for buyers. His advice went unheeded and he did not produce the map of the city. While other incidents led President Washington to fire L'Enfant, the designer's idea proved

correct, for the map that Andrew Ellicott created proved insufficient to spur lot sales and generate the funds the city needed to build its infrastructure.[7]

After a second limited sale of lots in the new city, the commissioners sold 6,000 lots to a speculator in order to continue the construction of the public buildings. Within the space of a few years, the speculators were bankrupt and had no money to pay the commissioners. They built only a small portion of the housing construction that they promised and foreclosures sparked litigation that led to disputed land ownership, destitute financers and insane builders. The three commissioners whom President Washington appointed to manage the initial stage of development hindered the project in many ways. They were parsimonious with the allocation of money, resulting in some shoddy workmanship on some public roads and on the few public buildings constructed. Even the Capitol Building seemed ever in a state of construction. The commissioners' frugal ways created an ever-disgruntled labor force, and the increased use of slave labor on construction jobs.[8]

The struggle for acquiring the needed financing for the development of the city plagued Washington's development up to the Civil War. Congressmen worried that providing the funds for the improvement of a road "might prove an entering wedge to future demands on Congress." Yet other politicians would complain of the city as a "sea of mud," because of the lack of road improvements. The limited allocation of funds left Washington with only one paved street up to 1845 (Pennsylvania Avenue, NW). The passage of a charter for the city in 1820 did provide some regular federal funding for the first time but it proved wildly insufficient. Many residents and visitors complained for decades over the limited government buildings, lack of pizzazz to the environment, and the lack of amenities in the city in general. The development of a water supply system came only after a fire threatened to burn the Capitol dome in the early 1850s and it did not measure up to the current urban standards. The Washington Canal remained an open sewer for the city's garbage.[9]

Despite the city charter's establishment of a popularly elected mayor and City Council, and the ability to create certain local government offices, these figures lacked the tax powers necessary to pay for city improvements. Decisions regarding laws and financing in the city remained the province of the House of Representatives and the Senate District committees. The District lacked representation and votes in both the House of Representatives and the Senate so they had little leverage with which to negotiate in Congress. Also, they had to battle with congressmen who had the interests of their own constituents in mind. Those interests resulted in a long delay in authorizing the necessary funding so that Washington could complete a canal to the Ohio Valley. When the local government took action in an attempt to build

the canal and compete for commerce it found itself behind New York City and Philadelphia and secondary to Baltimore in the mid–Atlantic region.

After the Civil War several groups emerged with an interest in improving the physical circumstances of the city. Many Northerners saw the city as a symbol of the Union and deserving of improvements. The Radical Republicans in Congress viewed the city as an opportunity to put their agenda for a reconstituted country in place. Washington would briefly experience biracial politics, with efforts to appoint blacks to the city work force, but this ended less than two years after it started. Another group gained power and promoted an economic modernization program under the control of the new territorial government during the early 1870s. The famous Alexander Shepherd regime provided Washington with many public improvements but also resulted in the burden of a tremendous debt, alienating some in Congress and the old Washington southern business elite. These groups combined to pass the Washington Government Act of 1878, which abolished the territorial government and instituted a commission form of government for the District of Columbia. The short-circuiting of the territorial government and its economic program helped limit the incorporation of Washington, D.C., into the economic core of the country, composed of the large cities of Boston, New York, Philadelphia and Chicago.

This government consisted of three commissioners who received their appointment from the president. They oversaw the activities of the bureaucrats who ran the local government agencies. The commissioners also proposed actions for the consideration of the District Committees in the Senate and the House of Representatives. These two committees served as final arbiter. The revised form of government did result in the establishment of a fifty-fifty formula for sharing costs for the city's needs. Still, the city continued to lack representation and leverage in Congress.[10]

The Four Cities of Washington

Most large cities consist of the "local city" and the city within the larger metropolitan contexts, known as a "regional city." As the federal seat of government, Washington also has an "international city" and a "federal city." These four cities do not create a unified entity but constitute a complex arrangement of interest groups and dynamic demographic groupings of people that can exist independently and interdependently with one another at various times. The federal, local and regional cities offered places to build a stadium and numerous suggestions for stadiums came from many people, most of whom lacked the power and influence needed to make them a reality.[11]

International City

The international city consisted of the physical buildings that the foreign governments used in the District and also the people who staffed them. The buildings included both the embassies and the consulates. The people included the diplomats, staff, and less frequently, foreign dignitaries in Washington on official business. The international city did not have a great deal of influence on the choices made about stadiums in Washington. The greatest effect it had would have been indirect, as another reason why the city would need a stadium to host the Olympic Games.

Federal City: Environment

The federal city featured the physical buildings and monuments on federal property and the people who worked in the government as employees and as politicians. The legislative, executive and judicial branches, embodied in these physical buildings, signified the economic and political power of the federal city. The monuments and the memorials, with their symbolism and grandeur, formed a part of the federal city's cultural heft of being the capital of the world's most potent democracy.

During the first decades of Washington, the federal government only invested its monies in instances where federal reservations were involved. The Washington Navy Yard in the southeast quadrant of the city was one of the few areas developed extensively in the era. The northwest quadrant also benefited from federal construction projects. The Treasury Building went up near the White House in 1836, in a decade also witnessed the construction of the Post Office and the Patent Office on Seventh and F Streets, NW. While being built upon federal reservations, these buildings helped spur the creation of neighborhoods around Capitol Hill and downtown respectively. Typical delays from lack of funds and lack of interest in more construction limited the further federal city development through the Civil War.

A renewal of the federal government showed in a spate of building after the Civil War. When President Grant supported the continuation of Washington as the nation's capital he moved to support the city directly. Grant initiated one of the most extensive periods of federal office construction in the District's history during the 1870s, which included the Old Executive Office Building and the Pension Building, now known as the Building Museum. Other construction projects included the dome of the Capitol, the Cabin John Bridge, and the first Library of Congress building. This construction of federal buildings lasted for 20 years.[12]

As the centennial celebration of the city approached, it offered an impor-

tant opportunity to shape the federal city. While President William McKinley proposed a monument, Congress created a joint committee chaired by Senator James McMillan, a Republican from Michigan. This Senate Park Committee's plans called for a reshaping of the original L'Enfant plan for a broad tree-lined monumental alley, stretching from the Capitol west to include the newly created Potomac Flats near 23rd Street, between Pennsylvania Avenue, NW and Independence Avenue, SW. The Mall became one of the most notable features of federal city, and would deeply influence the activities surrounding proposed and built stadiums in Washington, D.C., for fifty years. [13]

However, the monies to implement the Park Commission's plans, popularly known as the McMillan Plan, came slowly. Some in Congress, particularly the members of the Committee on Public Buildings and Grounds, grew frustrated, especially over the "wasted" expense of paying rent and gaining no equity in buildings. They claimed that the government paid too much rental for buildings in Washington and there ought to be a building program speedily enacted to house government activities. A second and third building boom occurred in the 1930s and in the 1960s in a small perimeter around the Mall, through urban renewal and other projects. Most recently, the federal city has expanded into the suburbs, moving beyond the nearest ring to areas deeper into neighboring states and even into West Virginia and Pennsylvania. [14]

Federal City: Monuments and Memorials

The federal city did not initially invest in monuments either. For forty years, Congress could not arrive at a choice on how to memorialize the nation's first president while nearby Baltimore created statuary that symbolized George Washington and his efforts. The Washington National Monument Society started an obelisk but fundraising efforts fell far short, leaving the obelisk as a 150-foot stump from 1854 through 1876. Senator John Sherman, a Republican from Ohio, guided a $2 million appropriation through Congress to restart the building, which ended with the placement of the capstone on top in late 1884. [15]

The federal city has monuments along Pennsylvania and Constitution Avenues but also at the center of the squares and circles in most of local city. They depict famous military figures, statesmen, and others who played a role in the development of the nation. Others evoke memories of decisive activities in shaping the country. The establishment of the Mall with the McMillan Plan created a space for numerous monuments in the federal city. The Mall has become the premiere space for memorials, and these monuments successfully evoke the cultural resonance of the federal city. The monuments located there did not occur without significant debates and disputes. The two

presidents memorialized on the Mall each had proponents who advocated that a stadium be built in Washington instead.

Federal City: People

Some of the people who advocated for the stadium memorials were from each of the two human portions of the federal city: the government workers and the politicians. With the creation of new federal government agencies and the growth of older bureaus and departments, the work force required to carry out the responsibilities expanded significantly. The largest of the expansions of the work force occurred through the Civil War, and during the Progressive and New Deal Eras. The work force reached its apex in the late 1960s before dropping to about 300,000 in 1999.[16]

During the first three decades of the twentieth century, the most active participants in the proposed and constructed stadiums in the District included the leaders in the Office of Public Buildings and Grounds in the War Department and the National Capital Parks and Planning Commission (NCPPC). The Army Corps of Engineers considered the Public Buildings Office a very prestigious and desirable position and staffed it with the top of the West Point classes, providing them with the honorary rank of colonel. The NCPPC, later known as the National Capital Planning Commission (NCPC), counted prominent municipal engineers and urban planners as members. The NCPC, along with the National Park Service and the Environmental Protection Agency, played a large role in the proposed and constructed stadiums in the District through the end of the twentieth century.[17]

The politicians in the federal city grew significantly over the first two hundred years. The expanding nation resulted from the continuous inclusion of more states into the Union. Each new state increased the pool of politicians in the federal city, bringing two new Senators and at least one new member for the House of Representatives per state to the District of Columbia. Congress made itself the District's "City Council" in the 1878 government act. But the individual congressperson's attention went first to national issues and second to the needs of their constituents, often leaving the District a poor third.

The divided attention appeared in the allocation of committee membership. Congresspersons served on multiple committees, with Ways and Means, Appropriations and a few others considered to be the "best." The District Committees of both House and Senate appeared on the rank just below this, a good committee that members enjoyed because it was fun work. These committees oversaw the commissioners and city department but the Appropriations Committee decided on the District commissioners' requests in their

annual budgets. While a variety of congresspersons advocated for the con-
struction of a stadium in the District of Columbia, the chairpersons for the
House of Representatives' District Committee usually took the initiative.
Despite their power, they often lacked the necessary influence to convince
the other members of their chamber to allocate funding.[18]

Local City: Environment

Besides District-owned public buildings, the local city consists of the
houses and privately-owned public gathering spaces in the neighborhoods
throughout the four quadrants of Washington. The population of the local
city includes the politicians and workers of the District government, work-
ers in the private and nonprofit sectors, and the people who reside in the Dis-
trict of Columbia.

As noted earlier, the city struggled with the creation of the appropriate
infrastructure during the first half-century. In order to create city services,
the city incurred an enormous debt under the leadership of the territorial gov-
ernment. Over the next ninety years, under the fifty-fifty proposition, the
District developed the bureaucracies providing necessary services in build-
ings. The suburbs in Washington County paid for their own streets, sewage
and other services until the efforts of some congressmen, the District Com-
missioners, and various city offices, such as the Highway Department, helped
bring these services into a greater city system.

Even with this great surge of effort, on numerous occasions the plans
for new parks, streets and avenue extensions, and mass transit all suffered
from delays or never happened due to limited funding. Since the passage of
the District of Columbia Home Rule Act of 1973, the local city has experi-
enced its share of ups and downs. The local city has numerous school build-
ings in various states of decay and rows of boarded-up houses in many
neighborhoods. Despite some recent nearby gentrification there are housing
complexes that many citizens view as a netherworld.[19]

The business development of the local city did not include the heavy
industry to the extent of the northern cities nor the agricultural and textile
production of the cities to the south of Washington. The local city had 129
shops, three banks, and two newspapers by the 1820s but failed to have an
elegant hotel and a very large manufacturing firm through the Civil War.
Years of growth in manufacturing and services followed, with the expected
development of downtown shopping areas along Seventh Street, NW and
Fourteenth Street, NW and down E and F Streets, NW. However, despite its
efforts, the city could not win its attempts to hold national expositions and
world fairs, lacking both size and local economic capacity. The city became

a symbol rather than a center of national achievement. The presence of few large businesses resulted in the local city's having few opportunities for wealthy entrepreneurs to fund stadiums and teams.

The development of the business areas slowly drove the residences beyond the inner squares of the local city. The wealthy moved up Connecticut Avenue and Massachusetts Avenue into Dupont Circle, then beyond. The home that President Grover Cleveland purchased as a resort during the summer transitioned into Cleveland Park by the early 1890s. Le Droit Park, Mount Pleasant, Adams Morgan, and Columbia Heights all emerged and blossomed during the era as transportation networks made areas more accessible and the living more comfortable from the mid–1870s up through the 1920s. Still, as residents rode the improved transportation network of streetcars, they passed great stretches of vacant spaces. The areas to the east of the Capitol remained significantly less developed, lacking a fully paved Pennsylvania Avenue and other city services.[20]

As the industrial segued into the information age Washington profited. The city spread out far into the surrounding farmlands, resulting in a regional city. Washington ranked third in the nation in total receipts in legal, business, engineering, and management services in the 1990s. The area is vital today as a node for the information production and manipulation that made it a core global city.[21]

Local City: People

The local city included four groups of people: politicians, city workers, employees of nonprofits and local residents. The mayors running the local city before and slightly after the Civil War alienated both Congress and the local citizenry. The District commissioners were sometimes able and personable, but historians noted many were poor performers. Home Rule, with its more powerful mayor and City Council, has led both to improved neighborhoods and rising property values and to suffering, such as during the late 1980s and through the 1990s when the local city became a national joke. The local city politicians have had an enormous opportunity to promote stadium construction and also to negotiate directly with professional sporting teams regarding their futures in Washington, D.C.[22]

City workers have a mixed record of accomplishment. At the close of the 1980s, they earned the description as the worst city government in America. The situation has improved in several agencies to the extent that muckraking journalism focuses on people who work in the city but live in the suburbs. The involvement with the stadiums grew significantly after World War II. The nonprofit organizations in the local city included the local Cham-

ber of Commerce, the city Board of Trade, and a group of sports boosters who called themselves the Touchdown Club. They took very active roles in proposing stadiums during the early portion of the twentieth century and existed in other metropolitan areas as well.[23]

Residents numbered over 3,000 in 1800. Washington's population topped the 100,000 level in the 1870 census and for the next eighty years its growth kept pace with cities in the U.S. Washington ranked among the second ten of urban population, with African-Americans, old stock English and Irish comprising the largest ethnic groups. While the per capita income averaged 25 percent more than the country's average, the city had a homeowner rate 25 percent lower than the national average.[24] The local residents occasionally offered individual opinions on stadium issues through letters to the editor. Most residents offered their opinions through citizens' associations that provided the commissioners and members of Congress with their support for legislation proposing the construction of a stadium for a specific reason.

At the origins of professional sport in the U.S., the District had a limited number of people who could own a franchise. Washington's old society lacked the size and influence of Boston, New York and Philadelphia, but the city's figures exhibited a similar lack of interest in associating themselves with professional sports, such as baseball. The remains of the antebellum Washington society received the nickname "the ancients" from Mark Twain. They missed the city's "old jog trot way of life," as they held fast to their positions on Lafayette Square.

A new group of society folk pushed this change of life. A "nouveaux riche" came to Washington to create a new society. Twain labeled these newcomers the "parvenus." They came from the old eastern seaboard cities as well as from the new industrial boomtowns of the Midwest and from the mining areas of the West. Few identified with Washington, as most viewed the city as a site for their pleasure while they were in residence over the winter. Others viewed Washington as affording the opportunity to make money or receive patronage from the ever-growing federal government. Washington's cultural institutions received little charity from these figures and its sporting teams could expect even less. As the bishop of the Washington National Cathedral observed, "[T]hey bring wealth, magnificence, and luxury to the capital of the country [and] are ... actuated by no sense of civic, moral, or religious obligation regarding the welfare of the community...."[25]

Regional City: Environment

There are two definitions of regional city. The outlying areas around Washington, all the towns, counties and small cities in northern Virginia,

southern Maryland and the eastern shore, and eastern West Virginia compose one version. The second version of regional city located Washington as part of a section of the country, such as northeast and mid–Atlantic. As with the other cities, there is an environmental and a people component to these regional cities.

The outlying areas have offered new locations for federal government agencies and private and nonprofit businesses to operate since the 1950s. They began to exert a similar influence on the issue of stadiums in the District beginning in the 1980s. The section viewpoint examined the governments, business establishments and infrastructure in the mid–Atlantic area in contrast to that of the northeast and the southeast portions of the United States. The impact that being in the mid–Atlantic region has played on stadium construction and operation in Washington has varied over the 125 years, from isolating the city Velodrome in the early 1900s to enabling the city to bid as a region on hosting the Olympic Games.

Regional City: People

The politicians running the governing bodies, the workers managing the government operations, and the local residents comprised the three groups of people in the regional city. The politicians in positions of county executives and on legislative bodies provided tax and other incentives to team owners to construct a stadium in their jurisdictions. They also sometimes joined forces with Washington's mayor to support the local city's bid for a stadium. The government workers have often supplied their local politicians with the documentation to support their political choices. The local residents presented positions usually in support of stadium construction in their hometowns.

The city has had to battle the struggle to resist acknowledging Washington, D.C., as the nation's capital. The city has lived with a begrudgingly limited acceptance of Washington's position and need for funding. The city has had to cope with needing to create a consensus among many small fiefdoms to get anything accomplished. This created the milieu in which all the proposals for and the building of stadiums occurred. Looking at these stories we see the changing ways Americans have valued sports and viewed their capital city and their nation.

1

D.C.'s First Families
Capitalism on Sports' Frontier

For three years influential Washington citizens sought to convince the magnates of major league baseball to give the city a team. Not the six-city marathon former D.C. Mayor Anthony Williams and others ran against leaders in Las Vegas, northern Virginia and three other locales for the Montreal Expos in 2003. Nor the waiting game the Lerners won a few years later. This struggle occurred over a century ago that featured the first family owners in Washington and evolved from a family affair that started on the field into a battle in the District's courts.

The First Family of D.C. Baseball

The group failed in their efforts to secure a franchise in either the National League or the American Association. Robert C. Hewett assumed the presidency of a team in an upstart third league, the Union Association (UA), in 1884. Years before the Griffiths and a century before today's Lerners, the Hewetts made local city baseball a family enterprise. A member of the Masons, Odd Fellows, Knights of Pythias and Red Men, Robert Hewett ran a feed business on Seventh Street, NW. He ran away at fourteen with "but three nights' schooling, on two of which the teacher was absent and the other the candle went out," under his belt. After making his fortune selling grain during the Civil War, Hewett bought real estate and became a landlord.[1]

Hewett had previous involvement with baseball teams in the District. He served as president for one of the city's earliest professional teams. During that time he met the man who managed his UA team, Michael B. Scanlon. Scanlon managed some of the city's successful teams in the years following the end of the Civil War. Irish-born Scanlon settled in New York at age 11 and served with the Union army for three years from 1863. He set-

tled in Washington and began managing Washington's semi-pro club, the Nationals, in 1868 and assembled one of the most famous teams in the country. He started a pool hall business during the off season.[2]

The Union Association Nationals rented the area where the U.S. Senate parking garage exists today. The owners filled in the "Capital Grounds" and erected a grandstand along C Street, NE at New Jersey Avenue that seated 3,500 people. As they prepared for the season, one of the rival major leagues, the American Association, started a franchise in Washington to compete against the Hewett team for attendance. The American Association team's effort failed.

The UA did itself in. The UA organizer, Henry Lucas, stacked his own team with the best players. Lucas also manipulated the schedule to ensure that his St. Louis team started the season with a long winning streak. Without a pennant race, attendance for the UA lagged. Hewett withdrew the Nationals from the league after receiving far less than their share of the gate receipts after games in St. Louis and Cincinnati.[3]

The next year Hewett found himself back running a team again in the minor leagues. Hewett brought the only child from his first marriage, Walter, into team management. The team improved the stadium, adding covered seating. In addition, they reoriented home plate to increase the distance from the left field fence so balls hit over it became home runs rather than ground rule singles.

Midseason, the Washington and Georgetown Railroad Company sold left field for $7,000. The purchaser, a Baltimore capitalist, planned to erect fine homes on these lots at First and B Streets, NE and the team was out of luck. Summing up the feelings of team leadership, Scanlon asserted, "The Washington and Georgetown Railroad Company should assist us by allowing us to remain at Capitol Park.... In every other large city [a street railroad company] has fitted up grounds and encouraged their maintenance with the most substantial backing."[4]

The team did not receive any help. The streetcar companies in other cities helped because the locations of the teams' stadiums led to increased numbers of riders for them. The location did not serve that purpose in Washington. The park sat on the edge of the central part of the local city where the expansion of housing would occur next. Nearly all the powerful figures in the local city supported this growth. According to these officials, that a team had its stadium sold in the middle of the season was simply too bad for the team. However, it showed very graphically the limited importance of sport at that time in U.S. culture.

Team management could not wait for outside assistance. After contemplating contraction, National League (NL) leadership invited Indianapolis

and Washington to form teams and join the league. Hewett and Scanlon needed funds for the security deposit that the NL required, for the salaries for the players and for the cost of a stadium. The Nationals' officers issued 40 shares of stock at $500 each for capital and incorporated as the Washington National Base Ball Club "to develop and maintain a proper appreciation of athletic and other manly sports and amusements...."[5]

The team executed a five-year lease on grounds bordering North Capitol Street, F and G streets, NE (across North Capitol Street from the Government Printing Office). Their recent experience prompted them to negotiate for an option to buy the property before the owners sold it to anyone else. Newspapers glowingly described the new park and its 7,500-person capacity. "It is large enough to accommodate the biggest crowds.... [It] is easily reached by cars, herdics or on foot and is surrounded by interesting objects, such as the dome of the Capitol, the smoke-stack of a factory on the left, a row of elegant dwellings on the right and such magnificent structures as the Pension office and the District buildings looming up on the horizon."

The ballpark compared slightly less favorably with the new stadium built in Chicago that same year. The home of the franchise that became the Chicago Cubs, the West Side Park held seating for 10,000, with private boxes on the roof of the one-story horseshoe-shaped stands. The woodwork received a fresh coat of terra cotta color and both teams received large dressing rooms with bathtub and shower baths. The team spent a reported $30,000 on lifting up the grounds. However, they subsidized the investment with a bicycle and horseracing track in a highly populous area that would draw visitors.

In contrast, the ballpark in Washington sat on the less developed eastern end of the local city. Undeveloped tracts existed near the ballpark in the neighborhood known as Swampoodle. Overcrowded and plagued with violence, the tenements and ramshackle dwellings in Swampoodle housed many of the itinerant and poorest laborers in the city. The first waves of Irish immigrants settled in the area, to be replaced by Italians in the last decade of the nineteenth and early twentieth centuries. Similar to slum districts across the country, the area was underserved by the city services and transportation networks. The horse car that took people to the park did not have a permanent track. Instead, the transportation company laid the track down the center of North Capitol Street, NW as needed.[6]

Baseball's fan base consisted of men in the working and middle classes, so Robert Hewett believed the location would enable the team to be a success. Hewett made the financial decisions. Michael Scanlon, like other managers of the day, made the personnel decisions and the traveling arrangements. Despite the beautiful surroundings, the team finished in last place in the National League.

Capital Park II, view toward the Capitol, 1888 (Historical Society of Washington, D.C.).

Near the end of the first season, the Nationals' management announced a loss of $10,000. Since this was their initial season, the team spent $18,000 on a series of one-time expenses, including $11,000 to purchase the release of players from other teams and $7,000 on grounds at Capital Park. Michael Scanlon informed the press that things appeared much rosier for the next season. They expected to spend $28,000 on salaries and $7,000 on travel and hotels for a total of $35,000 in expenses for 1887 season. If the team earned the same amount as during the 1886 season, $45,000, they would make $10,000 profit.

As the photograph of the stadium showed, the team used the stadium itself to raise revenue. The team offered space on the fences around part of the outfield to local advertisers. These included a steam laundry on the western border of Swampoodle, a feed and hay store and a local food merchant. Other advertisers that presumably appealed to the fan base included a local bottling company and two sporting goods vendors. The most intriguing advertising sign featured an elixir named Mist. The sign carried the claim that Mist was good for the blood.[7]

The situation must have looked better for the near future. At season's end, the team treasurer Charles White and two other board members sued the club for the one-fortieth share of stock they never received at the beginning of the season. Robert Hewett and Scanlon argued successfully in court that the club incorporated in 1886, being different from the 1885 club, did not recognize investment in the former organization. The new team ownership reelected Robert C. Hewett president and voted Walter F. Hewett the team's secretary and treasurer.

The players received similar questionable treatment from the elder Hewett. Outfielder Cliff Carroll refused to sign a contract for the 1887 season. He believed club management wronged him with a $100 fine for a slight offense. President Hewett agreed with Carroll and promised that he would remit the $100 if Carroll signed the contract. When Carroll went to the bank to cash the check, he discovered Hewett had placed a stop payment on the check. The player took his case to the Base Ball Players Union and a committee went to the annual meeting to inquire into the matter. Several owners went to Hewett and told him he had acted wrongly and suggested that he settle this problem before the union brought the case up at the League meeting. President Hewett did.

Before the start of the second season the elder Hewett maintained he was unfamiliar with all the details connected with the game, which led to some ill-judged actions. He announced to potential local buyers that "[the club] can be obtained at any time by returning the plant to its promoters and assuming its liabilities." Whether the result of the recent treatment from his fellow owners or not, Hewett suddenly wanted out of baseball. "The club has made a hard struggle, but has been anything but a paying enterprise," he stated. The Hewetts retained control of the team.[8]

The Nationals moved up one spot to seventh place at season's end. One fan asserted that the team lost because their players were outclassed in the League. The reporter covering the team for the sports journal *Sporting Life* agreed, noting: "The club is resting upon its oars watching the great grab game that is going on for young players I can not understand for no club in the League has demonstrated its weakness more forcibly than the Washington Club." Another reporter noted that the board of directors met but conducted no business. "If the press can arouse the directorate they will be doing a charitable act."

The reporters expressed a legitimate complaint. The team's best hitter, Paul Hines, announced he did not want to return to Washington. The management could not keep him. The board did little regarding improving the team. The board did vote Luther E. Burket the team's secretary and treasurer as Walter Hewett increasingly acted in his father's position.

Later that month team officials astonished the baseball world. A report leaked that the team management had made an offer to the St. Louis team's management of $12,000 in exchange for the rights to first baseman and manager Charlie Comiskey. The correspondent for the *Sporting News* informed fans, "It is plain to see that President Hewett is fully determined to strengthen his team to the utmost and in doing so money will be no object. Every one who is acquainted with Mr. Hewett knows that if he makes up his mind to do anything, that he will do it."

The correspondent proved wrong. The only successful transaction during the off season hurt the team. Management traded the .300 hitter Hines in exchange for an outfielder who would have only three at-bats with the team. Walter Hewett defended management's choices for the team in early 1888 in the Washington press. Whether he convinced them of anything was unclear. However, National League officials considered Washington an experimental combination whose future remained uncertain.

The team management did eventually meet again before the start of the 1888 season. Like many of today's teams they immediately moved to enhance their personal earnings from the team. Before the start of the season, the directors met at the Hewetts' feed store and promptly voted to raise season ticket prices by 50 percent to $30 for grandstand seats. Despite not improving their product the team management felt emboldened to charge more to see the games. The fans responded with disdain, as few purchased these tickets. They still had to pay more to see the games as the League's officials mandated that all teams boost bleacher ticket prices from 35 to 50 cents. Matters grew worse when the *Sporting Life* reporter wrote at the beginning of the season that the owners had not yet full confidence in the capacity of their team.[9]

The players might have felt similarly about the team's management. With Walter Hewett taking the reigns as field manager, the team won 10 and lost 29. When the Detroit team visited Grover Cleveland at the White House in late June of 1888, the President commented on the poor showing of the Washington team. The Hewetts hired Ted Sullivan as manager and the team improved slightly.

Events in team management turned for the worse. In mid-summer, the sixty-one-year-old Robert left with his wife and daughter Laura on a convalescence trip to Vermont. Rumors flew about the team's financial status and the possibility of a sale. Walter turned greater attention to the feed and flour stores. As the Nationals climbed to seventh place in late August, Walter Hewett assured the League that the team was comfortable financially. However, the rumors of a sale gained credence when Robert C. Hewett returned to Washington and died days later.

Members from the various groups to which the senior Hewett belonged

carried his coffin. The National League and the Chicago club sent wreaths. However, the Washington club provided no tribute. The four survivors shared in the division of a personal estate worth $250,000 (approximately $3,000,000 today). Hewett's second wife Rachel M. Hewett received the house and an allowance of $300 per month. Their 17-year-old daughter Laura received $50 per month, while their 19-year-old son Charles received $10 directly and $40 per month would be retained until he reached 21 years of age. Robert provided Walter with $20,000 outright (approximately $425,000 today). In addition, Walter, Rachel and Luther Burket became trustees of the real estate holdings that were to remain in trust for twenty years. These holdings produced monthly rental income of over $4800 a year (approximately $102,000 today). The rentals paid for Mrs. Hewett's monthly allotment and provided the three children with "pocket change."

Robert Hewett left his eldest son in an excellent position from which to run the team. Walter held majority of the stock and the premiere executive position, team president. He had the significant personal wealth from the $20,000 gift. Walter also had control of his regular income as the owner of the family's feed store. His position as one of the city's premiere grain dealers enabled Walter to be voted the vice president of the Washington Grain Exchange in 1890. Walter expanded into the building supplies business but lost control of the business in 1895. A local member of Democratic Party organizations, Hewett would serve on one of the committees required to run the inaugural festivities for Grover Cleveland when he won the presidency in the election of 1892.[10]

The Eldest Son Takes the Helm

The beat reporter for *Sporting Life* believed that the team's future hinged on Walter's actions. "[However,] he prefers to devote his active attention to the flour and feed business. The life of a base ball magnate is not congenial to him." Did this attitude emerge before or after he managed the team? Walter Hewett demonstrated his limited baseball acumen when at season's end he did not act to secure any of the best players from the bankrupt Detroit team despite Washington's obvious weaknesses. He sold two pitchers and an infielder for $4,200 to the Columbus minor league team. Instead, Hewett sought a star and aimed at acquiring the New York Giants' shortstop John Ward. He offered the future Hall-of-Famer a contract for $5,000, the largest amount ever offered to a player. Ward asked for $6,000 and when Hewett refused, Ward opted to stay in New York for less than the $5,000 salary.

The son's organizational infighting skills might have been sharper than his baseball sense. Installed as team president, Walter leaked to the press that

the club owed his late father's estate $23,000. He promptly informed team stockholders that they owned $500 per share held. This heavy assessment created dissatisfaction among board members and caused several small shareholders to want out of the business. Several took Hewett's buyout offer but some wanted more money and their proportional share of the valuation of the Capital Park lease. Hewett refused his fellow board members while continuing to put his stamp on the team.

The young magnate also alienated other owners. They accused him of trying to pry players from every major and most of the minor league teams. Perhaps the older owners used this against him because of the Nationals owner's poor choices. Walter spent $5,000 to acquire second baseman Sam Wise from the Phillies. Wise hit .250 for his new team. While an upgrade from the last second baseman, Al Myers, the change hardly warranted the purchase price.

Hewett continued reshaping the team with the purchase of shortstop and new manager John Morrill from the Boston team for $6,000. The local sportswriters expressed pleasure with the deal, describing Morrill's hand-

Manager Walter Hewett and the 1888 Nationals. Left to right: front row — O'Day, Deasley, Hoy, Shock, O'Brien, and Myers; middle row (seated) — Irwin, Wilmot, Gardner, Donnelly, and Hewett; back row (standing) — Mack, Daily, Murray, Whitney, and Gilmore (Library of Congress).

some presence and the expectation that he would guide his fellow players well. Over the year, the 34-year-old Morrill hit .198 with the Boston Bean-eaters while managing them to a fourth-place finish in 1888. In his fourteenth major league season, Morrill met no one's positive expectations, as he hit for a .185 average and led the team into last place with over twice the number of losses as wins. He became such a defensive liability that he transferred himself from third to first base.

Hewett gave up on Morrill in early June. He purchased Arthur Irwin from the Philadelphia Quakers for $3,000 in early June and installed him as the manager. Although three years younger than Morrill, the shortstop fared as poorly as Morrill had, barely hitting his weight in 1888 (.219). He batted .233 for the Nationals but sparked the team to a 22–10 record, prompting the observation from the local press: "The Washingtons are playing great ball now."[11]

The team's turnaround could have attracted the numbers of tourists who visited the nation's capital in the late spring and early summer. However, the guidebooks available for tourists to the city featured the federal city, particularly the White House and Capitol. The local city included a few buildings. The listings for entertainment included the location of the opera and theater companies but not the baseball team. Despite including small maps of the Capitol Hill area, they did not include Capital Park as a site.

The absence of baseball from these tourist books could reflect the middle-class bias among the writers and/or the readers against this working-class sport. The guidebooks also did not include other amusement locations with working-class reputations, such as pool halls. Indeed, these places had the reputation of being part of the all-male bachelor culture of the era. However, scholars have observed that the class antagonism toward public amusements such as sports began to diminish among many within the middle class during the late nineteenth century. Thus antagonism was not the sole factor in omitting the Nationals as a possible amusement. The lack of inclusion showed the place of the sport in the culture at the time as much less prevalent and important, both in the world of amusements and overall, than it would become.[12]

The inclusion of the team as a Washington entertainment attraction would have been for naught. In the dog days of summer, Walter Hewett sold the option and the lease which the Washington Baseball Club held on the 322,000 square feet of ground that constituted Capitol Park. Chester A. Snow, a well-known patent attorney, purchased the lot at an estimated price of 70 cents a square foot. Snow would not disclose what he intended to do with the grounds. The team management auctioned off the ground stands, fencing and other materials.

Hewett announced that he expected to secure grounds more convenient to the Nationals' downtown patrons. Washington fans and the newspaper reporters noted that Hewett would struggle to find a new location. Very few open lots of the necessary size for a stadium existed in the core of the local city. Those areas the federal government reserved for its use could not be used for a stadium. The remaining spaces contained residences that made the surrounding empty grounds too small to use for the ballpark.

The team finished the season poorly after the sale of their home field. During the off season, Hewett met with three well-known Washingtonians, and the trio and Walter forged a syndicate. The members each agreed to advance half of the cost necessary to build a ball park and to place the baseball team on a first-class basis. Hewett left the city to attend the NL's winter meetings and nothing more occurred with the syndicate.

The National League owners had tremendous worries as a new league emerged to create serious competition for attendance. Many baseball players left their teams in both the NL and AA to join the new eight-team combine established for the 1890 season, known as the Players' League. Hewett's Nationals had lost many of the best members to the Players' League teams in Philadelphia and Buffalo. League officials used legal threats to undercut their new competitors and considered eliminating the weaker teams in their own league to improve the financial circumstances.

In January, Walter Hewett developed his own response to the three baseball league crisis. He announced that the Baltimore ownership would purchase his franchise for $25,000. The newly-combined team would share home dates between the two cities. Two weeks later the deal vanished. National League officials expressed their concern about the team's status. President Nick Young worried about Walter's confusing, dilatory tactics and requested definite actions toward finding a stadium in Washington. By early March 1890, team management had still failed to secure grounds.

The season loomed and the National League published a schedule for the new ten-team league. Meanwhile they worked frantically in the backrooms of the League's offices to whittle membership down. Within a week, Washington and Indianapolis each accepted $20,000 to leave the League. A seemingly more solidified unit, National League owners turned their wary eyes to their uneasy alliance with the American Association and their new enemy, the Players' League. The ease with which the Washington team left the NL and the lack of protest indicate that the sport affected a small minority of the population and a limited amount of outside business interests. Walter Hewett's actions might have signaled the lack of interest he held for continuing in the sport, having secured a significant amount of money from selling the grounds and for leaving the National League.[13]

"Show Me the Money"

The Washington Baseball Club's new assets prompted Walter's half-sister Laura G. (Hewett) Robinson, to wonder about the state of her deceased father's estate. She brought suit against the three executors, her mother, stepbrother, and Mr. Burket, to discover what happened to Robert Hewett's assets. Robinson claimed the team owed her father's estate $23,000 and the club received $20,000 from leaving the League and $12,000 from sale of Capitol Park.

The executors issued individual responses to the suit. Her mother Rachel denied that the club had sufficient assets for payment of all its indebtedness. Walter Hewett denied the club owed his father any more than $10,000, contradicting his own statement of one year earlier. A few weeks later, Mrs. Robinson added a claim that Walter Hewett purchased stock of the club from other board members for $300 per share and paid for it out of the club's assets. The team meant more to Walter Hewett as an asset to liquidate than one to maintain as a going concern.

Others wondered about the financial affairs of the baseball club. Two stockholders, Michael Scanlon and Mary C. Cronin, who inherited her husband's share, instituted their own lawsuit. They alleged that the sale of Capitol Park that Chester Snow, Walter Hewett and Luther Burket engineered was irregular because there was no official meeting of the team's board members. The plaintiffs noted that the defendants received the $12,000 for the lot and asserted that the small amount was evidence of a fraudulent combination to defraud the baseball club corporation. They also sought accounting for the $14,000 for the sale of players, $850 for the sale of the grandstand and fencing, and $20,000 for the sale of the franchise of the club acquired during the last year and a half. The defendants won a demurrer on the case because the complaint lacked the addresses of the plaintiffs and their complaint contained too many claims.

While these cases moved through Equity Court, the future of Capitol Park became clear. Two years earlier, a grand jury had declared the Government Printing Office's existing four-story wooden building on North Capitol and H Streets a fire hazard and a death trap. Congress empowered a board of commissioners, which included the head of the Government Printing Office and the Architect of the Capitol, to find an appropriate site for a new Government Printing Office building. In late July 1890, the Senate passed an appropriations bill that included $250,000 for the purchase of the lot where Capitol Park stood. The trio negotiated with Chester A. Snow and purchased the Capitol Park lot for $243,175. Snow profited from the knowledge that the federal city needed to expand and would be looking to

purchase the local city area near the existing Government Printing Office building.

The Scanlon-Cronin Suit Against Walter Hewett

The court case against Hewett blocked the completion of the sale. Now representing the Washington National Baseball Club, Scanlon and Cronin, later joined by a prominent resident of the District, Charles E. White, submitted a new claim against team management Walter Hewett and Luther Burket. The suit also made Chester Snow and former property owner Thomas W. Smith co-defendants. The plaintiffs still asserted that Hewett and Burket acted fraudulently when they sold the property to Snow and deprived the club of all its rights and interests in the property. They claimed that all the defendants hid the sale of the property to Snow through using an intermediary named Jack Cole to make the initial purchase.[14]

Only one of the defendants testified. Thomas W. Smith insisted nothing fraudulent occurred with the sale. He explained that the sale of the land to Jack Cole as an intermediary was necessary only because Snow needed his wife's signature in order to purchase the property. Mrs. Ada Snow happened to be out of town. Whether Mrs. Ada Snow was in town or approved of the Capitol Park purchase remains a mystery. However, within a year the 24-year-old divorced Chester Snow after six years of "suffering through association with her husband, whose temper was not compatible with mine." The pair parted with Chester Snow bestowing property upon his ex-wife in lieu of alimony.

Smith concluded his testimony by noting that approval of the sale occurred at the baseball club's stockholders meeting in July 1889. He stated that present at this meeting were 17 of the 20 shareholders of the team. Hewett and Burket sent a written response that denied that either of the plaintiffs owned stock at the time of the assignment of the lease to Chester Snow. Hewett denied that he received the money that the plaintiffs claim he did from the sales of the team's assets. He asserted that his statements regarding personal money he spent on the team were also true. The pair delayed appearing in court in person, ignoring a subpoena. When they arrived in court, Burket stated that he had not been able to find the papers documenting the team's finances.

New property owner Chester A. Snow filed a crossbill to Scanlon and Cronin. In his suit, Snow asserted that the plaintiffs filed the suit to hinder the sale of his property. Whatever the original sentiment during the incorporation of the Washington Base Ball Club, one of its founders found himself suddenly on the defensive in a court case that he had initiated. Scanlon

denied that a "phony Board" had the authority to pass the resolution authorizing the park's sale. Further, he reasserted that his suit's purpose was to receive an accounting of the team's finances from Hewett. However, both the Special Term Judge and the Appeals Court reviewed the suit and disagreed with Scanlon, accepting Snow's crossbill while ordering Scanlon, Cronin and White to cover court costs.

In the midst of the Scanlon case Walter Hewett took himself to court. The Hewett family members sued Walter, Rachel Hewett and Luther Burket, the trio of trustees for Robert C. Hewett's estate. The claimants argued that the tester, the late Robert C. Hewett, had no right to postpone the division of his real estate holdings throughout the city of Washington and neighboring Maryland for twenty years. The family members claimed that they could improve property if under the charge of the ultimate owner. Not surprisingly, the joint answer of the defendants claimed they believed the complainants were entitled to the present division of the estate. The Equity Court Judge agreed to the division of the real estate. The children each received $90,000 worth of properties, about $1,844,000 in today's terms. Mrs. Hewett received her house.

The division of the assets prompted the family members to sue one another over the next decade. While the Hewett family battled in the equity courts had only begun, their influence on local city baseball ended. The Hewetts demonstrated that a stadium with a view of the Capitol did not guarantee a winning team or gate receipts, both of which depended upon good management. The Hewetts established the pattern Washington D.C.'s baseball team owners continued, exhibiting greater concern over their personal finances than with the team's fortune on the field.

After the NL bought out Walter Hewett in 1890, the remaining NL owners formed a war committee to battle the newly formed Players' League. The owners began the public relations war against the new league. They referred to the many players who jumped from their teams to join the new league as "spoiled and greedy" in the media. Privately, they convinced their AA brethren to field teams in Toledo, Ohio, and in Rochester, Syracuse, and Brooklyn, New York to drain attendance away from the Players' League franchises in Brooklyn, Buffalo, and Cleveland.[15]

This battle royal damaged financial ledgers across the board. A schism between Players' League owners and the players prompted that league's demise. The AA's Philadelphia Athletics team went into receivership during the middle of the season. The four additions to the AA League ended the season defunct, requiring the remaining teams to expend their cash to buy the owners out of their franchises. The AA/NL owners devised a remedy for the AA's financial problems. The owners admitted the Boston Players' League

franchise for the new season. They also added new franchises in Cincinnati, Milwaukee and Washington, and allowed the owners of the Philadelphia Players' League franchise to purchase the Athletics franchise in the AA League.

This turbulent environment provided Michael Scanlon with an opportunity to return to the head of the Washington baseball world. Scanlon had worked since the moment Hewett sold the Washington franchise to bring major league baseball back to Washington. As his effort neared success, newspaper reporters asked the veteran of D.C. baseball if Walter Hewett would have anything to do with the new team. Scanlon responded, "Nothing whatever." Without delay he added, "He has had a monopoly of the sport for several years now and has made a failure of it. We will try it without him this time, and I think the result will be successful."

Scanlon convened a board of directors meeting for the corporation that owned the city's new American Association franchise in the winter of 1891. After creating the corporation's charter, the holders of the 28 shares of stock paid $125 each, with the expectation that they would pay the remaining $125 value per share on April 1. Besides finding the men interested in this investment whereas Walter Hewett had not, Scanlon found playing grounds while Hewett had informed National League officials that he could not find new baseball grounds in 1890. Scanlon looked north of Florida Avenue, outside the boundary of the local city into Washington County. He paid $1200 for the ability to lease a park with a rich history of serving many communities in the District.

The corporation arranged to construct a field in a park on Seventh Street Extended near Pomeroy (now W) Street, NW. While officially known as Levi Park, this square had additional names in its recent past, including Beyer's Park and Old Schuetzen Park. Beyer's Park served the city's Irish and Scottish communities as a location for picnics and political events as well as the annual Gaelic Games. At old Schuetzen Park, the small but prominent German-American community hosted its first annual festival before they moved into a park area in Columbia Heights.

The park also contained buildings on its northern and western edges. In 1865, the upper portion of the square park became the location for the Freedmen's Hospital. The hospital then moved two blocks east when it became the teaching hospital for the recently formed Howard University. A year earlier, the Maryland House Hotel had opened on the western portion of the park at Seventh Street. Originally a resort, offering a bowling alley, ball field and amusement park, the property shifted its focus to the hotel as the ball field and the rest of the city removed the sense of country from the resort.[16]

The new stadium sat in the southwestern portion of an area known as Howardtown, a community of middle-class and poor blacks. The ball field

arrived at a time when these residents battled their new neighbors in one of the city's first suburbs, Le Droit Park. Conceived of fifteen years earlier as a quiet, aristocratic enclave, Le Droit Park also offered easy accessibility to the city through the streetcar on Seventh Street. Le Droit Park struggled against encroachments on its "bucolic" existence. The residents used fencing along its northern and western borders to block off the Howardtown residents' ability to navigate downtown through their neighborhood. The District commissioners aligned with the opponents of the fencing and carried the battles into the court system. Within a few years, the continued expansion of commercial ventures all around the area, and the settlement of the first black family in Le Droit Park, sparked the transition of the area from "romantic suburb to racial enclave."[17]

The new ball field enjoyed the same transportation advantages as the two battling communities. Patrons could use the Seventh Street car as they would. They could also arrive on the Ninth Street car and take a short walk. Even with connections these cars offered most downtown residents access to the field in 12 minutes.

The team's ownership had to create the stadium from the unimproved areas in the park. Scanlon observed that the new playing field required a work crew to fell hundreds of oak trees over the winter. This clearance enabled the construction of the grounds and the "finest bleachers with places for people to rest their feet without putting them against the backs of the people in front." The ownership stated that they would spend $7,000 to $8,000 on the grandstands.

As this clearance began, the National Baseball Club received its permit to erect a grandstand and bleachers in accordance with the plans approved by the District's inspector of buildings. Shaped like a horseshoe and one story high, the wood frame grandstands had tin roofs and contained 1,200 folding chairs. In the center, newspaper boys sat in the press box and provided spectators answers to their questions. A central tower rising above the roof provided the seating of exalted personages. The team constructed bleaching board benches to the south of the grandstand, offering 2,000 seats for the less affluent fans. The newspapers suggested that the design provide space behind the grandstand for carriages to park. They also suggested that the team place the side fencing next to a run of oak trees already on site to partially shade the field and make the grounds as attractive as any in the country. The franchise spent $5,000 for the construction, as much as they spent to create the clearance for the ball field, for a total worth approximately $200,000 in 2005 dollars.[18]

The promise of a new team and the building of a new stadium carried cachet then as they do now. The team drew 4,000 fans to the opening games

at National Park. However, within a month, the team's poor play resulted in team management's engaging in rash moves. Scanlon and the directors provided advance money to players who, the columnist for the *Sporting News* observed, rarely merited carfare. By mid–June, newspapers headlines blared, the Washington club lost games with astonishing regularity and, of course, this made the "cranks" (fans) sore. Despite their poor play, the team averaged 1,200 people per game. However, team investors realized the team could not draw the average of 2,000 necessary to realize a handsome profit and presumably readied to give up the franchise. Their worries disappeared in the larger events that shaped major league baseball.[19]

The weakened state of many of the American Association franchises drove the AA out of business. The desires of the National League owners to control the game under their imprimatur resulted in the creation of a National League with twelve clubs at the end of 1891. Baltimore, Louisville and St. Louis withdrew from the American Association and joined the National League. The Washington team withdrew but did not remain intact. Instead, the major league franchise for the District of Columbia went to the owners of the Philadelphia Athletics team of the American Association. For the second time in as many years, owners George and Jacob Earl Wagner packed up their team and joined a new league.

The Butchers from Philadelphia: Carving Up D.C. Sports

The owners of the Wagner Brothers meat packing company inherited the Hewett family baseball heritage and became Washington's second baseball family. If Robert Hewett and his son Walter's rare expenditures on the baseball team went toward poor decisions, George and J. Earl Wagner acted more capriciously and set a standard for pillage that would not be challenged for seventy years.

The proprietors of seven butcher shops in central Philadelphia, the Wagner Brothers received most of their $76,000 investment in the Philadelphia Athletics franchise back. The newspapers informed the public that the Wagners spent $6,500 for twenty-six out of 30 shares of stock and assumed $8,000 in club debt. They assured the public that they would not attempt to retrieve previous losses at the expense of the Washington public.

The Athletics finished the 1891 season in fifth place. Combining them with the best of the Washington team bode well for the new team's prospects. The Wagners promised to field a competitive team, promoting excitement in the local newspapers and among the city's baseball cranks. *Sporting Life* likened the excitement to the lover's ecstasy on being accepted by his beloved.

The new owners built support through offering positions on the Board of Directors to local baseball men Michael Scanlon and Charles E. White. In addition, the new owners added to the bleachers to create more seating and literally raised the roof on the grandstand to include more seats and establish an area of high-priced private boxes.[20]

The baseball cranks and other locals rewarded the Wagners for their promises. Nearly 6,500 people attended Opening Day. They continued to attend in such large numbers that one observer noted, "George Wagner has a gold mine in the possession of the local club property." A mere two games into the season, trouble between the Wagners and Manager Billy Barnie led to the firing of the respected and popular field leader. The owners hired another respected manager, Arthur Irwin, to a two-year contract. The League played a split season to determine the two teams to meet in the championships. Irwin led Washington to a seventh-place finish in the first half, the best finish for the city's teams in the National League.

However, the public disliked many of Irwin's personnel choices. Shortly into the second season, fans called for his firing. They grew increasingly boisterous as the team made its move toward the basement in the second season. The Wagners made the change with George noting, "Last year the Athletics landed fourth without a manager and I have about come to the conclusion that only a playing manager will fill the want in Washington." Danny Richardson ran the club from second base but their play remained poor and attendance took a nose dive. The Wagners made the same significant mistake the preceding year's owners had and did not maintain a consistent team or manager.

George Wagner kept the business of sport foremost in his mind. He announced at season's end his expectation that the streetcar companies servicing the park would again contribute a combined $800 to the franchise. Scanlon had tried this unsuccessfully a decade earlier but the Wagners negotiated with the streetcar companies more successfully. Since their park was located on the edge of the local city, they argued that it generated riders for the streetcar companies. The Wagners viewed the role of sport as that of a profit generating enterprise.[21]

Rumors of George Wagner's desire to buy the Pittsburgh franchise soon appeared. Wagner thought Pittsburgh a better market for his meat goods and wanted to establish a large store there. The District already had three butchers with stores at each of the city's main markets. The city also had a ready supply of meat coming in from the eastern border with the state of Maryland. The Wagners' involvement as the owners of a baseball team in Washington extended beyond making a profit from the team. Sport would provide them the opportunity to expand their core business.

Despite rumblings from Walter Hewett among other locals, Wagner

could not find a buyer for the Washington team. Sportswriters informed D.C. fans that being smart baseball men, the Wagners would put together one of the strongest teams in the League. The personnel part of the business of sport proved less straightforward. Wagner traded fan favorite but unhappy member of the Washington squad, infielder Danny Richardson, for infielder Billy Joyce. Directors Scanlon and White resigned in protest that the Senators had not received ample compensation in the deal.[22]

The question of whether the local directors were correct could not be resolved in 1893. While Richardson hit in the low .200s for the Brooklyn team, Joyce refused to play for Washington or in the major leagues. He missed little but disappointment in Washington as the team finished last, fourteen games worse than the year before. The editors of the *Post* asserted, "Mr. Wagner cannot hope to arouse much enthusiasm or interest in this city in baseball. His style of doing business has alienated patrons and fellow owners."

The Wagners then made an imperious move. The owners decided on their own to move the last home games of the season to Chicago because the crowds who attended the World's Fair in the city might increase ticket sales and profits. This action irked District residents. It also annoyed the other baseball magnates, who added a $1,000 penalty for such action to the League's bylaws at their winter meetings. The newspaper concluded its assessment with "the continuation of the present management would be fatal to any success next season." George Wagner reportedly offered the Washington team, now popularly known as the Senators, to a syndicate led by Walter Hewett for $30,000, double what he had paid for the team two years earlier. No negotiations ensued.

Looking for New Profits: Professional Bicycling

The Wagners and fellow magnates looked to expand their sporting empire. During the 1880s, amateur cycling held the interest of the public. Occasionally the amateur association faced the problem of racers desiring to leave the amateur ranks so they could earn cash prizes. In 1893, the baseball magnates established the National Cycling Association (NCA), an organization to run a professional cycling league that used the baseball parks to stage their meets. The editors of the Cycling Department of *Sporting Life* predicted the NCA would be profitable because of low costs and bicycling's high drawing capacity. George Wagner participated in creating the association and devising its bylaws, racing rules, and schedule. The owners in Baltimore, Louisville, Cleveland and Cincinnati opted out immediately. George Wagner considered laying down the track at the baseball grounds, then decided the cost was prohibitive and chose not to participate in the NCA.[23]

The racing season began over the July 4th holiday. Meets occurred weekly through the end of October. Of the nineteen meets, four races took place in New York, three each in Brooklyn, Boston and St. Louis, and two races in Philadelphia. The remaining four meets occurred in the non–National League places of Milwaukee, Wisconsin; Troy, New York; and Springfield, Massachusetts. The races averaged turnouts of 6,000 persons, who greeted the sport enthusiastically. The sporting press noted, "Racing for cash prizes the men will ride faster and try harder for success than they ever thought themselves capable of doing."

As sports departments of today do with golf and tennis, the sports weeklies printed a list of the top money winners in bicycling for the season. Despite attendance and media coverage, during the winter of 1894, the baseball magnates in the NCA admitted a reorganization was necessary. The NCA lost $12,000 in purses alone and operation expenses ran the debt to nearly $20,000. The big-name racers from amateur cycling did not join the NCA, limiting the popularity and profitability of the professional league.

Another Pitiful Baseball Season

The Wagners escaped the NCA's financial loss. Those who absorbed that loss had little time to focus on their wounds as the new baseball season arrived. The editors of the *Washington Star* offered an observation of the city's possibilities to the Wagners: "With only a little encouragement this city would excel all others as a center of baseball enthusiasm...." For the third time a new manager took over the Senators' helm during spring training and the chorus of positive assessments about the team's prospects began anew. The editors expressed their warning:

> [Team management] may be doing its utmost to secure possession of good playing talent, or it may be planning speculative activity in which the present dime will be preferred to the prospective dollar.... There is a dull season ahead if the management proposes to find its profits in the trading of good players and in public credulity.

Manager Gus Schmelz described the three solid weeks of training the players would endure. He created a competition between veterans and kids to determine who would play each position on the field. The veterans included "Scrappy" Bill Joyce, who decided he would rather play with a bad team than not at all. These competitions were undercut when the butchers sliced a veteran pitcher and a popular catcher from the squad in a deal with New York. The pitcher traded to New York, Jouett Meekin, won 30 games that year. His batterymate Duke Farrell hit .285 over three years with the Giants. Mean-

while new Senator Charlie Petty pitched very poorly for one year in D.C. The other man who came in the trade, utility infielder Jack McMahon, refused to show up in Washington.

Team management did not want the financial arrangements made known. However, an official of the Brooklyn club told the press that he saw the check for $7,500 the New York owners gave the Wagners. The trade damaged the perception of the Senators' chances among the magnates. When St. Louis owner Chris Von Der Ahe saw the schedule for the 1894 season he complained, "My holiday attraction, my Fourth of July games, will not attract a corporal's guard. The Washingtons are last now, and will be last all the season, yet I am expected to play them on my only holiday at home."[24]

During the first month, the team fought hard on the field. As the team's record dropped from 2 wins and 8 losses to 3 wins and 22 defeats, rumors circulated that the brethren of baseball owners had tired of the Wagners and the way they did business. Washington was no money maker in the eyes of the other owners. The team earned $29,000 in receipts for the year, ranking them second to last in the league. The other owners wanted to make money through improving the product and generating more interest rather than through selling off team assets. J. Earl Wagner taunted the other owners, noting that talk of booting the Wagners from the League was folly because the twelve clubs had a ten-year binding contract.

Despite or perhaps because of their Wagnerian bravado, the team's best players, including Scrappy Joyce, sought trades to leave Washington behind. The *Star* editors sought a solution to the doldrums the Wagners' pernicious ownership caused in Washington. They wrote that in England a prize went to the donkey that finished last in a race. They proposed that the last-place teams in the National League engage in a contest for a booby prize. Sport had a role as a contest to win and as a method of building community spirit and identification absent from the Wagner's equation.[25]

Looking for New Profits: Professional Soccer

The baseball magnates again sought to expand their sporting empires. Near the end of the 1894 season, representatives from the six Eastern clubs met in New York City to form the American League of Professional Foot Ball Clubs (ALPF). The group asserted that Association football, similar to what the United States calls soccer today, would become the country's winter sport. The games occurred at the baseball parks, enabling the owners to put the fields to work earning a profit during an additional season. The magnates used the names and the managers of their baseball teams for these squads, expecting that a brand-name loyalty would bring in spectators.

The league used a constitution similar to the one used by National League baseball and rules that followed those established in England. The owners decided on appropriate team uniforms and began working on a schedule of games to be played between October and January 1. As writer Steve Holroyd notes, the early attempt to professionalize soccer in the United States predates leagues of American football and basketball. Unfortunately, the effort was partially undermined by the Wagners and their fellow baseball owners.[26]

The American Association of Foot Ball Clubs already had a twelve-year history. Based in New England and the mid–Atlantic states, the team owners sought to stop the new league's encroachment on their game. Although run as much for pleasure as for profit, the American Association clubs passed a rule prohibiting any person who played with the American League from playing in the American Association. The baseball magnates countered with contracts of $75 month to entice players but soon discovered most players required double the figure. Those teams engaged in the battle for the National League baseball pennant, particularly Baltimore, had no time to form their football team.[27]

After observing these unanticipated costs and follies, a man identified with National League baseball questioned the choice of the magnates in football. "The League might have been a financial success by adopting the college game. The Collegians have the following...." The magnates chose not to support a league that played the college style of American football because of its violence and bad reputation. Reporters noted that with the ALPF game, there was not nearly the chance for the injury or crippling of players that existed in the college game, yet it filled the requirements of an exciting, scientific game.

The ALPF inaugurated its 25-game schedule. In order to draw more crowds, the Wagners offered free admission to ladies that brought baseball admission books with them. The owners made the mistake of staging games in the afternoon twice during the week. Unfortunately, this game time occurred when the core audience for this type of football, the immigrant populations of these cities, were at work. Therefore this ripe audience could not attend the games. Consequently, the turnouts for games numbered in the hundreds instead of the thousands. The baseball magnates promised to sustain losses while educating prospective regular patrons in the game. The next year, they proposed that they would play game under electric lights two nights a week in the six cities during the summer.

This changed after a mid–October game where the football Baltimore Orioles found the Washington Senators as easy to defeat as their baseball counterparts. One of the Senators read an article in a Manchester, England, newspaper about an old baseball manager and scout named Ted Sullivan who

took Manchester "football" players to Glasgow. The names were identical to four players on the Baltimore team. Oriole management's claims that the players hailed from Detroit did not satisfactorily address concerns.

The allegations regarding illegal alien workers in the ALPF reached the U.S. government. Secretary Carlisle of the Treasury Department commented, "In the opinion of the department, football players are not artists, and, coming into the United States under contact, would be prohibited from landing. The Immigration Bureau of the Treasury Department, in the interest of American sport, will probably investigate the allegations made." Two days later, the magnates announced their decision to disband the ALPF. Whether out of fear over an investigation, concern about their baseball enterprises, loss of money, their football's inability to wrest interest of fans from the collegiate-style football, or all of the above, the Wagners and other magnates failed to find a second sporting use for their ballparks.[28]

Looking for New Profits: Outside Sport

The half owner and president of the Senators, J. Earl Wagner, pursued other methods to use his baseball team to maximize his investments. He invested in a production of Charles Hoyt's play *A Texas Steer*. The farce about a wealthy, illiterate cowboy who became a congressman played to appreciative audiences in Washington, D.C., and in New York City in the early 1890s. The company toured successfully during the winter of 1895 and early 1896 under the management of Gus Schmelz, the Senators' manager. J. Earl told his fellow magnates at the winter league meeting that he would "give up base ball in order to devote more time to theatricals!" The comment fueled whispers of the team's possible sale. However, Washington, D.C., newspaper owner and businessman John Rolls McLean's interest in making the purchase ended with him saying, "No, I have all the trouble I care for."

The validity of the statement can not be questioned. McLean owned the *Cincinnati Inquirer* and the *Washington Post*. He served as a director of the American Security and Trust Company and the Riggs National Bank. His additional business activities included land development. After his parents moved from Ohio and established themselves as members of the city's new society, John Rolls moved to Washington and joined the ranks. This nouveaux riche class contributed little to the high arts cultural institutions of Washington. If they would not provide to institutions which were "appropriate" for members of society it would seem highly unlikely that McLean would expend his money on the city baseball team, predominantly owned and run by the working and middlebrow.

Promises of great improvement on the field again filled the spring train-

ing season. The Wagners added a complaint about the District commissioners. These city officials planned to expand the streets in the new subdivisions, such as Le Droit Park, beyond the old city boundary line, including extending Sixth Street through right field. J. Earl complained, "But for the street extension scheme, I would have a $30,000 grand stand ready for the fans." Yet two months later, Wagner was, as the correspondent for *Sporting Life* related, shaking his own hand. Wagner praised himself for building the covered stand erected on right field from grandstand to first base and the open seats that adjoined this new stand and extended to the score board. The left field seats were covered and enlarged to provide more tiers of folding chairs.

Don't Leave Well Enough Alone

The Wagners might have filled the new stands because the team played well under player-manager "Scrappy" Joyce. Fans flocked to National Park. As a letter to the *Washington Post* suggested, fans wanted Earl Wagner to keep Joyce as his leader on the baseball diamond and relegate the whiskered Schmelz to his theatrical business. The Wagners maintained an uneasy balance between their field and dugout leaders. The men divided the team's loyalties.

Instead of dealing with the schism the Wagners paid $1,000 to slice off the team's only utility man. This man had been described as the future of the team three months earlier. They tossed the team's current second basemen into the deal for a similar type of second baseman. The change caused great harm. After a hot summer road trip, players drank, divided into factions, and rebelled against Manager Gus Schmelz; the Wagners had to make another change.

The butchers turned their earlier loss into a net gain of $1,500 as they sent Joyce to New York. In exchange they also received a suspended pitcher, Duke Farrell, and $2,500. Letters from members of the Ancient and Honorable Order of Senatorial Rooters understood the move as a financial consideration. They cited the uselessness of the players the Senators received and the team's lack of an effective replacement for Joyce at third base. They called upon fellow members to show their disgust by vacating the bleachers. With Joyce's departure, Manager Schmelz regained total control of the team.

Despite the roller-coaster season, the Senators drew well. The team averaged 3,590 fans, placing them seventh in the league despite their ninth-place finish. The team finished second to Cincinnati in reaching their market, with the daily attendance representing one patron for every 64 people in the city. The chart below also illustrates a limited growth potential for the market, with only Louisville having a smaller population than Washington, D.C.

Figure 1. Averages in Attendance for
12 National League Cities in 1896[29]

Team	1890 Population (from Census)	Daily Average Attendance	Daily Average Attendance: Ratio to Population
Philadelphia	1,046,964	5,585	1 to every 187
Cincinnati	296,908	4,944	1 to every 60
New York	1,710,715	4,489	1 to every 381
Baltimore	434,439	4,489	1 to every 96
Boston	448,477	3,940	1 to every 114
Chicago	1,099,850	3,790*	1 to every 290
Washington	230,392	3,590	1 to every 64
Brooklyn	853,945	3,416	1 to every 250
Pittsburgh	238,617	3,345	1 to every 71
Cleveland	261,353	2,458	1 to every 106
St. Louis	451,770	2,306*	1 to every 195
Louisville	161,129	1,511*	1 to every 106

*Does not include Sunday games

The team's ineptness on the field carried through the middle of the next season and hurt attendance. The Wagners accepted Schmelz's resignation; Earl Wagner assumed charge of the team. In a letter that inadvertently fell into the local media's hands, Wagner predated the words of many a modern sports team owners when he wrote that he considered "the team a dismal failure notwithstanding the high salaries paid." With such a vote of confidence, fans stopped patronizing the "Brown aggregation of consistent losers."

Earl Wagner assumed the player development responsibility of management as well. He left on a search for new faces. While sitting with Boston Beaneaters' President Arthur H. Soden watching his team play, Wagner met a deputy of Boston city Sheriff O'Brien. An unsettled account between a printing company and the *Texas Steer* company prompted Boston's finest to detain Mr. Wagner until he showed cause why he could not pay the $800 bill. The bail bondsman never appeared so Washington's owner sat in the Charles Street Jail until Mr. Soden arrived very late that evening to bail his friend out. Wagner complained, calling the New York firm's effort outrageous in view of three prior court decisions ruling against it.

Proclaimed a big financial success during its run, how does a production, after two dormant years, owe money? The Shubert brothers produced a tour of New England for *Texas Steer* later in the 1897–1898 season. The production made a lot of money. The earnings bankrolled the Schuberts' first theater. Had the Wagners mismanaged the production into another losing

investment? Were they forerunners in the creative accounting that would become increasingly commonplace in professional sports?

That the Wagners did not earn a profit from the production company seems curious. It appeared downright questionable after the creativity Washington's magnate had brought to the National League winter meeting in December 1897. Earl Wagner broached his idea of "reciprocity" (trading of stars of equal value between teams) and intrigued some owners. Philadelphia's majority stockholder John Rogers countered with a more traditional approach, offering Wagner $25,000 for his top four players. The Senators' owner laughed but that night must have mulled the proposition over.

The next day he melded his earlier idea with Rogers' offer. Earl proposed to Rogers and the Quakers' minority stockholder Al Reach that they give him $30,000 and take the first twenty players from a pool of the Quakers and Senators. Rogers reeled groggily to an onyx pillar but was revived by Brooklyn owner Charles Napoleon Byrnes invitation to the bar. Rogers responded, "[W]e couldn't afford to take the chance. What would the public of Washington and Philadelphia say, Earl?"

Wagner thought neither the public nor press would pose a problem. Earl sent a newspaper card to the press that explained the proposition, stating he believed that the deal would make both teams stronger. While one team would have the best players from two teams, the other would have a lot of money and extra players to acquire the best young players.

Rogers rebuffed Wagner's offer the next day over the fear of not creating a winning ball team out of his twenty choices. Earl showed the Wagnerian bravado. The Washingtons' magnate offered the Quakers' owners $30,000 to let him choose twenty players for the Washington squad. Rogers responded with utter aloofness and Wagner ended their discussions. Washington's owner was one year ahead of his colleagues. Both the Brooklyn-Baltimore owners and the St. Louis-Cleveland owners engaged in the pooling of their best players on one team (Brooklyn and St. Louis) before the 1899 season began, but they undermined the Baltimore and Cleveland teams in the process.

The Washington management in the 1899 season became one of the first to engage in another activity that became more common in the twentieth century. The Wagners rehired a man that they had replaced as their manager years earlier. Arthur Irwin, who managed the Senators during their first season, received total control over the team's operation for what would be the team's last season. However, after another finish near the bottom of the National League, a large group of baseball followers met at Willard's Hotel, led by Michael Scanlon. The Wagners offered Scanlon the option to buy the club for $30,000. The purchasers asked about the lease on National Park, which still had five years remaining. However, the lease would be useless if

the District commissioners' plans to extend Sixth Street through National Park's right field received congressional approval.

The expansion of the local city moved into Washington County. If the planned infrastructure accompanied the new development of Le Droit Park, the District would lose another ball park. This time, the political powers of the local city and the federal city would take the stadium away from the local sports franchise. It the politicians built their streets, the marginalization of professional sports in the culture would be writ into the landscape in Washington, D.C., where the nearest stadium would be twenty minutes from the city's population centers.

The status of the NL proved another significant concern. Rampant doubt about the continuation of the 12-team National League abounded. The callous management in Cleveland, Baltimore, and Louisville increased fans' disenchantment and undercut the franchises' ability to continue playing. Still, Scanlon and his partners offered shares in the baseball team for $500 each, the money to be paid when the full 100 shares had been sold. The uncertainty about the ballpark and the size of the National League resulted in the group's not being able to raise the purchase price and an additional $20,000 for operations.

Unable to sell, the Wagner brothers resumed insisting that they wanted to remain in baseball. But the most influential NL owners formed a consolidation committee that sought to reduce the teams in the league to eight. The Wagners put a high price on their franchise, which created a stumbling block. Meanwhile, the NL owners did purchase the Louisville and Cleveland teams. The continued existence of the Washington and Baltimore teams provided newspapers the opportunity to speculate about the possibility of a ten-team National League.

A burgeoning new major league, the American Association of Baseball Clubs, emerged. This group started making plans to find the backing for franchises in eight eastern cities. The NL owners recognized the challenge to their financial base and countered with the threat of placing "Class A" clubs in the same cities as the American Association. Neither of these leagues would have teams in Washington, ensuring the city of minor league status at best. Washington fans and former players asserted that the city would not support a minor league club. As one of the Wagners' many former managers, Tom Brown, observed, "This, the Capital of the nation, is built too much on cosmopolitan lines to stand for a bunch of minor leaguers."

In early February 1900, Earl Wagner filed an application with the National League office for twenty-five blank contracts. He intended to forward them to various Senators for their signatures. A day later, the American Association effort collapsed when no backer appeared in Philadelphia to round out

the eight-team league. John McGraw and Wilbert Robinson gave up on their attempt to field a Baltimore team and made overtures to return to the National League as long as they remained in Baltimore. Less than a week later, Earl Wagner signed eight of his players to contracts and shipped them off to his friend Mr. Soden, the owner of the Boston Beaneaters. The *Washington Post* observed, "The Washington management received $7,500 for the consignment of baseball bones and flesh it delivered to Boston. The traffic appears to be good."

The total sales netted the brothers approximately $15,000. They also received the amount paid for the franchise, approximately $25,000. Earl Wagner noted that he and his brother had made $130,000 from the ownership of the team during the eight seasons, over three million dollars in today's currency. After running a team that spent years in the bottom of the league, the Wagners left Washington without a baseball club and with a government initiative to build a street through the only big league ball park in the city.

In *Creating the National Pastime*, G. Edward White argues that baseball teams became a focus of a city's civic pride in the early twentieth century. This became more accurate as urban populations exploded and cities' environments and reputations improved. But as Washington's experience with the Wagner brothers illustrated, the emotional investment that created a cultural symbol out of a private enterprise is an exceedingly risky attachment. Yearly promises of long-term success can be derailed as the temptation for personal short-term gains appears before franchise owners.

Palisades Dreams

The baseball magnates thought the popularity of amateur cycling meant the possibility of making money controlling a professional version of the sport. As we learned, the cost of the track motivated the Wagners not to join the National Cycling Association (NCA), and they saved themselves from the money-losing proposition. The NCA in 1893 could not attract the biggest names in the sport because these racers did not want to lose their amateur status with the League of American Wheelmen (LAW). The baseball magnates and others who would professionalize the sport provided the organizational skills and the influx of money missing from the amateur organizations. This schism between amateurs and professionals bedeviled the sport into the twentieth century.

The District lacked a feasible bicycle track. The existing tracks in Ivy City and at Benning race track were too far from downtown to draw the necessary attendance. The Young Men's Christian Association park at Seventeenth

and U Streets NW had been used for racing. However, the District commis-
sioners' plan for the extension of streets and avenues included bisecting the
track with an extension of Seventeenth Street.

One of many bicycle groups in Washington, the Victor Cycle Club,
sought to organize more bicycle races in the city. They joined with the LAW
and the Associated Cycle Clubs to create an organization that would build a
track owned by and solely for the use of cyclists. After insufficient turnout
led to the cancellation of the first meetings, the groups finally met and deemed
none of the offers of land for a track site suitable for the purpose.

Despite this failure, the cycling fraternity in the city continued to clamor
for a good track for race meets. In 1895, the Columbia Athletic Club spent
money building a track that was five-and-a-half laps to the mile at Van Ness
Park, south of the White House. However, only a few of the city's wheelmen
joined in the organization created to pay for the track's construction and
maintenance. The track quickly degraded into poor condition.

Notwithstanding Washington's failures, the sport attained such popu-
larity that the *Washington Post* declared it the national pastime. The New York
cycling weekly *American Wheelman* began publishing a daily cycling paper.
People wanted to know daily what happened at the cycling centers all over
the world. By the mid–1890s, the United States had over 400 bicycle manu-
facturers and they wanted to seize as large a share of the market as they pos-
sibly could. The drive among the bicycle manufacturers provided further
impetus to the growth of professional cycling in the United States.[30]

The Development of the Palisades

The International Athletic Park and Amusement Company incorporated
in early 1896 to create a suitable track and athletic grounds. Their plan
involved acquiring suitable land in the District to create a community with
buildings, lighting and water, and to lay out streets. The plans also included
the establishment and maintenance of a bicycle track and a field for other
athletic sports, amusements and entertainments. They constructed their sta-
dium in the Palisades suburb of Washington, south of Conduit Road but
north of the canal, bounded on the west by the Reservoir and by empty land
to the east. It was situated about three miles from downtown along the Wash-
ington and Great Falls Electric Railway Company route.

The purchasers raised money through stock in the business. Their cap-
ital stock offer raised $20,000 from shares valued at $10 each. The president
of the company, Mr. Jacob P. Clark, a wealthy lawyer originally from Toronto,
Canada, also was prominently identified with sporting events. Treasurer W.C.
Clark was a son of the president and a well-known real estate dealer. W.S.

McKean, the vice president, had built the cycle track at Asbury Park, New Jersey. They served on the board of directors with three other men.[31]

A display advertisement in the *Washington Post* linked the new bicycle track with a streetcar company and a company involved with the development of this area of Washington. Mr. Clark presided over the Athletic Park Company, and held the presidency of the Washington and Great Falls Electric Railway Company. Jacob P. Clark also was the chief principal in the Palisades of the Potomac Land Improvement Company, the corporation involved in creating residential communities in the area. The Land Improvement Company had started six years earlier with the Palisades of the Potomac #1, located between 48th Street and Conduit Place with U Street to the south and Albany Street on the north.

The Palisades Land Improvement Company had not been the first to push the western boundary of Washington. A few years earlier, Edward and Edwin Baltzley sold their patent on the "spatterless egg beater" and their Keystone Manufacturing Company, producer of the "spatterless egg beater." They established a residential development called "Glen Echo on the Potomac." In 1891 the Baltzleys, who experienced difficulty selling property so far out in the country, deeded 80 acres of their Glen Echo property to create a National Chautauqua Assembly to attract potential buyers. After only one season, however, a widespread rumor of a malaria epidemic in Glen Echo forced the Chautauqua to close. The Baltzleys maintained control of the area.

Jacob Clark and his company attempted to pick up from where the Glen Echo development left off. However, their tracts of land sat closer to the local city area. Their sales promotional map from 1891 declared that the area was "Destined to shortly become most fashionable as well as most desirable suburb of Washington." Clark built a brown-stone residence with a dome-covered observatory, a porte-cochère, a billiard-room and all the modern appliances for his family. Two other houses in the area contained over ten rooms.

The Palisades of the Potomac #1 aimed for the upper-middle-class government worker market. The company took the term Palisades from the fashionable area on the Hudson River in New York. The company attempted to create a similar area in Washington. In the first year, the land improvement company earned $138,655 from lot sales, netting $34,000 in profit.

The company continued to expand in this area that served as Washington's summer resort. The second subdivision contained 53 lots of approximately 3,000 square feet. In 1896, the Land Improvement Company laid out Palisades of the Potomac #3, located just south of the newly built Athletic Park. The railway line crossed through the entire Athletic Park, providing spectators the opportunity to see all the developments that the land improvement

company built on their way to see the bicycle races. The Clarks and other principals with the Land Improvement Company foresaw the spectators for the stadium as potential purchasers of the lots in the Palisades. This potential started to be realized as their advertisement for subdivision #3 declared that the track and the presence of the railway line improvements were boons which would soon lead to the filling up of the subdivision.[32]

A lawsuit brought against Jacob Clark a few years later illuminated the defendant's business practices. Martha M. Read won a $2,000 judgment against Jacob Clark. Shortly thereafter, Mrs. Read needed to bring Clark to court again to force him to pay it. Mrs. Read described how Jacob Clark moved his land assets around with the skill of a three-card monte dealer on a city street. The movement placed the assets in the hands of family, friends, and unknown others, keeping Clark from having available assets against which to pay court judgments.

The most complicated of these maneuvers involved assets related to the IAP. Mrs. Read alleged that on July 15, 1896, Jacob Clark, his sons and others created the International Athletic Park and Amusement Company and conveyed to said corporation about 80 acres for the sum of $87,000. On that day, a deed executed to Clarence A. Brandenburg and Edwin C. Clark, trustees, stipulated other financial agreements. The IAP stockholders resolved to purchase said tract for assuming the payment of a certain deed of trust for $45,000 payable April 1904. They would also execute a deed of trust to secure $30,000 in cash and the remaining $12,800 paid in stock to Clark. On January 24, 1900, the trustees of the IAP claimed the $30,000 had been paid, so they wrote "paid" and "cancelled" across the notes. Read asked what Clark had made of the $12,800 worth of capital stock of said corporation. On the same day, the IAP executed a first and second deed of trust upon the land and improvements of the said corporation to secure the issue of gold-bearing bonds aggregating to $100,000, executed through Clark as company president.[33]

Bicycle Racing in Washington: Year One

Before the inaugural season began, decisions by the LAW made the ability of the track to operate at a profit more difficult. The LAW abolished the Class B "semi-professional" department, making it more difficult for racers on the circuit. A Class B man might have earned prize winnings of $6,000 during the previous season. He might have subsidized himself through a salary of $2,000 from a tire firm paid to him $25 a week, and a saddle manufacturer who paid him a dollar for every race in which he used their saddle. With the rule changes, racers had to join the amateur ranks and thus had to

have their own funding, or they had to be professional and make money only on the circuit.

The elimination of Class B limited the number of opportunities riders had to race professionally. Race promoters found Class B useful because they could acquire the five-hundred-dollar pianos, one-hundred-dollar diamonds and so on that comprised the race prizes pretty cheaply, and maximize their profit that way. Racing for cash was a different matter and many promoters resisted holding tournaments on the National Circuit. In addition, the extensive travel for those on the country-wide circuit taxed the racers and hurt their ability to set records. The LAW's Racing Board decided to start their National Circuit races during May in Oakland and end the 49-race season at Washington, D.C., in the middle of October.[34]

The International Athletic Park Company aimed to hold the opening day races on Decoration Day (now known as Memorial Day). They constructed a simple ⅓ of a mile dirt oval track. On one side they built a grandstand, thirty by two hundred and eight feet with thirty feet to the roof, for the expensive seats. On another side was an open stand, twenty-five feet by one hundred feet and fifteen feet high, for "bleacher" seating. These stands cost the company $4,000 and were completed in time for the opening races. Little money went to offering racers any accommodations at the IAP, and one amateur referred to their training rooms as suitable to be coal bins.

The IAP management sought to make an event out of coming to see the races. The Decoration Day opening included several bicycle races, fancy and trick riding by Master J.H. Cabrera, athletic events, obstacle races and a bicycle parade. The Mount Pleasant Field Band gave an exhibition of the various bugle calls of the army in a feature titled "Camp Life." Over 1,500 paid admission prices ranging from 25, 50, or 75 cents for seating in the grandstand to $6 for the box area. The drawing on the next page represents Richard Mansfield's view of the day from the vantage point of the 1930s. Racer Fred Schade attended Georgetown University in the city and was a fan favorite. He won regularly in intercollegiate events and on the amateur Southern circuit.

Over the summer weekends, management held bicycle races, such as the second intercity challenge races between Baltimore and Washington. They staged other events, such as the first annual field day and sports of Company C, Washington Light Infantry to bring spectators to the International Athletic Park. But problems arose that would plague the business throughout its existence. On one occasion, a bicycle meet had to be postponed on account of the short time which the management had to complete the arrangements. On the occasion of the first bicycle race scheduled for the middle of the week, rain came and turned the dirt track into impassable mud.

The management strove to broaden the appeal of the park. They moved

Spectators at International Athletic Park. Drawing by Richard Mansfield, c. 1930s. Fred Schade was a well-known local racer (Historical Society of Washington, D.C.).

to market to those Washingtonians who came to the area for summer vacations and relaxation in the cooler environs. The city granted the park management, under the auspices of the International Athletic Club, a retail liquor license. Jacob Clark and the others on the board wanted to house the bar in a handsome clubhouse. The clubhouse would also feature special attractions and be a place for general rendezvous for spectators and racers. The board planned to supplement the bicycle track with a half-mile trotting track.[35]

While not being a profit earner in its own right during the first year, the track accounted for a portion of those gains that the other related businesses made. The Potomac Land Improvement Company fared well. A promotional piece noted that the company sold 85 of the 181 lots in subdivision number 3 by the end of 1897. As the ad stated, the majority of the lots, each a total area of 3,125 square feet, remained available for purchase at the low figure of $350 and upwards. The next subdivision, number four, had been recently laid out north of the International Athletic Park, and the ad promised the beginning of sales shortly. The Great Falls-Washington Railway benefited substantially. The streetcar carried 579,013 passengers during the year for receipts of $24,462.36 while operating and general expenses amounted to $13,691.76. The reporter noted that the number of passengers and profit margin were an excellent showing for the first year of operation for the road.

The Great Falls-Washington Railway enjoyed an unusual relationship with the IAP. The streetcar companies subsidized the sport and entertainment location to spur ridership. As noted earlier, the Wagners received a subsidy of $800 from the two streetcars running people to the Senators' games during the first year. More often, the streetcar company created a destination point along its line to spur usage of the transit system. In Philadelphia, the Pennsylvania railroad built a bicycle track at its Young Men's Christian Association lot on 52nd Street and the Rail road that summer and drew 2,000 spectators to the opening. Streetcars companies in cities around the country, from Baltimore, Maryland, to Portland, Oregon, constructed amusement parks at the end of their lines. In the Washington local and regional city, this did not happen.

Ironically, an analysis of the attendance for racing at the park declared that the related streetcar company remained the biggest reason for the poor turnout. The streetcar company did not install a double track as they had promised for the last two years. This made trips to the park and to Glen Echo slower and more arduous than those to tracks in other cities that were built at a greater distance from downtown than the International Athletic Park. The Clark brothers could not have been thrilled when a news article appeared in the papers in early January citing the need for a bicycle track. The piece observed that "it was demonstrated that there were not proper facilities for

carrying the public to the International Athletic Park on the street cars, while the four-mile spin [on a bicycle] out to the park on a dusty road was not inviting."[36]

The IAP's regional city location hurt its business because of the difficulties of getting potential audiences to the park. Efforts to create a bicycle racetrack in the city limits within easy access to the largest segment of the population continued. R.M. Dobbins tried to lease the National Baseball Park but the Wagners refused. Dobbins then met with the officials of both the Metropolitan and the Columbia Railroad to inquire about using their depots. He chose the Metropolitan terminus near Lincoln Park (15th Street and East Capitol Street, NE) and planned a quarter-mile track with a grandstand accommodating 2,000 and bleachers providing room for another 1,500 people.

Other tracks struggled as well. The owners of the tracks in the country's fourteen largest cities created the National Cycle Track Association (NCTA) to improve cycle tracks, the race meet structure, and cycle racing in general. Meanwhile, J.P. Clark negotiated a contract with the Washington Cycle Board of Trade that granted his park exclusive rights to racing on every holiday and desirable day on which race meets could be given for all of 1897.

Bicycle Racing in Washington, Year Two: Bring in Other Entertainment

Park management attempted to broaden their entertainment in an effort to increase the viability of their businesses. The park staged an afternoon of broadsword battles. A cornet player heralded the entrance of a mounted knight representing England and from the opposite side a knight supposedly from France. The reporter for the *Washington Post* observed that the horse saw the flashing steel in the hands of the Frenchman and became extraordinarily cautious to avoid the battle. The knight from England dismounted and the Frenchman bested him 11 to 10 in a ground contest.

The joust had not gone as planned. Captain Duncan Ross, the emcee for the event, ran out to announce the next contest, between the Blue and the Gray. Mounted on the same horse, the Federal found himself forced to dismount in order to get anywhere near the Confederate. Ross ran onto the field and forcefully insisted the man remount. The Federal punched Ross on the chin. The police rushed in, as did most of the 400 in the crowd, creating the first real fight of the afternoon. When the scrap ended, Ross announced that the battle between himself and the champion of Great Britain, James C. Daly, had to be called because Daly left when Mr. Clark refused to pay him a promised $1,500 fee.

After this anarchy, Clark and the rest of his investors must have been relieved to start the cycling season. However, they immediately declined the spring race dates the LAW offered to them, expecting that changes would be made to the dates for the national circuit races. By late May, the first date of racing seemed a great event as a large crowd rode out on bicycles or in carriages. The owners sought to enhance their circumstances through obtaining a renewal of their license to sell liquor at International Park. While Mr. James Sullivan and J.P. Clark spoke for the applicant before the Excise Board, and Stilson Hutchins, president of the Great Falls Railway Company, wrote a letter in support, Dr. Hugh Johnston of Metropolitan M.E. Church, Mrs. La Fetra of the Women's Rescue League, and Mrs. C.E. Emig, president of the Women's Christian Temperance Union, spoke against the application.[37]

After failing to obtain their liquor license renewal, the park owners opted to schedule weekly bicycle meets. They would also continue their effort at showing a diversity of programming to draw more spectators. This programming did not include women's racing. The owners refused to lease their track to female racers, standing fast with the LAW, which argued that female racing did not benefit the popularity or good of the wheel. The number of bicycle meets held at the IAP dropped from fifteen to eight during this second year. Between May and September 1897, the Park held 54 races but only twelve included professionals. Only the Decoration Day and July 4 holiday races drew the large crowds that came to the national circuit races in 1896.

The turnout made the track management hopeful for Labor Day. They made arrangements to increase seating capacity by 300 before the Labor Day meet. The plans included turning the private boxes on each side of the grandstand into four rows of seats and creating private boxes out of the press boxes that flanked the entrance to the park. However, the work did not start until mid–September so they missed the holiday crowd. The changes did enable 5,000 enthusiasts to attend the last National Circuit meet of the season at International Athletic Park. This positive momentum did not continue. The intercity races with Baltimore's bicyclists that management created in an effort to exploit the rivalry between the two cities left the management disgusted over the turnout and unwilling to continue that effort. Two years of racing had far from seized the public's imagination.

The management of the International Athletic Park and other members of the NCTA met to discuss their relationship with the LAW Racing Board. The executives expressed frustration over Racing Board chairman Albert Mott's refusal to grant them waivers to hold meets on dates when meets had been sanctioned in nearby places. NCTA Secretary Drucker said, "Our members have over $2 million invested in cycle tracks and the refusal of the Racing Board to grant sanctions on such flimsy excuses is ridiculous and unfair."

One week later, Drucker admitted that he met with the Racing Board to devise a way to place the big tracks on a better-paying basis. The managers now planned to run a professional rider circuit that fall. Near the close of the season, Boston's Charles River Track reported that the business had only one money-making date all year. The track's decisions to implement lighting and motorized pacing resulted in a $30,000 loss. The Association noted that track owners determined that promoters made money from proceeds of meets but the NCTA members could not earn enough to pay a good percentage of the money they invested.[38]

Annual figures revealed that the racing paid handsomely for the LAW's Racing Board. The Division noted that tracks in the United States held 2,912 meets with 17,316 races during 1897. The meets drew over 8 million spectators, an average of over 2,700 people per event. The International Athletic Park fell below that average attendance. While the 9,000 racers (both pro and amateurs) earned $1,645,020, the total gate equaled $3.6 million. The LAW Racing Board earned $9,426.97 in receipts and netted $1,832.58, a profit of 19 percent.

The NCTA members noticed the LAW's earnings. The organization wanted to promote races themselves for 1898. Their plan called for a schedule that would remove conflicts among races and would keep in mind that the circuit would be carrying racers through from point to point. Washington and nine other cities received both spring and fall meets for the 1898 season. The tracks shared the $50,000 in purses that the group offered for the prizes in both the short and middle-distance races.

However, racing still required the sanction of the LAW's Racing Board and its leader, chairman Albert Mott. Tracks, particularly in the midwest and west, disliked the LAW's continued ban on Sunday racing. In addition, every track lost income when the Board required that promoters inset in the program the name of the wheel and tire of all professionals, removing the company's incentive to advertise with the track and promoters. The Board followed that decision up with the mandate that the tracks pick up costs of prizes if the club that rented the track couldn't because the gate receipts were too low.[39]

Bicycle Racing in Washington: A Local Bicycle Club Takes Charge

The NCTA realized that they needed to diversify their product to increase their gate. One plan involved hiring racing team to represent the country's large cities. The teams raced each other on their home tracks to promote intercity team contests on the same plan followed by baseball leagues. Asso-

ciation officials estimated that the teams required an investment of $24,000 for the racers' salaries.

The financial structure of bicycle racing suffered an additional blow. The manufacturers of bicycles claimed they did not have the money to spend on hiring racers to serve as billboards for their products. The correspondent for *Sporting Life* observed that decision might drive the majority of the third-, fourth- and fifth-rate racers out of the business. He claimed that without them, bicycle racing would lose much of the personal variety it had, and would also lose some of its spectacular quality. The reporter then noted:

> The proposition to race cycling men in classes, as is done with trotting horses, has been made, but has never found much favor. It would probably help matters some if this were done. Horses in the 2.50 class frequently make as spirited contests as the 2.15 steppers. What certainly seems needed is more variety in the character of events. This would increase the interest of the public and widen the opportunities for the men. There is too much of the sameness in the average race meets.

The NCTA sought other methods to bring in innovation and save money simultaneously. The organization spent $15,000 on thirty-two pacing machines. The motorized cycles (motorcycles) would offer increased speed and the chance to replace the highly expensive bicycle-riding pacesetters. Whether they would be used to add diversity to the racing meets remained a question.[40]

The Park Bicycle Club of Washington, D.C., signed a five-year lease to manage races at the International Athletic Park. This generated income for the Clarks' company and relieved them of the headache of promoting races. The Bicycle Club worked with the NCTA to improve attendance, establishing six big racing days and night entertainments, including racing, tournaments, lantern runs and picnics.

The club made other moves. They invested in the track, constructing a new board surface. The new surface made the track the first of its kind south of Philadelphia, and promised to increase the speed at International Park. In early June, the track began a season of night races that used a searchlight to follow the racers. Baltimore's night racing had attracted 5,000 fans during the summer of 1897. Since that city had a reputation as less interested in bicycling than Washington, expectations for turnouts were high.

The evening races attracted a large audience. The Park Bicycle Club brought the biggest name in racing, Welshman Jimmy Michael, to Washington for a head-to-head ten-mile paced bicycle race with American Jimmy Moran. In conjunction with the racer's management, the club arranged with the streetcar company to handle the large crowd they anticipated for the event. One week earlier, Michael beat Tom Linton in a twenty-five mile paced race

in New York before over 15,000 spectators. Michael arrived in Washington but so did rain, forcing a postponement of the match. President J.D. Lasley of the Park Bicycle Club announced that there remained a strong possibility of staging a race with Jimmy Michael, and the club again hoped to sell out the grandstand. On August 8, 4,000 fans arrived again but watched as the race disappeared under the raindrops. A week later, 5,000 people saw four scheduled races but illness prevented Michael from participating, disappointing the assembled.[41]

Other problems made management of the track difficult for the Park Bicycle Club. President Lasley laid them on the LAW Racing Board and led the group out of the League of American Wheelmen. He informed the public that the LAW aimed to control racing for the benefit of a small number of people in their organization. Lasley noted that the Association also imposed large fines on riders and provided them with no recourse for appeal or explanation.

A month later, a group of star professional bicycle racers rebelled against the LAW. They referred to the LAW as anti-racing and not in the interest of professional riders. Thirty racers formed the American Racing Cyclists' Union. The union sought three things: ending the limit to cash prizes for races, allowing for Sunday racing, and running the national circuit from July through September, so that racers could go other places during the spring and late fall.

The track owners and the union found common interest. Washington, D.C., played a leading role in this extraordinary happening for professional sports as the athletes, the promoters of the sport, and the owners of the stadiums joined together to take on the governing body of the sport. The Park Bicycle Club sponsored the first meet of the new Racing Cyclists' Union at the International Athletic Park in early October.

The LAW responded punitively. They handed out fines and suspended the riders and trainers and blacklisted the Park Cycle Club for holding a meet without their sanction. While some fans doled out abuse to the unionists, the prominent black racer Marshall "Major" Taylor took such abuse that he resigned from the union and rejoined the LAW. Meanwhile, other professional riders feared joining the union because of a probable suspension from the LAW and local amateurs feared racing at the park for much the same reason.

During the 1898 season, both the Park Bicycle Club and International Athletic Park fared poorly. The local newspaper cycling column argued that the organizations suffered that year from bad weather from two systemic reasons. The first problem centered on the Park's limited accommodations, providing seating for only 2,500 people total as opposed to other tracks which

could hold 10,000. The second difficulty involved the location of Washington, whose distance from the cycling centers of Philadelphia and New York resulted in the need to pay too much money to bring noted riders down to race at the track.[42]

In December, several track owners east of the Mississippi River joined with the Cyclists' Union and a few race meet promoters. These groups united to form the National Cycling Association (NCA) to handle the management of bicycle racing in the United States. The battle with the LAW's Racing Board over the organization that would control bicycle racing lasted half a year. The NCA initially seemed to have control and were expected to broaden the definition of classes, allow Sunday racing, and place no limit on professional prizes.

The LAW made moves to entice the professionals. They offered them a voice in the assembly and on racing board, although the LAW would still not allow them to become members. The LAW retained nearly 2,000 tracks and 25,000 members under their control, including 531 racers. The NCA controlled the largest tracks, including the IAP, and had the biggest stars in racing among their 100 men. Starting with the 1899 season, the NCA riders voted to segregate black from white riders. The press war between the two organizations ensued.

The NCA and the Park Bicycle Club held their first race of the season near the end of May. The Decoration Day crowd did not meet the size seen in previous years. The club received two dates on the NCA's Grand Circuit, including the end of the season when the one-mile national tandem championships would be decided. The races on the July 4th holiday generated small audiences and little excitement. In mid–August, the club announced that, because of the lack of patronage, no more bicycle races would occur until the grand circuit race of September 14. Club president J.D. Lasley stated that he was closing out his bicycle branch business and entering into a new field. However, he promised to continue being involved with managing bicycle racing in Washington until the end of the season.[43]

Two months later, the Washington Traction and Electric Company, now in control of the united street railways in the city, stepped in. The company secured a majority of the stock of the Park Bicycle Club and proposed to convert the IAP into a pleasure park. They planned to pattern it after Baltimore's Electric Park, which had formerly been a bicycle race track. But the streetcar conglomerate had recently reduced fares by one-third on its line to Glen Echo, and during 1899, the new Glen Echo Park rapidly gained public favor with concerts and rides. The streetcar company never developed International Athletic Park into an amusement park. Instead, in 1911, the company purchased Glen Echo Park and brought in new rides and activities that made it the pre-

miere amusement park for whites in the Washington area over the next fifty years.

The International Athletic Park continued to hold race meets in 1900. However, the company appeared on the list of delinquent taxes for the District under County-Agricultural for $176.02 and $12.92. Near the end of 1900, William W. Frazier of Philadelphia instituted proceedings in District Supreme Court against the International Athletic Park and Amusement Company to receive the $45,000 that Jacob Clark owed him.[44]

The IAP and its bicycle racing helped the finances of the streetcar line while providing little in earnings for its own management. What effect did the park have its stated goal of creating a Palisades community? Sixteen houses existed in the four Palisades developments by 1905, an increase of thirteen over the three built on spec. This growth barely created an enclave, let alone a suburban community. Writers have noted that the competition in suburban growth, particularly with Chevy Chase and Kensington, slowed the potential development of the Palisades. Certainly, the promise of cheaper rail transit and the possible expansion of the water reservoir did not occur, and this undercut the development as well.

Clark did not invest much money in the necessary amenities. As Mrs. Martha Read observed during her suit against him for nonpayment of a $2,000 promissory note, promised improvements to the subdivisions often never arrived. A dirt path often full of mud served as the way to the streetcar line from her property in one of the subdivisions. As both the Read and Frazier suits illuminated, Clark issued promissory notes, then sought to keep the money himself through sidestepping these creditors. The IAP could not help the Palisades develop at the end of the nineteenth century. The sport stadium did not turn a profit. Its location on the cusp of the local/regional city of the District only partially facilitated Jacob Clark's primary business of real estate.[45]

The Hewetts', Wagner brothers' and Clarks' sporting activities left marks on the landscape of Washington, D.C. The suit against Walter Hewett influenced the location of the Government Printing Office's second building, which is referred to as the old GPO building today. The Wagners' use of National Park may have influenced why both Sixth Street and New Jersey Avenue, NW both stop where they do today. The Clarks created the International Athletic Park near the District's Maryland border in the Palisades.

The trio had a minor impact on the early years of professional sports. The Wagners first proposed that two National League baseball teams consolidate. The Clarks' IAP played host to the first race meet of a professional cyclists' union. These frontier families in the local city's sports each made a more significant contribution to professional sports in Washington, D.C. In this wide-open environment of the early years of professional sports capital-

ism, these families exploited rather than nurtured each of the parts that comprise the District of Columbia. They viewed sports as a means to improve their primary businesses, whether the Wagners' butcher shops or the Clarks' real estate development. The trio established a tradition of losing teams and poorly run sporting operations that continued into the beginning of the twentieth century despite the creation of new operations to run these two professional sports.

2

Northeastern Horizons
Inclusion in the Professional Leagues

The pioneers of professional baseball and bicycle racing in Washington, D.C., did not succeed in establishing long-term franchises. While the National League retrenched and the National Cycling Association dispersed at the turn of the twentieth century, new professional associations emerged in these two sports. The executives of these associations believed that sports would succeed to the benefit of all their members if they used the new business techniques of the era. The city of Washington would join the larger cities to its north and west in these new sporting leagues.

Under these associations sports served as pioneers in Washington. Their sports stadiums brought development to previously barren areas in the northeast section of the city. They expanded the size of the local city. Like the International Athletic Park, the two new stadiums at the beginning of the twentieth century needed the streetcar lines to provide effective service to these sports stadiums. Both Washington franchises depended upon the federal city workers and local city workers and residents to be repeat customers to remain financially solvent. Whether Washington could measure up both geographically and financially with the cities in the northeastern U.S. that dominated these associations remained a key to the success of both franchises as well. The limited foresight and funds of the District's local city money class damaged the sports franchises' chances to flourish in these associations.

Interest in building a new bicycle track remained vibrant despite the current affairs at the International Athletic Park. By the summer of 1898, the man who had secured the construction of the Coliseum Bicycle Track in Baltimore engaged in discussions about a track in the eastern part of Washington. The current word was that the new place, like Baltimore's track, would have a covered grandstand and open track so that it could qualify for outdoor records. The entire place could be covered during the winter so that it

could continue the racing season. However, little action resulted from these discussions.

The collapse of the Park Bicycle Club as promoter left a vacancy that an attorney from Baltimore, C. Ross Klosterman, arrived to fill. Klosterman promoted races at the International Athletic Park (IAP) during the racing season in 1900. However, these races often drew smaller crowds than those that had attended previously. Professional racing increased in popularity as the National Cycling Association (NCA) trumpeted that they held over 700 race meets throughout the country. Under the NCA, professional riders won over $100,000 in guaranteed prizes in their second year of controlling racing.

Everyone realized that changes needed to occur to make Washington a viable member of the NCA. Klosterman developed plans to leave IAP and establish a park inside the local city. The new bicycle track had to be more accessible to the city's population. The NCA and the track's management needed to hold programs that stoked the interest of the sport's fans. Klosterman served as a member of the NCA's executive board. His key role was to enhance the city's position within the organization and Washington's prospects for being successful in the new league.

By 1901, the NCA and the American Association, a motorcycle racing crew with "bowl" tracks in New York, Philadelphia, and Providence, Rhode Island, created a national professional racing system. The New York and Providence tracks joined with Boston and other New England cities to form one race circuit. The organization's second circuit consisted of twice-weekly races in Baltimore, Philadelphia and Washington, with racers also meeting at tracks in the "western" cities of Pittsburgh, Indianapolis, and Louisville. The NCA announced its grand circuit schedule. In this national grouping of the top races, similar to the grand circuit that the League of American Wheelmen used in the late nineteenth century, Washington received a date in early September.

The NCA and Klosterman believed that new times were coming for bicycle racing in the nation's capital. Klosterman leased the property at the square where A, B, 14th and 15th Streets, NE met. The eastern section of the city on Capitol Hill all but stopped at Lincoln Park so the Metropolitan Streetcar terminus represented the bicycle track's only neighbor. The District Commissioners' Office issued permits for the construction of two covered grandstands and two open stands along with one oblong cycle track. The estimated cost for building the track amounted to $12,000, or $200,000 today.

The real estate map from the beginning of the twentieth century illuminates the limited development of the area. The track occupied the entire city square numbered 1056. The largest residential area sat a block to the north and east. Approximately twenty brick houses sat within the triangle created

by North Carolina Avenue, 14th Street and B Street, NE in square 1034. Another ten brick homes existed at the further end of the square, with wood structures intermittently located there. Much more scattered housing existed closer to East Capitol Street. Several of these buildings remained unoccupied.

When completed in late May, the Washington Coliseum had lights and seating for 5,000 with standing room to handle larger crowds. A 14-minute streetcar ride from the center of the city enabled the majority of local city residents to reach the stadium. The ride topped the fastest ride to the old International Athletic Park by nearly half, enhancing the coliseum's viability significantly. The ⅙ of a mile track encircled a grass field. The owners expected to host local football contests during the off season of cycling as a way of increasing financial gain and keeping the Coliseum in the locals' minds. Crucially, the lessors chose not to cover the stadium.[1]

Klosterman sought to outfit the fancy new stadium with top-notch bicycle racing. His IAP experience revealed that racing changed with the development of the motorcycle. Klosterman and coliseum manager Will C. Bryan

Map of Coliseum Bicycle Track and surrounding area (Baist Map, 1903, at Washingtoniana Division, Washington, D.C., Public Library).

ordered two four-horsepower engine motorcycles, guaranteed to develop a speed of one mile a minute. They planned to use these machines as pacesetters in Washington and Baltimore. Klosterman sought to build a group of top-notch racers as well. He contracted with French champion racer Eduard Taylore to train in Washington and race on his local tracks.

The NCA and the Beginning of the Circuit

The track opened in May 1901 to a very large crowd. Attendees included the sophisticates of racing among the city's bicycle clubs and interested spectators. Under open night sky lit by a string of fifty arc lights circling the track, the crowd awaited the high speeds and head-to-head battle around the narrow oval. However, the races did not come off without glitches. During one race, the engine of his pacesetter motorcycle failed twice and another pacer snapped the chain on his machine, leading to a slow finish. Despite these drawbacks a good crowd came out for the Decoration Day holiday. The program, featuring bicycling superstar Jimmy Michael winning a tight twenty-mile head-to-head match, drew 4,000 spectators.

The rainy weather that harmed the cycling season a few years earlier undid this early success. Rains forced the cancellation of several races in June. The track management sought to regenerate interest in the sport, beginning a series of races that they billed as international contests. These match races featured two riders reportedly from countries around the world. The coliseum management created this gimmick to take advantage of the international nature of the sport and the celebrity of individual racers.

The concept started poorly as the first match had to be postponed twice. Still, the coliseum hosted its largest crowd yet to see Swede Johnny Nelson beat Canadian Burns Pierce. However, just as they built interest, an accident at the power house of the electric light plant cut power to the entire eastern section of the city. The bicycle races ended for that evening. The lights failed again on July 4th, forcing postponement until the next night. Even with the city's failed infrastructure service, the next international race between Nelson and the French champion Albert Champion drew very well.

The strong turnouts continued through the remainder of the scheduled season. Over 4,000 spectators filled every grandstand seat and crowded around the rail ten deep to see good races nightly. Occasionally, they received an extra treat as "bumping" caused fights to erupt between riders. Another large crowd turned out in anticipation of ever-greater speeds as the coliseum hosted the first motorcycle races held in the city. The "snorters" did not disappoint.[2]

The management aimed to build upon their recent successes. Kloster-

man traveled to New York City and spoke with the biggest stars in motor-paced racing about events in Baltimore and Washington after the season turned cold up north. Large crowds attended these races, including 3,000 to see Marshall "Major" Taylor best the Canadian champion Archie McEachern at two of three distances. Cold weather during the first few races in October held down the crowds to the several hundred people who could withstand the shivering.

The bicycle tracks in the larger cities in the northeastern United States dominated the NCA and the sport. They had the size and spectator base that enabled them to pay for the services of the best racers. Klosterman tried to improve the financial circumstances of his Washington Coliseum through taking advantage of the seasonal climate that the District of Columbia offered. Unfortunately, the weather betrayed his efforts that year and the warmer weather did not last long enough for the bicycle track to profit significantly.

Necessary Revisions: The NCA and Year Two

The next year, the sport's leaders projected a boom in cycle racing. Several cities in the South planned to construct bicycle tracks. The NCA had one year of experience with the circuit and made several changes. In the reorganized circuit, Washington, Baltimore and Pittsburgh now made up the western section. The grand circuit schedule included 25 tracks that held weekly meets from the end of May through October.

Klosterman became the district chairman of the National Cycling Association. In Washington, he conferred with his new track manager Whitman Osgood concerning the opening of the Coliseum season. The president of the Washington Printing Company and prominent newspaperman, Whitman Osgood successfully managed the Chase Theater in Washington and turned around the fortunes of the Music Academy in a single year. Married with two children, Osgood enjoyed racing yachts and taking his family on daring automobile trips.

Osgood predicted the city would experience the boom in cycle racing. He noted that almost all streetcar tracks in the city ran to the coliseum and spectators reached the stadium for only a single fare. The track would have a 6,000 capacity after management added new bleachers and Osgood noted management planned to engage in more advertising. In addition, the Western Union Telegraph Company, in anticipation of demand of news from the track, put in a large telegraph service and the local phone company intended to establish a station at the coliseum.[3]

Klosterman thought the shorter races would offer more satisfaction to the public. Track management made changes, intending to hold five-mile

heat races instead of the twenty-mile events. They opened the track on May 21 with sprint, paced and unpaced distance races, and a three-man motorized race. The turnout was fantastic and the reporter for the *Washington Star* observed that the new bleachers provided seating and took the throng away from the center of the track. This provided officials and riders a better chance to work freely.

Despite this planning, Osgood noted the public wanted motorcycle races and more than one night of racing each week. The coliseum manager presumably fulfilled his promise of increasing advertisements. Announcements of the bicycle races coming up at the coliseum appeared regularly in the *Washington Star* not as classified displays but as articles in the sports section. These articles followed a similar format and they lacked any news element besides a listing of the races. This seems to indicate that these articles were Osgood's inventive solution for his need to advertise.

The advertisements provided increased attention but that did not result in increased attendance. The crowd for Memorial Day dropped to 3,000. The track changed the racing schedule to every Wednesday and Friday evening, providing two motorcycle races, motor-paced races and amateur events. Rain led to postponements of several meets, destroying any potential continuity. Over the next few meets management tried other methods to bring crowds to the coliseum. Osgood added other acts that appeared between races, including trained donkeys and jugglers. They even ended one evening with a bout of wrestling. The races still drew small crowds.

Osgood juggled multiple tasks. He continued to drum up audience interest, manage the track, and book the meets. The coliseum lost the possible big draw of the July 4th holiday because Osgood could not book satisfactory stars. He complained that the larger northern tracks had everybody worth having under contract for holiday events. The next week, a match race vanished when one racer claimed his motorcycles did not work. The week after, the big draw match between racing stars Albert Champion and Hugh McLean did not occur when both racers missed the train from Pittsburgh. The newspapers noted that management could not make riders come to Washington and the offer of half of the gate receipts to these two riders did not ensure their arrival.[4]

At the end of July, the NCA circuit event came to the city with the top racers in the Association. Through the negotiations of Osgood, one more star, Major Taylor, joined the NCA racers, vying in three races for prizes worth $350. However, the announcement of his addition came too late to bring out Taylor's large D.C. following. Thus, the possible extra 1,000 spectators in the standing room area did not occur.

The Association's grand circuit meet provided only a brief respite from

the coliseum's regular misfortune. At the end of July threatening weather resulted in a small crowd for the eight races of amateurs. A week later, rain made the track too slippery to hold the evening races. Management issued their response of promising to honor the tickets the next evening.

The NCA's structure caused problems for the coliseum's plans. One of the racers wanted to leave for his next event in Springfield, Massachusetts. Osgood had to fight with him in order to keep the racer in town for the make-up race. At the next meet, the crankiness of the motors wiped out one race and the demolition of another motorcycle made the stellar attraction of the night a one-sided affair. Only the half-mile amateur race went off without mishap.

The remainder of the summer proved little better for bicycle racing in the city. In mid–August, manager Osgood retired from the track business, offering the observation that the sport failed to pay. Osgood tired of trying to induce people to go out to the track and had done nothing but lose money all season. The coliseum management canceled races by the circuit chasers of the NCA for the remainder of the season.

The changes that the NCA administrators made in the beginning of the year did not help the Washington Coliseum significantly. The limitations of transportation hurt Washington's bicycle franchise. The NCA had difficulty using the train system to transport the bicycle racers from Pittsburgh to Washington for races on back-to-back evenings. Even if the racers could come, the city's location outside of the northeast and the inability of Baltimore to draw big enough crowds made inducing bicyclists to come a difficult proposition. The financial draw of the area was too limited for some racers, particularly the stars, to expend the time to travel to Washington then back to the northeastern cluster of cities.

The experiences of the 1902 season stayed on the minds of the members of the National Cycling Association. When they convened the next spring, they focused upon ironing out the difficulties of transporting racers around to all the cities on time. They arrived at the decision to assign riders to represent specific tracks. The membership thought the specific assignment would build the kind of local identification with a sporting figure that was part of the attraction of baseball. In addition, the members restructured the twelve-city circuit of motor-paced bicycle racing in an effort to make sure that riders reached the tracks for the scheduled races.[5]

The End of Professional Cycling in Washington

While a new track near Cabin John Bridge received consideration, it was deemed advisable to continue holding the races at the coliseum. The stadium

would host the three-man races every Thursday from June 1 to September 1. The *Star* ran consecutive daily articles about opening night's meet that again read more like advertisements than news stories. A big crowd and good weather greeted the opening of the season. However, motors went wrong, causing postponement of the races. Management opted to stage a two-mile exhibition race with George Leander for the crowd. Leander thrilled all with a fast first mile but then his pacer's motor burned out, bringing his efforts to a halt.

The next week Manager Klosterman planned a three-cornered race with fourteen-horsepower motorcycles. These machines could reach speeds of a mile a minute. Rain forced cancellation of the regular meet on Thursday. Storms forced the meet's postponement twice more later that week. For the third week, the public wended their way out to the park for races. However, no lights, music or hum of speeding motors were there to greet them. The riders were not able to appear so Klosterman and Osgood, who had returned in the spring, did not open the track. For the final week of June, Klosterman promised the public that the tickets for June 4th remained good. The good will this fostered disappeared in early July when Klosterman canceled another meet because of the uncertainty of getting the riders to the coliseum on time.

Manager Osgood again severed his connection with the track, observing that motor-paced racing was a hopeless case under the existing unreliable status of the game. Osgood expressed his frustration with racing. He appeared to be an accurate critic. However, his reaction may have revealed the intemperance and cruelty that his first wife charged him with after thirty-two years of marriage in 1920. Two years later he died at the age of 59. Two months before his death Osgood had remarried and completed a will that gave his new wife his $200,000 estate.[6]

Troubles beset the NCA before the start of the 1904 racing season. The professional riders announced that they had lost their faith in the National Cycling Association. In an ironic twist, the riders sought to return to the ranks of the League of American Wheelmen, the organization that they had left five years earlier. The riders expressed impatience with the numerous NCA rules and believed that the promoters received all the money and glory from the cycling business. At their winter meetings, the NCA managers sought to reestablish their national agreement with tracks from Boston to Washington. The leadership confessed that their plan drawn up the previous year "looked good on paper but it fell through in the first month of its existence last year." They accomplished little at their meeting that winter.

Months later the leaders undermined their organization with a few pronouncements. They declared against motor-paced bicycle races and motor-

cycle races. While these races offered speed and excitement that thrilled the spectators, the big machines suffered many mishaps that kept crowds waiting until the unruly apparatus was repaired. After years of testing the patience of owners and fans, the motorcycles had worn out their welcome.

The motorcyclists expressed their pleasure with leaving the NCA. Those with an interest in motorcycle racing formed a new organization with 1000 members. Their new group featured plans that did not include "large dues to make payments of fat salaries to officers." This proclamation made the perceptions of the riders clear.

The NCA leadership also increased the alienation of the riders. They issued claims that stressed their frustration with riders who failed to fulfill their obligations to ride when advertised. The leadership then claimed that there would be a revival of the once-popular sport of bicycle races. However, NCA President A.G. Batcheldor appeared not to agree. Batcheldor cut his connections with cycling and became identified with another professional sport, automobile racing.

Meanwhile different circumstances arose in the northeastern states. Bicycling prospered in both New England and the mid–Atlantic area down to Philadelphia. Cities including Boston and Springfield in Massachusetts and Newark in New Jersey benefited from having tremendous velodromes and the proximity to one another to make the racing circuit manageable. In Washington, the faithful *Evening Star* ran few articles on bicycling and began including a regular column titled "Automobiling."

Klosterman relinquished his lease on the coliseum and returned his focus to his native city and legal practice. The attorney stood on the corner of Eutaw and Fayette Streets a few years later when John A. Havercamp approached him and accused him of ruining his home. Havercamp tried to draw a .38 caliber revolver but the hammer of the weapon caught in the back of his coat and enabled Klosterman to grab the weapon.[7]

Despite the attempt of the NCA to systematize the sport, the "national" association cycle racing floundered. The Washington franchise suffered from its geographical distance from the hubs of cycling in the northeastern U.S. Like the NCA, the coliseum management sought to create a market for cycle racing as entertainment. They struggled with establishing the sport as a regular program because of inclement weather and the unreliability of the motorcycles. The breakdown of these machines cost the sport the ability to demonstrate the thrill of high speeds to its audience.

The NCA and coliseum management sought other methods of building the sport's entertainment market. Management added supplemental novelty acts to the race card. Had that worked, the rise would have only been a momentary blip. On a more structural level, the NCA and the coliseum tried

to associate specific riders with individual racetracks. They hoped this might build allegiances based on city identification, as professional baseball teams enjoyed. If not, they thought this might create a market through the spectator developing an identification with an individual rider. That in turn would make the racer into a celebrity like certain theater actors in that era. While the strategy failed, this revealed the role of sports in the lives of people during the era, to supply entertainment that offered meaning through identification with the team from your city or with a celebrity sports hero.

The Coliseum: Life After Cycling

Two men thought they could continue the coliseum's sporting life. Thomas C. Noyes, the youngest son of the *Washington Star*'s publisher, and Charles White, who had earlier sued Walter Hewett, assumed the coliseum lease. They made the building available for the new city-wide baseball league that started in the spring of 1904. The Capital City League played their games there for three years. Other sporting events held at the Coliseum included a field meet organized by the Premier Athletic Club, a black group, and Columbia Athletic Club football.

In April 1905, Noyes and White invested in a dancing pavilion, new seats and stairways for the coliseum. By August, neighbors complained to the District commissioners about noise at the coliseum. The commissioners responded that they could not resolve the matter. The District courts were the proper location for a decision regarding rights. In November, a judge decided that the District of Columbia could not prevent the holding of dances in the coliseum. If things became disorderly the responsibility would then be with the city police.[8]

Some in the federal and local cities used the coliseum for their recreational activities. Others attended as spectators of the sports or went to dance. Yet for a number of the local city residents, the coliseum brought little joy of community identification. Instead, the stadium represented a nuisance neighbor.

These irate neighbors were new to the area. Over the last few years they had purchased the row after row of attractive residences that began filling the area near Lincoln Park. The houses cost from $3,000 to $7,500, approximately $70,000 to $170,000 in today's value. Less than two years after their losing battle in the District Courts, the neighbors received word of the sale of the entire square where the coliseum sat. The builders William Munsey Kennedy and Davis purchased and subdivided the property, and made plans to build eighty houses. They completed the first twenty six-room houses, equipped with modern bath and furnace heat, near the end of 1907.

The demolition of the coliseum put an exclamation mark on the end of the second phase of professional bicycle racing in Washington. The coliseum's bicycle races brought more people to east Capitol Hill. Builders soon erected residences in the previously barren area. Shortly thereafter these neighbors engaged in conflict with the coliseum. While the coliseum's days reached their end, under the banner of a new baseball league a new team started in the city's Trinidad neighborhood.[9]

Competing Professional Baseball Leagues

The Wagner brothers' sale of the Senators described in the previous chapter left Washington without baseball for the 1900 season. The Western League, an ally of the National League (NL) during its successful struggle against the American Association, renamed itself the American League (AL). While the NL contracted, the AL gained a franchise in Chicago, a solid baseball city, and in Cleveland.

The president of the American League, Ban Johnson, began as a collegiate and semi-pro catcher. He switched to sports writing for a Cincinnati newspaper after injuries. Johnson assumed the leadership of the Western League in the early 1890s. He made it a successful business and made additional gains siding with the NL. One year later, he planned to continue the AL's expansion and even to alter its focus from a western to an eastern league. Johnson planned to use higher salaries to entice star players to his upstart major league and win the battle over attendance.[10]

The AL president sent several representatives out to seek playing fields in Philadelphia, Boston, and Baltimore, sparking a war with the owners in the NL. Johnson planned to relocate four of the teams from smaller "western" cities of Buffalo, Indianapolis, Minneapolis, and Kansas City to new eastern locations. The owner of the Kansas City team, Jimmy Manning, did not want to come east with his team. Manning did not want to leave the other business interests he owned in Kansas City. However, Ban Johnson pressured him to accept the new Washington, D.C., franchise. Johnson had paved the way, visiting with Michael Scanlon and O'Donnell to address their concern that local people be included in the new Washington team. The president of the new league examined potential sites for a stadium, determining that National Park was unfit.

Manning dragged his feet on moving. As the dean of Washington baseball, Michael Scanlon chimed in to protect the interests of the city. He wondered aloud what kind of team Washington would receive because Manning's team finished in last place during the 1900 season. Scanlon noted that no one wanted another round of "alien owners" like the Wagner brothers, whom the

newspaper reporters noted were focused on the team's bottom line. Acutely aware of the Washington Senators during the 1890s, Scanlon asserted that, "Local patrons are sick and tired of chasing rainbows every summer in the way of unfulfilled promises."

The old baseball man sharply assessed the prospects for Washington's new club if Manning's Kansas City team came to the city. "Manning has nothing to offer in the way of a great team.... Should he come here with a loser he will have but little sympathy and still smaller patronage." Scanlon and other local baseball men believed that having local partners would help direct the team toward building a winner. However, Washington's early baseball history under the control of Scanlon and the Hewetts belied this claim.

The National League magnates attacked their new rival. They granted a newly formed Western League the ability to invade the former American League territories of Kansas City and Minneapolis and St. Paul. The move of another team into Kansas City limited Manning's options. Rumors swirled about a second strategy, a possible ten-team National League that would put a team back in Washington under the Wagners' ownership in 1902. While this move would wipe out the National League owners' debt of $25,000 to the Wagners, it deeply displeased many Washington citizens.

The NL magnates opted against expansion. Instead they backed the American Association as a new league to compete for patrons by playing games on the same day as American League teams. The Washington squad in this American Association came under the management of Charles White and Will C. Bryan. Bryan later became the manager of the Coliseum bicycle track.

In early 1901, the Manning and White-Bryan squads scrambled intensely to find a location for a baseball stadium. The difficulties of finding an appropriate area for a baseball park in the center city that plagued Walter Hewett in 1890 had worsened. Neither the American Association nor American League team ownership wanted the old grounds on Seventh Street and Florida Avenue. Both dismissed the park as old and in need of too much repair. They also knew that the District commissioners' highway plan called for extending Sixth Street and New Jersey Avenue through right field.

While the American Association group continued to look, the AL team of Manning and Johnson sought to purchase the circus grounds bounded by North Capitol, L, M and First Streets, NE. Located five squares north of the old Capitol Baseball Park, the grounds offered ample size and excellent accessibility from the New York Avenue, Fourth Street and North Capitol Street streetcar lines. However, new and long-time residents feared that a stadium with wooden grandstands would be a fire hazard. The team's owners tried to quell this opposition with a promise to construct steel stands. The filings of

protest against granting the building permit continued coming in from neighbors, presumably spurred on by the National League owners.

Within a month, newspaper reporters despaired over Washington's poor prospects of getting a major league franchise. The American Association club's management failed to obtain the local funding it needed. They counted on funds from the streetcar conglomerate. The Washington Traction Company would not shoulder the lion's share of fitting up a well-equipped playing ground. Meanwhile, the National League had effectively stopped Manning from using the old circus lot. When Manning found no other landowners interested in offering him a lease for more than three years let alone the ten he required, the NL magnates spread rumors about the Manning team's demise.

Despite the financial difficulties Bryan continued his efforts to form a team. A month before the season the American Association team signed seven of the fifteen players needed to complete a roster. However, the National League magnates changed their plans toward the new league. The NL's leaders reorganized its schedule to oppose the schedule of the American League, believing this more effective than sponsoring the American Association team as a counterattraction. However, the NL leadership wanted the American Association team to continue and pushed for them to play at National Park, presumably to pick up the cost of the $2,400 lease. With little but verbal support from the NL, the Association team failed to materialize.[11]

The AL group's backup plans for a location came to fruition. In June 1900, the Washington Brick Company went out of business because the nearby supply of the clay needed for their product was exhausted. Ownership started a new company based in Virginia, but retained sixty acres of land between Florida Avenue, Bladensburg Road, Mount Olivet Road and Trinidad Avenue, NE. The AL leadership negotiated a lease on a portion of the grounds, at Fourteenth and H Streets, NE.

The decision to build the stadium twenty-five minutes from downtown met with general approval. Local newspapers noted, "The luxury of two car systems would have to be dispensed with so the location near the terminus of a direct route is generally approved. The location is more difficult for the downtown but uptown enthusiasts can use the Columbia line." The reporters for the national sports weeklies felt differently, referring to the location as "inaccessible and unattractive to nine-tenths of the patrons of the national game in this city." After bemoaning the thousands of dollars necessary to create a playing field, one reporter asserted that "it would not tempt the local fans as a site in the northwestern or northern part of the city."[12]

The stadium's location made getting to the game more difficult than it

had been at the Seventh Street Park. Most of the federal city's workers had to travel both uptown and eastward from their downtown and Mall locations while the local city workers and residents in the northwest and southwest areas faced the longer trip as well.

However, the location expanded the local city. The area had only recently been devoted to mining and industry. The building of the stadium in the area changed the location to a commercial/entertainment zone. Going to games brought more people in contact with their section of the city, enhancing its prospects for development.

Building the Stadium

Creating the newly dubbed American Park required two separate tasks. First, the workers had to remove the leftover materials from the brick company and fill in the quarry. Only then could they begin the construction of all the facets of a stadium. The crew had less than three months to complete the tasks.

The new Washington stadium's construction attracted media attention in local and regional newspapers, and in the national sports weeklies. With team president Fred Postal based in Detroit, Jimmy Manning, now the Senators' vice president and manager, oversaw the project with a groundskeeper, foreman and a hundred workers. His groundskeeper worked with wagons full of dirt and a large crew to fill in the brick company's excavation pit. After nearly a month, they nearly filled the gulch in left field and could plan for making the outfield a level piece of graded ground by the end of the next week. But the shaping of the grounds for the infield had to wait because the lumber for the stands lay on top of that area.

Sunderland Brothers Architects sent their stadium plans to the eight to ten contractors interested in bidding on the contract. The architects consulted with District Engineer Snowden Ashford and outlined their general plans. The playing field, angled to keep the sun from the eyes of spectators and most of the players, had dimensions of 295 feet to the left field fence, 550 feet in center and 455 feet in right field. Both the grandstand and the fences would be against the District's fire regulations concerning wooden frame structures.

The stadium sat in the Trinidad area of the city. Few houses existed in the neighborhood of the ballpark. The ballpark could be an impetus to the expansion of residential development and city services into the northeast section of Washington. The park could also be a stellar example of new stadium design, including the use of steel and concrete for the grandstands. If they made the stadium both state-of-the-art and sizeable then it would enable the

Bleachers and grandstand along right-field line at American League Park I, built on a former quarry in Northeast D.C., c. 1902 (Library of Congress).

team to draw large numbers of patrons. This capacity would place the team among the bigger cities in the League in earnings potential.

However, the ballpark's isolated location led everyone to expect that District Engineer Commissioner Captain Beach would waive the restriction on wood construction. Beach did waive the rule. Within two weeks Manning received the building permit to construct the grandstand, bleachers and fencing. The Washington club chose not to make the grandstands out of steel and concrete, which would become the standard by the end of the decade. Along with the building of a clubhouse for the players, total construction cost approached $10,000 (approximately $200,000 today).

Despite not being built with the new materials, the new stadium would feature some updated aspects in its design. A one-story grandstand occupied three sides of the stadium. The grandstand contained a front row of boxes accommodating 300 people and 2,200 folding chairs in the remainder of the space, a total capacity of 2,500. Female spectators also received the benefit of ladies' maids in attendance.

Outfield at American League Park I, c. 1902 (Library of Congress).

The stadium included plans for parking. The design placed a wheelhouse near the southwest corner of the stand. This provided bicyclists a place to check their vehicles without charge before entering. Management banned the admittance of bicycles inside the gates. As a result, "there will be no consequent rubbing of muddy wheels against the clothing of patrons during the game." Manning included a box section exclusively for the use of President McKinley and his family and staff. On the roof of the grandstands, newspaper and wire service reporters made notes on the game.

The patrons of the bleachers came in through a different entrance than those with grandstand seating. At the new park they received better treatment than in old National Park. Now they did not have to go through mud and dust to reach the bleachers, but crossed boardwalks under the main stand around to the left field and right field seats. The bleachers were an innovation in stadium design; the AL Park was the first to have bleachers on both sides of the field. The structure appears in the nearby photograph.

However, construction problems emerged immediately as the body of

the right field section went up only to come down very quickly. According to the sports weekly reporter, the bleachers had a six-inch rather than the planned eight-inch incline. This small distance between the height of the seats and that of the stairs placed the knees of the bleacher dwellers into their own faces. The problem was discovered after a week, and the woodwork required rebuilding. The local newspapers provided a different reason, asserting that the six-inch rise was planned and the nineteen inches of the bench certainly provided the spectators in the bleachers a comfortable seat. However, the arrangement resulted in the views of the people being obstructed by the heads of the people in the row directly in front of them. Whether scrunching up their fans or stacking them up so they could not see, the snafu wrought as many red faces from embarrassment as red ink in construction costs.

While the wheelhouse served as a solution to the parking problems of the era, that was only one part of the transportation issues surrounding stadiums. The public transit system had to move a large number of people safely and in the appropriate time limits. The concern expressed over the number of streetcar lines serving the stadium emerged immediately as over 7,000 people planned to attend on opening day.

The Washington Traction Company worked with the team to bank cars up on the Eleventh Street, NW switch an hour prior to game time to dispatch them to the park as soon as they filled up. A number of special cars ran at short intervals from the Bureau of Printing and Engraving to the grounds for fans in that section of the city. The Columbia Railway increased regular service to provide cars leaving the Treasury terminus of the road at one-minute intervals.

The team and company had to make plans for travel back into the main residential areas of the city also. At game's end banked cars on the Benning Avenue, NE switch returned to the various parts of the city from the stadium as soon as they filled up. The disappearance of the horses and laying down of the track necessary for moving spectators to and from Capitol Park in the late 1880s marked an improvement. Still, the size of the streetcars and the limited number of tracks available resulted in the need to pack spectators in both before and after games, presumably discouraging some future patronage.[13]

Manning Lasts a Year

The successful start of the AL induced the NL magnates to wage a fear campaign to undermine the new league. They argued that a team needed $80,000 yearly to operate, hoping to convince fans that the new teams would

go bankrupt. The AL leaders fought back with the argument that $20,000 covered salaries and expenses. Washington baseball fans started the season with the belief their team had a good chance to win the pennant. The patrons turned out in sizeable crowds of 3,000 to 5,000 in the first months of the year as the team sat in second place.

Inclement weather resulted in the need to make up thirteen home games as the team hit mid–July. Two weeks later a slump led to the Senators' falling below .500. Still in mid–August, 2,000 patrons attended a Senators game despite the team's huge drop in the standings. Others fans expressed loyalty despite lacking the cash to purchase tickets. The many days of rain filled a brickyard bathing pool a block north of the stadium. Boys of the neighborhood regularly went to the pond to possibly secure a ball batted over the left field fence. The return of the ball gained them access to the park.

During the off season, the team's top two stockholders convened in Detroit. Postal and Manning agreed on expending more money on the stadium and team. The stadium improvements centered on the problematic right-field bleachers, which were considered too close to the field. They planned to move them an additional forty feet from the diamond.

The expenditures for the team resulted in personnel moves. Manning lured two pitchers, third baseman Harry Wolverton and star outfielder Ed Delehanty from the Philadelphia Phillies to his team. Delehanty received a $4,000 salary, Wolverton and Al Orth $3,000, and Happy Townsend $2,400. As a way to afford these larger salaries, Manning planned on using a roster of only 14 players for the coming season, two less than the average for major league teams. Yet within days, the popular manager chose to transfer 51 of his 54 shares to Postal. He then informed the press that he was leaving to take on another business venture.

While Manning's reason had validity, it accounted for only part of the story. Rumors about additional reasons for Manning's departure quickly appeared. Reportedly Manning feuded with League president Ban Johnson over not being allowed to borrow money against the American League reserve fund to purchase players. Manning interpreted Johnson's denial of the reserve money as another of several personal slights. He also viewed the denial as indicative that the president was not interested in making Washington a better team. Johnson and the other powers in the League had reservations about Washington's manager and majority owner over the entire year. They interpreted Manning's desire not to leave Kansas City as part of his nature, viewing the man as too conservative and unwilling to take risks.

The stadium in Washington played a significant role in this rupture between Manning and the other magnates. The other owners believed Manning carried on a too liberal policy of spending on the building. They thought

that he need not have established such a first-class plant and run it at this top level. However, he needed to construct the ballpark from scratch so $10,000 does not appear to be an enormous sum. The ballpark cost $2,000 less than the Coliseum bicycle track. It is uncertain how Manning's fellow magnates expected him to spend less during its construction and operation.

Given these issues about expenditures, it was not surprising that rumors also circulated that Manning and the team were losing money. However, Manning's shares earned him about $15,000. He reportedly netted between $1,000 and $4,000 in profit over the one year. Other articles called the rumor about the team losing money "twaddle." These observers argued that the team had a poor schedule (no home dates during any of the three big holidays), endured numerous rainouts and the assassination of United States President William McKinley (which soured many in the country), and had a bad slump but they did not come undone.

The team announced a new stockholder and manager simultaneously. When Tom Loftus, until recently the Chicago Cubs' manager, assumed the managerial duties of the Senators he purchased stock, although no one was certain of the amount. Majority owner Fred Postal provided his proportional amount for every improvement that may be made in the club property or the team. With the typical optimism of the new spring, the local newspapers predicted the team would be good and large crowds would enhance the value of AL Park. Presumably to reduce costs, Postal and Loftus opted to carry 15 men, the second lowest total among the eight teams in the AL. Most of the players had not been on the team in its inaugural season.[14]

The Absentee Owner

On opening day, after parading through the city in carriages, each team separately marched into the park with a band playing. The band moved to the top of the grandstand and provided music for the 8,000 spectators. This crowd included members of the Senate and the House of Representatives. The changes wrought little positive effect as the team reached next to last place by Decoration Day. The holiday double-header drew 4,000 to the morning game and 9,200 to the afternoon game. The combined total of 13,200 represented 1,000 less than the second lowest of the day's attendance figures (for two games played in Baltimore).

Despite its recent construction the stadium offered a small capacity. This undermined the team's few chances to bring in a lot of spectators. This hurt them significantly on the occasions that they had a big draw, or on a holiday double-header. The afternoon game on Decoration Day filled every seat and the standing-room section. The crowd also included 1,000 people standing

behind ropes in right field. More could have attended the game if seating had been available.

Perhaps this prompted the friends of the club to urge the team to move back to National Park for the beginning of the new season. Some observers acknowledged that the team made money. Many patrons of the game had begun getting used to traveling out in the northeast. In addition, the possible street extension through the Seventh Street stadium remained. The team performed little better and finished the year in sixth place.

At the end of the season a majority of owners tired of the war between the leagues. The war resulted in escalating player salaries and the stealing of players off each others' rosters. The owners formed a committee charged with negotiating a peace between the NL and AL. The committee members forged a peace. The end of the fighting paved the way for a creation of the World Series to determine the overall champion for the season. The peace hampered the players' opportunities for salary increases and led to a firming up of team rosters.

Most importantly, the American League could now transplant the Baltimore team it held in receivership to New York City for the start of the 1903 season. A rumor spread that Tom Loftus wanted to manage this New York team. Initially, Postal did not believe the news. Loftus admitted to it, saying he had no contract with the Washington club. He viewed himself free to accept the New York berth if the league wished to send him there. Postal objected to the move. "Loftus is not only my manager, but my business associate and partner and I need him in Washington." If his positive plea did not work, Postal also noted that he could sell his share of the Senators to the syndicate that wanted to take the team to Pittsburgh and become an owner of the New York team himself.[15]

The Loftus situation raised many questions. Managing a team in New York offered many benefits. Yet why would an owner and manager of one team want to move to simply be the manager of another team? As an owner, would he not have been able to arrange for a renewal of his contract as the Senators' manager? After one year of leadership, did he not want to see how the team would shape up under his second year of guidance? At the very least Loftus's desire to move on indicated that the manager had little mental or emotional investment in the Washington team. The remarks that President Postal made indicated that the amount of his investment also appeared to have obvious limits.

Word spread that owner Fred Postal wanted to sell his shares in the team. Patrons' fears of an ownerless team increased as reporters noted that Postal had invested in the team as a favor to his friend Ban Johnson. Now he wanted to recoup his investment. The minority stockholders in Washington met with

the largest single shareholder in February. They spent a few weeks trying to sell Postal's 48 percent holdings in the team. When the entire portion could not be sold, Postal agreed that he would hold his shares. As soon as he left Washington the minority shareholders heard that Postal secretly informed his attorney, Milton J. Lambert, to sell his share of the club. The other shareholders took this as evidence of bad faith. Loftus joined with the local shareholders to solidify their position as the majority shareholders and the decision makers for the Senators.

This news of Postal's attempted sale also sparked worries among property owners and the Freedman's Hospital about National Park. Anticipating that new owners might forsake AL Park, they filed protests to the District commissioners against allowing baseball to be played on the Seventh Street grounds again. Their fears disappeared when the Totten estate would not provide a long-term lease for the grounds. The team's management knew that moving the grandstands between the parks would cost between $5,000 and $8,000 and they would not make that type of an investment without a guarantee that the park wouldn't be sold out from under them.

As noted in the previous chapter, this had already happened to the Hewett club. The possibility that it could happen provided an illustration of the position of sport in U.S. culture held at the time. Clearly, professional sports did not hold the exalted position it does in today's culture. The weakness of its stature is apparent in that the Senators could not exert significant pressure to force a landlord to provide them with a favorable deal. This appeared to be the only item holding the team from transferring home fields. The District commissioners notified the complainants that their office had no discretion in the matter of leasing the old stadium and would be forced to act favorably if they received an application for a license.

Since the team chose to stay at AL Park, management painted the grandstand, re-sodded the outfield, and repaired the fencing. Manager Loftus discussed the refreshment and advertising services with interested businessmen and awarded both contracts to former baseball owner Walter Hewett for the second consecutive year. Loftus made the more momentous decision of declining a reported offer for the services of their aging slugger Ed Delehanty.

The star outfielder had financial difficulties. He compounded them by accepting advances on his salary from both the New York Giants and the Senators. After the peace treaty between the two leagues the newly united owners forced Delehanty to play for the Senators. The aging star preferred not to play in Washington. The newly created New York AL team reportedly offered to cover both teams' salary investments and also provided Washington with a bonus, a total expenditure of $10,000 for the slugger's services, but Senators management declined. Mid-season, the slugger would die under

mysterious circumstances on a road trip. His loss hurt the team on the field and at the gate.[16]

The first season of peace between the two leagues also enabled the team and the stadium to make history. During the exhibition season, the Senators hosted the Phillies at AL Park in the first game ever played between AL and NL teams. The Senators won. The club promptly set an attendance record for American League Park on opening day. District Commissioner Henry Litchfield West threw out the first ball and the big crowd created a famine around the refreshment stand. However, one observer noted that the "poor handling of the crowd by the railroad company on opening day resulted in a reopening of the Seventh Street grounds proposition."

Two weeks into the season the Senators sustained their first of many losing streaks. At the end of a May, despite a record with three times as many losses as wins, the club drew 3,500 to a home game. In June, they topped themselves with five wins and nineteen losses. This solidified their status as the worst team in the league. Despite the record, when the western teams came to D.C. for the last time in mid–July the gate receipts for Chicago numbered 11,000, or over 2,000 per game. According to one-time Chicago White Sox manager Clark Griffith, a team made money if they averaged 2,000 a game and the western clubs earned one-third more the first trip through Washington and the other eastern cities. Thus, Washington and other teams in the league earned enough revenue to turn a profit.

Frustrated with the current ownership situation, Postal acted. He met with members of the local group, including the old D.C. baseball man Michael Scanlon, and negotiated to purchase their four percent of team stock to boost his own holdings to 52 percent of the team. With his controlling interest, Postal intended to exert control over a team that had the second largest payroll in the AL, yet sat mired in last place.

Postal would not receive this opportunity. AL president Johnson inserted himself into the negotiations among the team owners. The potential sale became problematic when everyone discovered that the team carried an $8,000 debt. Finally, Johnson pushed Postal to sell his 52 percent of the stock for $15,600 and accept his proportional share of the team's losses. Postal expressed his frustration over his inability to control affairs and dictate club policy but left happily despite not making any money.

The AL president's actions, including his handing the negotiations with Postal, sparked much speculation. First, he invalidated Postal's purchase of the four shares that gave him majority ownership. Second, Johnson usurped the position of the local investors' VP Charles Jacobsen and Director Cochran. Third, some baseball reporters noted that Johnson rejected purchasers who insisted on putting in their own manager. Why was Johnson so interested in

who owned the team? The reporters who questioned the final sale postulated that Johnson wanted to retain Loftus as the Senators' manager and shareholder to have his vote on AL issues.

Indeed, Loftus had only one winning record as a manager in eight years. Soon news emerged that Johnson held over 70 percent of the team's stock. The AL president hid the truth of the team's sale to minimize potential opposition in the District and among the other team owners. One scribe summed the situation up: "The Senators were an inmate of the AL's orphans' home. This condition will continue to exist until the portly President can find a guardian who will care for the orphan according to the plans and policy which he will form and enunciate."[17]

Despite the new league's attempts to rationalize the baseball business the league could still suffer from imperious leadership and internal battles. Washington, D.C., was included in the AL. However, the league was dominated by its northeastern cities and Chicago. The District was not really in the same ballpark as its northern counterparts. The lack of a local city resident with the money to own the club resulted in the D.C. team's interests and the interests of its fans being sacrificed by the league's power brokers.

The local city public opinion makers seemed oblivious to precisely what Washington lacked. The city's newspaper editors observed that the Senators' ownership received strong public support considering the product that went out on the field. They insisted that team owners would profit heavily if they created a top division team so that lack of effort to this end confused the editors. The team finished last in the AL standings, and its home attendance of 128,878 finished nearly 100,000 below New York, the team with the next lowest total.

At the close of the first season of peace the current version of the World Series began. Most baseball fans know that the 1903 version involved the Pittsburgh Pirates and the Boston Americans (later Red Sox) playing a best-of-nine affair. The 1904 version would not be played because of New York Giants manager John McGraw's antipathy toward the American League. His team would play in the 1905 World Series and the string of contests remained unbroken until the strike year of 1994.

The World Series involved the best teams. Ever conscious of making money, several other American and National League teams also squared off against one another in a series. The Browns and the Cardinals played from the beginning of one weekend to the end of the next weekend to determine the top team in St. Louis. The teams from Cleveland and Cincinnati played for the championship of the state of Ohio. The Cubs topped the White Sox in the Chicago series and the Athletics bested the Phillies for the Philadelphia championship.

That first year the two New York teams did not play. Manager John McGraw refused to play the New York American League ball club. The next year featured another St. Louis series and Chicago series as well as a Boston series. The profitability of these contests was considerable. After the close of the 1908 season, the owners tried to play Cleveland against Pittsburgh but the Cleveland players disbanded for their off season homes too quickly for them to create the series.

These series illuminate several interesting aspects about the sport of this era. Both the owners and players made significantly less money than they would even by the 1920s. Thus, the series proved viable as outlets for them to earn more gate receipts and more salary respectively. The existence of these series showed that the World Series was not played apart from other baseball games. The championship of baseball had not attained the exalted status that would come in later years. These other series featured two teams that battled for a city or state championship, thus showing the game's local focus. These series allowed local fans of both teams to visit the ballparks and watch their teams complete for the bragging rights of being the best in the community. The limited mass media of the era enhanced the local focus through not being able to easily broadcast the World Series to areas throughout the country.

These city series showed the limitations that sport owners faced in Washington. The team did not participate in these city series. While perhaps not being a good ball club played a part in their not participating, the lack of a natural rival due to geography seemed much more likely to be the reason. As the only team in the southeastern mid–Atlantic states, Washington not only had no intercity rival, it had no regional rival.

The closest geographic rival had been in Baltimore. The AL shifted that franchise to New York City that year. Even if the Baltimore team still existed, the experience of the bicycle racing in Washington had showed that the potential rivalry between the two cities did not always generate interest amid the spectators of sport. The Washington baseball team's lack of participation in these city or state series cost the owners the opportunity to improve their tenuous financial situation and community relations.

Who Owns the Senators?

The instability within team management increased during the off season. The press reported that the American League asked the indulgence of the Washington baseball public because they had not found proper owners. They further postulated that the Senators might play under the management of the League that season. Washington baseball fans rejoiced in mid–Febru-

ary when Johnson reportedly negotiated the team's sale. Local city resident John R. McLean, proprietor of the *Cincinnati Inquirer,* and federal city worker Representative James W. Wadsworth of Genesco, New York, expressed interest in making the purchase. However, significant details remained unresolved and the bidders commenced to reduce the value of their offer. Their final price turned out to be a figure Johnson found entirely inadequate.

The probability of the Senators' operating under AL receivership mandated that the League president turn his attention to finding a new manager. Johnson also began negotiating for the use of the Seventh Street stadium. According to one reporter, the latter proposition would be greeted very positively by patrons who lived in the northwest, and the Navy Yard in the southeast would increase attendance by 500 and more on special occasions.

The end of the sale of the club to the McLean-Wadsworth partnership opened up a variety of possibilities that fueled speculation. While many in Washington speculated on what type of support the AL would give the team, the Philadelphia newspapers reported that the Wagners were interested in buying the team. The potential return of the "Butcher Brothers" sent shivers down many a patron's spine. One reporter noted, "[Fans] fell upon their knees in loud petitions to the gods to be spared that awful calamity ... that affliction...."

Johnson could not resolve the Washington franchise's issues as he had those of the team from Baltimore. The League needed someone to handle the team's affairs. Former manager Tom Loftus returned to the city and oversaw the picking of the team and moving of the grandstands to the new home field at Seventh Street. Loftus was averse to coming back but Johnson needed someone to look after the affairs of the team. Reporters observed that Loftus would find it no easy task to pick a desirable team from the number of players secured.

As Loftus toiled, the youngest son of the proprietor of the *Evening Star,* Thomas C. Noyes, businessman William J. Dwyer and attorney Wilton J. Lambert purchased the team. Lambert became the team president and Dwyer its vice president and business manager. They hired a contractor to unbolt the old grandstand and bleachers and rebuild them at National Park. They also carried over most of the fencing from the American League Park and sod to use on the new park's diamond. Dwyer quickly provided the usual preseason rosy scenario of the team winning games and drawing big crowds. The nearby photograph shows the stadium in 1907 with advertising on the bleaching boards across the outfield. The amount seems to be slightly more than in the Capitol Park II stadium shown in the last chapter. The grandstand seats had roofing to shade the patrons from the sun.[18]

Rotating Managers

On opening day, Dwyer was proved correct as ten thousand attended the game. Finding room for everyone required allowing part of the crowd to watch from on the field just inside the fence in right field. Non-paying spectators watched from the roofs and upper windows of nearby houses. Each of the next two games drew 2,000 spectators. Under the guidance of catcher and interim manager Malachi Kittridge the team started the season 0–13. When they defeated New York for their first win, the *Star* declaimed the victory an amazing feat. After seventeen games, player-manager Patsy Donovan seized the reigns and the outfielder hit .229, his worst year since playing for the Washington Nationals in 1892. His 37-97 record also made it an easy decision for the owners not to re-sign him.

A young first baseman who joined the team in 1904 assumed the Senators' reigns the next season. The team won a few more games than they lost during Jake Stahl's first month as manager. Optimism came from all corners. The correspondent for *Sporting News* wrote, "[T]he new Senators owners can reap profit and be in position to compete with the rich rival teams for pick of the best players. The receipts in three months will ensure financial success."

The team's owners agreed. They made appropriate changes to the stadium in anticipation of success on the diamond. While the team went on the road for a few games they made improvements to the park that added 500 bleacher seats and provided additional exits for spectators in both the grandstands and the bleachers. After their return from a road trip the team's record stood at 17-23 and they drew 4,500 fans to the park. The losses began piling up and the attendance dropped. At the end of the home stand the team's 22-34 record firmly placed them in the seventh-place position. Dwyer resigned as the team's business manager that month and the team remained in next to last at the end of the year.[19]

Stahl led the squad to another finish in seventh place in the 1906 season. Team management hired Joe Cantillon to lead the Senators. As a major league umpire Cantillon had developed a reputation as a brainy man. He had established his managerial skills bringing two minor league teams that he owned into second place in successive years. Before the beginning of the 1907 campaign, praise abounded for Cantillon's abilities and his acquisitions.

Reporters noted that the 1906 squad was not weak. They asserted that Stahl's lack of natural leadership did the team in. Local fandom considered a finish in the top four of the AL a good possibility. However, Stahl resented that management gave him no warning before securing Cantillon. The first baseman refused to report to the team through the first month of the season.

American League Park II, perspective from Freedman's Hospital, 1907 (Library of Congress).

The Senators could only end his holdout by trading Stahl to the Chicago White Sox for cash. Meanwhile, the team began the season at 4–9 and the record deteriorated from there. Expectations sank to a new low. One reporter quipped that the Senators made a mistake today and won a game.

After these two years only Cantillon appeared optimistic. When the manager informed a life-long baseball man that his bunch would finish ahead of the Boston team in 1909, the listener quipped, "If you do I will quit baseball." Indeed, one reporter noted that Cantillon delighted in picking up men that other clubs found hard to manage and now Sir Joseph must realize his great mistake. The baseball writers appeared to enjoy making light of Cantillon and Washington. While covering the Chicago White Sox visiting the District in the summer, scribe Ring Lardner noted the light competition from the Senators yet expressed amazement that any other team could win in the city's heat.

During his last season, Cantillon used the team's sole star, starting pitcher Walter Johnson, in relief after being told by the star that his arm was not right. Johnson's arm hung limp by his side after pitching an inning. Even after the possible ending of a star pitcher's career, the manager placed a positive outlook on the club, calling it the best since he has been in Washington. When asked if he would continue managing, Cantillon admitted that the club's officials had not spoken to him about their plans for the upcoming season. At the board of directors meeting later that fall, Cantillon and Senators president Thomas C. Noyes both faced the possibility of not returning to their posts.

Rumors abounded that solid players with both the Chicago White Sox and Philadelphia Athletics vied to become the team's new manager. However, the Washington board of directors decided to retain manager Joe Cantillon. When the decision came to Ban Johnson's attention he fired off a telegram informing the board to await his special delivery letter. The letter requested that they fire the manager, noting that some owners objected to him because he was a traitor to the American League. Johnson included an indirect threat to take the franchise away. The Senators' owners did as instructed and hired Jimmy McAleer, formerly of St. Louis, as the new manager. At the AL winter meeting, Cantillon was exonerated of charges of being a traitor.

Despite Cantillon's unpopularity with the majority of patrons, his ousting made many wonder if Johnson or the AL owned the Senators. The local reporters observed that Johnson acted like a tsar. They declared that it appeared unseemly that Johnson or any other league official would tamper with the affairs of any club. They noted, "Cantillon's discharge merely added to the opinion of the few who have hitherto believed that the American League has less of sporting enterprise than of business acumen." The owner of the Chicago White Sox, Charles Comiskey had formed an opposition to Johnson, so why the Senators' owners chose not to join forces will remain unclear.

While fighting to retain Cantillon's services appeared unworthy, fighting for business autonomy does not.

The business acumen of the Senators' club owners appeared worthy of questioning to the reporters. They observed that for guiding their team to the AL's basement for three years, Cantillon received $21,000 plus 10 percent of the club's profit. New manager McAleer would get a salary of $10,000, much more than he received from St. Louis one year before. Both local and national team reporters viewed these decisions with consternation and the team's seventh-place finish in 1910 did little to change their minds.[20]

While funds went toward management the club maintained one of the poorest stadiums in both the major and minor leagues. As one reporter noted, "A losing team earns good dividends on the investment so there is no good excuse why patrons here pay the same prices and do not have decent accommodations." During spring training before the 1911 season the management had no choice but to examine their stadium situation. The team had recently purchased the grounds from the Totten estate and added to them, presumably anticipating the construction of a new stadium. However, in mid–March a plumber left a blow lamp exposed that set fire to papers that lay underneath the 50-cent seat pavilion in right field. The fire spread quickly, destroying nearly all the wood-frame stands. The team's insurance covered $15,000 of the $20,000 losses.

Throughout the city there was grave concern that the fire made it impossible for the team to begin its season at home. The team management responded quickly and planned to build a steel and concrete structure with a seating capacity of 15,000 at a cost of $125,000. They hired the Osborne Construction Company of Cleveland to supervise construction and the Fuller Construction Company to build the stadium. While presumably not modeled after any particular park, the Senators' new home resembled two of the newest stadiums, Philadelphia's Shibe Park, a 20,000 capacity stadium completed for opening day in 1909 at a cost of $333,000, and Forbes Field in Pittsburgh, a 25,000-seat stadium finished in July 1909 for a approximately $500,000. The firms worked in three eight-hour shifts to complete the job in less than two months.[21]

As a turnout of 16,000 people overflowed in the new stadium for the opening day game, the franchise moved into a new era. The completion of American League Park enabled Washington to join the majority of major league teams in having a steel and concrete stadium as their home field. However, within two years the shortsightedness of the owners and their limited funds became clear when the team needed to put in additional seating to host the Army-Navy football game. They did not make the changes and the calls for building a new stadium in Washington continued.

3

Oh to Be in Philadelphia
The Army-Navy Game

"War Department Proposes Great Structure to Seat 40,000." A newspaper headline like this seems odd in our times. Less than one hundred years ago it appeared in the *Washington Post*. The proposal came as part of a larger plan for the conversion of the gardens and empty areas of East Potomac Park into a model playground for the people of the District. The plan's principal feature, a great stadium at the widest part of the newly reclaimed peninsula, suitable for holding the annual football games between the West Point and Annapolis teams. This attempt in 1913 to bring the Army-Navy game to Washington was neither the first nor last time that citizens of the District tried to bring Washington a game they believed rightfully belonged with them.

Potomac Park

Congress disbanded the District's territorial government in the middle of the 1870s. Shortly thereafter, the new District commissioners, the District Committees in each house of Congress, and the executive agencies with responsibilities for overseeing federal properties in Washington faced an enormous problem. The river front of the city, an area known as the "Potomac Flats," contained silt, sewage, and salt water grasses. This brought navigation upriver to a halt. Some called these marshlands south of Constitution Avenue, which was then known as B Street, "an offensive and pestiferous public nuisance." Newspaper editors argued that everyone knew they needed to be reclaimed. On Lincoln's Birthday in 1881, the Potomac River broke its banks and flooded Washington along Pennsylvania Avenue and Constitution from Sixteenth Street to First Street, NW, wreaking hundreds of thousands of dollars in damage.

After studying the situation for a year, Congress apportioned over two and a half million dollars to the U.S. Army Corps of Engineers for the fifteen-year project to remove this health, sanitation, and flood problem. Under the leadership of Washington District Engineer Major Peter C. Hains, contractors dredged the river channel and dumped the spoil on the Flats. The operation reclaimed 600 acres formed into two tracts of land, sitting several feet above high tide and flanking a tidal basin. Soon, high weeds, willows, trees and underbrush made the need for maintenance obvious while prompting calls to make the land more useful. Starting in 1886, the U.S. government initiated suits to settle private claims and establish its right to the Flats. A decade later, some claims remained, amid calls for the new land to be sold for private use.

Congress resolved the issues surrounding the fate of the Potomac Flats favorably to the majority of the District residents. Members opted to accept the bill that mandated the Flats become a park for the people rather than reserve them for a purpose Congress would specify some time in the future. They elected not to make the city responsible for half the cost of the reclamation project. Finally, they selected the name Potomac Park rather than calling the park Riverside. By the end of the century, the Corps of Engineers turned over its responsibility for the maintenance of the parks to a division within the War Department.

In 1901, the Office of Public Buildings and Grounds within the War Department assumed responsibility for East and West Potomac Park. During the thirty years the agency managed these areas, the bureau expanded from seven to nine divisions and the superintendent required two assistants. The superintendent, an Army engineer, served as the executive and disbursing officer for the many commissions charged with building the statues and memorials in Washington. He received the temporary rank of colonel.

The new organization assumed responsibility at an amazing time in urban planning. The country underwent significant reform and remodeling of urban areas because of the City Beautiful movement of that era. In Washington, Congress and city planners had recently created and shaped Washington with the development of the McMillan Plan for the National Mall. Deeply informed by both activities, engineer Colonel Theodore A. Bingham submitted the first plans for the parks. His requests included the development of Japanese gardens, nurseries, athletic areas, and a military parade field. Early improvements to the areas featured streets along the river and around the tidal basin.[1]

West Potomac Park: The First Washington Location for Army-Navy Games

Soon after the completion of the grading for an athletic field in West Potomac Park, superintendent Colonel Charles S. Bromwell foresaw an opportunity. He advocated for the erection of permanent stands in the area. This "stadium" would enable Washington to host the Army-Navy football game, baseball games and other sports.

The Kentucky native graduated from the United States Military Academy (West Point) in the early 1890s. He continued his education at United States Engineer School of Application. The captain established a reputation for his efficient service in the chief of engineers' office leading several public works and engineering projects in Washington and around the country.

Bromwell received a temporary rank of colonel upon taking the reins of the Office of Public Buildings and Grounds. He was lover of sea air ("[T]he sea air on the [Maine] coast can not be improved upon," he once said) whose largest task involved overseeing the remodeling of the White House. However, the Colonel established himself with the local residents as a devotee of flowers. Bromwell oversaw the planting of flower beds in West Potomac Park and established a chrysanthemum show in the District. His most notable achievement would be his artistic development of Potomac Park.[2]

The football game had recently failed to draw the expected attendance at the stadium in Princeton, New Jersey. Colonel Bromwell took the opportunity to promote moving the game to Washington. The Colonel informed the media that "the new athletic field at the Potomac Park would be far more desirable [than the White House Ellipse lot].... [We have] put it into such shape that there would be plenty of room for the gridiron and seats for fully 100,000 people." He observed that

> A stadium such as Harvard has would give sports a great stimulus in Washington. The playing on public grounds would make the seats free, the idea being either to get Congress to appropriate enough money to build the stands or raise the necessary sum by public subscription.

The Colonel and many other residents of Washington believed that the city was the natural and logical location for the game. As the seat of the federal government, Washington provided both services with their funding and initiatives. Bromwell buttressed this argument with assertions about the beautiful environment in which the game would be staged and the ability of the city's transit system to handle great crowds.

The Bromwell plan placed the stadium in the federal city, under the control of his office. The organization offered a unique method to resolve concerns over funding, suggesting public-private cooperation. The leaders argued

that if Congress granted part of the money, the rest could be raised by sub-scription among the citizens of Washington. This money would be supple-mented by others who had an interest in seeing a permanent place chosen for the Army-Navy game. This marked the event as one of the first times that the federal government offered to pay for the construction of an athletic venue.

Building a stadium to bring the game down to Washington found sup-porters both within both the services and the federal government. As the end of 1905 approached, the feeling among officers of the two branches of the service was that the game's coming to the District appeared very likely. The former officer in charge of the Office of Public Buildings and Grounds, Col-onel Fred Symons, endorsed Bromwell's plan. Symons had spoken highly of Bromwell and accompanied the young colonel to meet the President during the transition between the two men's terms as superintendent.

> Washington, the seat of government, is the natural and logical place for the con-test. It should be played here, and I think it will be if it can be shown that this city can furnish a proper field. If arrangements can be made to build seats at Potomac Park, at the foot of Fourteenth Street, I think that would be an ideal place, and the game would become a fixture in Washington's calendar. It is a loca-tion destined to be one of the most beautiful and interesting sections in Wash-ington. Great crowds could be easily handled by the steam and street cars, automobiles and carriages along a pretty driveway, and the field is within walk-ing distance of the center of the city.

Symons studied athletic fields of the country during his tenure. He observed that a stadium fashioned after Harvard's building would have a 40,000 capacity. If the stadium were made out of concrete with steel stands the cost would be $250,000. Although that was expensive, the Office of Pub-lic Buildings and Grounds thought that the stadium could be used for many other purposes. The various baseball leagues of the city could play there dur-ing the summer, and a large military drill or review or other outdoor assem-blage could perhaps be attracted.

The argument for other usages illuminated a crucial cultural attitude during that Progressive Era. The value of sport could not solely justify the cost of building a stadium. Neither could the argument that hosting the game would generate significant income. There had to be greater societal purpose, such as providing locals with a place to play games and the military a place to practice their preparedness.

The members of the services had their own particular reasons for seek-ing another location for their annual game. Many found that the amount of travel time to reach the host town too much to accept. In addition, the play-ers and many spectators needed to have accommodations for overnight stays

and the host town could not always meet this need. Washington, along with Philadelphia and New York City, appeared to have the chance to host the game for the upcoming season.

Washington citizens also supported the stadium plan. However, Congress did not act on the plan. Over the next few years groups of citizens kept working for the plan. The Georgetown Citizens' Association invited the next officer in charge of the Office of Public Buildings to address them on the topic. The superintendent during those years, Colonel Spencer Cosby, could only tell his audience, "It is also hoped that Congress eventually will see the wisdom of erecting a stadium in that park."

A local Marylander, Major Cosby graduated at the top of his class from West Point in 1891. Cosby made a name for himself as an engineer during the Spanish-American War and the Philippines Insurrection. He returned to Washington in late 1905. He took charge of the water supply system in the District and he earned a reputation as highly capable. Cosby established an intimate friendship with William Howard Taft. When Taft assumed the presidency in 1909, he wanted a man capable in engineering and in the many social demands that went with being the superintendent, and he chose Cosby.[3]

As Cosby made his effort he received substantial support from District citizens and organizations. The Washington Chamber of Commerce, which defined its mission as aiding in bringing about improvements in the District of Columbia, lent its support to the plan and promised an effort toward securing private funds. However, the citizens and businesses in both New York and Philadelphia also strove to have the game staged in their cities. What were all these groups after?

Intercollegiate Football and Early Army-Navy Games

Intercollegiate football grew slowly from its first contest in 1869. The majority of the colleges playing the game resided in the northeast. Consistent rule changes occurred, from shaping the field into its current dimensions in the mid–1870s, to lowering the number of players on the field for each side from 25 to 15 to 11 in the early 1880s. Two significant rules developments came later. The first involved the establishment of a line of scrimmage to begin plays. The second created a requirement of moving the ball at least five yards in three downs. All of these advances in the formation of the game widened its appeal. Over 200 colleges had teams at the beginning of the twentieth century.

Neither the rule changes nor the spread of the game helped the sport with its large number of injuries. When Harvard introduced the flying wedge formation during the game against Yale in 1892 so many injuries were inflicted

on the team from New Haven that officials banned the formation the next year. Two years later the teams carted off seven players from the field. This prompted the two schools to not communicate with each other for the next two years.

When injuries and fatalities occurred, they naturally led to subsequent public relations difficulties. The newspapers of the day fanned these stories like a flame. The *Washington Evening Star* carried information about yearly fatalities in both their news and editorial sections. As a result, the sport became inextricably linked with serious injuries and fatalities. The *Star* editors noted:

> Football has endured a decade of popular prejudice against the game because of the deaths and disablements that occur due to the brutality of players. The death roll of the sport continues to increase from year to year, while an unknown number of dislocations and other serious injuries have accumulated. Parents and college faculties are speaking up against the brutality which the game fostered. Newspapers have done good work agitating for reform.

The game required the breaking of the enemy's line to score. This resulted in the players' being persistently pummeled. Some teams added less sportsmanlike behavior to achieve the required goal. The "going for" a particular player on the other team included bumping, tripping, kicking, and deliberately beating the man. During the 1903 football season, seventeen people died and sixty-five sustained serious injuries. In Washington, the police appeared at the annual Thanksgiving Day game to maintain the peace between the teams and among the spectators. Despite the introduction of new restrictions on tight formations and dragging ball-carriers, eighteen players died as a result of football injuries in 1905.

Some colleges and universities, including Columbia University, reacted to the "carnage." Two universities banned the playing of the sport. Most of schools did not react, sparking a national controversy. President Theodore Roosevelt interjected himself into this situation in an effort to save the game and the colleges from themselves.

A group composed of nineteen prominent football-playing colleges acted. They formed the American Intercollegiate Committee to address concerns over the sport. The members sought to refine the rules of football through an attempt to "open up" the game and to eliminate unnecessary roughness and brutality. They legalized certain types of forward passes to address the former. The Committee addressed both goals by also imposing a neutral zone before the line of scrimmage with the requirement that at least six players be positioned on each side. They also added disqualification rules for unnecessary roughness and unsportsmanlike conduct to accomplish their latter goal as well. The meetings created an ongoing entity called the Inter-

collegiate Athletic Association of the United States with the responsibility to regulate college athletics.

The new rules did not have the anticipated success. The sport remained violent with thirty-three deaths during the 1908 season. Another thirty deaths and two hundred sixteen injuries occurred the following year. Newspapers across the country ran articles that listed football deaths and injuries in charts by state, type of football, and cause of death or type of injury. The editors called on parents to assume the responsibility for stopping these occurrences.

The newspapers of Washington acted similarly. The *Star* staff cited an instance where a high school football game in Montclair, New Jersey, was postponed indefinitely. The mothers of the players notified the principals of each school that they would hold each personally responsible for everything that happened on the field. The intercollegiate athletic organization revised the rules again, eliminating the flying tackle and removing the restrictions on the forward pass. The numbers of fatalities and injuries declined slowly, only to peak again in the early 1930s. The National Collegiate Athletics Association (NCAA) responded to criticism of the sport's brutality with the statement that it was occurring because of a lack of supervision and ignorance of rules of the game.[4]

Twenty years after the start of collegiate football, Cadet Dennis Mahan Michie accepted a "challenge" from the Naval Academy. The two squads faced off on The Plain at West Point on November 29, 1890. The series experienced a five-year hiatus after the 1893 Navy victory sparked an incident that reputedly almost brought a rear admiral and a brigadier general to the dueling grounds. Under the guidance of President Grover Cleveland, the secretaries for the Navy and for War reached an agreement. The pact prohibited both Navy and Army from playing any games away from their respective home fields.

In 1899, Philadelphia was chosen as a neutral locale to host the Army-Navy game. The rivalry began anew at the University of Pennsylvania's Franklin Field. While the stadium had been constructed only a few years earlier, its small size resulted in a pressure for tickets that sparked a scandal. The academies discovered that members were selling the tickets that they received to scalpers. All parties agreed on selling the tickets for the game and providing the receipts to charities. In 1904, the box seats auctioned off brought an average of $50 apiece for total receipts of $5,700, or $800 more than in 1903. Still, the limited size of the stadium prompted pressure for tickets and the academies began to complain about not receiving the number of game tickets that they wanted. They moved the game to Princeton, New Jersey, for 1905, but as already noted, it left after one season.

The game returned to Franklin Field, where a temporary stand on the west end increased the seating capacity by nearly 3,000. However, the Uni-

versity of Pennsylvania claimed that the stand spoiled the beauty of Franklin Field and its presence closed off the running track for four weeks. Consequently, the school officials refused to erect the stand for the game in 1908. The two services battled over the course to take, whether to return to Philadelphia under the new conditions or move the game.

An article in a local Washington newspaper helped explain part of the game's attraction. The piece noted that football generated an estimated $20 million in expenditures. The two largest games, Harvard-Yale and Army-Navy, each accounted for $1 million in total expenditures. These included the direct ones that only a few shared, such as for tickets and concessions at the game. But they also included the indirect expenses that benefited the host city, such as for transportation, hotels, food after the game.[5]

Local Citizens' Initiatives

The Washington Chamber of Commerce's Conventions Committee called upon the District commissioners to urge them to bring the game to Washington, D.C. They noted that the officers were dissatisfied with Franklin Field as the place for the game because they had been unable to obtain the 8,000 seats they desired. They asserted that temporary stands could be erected to seat 40,000 on the White House ellipse.

According to their calculations, the game brought $150,000 to Philadelphia each year. They predicted that amount would be double in Washington because people would stay to see the city. They game would be one of the big social events of the year and the president and cabinet officers would make a point of attending. They noted that they needed to obtain the consent of the Secretary of War and the Secretary of the Navy, and to convince the athletic associations of both academies that Washington could handle the crowd.

While the Chamber proposed one method of hosting the game in Washington without building a stadium, the American League Washington Baseball Club became involved in another. According to the *Boston Globe*, prominent officers in both the Army and the Navy conferred with the president of the Washington Senators. These discussions seemed appropriate given that the superintendents of the two academies arranged for the 1913 game to occur at the Polo Grounds in New York City. The New York Giants had remodeled their ballpark to accommodate 40,000 spectators and to form a complete oval around the gridiron.

The baseball club offered 1,250 seats to each of the academies. They also offered them the option to purchase several thousand more if they desired. President Minor believed that the Senators, in association with local civic organizations, could arrange to hold the game. They team could erect extra

stands in the recently rebuilt baseball stadium discussed at the end of the last chapter to handle 40,000 people for the game. They team sought a three-year commitment from the two services. Unfortunately neither plan came to fruition. The organizations concluded that they could not raise the required funds without congressional or other support.

The two plans demonstrated the high degree of local citizen interest in having the game in Washington. The Chamber's and the Washington Baseball Club's efforts demonstrated the various approaches to creating an appropriate stadium for the contest. The Chamber sought to create stands on public grounds. The baseball team sought to temporarily expand their park to create the room to handle the crowd for the Army-Navy game. Despite their efforts the District's local city lacked the resources to pay for the cost of even the modification of an existing baseball stadium.

The next year, the Chamber of Commerce joined the team's effort. Both groups sought to raise the funds required to build additional seating on the back of the outfield gardens at American League Park. The president of the organization, William F. Gude, conferred with members of the executive committee to develop the plans. They believed that if they could extend an invitation to the two academies they would then have an assurance of receiving ample financial support to build, organize and run the game. The trade association did not succeed. Had they been able to build the additional seating, both the Senators baseball team and the Washington football teams to later play at what became renamed Griffith Park would have benefited enormously over many years.[6]

Efforts to Hold the Army-Navy Game in East Potomac Park

Meanwhile, Superintendent of Public Buildings Colonel Cosby submitted to the House Committee on Appropriations plans that proposed a stadium for East Potomac Park. The park would become a model playground for the people of the District, suitable for all classes of outdoor sports. While admitting that these plans involved an expenditure of much more money than available for the purpose, Cosby noted they were highly endorsed by the officials generally. He argued that the stadium would be suitable for holding the annual football games between the West Point and Annapolis teams and similar national sporting events. The advocates noted that the stadium would enable the city to host the armed services' football game. Again, these proponents justified the expenditure for the stadium by mentioning that it could serve a larger purpose, as a means of amusement and instruction to the general public. Congress took no action on the plans.

Later that summer, the Senate and House considered another plan. This time they would allow the chief engineer to build temporary seating on the polo grounds in West Potomac Park to enable the two services to play their annual game in Washington. Secretary of War Lindley Miller Garrison notified Congress that the War Department, in its role as custodian of public grounds in Washington, had no objection. In addition, the War Department would allow a nominal admission charge.

The House Military Committee approved Washington as the location for the game. A joint resolution authorizing the use of the polo field in West Potomac Park for the football game went before the entire House of Representatives. The academies would have the responsibility for building and removing all the necessary stands and other structures as well as the management of the business side. The projections called for stands to seat 47,500 spectators and a hundred boxes for high officials and other special guests. The resolution went dormant.

The illustration on the following page depicts the plans for the football field for the armed services' game. The stadium contained two rings of seating surrounding the rectangular field. The inner ring included eight sets of box seats. The outer ring included banked grandstands. Access to the seating came from six entrances; there were two on each side of the central seating and one each at either end of the stadium. Closest to the field, in the center of the seating area, the designer, P.A. McHugh of Chicago and Cleveland, included box seating for the president.

The Navy, which had hoped to hold the game in the city because of its proximity to Annapolis, conceded that they needed to find another location. The White House Ellipse was the only available place to play that could hold 40,000 spectators. However, the concessions required to use the site made the plan untenable. Despite the futility of these efforts, each one raised public awareness and interest.

Members of Congress remained interested in the construction of a stadium to house the game. Several Congressmen offered the new engineering officer in charge of public buildings and grounds, Colonel William W. Harts, suggestions regarding the plans he submitted for East Potomac Park. The proposed improvements included boat landings, a golf course, tennis courts, and a provision for a stadium to hold 60,000 people, in which the Army-Navy football games could be played. These plans received the approval of the Chief of the Army Engineers and the acting Secretary of War.

Selected by Woodrow Wilson, Harts had recently completed his bachelor of science degree at Princeton University. Severely wounded while serving in the Spanish-American War, Harts served in the Philippines during the Insurrection of 1902. He returned to the United States and became a mem-

Stadium seating plan for Army-Navy game in East Potomac Park, 1914 (Library of Congress).

ber of the debris commission, responsible for clearing up San Francisco after the 1906 earthquake.

The colonel developed a focus on the park system of the District. He worked furiously throughout his tenure to expand the number of parks in Washington and to beautify them in the interests of a "finer Capital." Harts appeared as a speaker at city events held by charities and the public library. He also published articles about beautifying Washington in professional journals, such as the Journal of the American Institute of Architects. He became so vital to the city's planning that President Wilson waived the required appointment of a new superintendent when Harts's term expired after four years. The president described Harts as "one of the most useful officers in the government service."[7]

The East Potomac Park plans went to the members of the Commission of Fine Arts. The executive order dated October 25, 1910, required that the plans for any public building in Washington, D.C., had to be submitted to the Commission of Fine Arts for its comment and advice. The Commission

advised the federal and District
governments on art and architec-
ture that influenced the appearance
of the city. This included the loca-
tion of statues, fountains, and
monuments in the public squares,
streets and parks in the District of
Columbia, and the selection of
artists for the execution of same.

The members who served on
the Commission during 1914 in-
cluded three architects, one land-
scape architect, a painter, a sculp-
tor, an author, and the current
officer in charge of public build-
ings and grounds. Under the lead-
ership of Daniel Chester French
and the world-renowned Frederick
Law Olmsted, the Commission
members backed the plans. They
concluded that when fully devel-
oped, East Potomac Park would
take its place with the three other
great island parks of the world. The
members felt hopeful that these
plans would reach fruition. The

Colonel William W. Harts, superintendent,
Public Buildings and Grounds, 1913–1917
(Office of History, U.S. Army Corps of Engi-
neers).

Congress had already sanctioned the project by making an initial appropri-
ation of $50,000 toward the construction of a field house.

After making the request, Colonel Harts spoke to groups throughout
the District about his plans for a recreational site. The area would offer citi-
zens and visitors boating facilities, grounds for parades and field sports, and
baseball and football fields. Other attributes included tennis courts, a golf
course and swimming facilities with a field house that contained 2,000 lock-
ers.

The keystone was a U-shaped stadium near the main entrance. The sta-
dium would have concrete seats for 6,000. Its shape enabled wooden tempo-
rary seating on each side to provide for 34,000 more spectators. Within the
stadium lay a running track, and at each end of the wings were practice fields
for football and other team sports. Its location provided a view of the river
in the foreground and rolling hills beyond. The projected cost included
$110,600 for the stadium and $1.55 million for the entire public recreation

grounds project. This amounted to approximately $2 million in today's dollars for the stadium and nearly $28 million for the scope of the plan.

Harts plan expanded upon Colonel Cosby's plan to develop a recreational area within the federal city. The plan did not include a provision for charging admission to enter the stadium. Perhaps the inclusion of this money-generating potential might have quelled congressional doubt over the construction costs. Presumably Colonel Harts and his agency believed charging admission on federal government grounds was illegal. Indeed, a superintendent would take this position in the near future. The cost provided a large stumbling block. The plan mandated that the federal government would pay for and manage the site.

The colonel and his plan received support of the opinion makers in Washington. The editors of two of the city newspapers noted that the lower Potomac Park plans had as an eventual object the establishment of a stadium in which prowess of contesting athletes may be tried out. "The American people are entitled to a Capital that will be more in harmony with and in proportion to the national size, strength, wealth and high ideals." Cities groups, including Associated Charities, invited Harts to present his plan to large audiences and locations like Rauscher's displayed the drawings for the public to see in the hall.

Through the winters of 1915 through 1917, Harts and even Secretary of War Newton Baker continued the effort to build the entire park plan, including the stadium. The colonel and the highest-ranking civilian in the department lectured to the Washington Society of Fine Arts, where Colonel Harts outlined plans for the future. The newspaper reporter noted that one of the most striking points he brought out involved the proposed athletic and recreation center in Potomac Park, including a stadium in which the Army and Navy football games would be held.

Others outside of Washington's citizens also believed in the value of the stadium project. During congressional testimony, Colonel Robert M. Thompson stated that it was hoped the Army-Navy game could be held in the national capital. "This game has been turned into a great gladiatorial contest, which it should not be. If it were at Washington this would not be the case. It would be more nearly pure sport." An article in the *Christian Science Monitor* featured the development of golf courses in the Park. The reporter mentioned that these courses would lie south of a great stadium in which it was expected Army-Navy football games would be played. Harts oversaw the beginning of the construction of the golf courses while continuing to promote the entire project. However, within two months, the United States joined the fighting in World War I and military encampments covered much of the grounds of East Potomac Park.[8]

A Variety of Locations:
Army-Navy during the Roaring Twenties

After two years of not holding the game because of World War I, the academies met again in New York's Polo Grounds in 1920. Soon after, the argument about the best location for the game resumed. Each academy preferred to play in an urban area close to its own location. Over the decade Baltimore and Chicago hosted the game as well as Philadelphia and New York City. The last two years of the 1920s, the academies could not agree on what players would be eligible to play. Despite the intervention of Representative Hamilton Fish, a Republican from New York, negotiations did not solve the dispute and the services did not play one another in 1928 or 1929.

The superintendent of the public buildings and grounds office and various groups of private citizens attempted to build a stadium in Washington to host the annual game between the services. In the early 1920s, a group formed a District Athletic Association. Their plan featured private funding as the source for constructing the stadium. The Association's effort did not advance far.

Colonel Clarence O. Sherrill replaced the gregarious and popular Harts as the Superintendent of the Office of Public Buildings in 1921. Sherrill attained the funding from Congress to establish a bathing beach for blacks to use in segregated Washington. He pushed for the creation of an arboretum and struggled to keep people from using the parks for "parking"— kissing and engaging in other romantic activities— in their cars.[9]

Sherrill exhibited plans for a proposed stadium in Potomac Park. He based his plans on those developed a decade earlier. He added the already-erected field house and golf course. He continued to place the financial responsibility for the stadium's construction on the federal government. Others advocated that the stadium could be self-sufficient. Sherrill argued that if the stadium were made to be self-supporting, it should be located on private ground where admission could be charged.

Sherrill's position indicated that it would be illegal to have a stadium admission charge if the stadium were built in the federal city. Yet, the golf course in the Park operated on a self-supporting basis through charging players, so there appeared to be an inconsistency. Sherrill promised his aid in any way possible to bring about the erection of such a stadium not on federal land but in the local city. The colonel received support from his superiors. Major Sultan said that the general of the armies was in sympathy with anything that tended toward physical development.

The local citizens again expressed their support for building a stadium to host the annual football game. W.J. Tucker of Anacostia Citizens Association asserted that many people regretted that the Army-Navy games were

not held in Washington. The local citizens wanted to see the stadium built to enable the nation's capital to host that game. The newspaper editors added their perspective. They bemoaned that "annually, as Thanksgiving season approaches, there is increased talk of a stadium in the District that is sufficiently spacious to accommodate 100,000 spectators, but nothing tangible has been done."

As the colonel reached the last year in his four-year term he made one last effort to generate legislation to build a stadium to host the football game. He provided the District Park and Planning Committee with his stadium plans in late summer 1925. Sherrill requested that they study the problem in order to recommend possible sites for the stadium to him. The locations being considered each offered accessibility by train, streetcars, and automobiles. In addition, each could provide parking for thousands of cars. The committee announced that present plans called for a stadium with a seating capacity of 65,000 persons. Similar to the Yale bowl, plans called for a large number of acres to be reserved for automobile parking. The sites ranged from the publicly-owned locations of East Potomac Park and Anacostia Park to privately-held land. Did the limitation on self-liquidation that Sherrill assumed four years earlier still apply?

The public announcement of the Committee report two months later prompted a number of citizens to offer suggestions and recommendations for sites. Three of these featured locations in the southeast section of Washington. The president of Gallaudet College, Dr. Percival Hall, urged that Sherrill use the site of Camp Meigs, located at Bowen Road at 46th Street. Meanwhile, the Congress Heights Citizens Association favored the stadium project in Wilson Park, and the Anacostia Citizens Association ventured to Sherrill that section E of the Anacostia Park along the Anacostia River was suitable. The colonel responded that these reactions indicated a great interest on the part of the citizens of the District and that it inspired him to go further with the project.

Perhaps the momentum would be unstoppable. The newspaper editors tossed in their suggestion of Brookland as an appropriate location for the stadium near Catholic University. They followed this with the observation that the present moment required that a civic organization make the initial move, then the rest would be simple. They called upon the Rotarians, the Kiwanis, and similar bodies to join together to bring the Army-Navy game to "the logical place" in 1926. The Chamber of Commerce again supported the effort for a stadium, joined by the Merchants and Manufacturers Association.

A new government agency joined the fray. One year earlier, Congress had established the National Capital Park Commission, soon to be renamed the National Capital Park and Planning Commission (NCPPC). The NCPPC

served as the federal government's central planning and development agency in the District of Columbia and nearby areas. The NCPPC approved Sherrill's stadium plan and supported the legislation by which the colonel planned to move to its construction.

The local city did not provide the support the colonel expected. A month passed and the District planning committee had not returned the completed report on potential locations. The citizens had not rallied in sufficient force to push Congress to construct a stadium. Sherrill met with a special committee of the Washington Chamber of Commerce, who called upon him to renew his effort for the stadium. The colonel expressed his exasperation but opted to address the Washington Board of Trade and the Federation of Citizens' Associations to measure their enthusiasm for the stadium. The groups provided Sherrill with the foundation he sought.

The District commissioners endorsed the project as well. Now large enough to seat 100,000 and shaped like a horseshoe, the stadium would be privately financed. The stadium would be constructed under the aegis of a private corporation established for that purpose. The commissioners promised to aid early enactment of the legislation enabling Congress to donate government ground for the stadium site and parking. A bill went into the House of Representatives that authorized the director of public buildings and parks to set aside a site for the national stadium project.

In one of his last acts as superintendent, Colonel Sherrill met with the chairman of the House Public Buildings and Parks Committee, Richard Nash Elliott, a Republican from Indiana. Sherrill provided Elliott with the information necessary to introduce the bill. At the committee's first meeting, Elliott introduced a measure to authorize the formation of a stadium corporation and the issuance of bonds to erect the stadium. The earnings of the stadium would pay down the bonds. In addition, earnings accrued to the municipal recreation sites, such as the public golf courses and the concessions that they operated, would also be added to the funds. Any remaining monies would add materially to the welfare coffers of the office of the director of public buildings and parks.

Several members of Congress had publicly given support to the movement for the stadium. Their interest was most piqued at the ability for Washington to stage national athletic events, especially the annual Army and Navy football game. The financing structure to the bill could help avoid a possible veto by President Calvin Coolidge. The limited-government Republican from Vermont openly frowned upon government expenditure for a stadium in Washington. However, Coolidge had said nothing regarding a self-liquidating stadium that would only involve the federal city in the act of providing a site on one of its properties.

As the Committee examined the bill, citizens in the District sought to promote their ideas about the stadium's location. The presidents of five District citizens' associations, in the Congress Heights, Lincoln Park, Randle Heights, Anacostia and East Washington Heights sections, proposed that Anacostia Park offered the best place for the stadium. They argued that no other place in the city offered as many advantages. These advantages included accessibility to local traffic, trains, streetcars and buses. In addition, the 66 acres in section E could host the stadium and some parking, with the adjoining sections providing the remaining acreage necessary for the lots.[10]

Superintendent Sherrill left Washington and the stadium project became the responsibility of the next superintendent, Major Ulysses S. Grant III. The first official word came from Grant's assistant director with Public Buildings and Public Parks, Major Carey H. Brown. The Ohio native, who graduated from the University of Chicago and West Point, informed the public that he believed that accessibility, construction, and acreage were the principal factors that governed the location of the national stadium.

A month after assuming his office, Grant made efforts to develop the stadium project. Grant met with civic leaders at a luncheon at the Army and Navy Club to discuss how to broadly and carefully develop the soundest financial plan. Attendees included federal city representatives, such as the Office of Public Buildings and the NCPPC, and those of the local city, including the Chamber of Commerce, Board of Trade and Federation of Citizens' Associations. Each group went to its memberships to devise plans. All plans would come to naught as Congress took no further action toward passage of the Elliott legislation to provide a site for the stadium.

The coming year, the NCPPC sponsored a national conference on city planning and offered an alternative to the Anacostia Park location for the stadium. They proposed to provide East Capitol Street with flair to match what the Mall offered to the west side of the Capitol. They envisioned a building for each of the states running from a point near the Capitol down to the Anacostia River. A stadium seating 100,000 persons and designed for Army-Navy football games and other major sports events would be erected in Anacostia Park at the end of East Capitol Street. The plans remained on the drawing boards as the Great Depression gripped the United States.[11]

The Army-Navy football game did not occur officially again in the first years of the 1930s as the two services continued their disagreement over eligibility requirements. However, the circumstances of the Great Depression helped motivate them to play a charity game in both 1930 and 1931. Each game raised hundreds of thousands of dollars for servicemen's charities as over 78,000 spectators attended the games at Yankee Stadium in the Bronx.

Despite the two services' not playing one another in a regularly scheduled game in the early 1930s, other cities attempted to lure them. Cities ranging from Chicago and New Orleans to Columbus, Ohio, put in bids to host the game in the mid–1930s. The Great Depression certainly motivated a greater number of cities to try to get the game in order to bring in money. The game also received extensive coverage in the newspapers and on the radio, providing additional revenue opportunities. Association with the football game between the services did wonders for a city's image. The greater media coverage provided more publicity about the city, reaching a greater number of people throughout the country, boosting tourism. In addition, being linked to the Armed Forces provided the city with the cachet of being associated with patriotism and the "Americanism" of athletics.

The cities did not obtain the game. The superintendent of the Naval Academy, Admiral David F. Sellers, informed the mayors of these cities that a trip to a distant point would interfere with the routine of training. Historically, the superintendents of the two academies had wanted the game in the city closest to their college. The decision makers for the two services signed a three-year deal with Philadelphia's Mayor S.D. Wilson to play the football game at the Municipal Stadium in Philadelphia's south side. The new stadium provided room for over 100,000 spectators, the largest crowd since over 110,000 people watched the game at Soldier Field in Chicago in 1926.

Organizations and individuals in Washington attempted to bring the Army-Navy game to the District in 1932. The two services reached an agreement regarding player eligibility and prepared to resume their annual contests that year. In 1931, the business elite in the local city, the Washington Board of Trade, established a subcommittee to plan for building a stadium in honor of George Washington's 200th birthday in 1932. The chairman of this subcommittee met with the planners of the NCPPC regarding a suitable site for the stadium. The group endorsed the NCPPC's plan, joining a local city organization again with a member of the federal city in a new effort to build a stadium in the District.

In 1932, members of the House of Representatives expressed a similar view. Representative Frederick Albert Britten, a Republican from Illinois, a former construction worker and business executive, pushed President Herbert Hoover to make the request that the game be played in Washington. Representative William Brockman Bankhead, a Democrat from Alabama, tried to use the power of the purse to motivate the services. He raised the issue of Washington's hosting the game during consideration of the naval appropriations bill. However, the approach did not work.

The father of actress Tallulah Bankhead, William Bankhead, wielded significant influence among his peers. He became a majority leader, then

Speaker of the House when the Democratic Party took power in a few years. His next move involved an unusual tactic to bring the game to Washington: manipulation through proposing a House resolution. The measure stated that the House of Representatives called on the authorities in charge of the Army-Navy game to play the game in Washington in 1932 in celebration of the George Washington Bicentennial.

This would not be a simple resolution to pass. Representatives Bertrand Hollis Snell, a former corporate executive and Republican from New York, and John Quillin Tilson, a former attorney and Republican from Connecticut, thought the resolution unusual. Both then added that they wanted to know where the game would be played. Representative Bloom from New York answered at the baseball park. Representative Schafer expressed concern over staging the game for 40,000 instead of 80,000 spectators. Representative Edward Wheeler Goss, a Republican from Connecticut, objected to the resolution on the basis of location and ticket availability.

After the discussion of two other issues, Representative Bankhead asked for the Speaker of the House to recognize him. Bankhead announced that he understood Mr. Goss was willing to withdraw his objection to the resolution. The Speaker waited for Bankhead to renew his resolution. The Speaker asked if there was any objection to the resolution and none occurred. The House agreed to the resolution. The *Washington Times* agreed also, observing that the game would take on added color if played at the seat of government. All officialdom and other Washingtonians would have the chance to attend the game and witness the colorful spectacle. These suggestions from a powerful member of the District's federal city and a local city opinion maker did not persuade the superintendents of the two service academies.[12]

At the Foot of the Grand Avenue

The NCPPC assumed the position of the most active federal city bureaucracy advocating for the construction of a District stadium in the early 1930s. The chairman of the NCPPC, Frederic A. Delano, pursued the development of East Capitol Street and the construction of the stadium. A graduate in law from Harvard, Delano worked as a general manager of railroad companies, then served on the Federal Reserve Board but resigned to accept a commission as a major in the Army Corps of Engineers. He earned a Distinguished Service Medal for his service during World War I. Active in civic concerns after settling in the District, Delano accepted President Calvin Coolidge's nomination of him to the position of chairman of the NCPPC.

The federal city's planning arm continued its plans for the stadium at the end of East Capitol Street. The organization asserted that this would help

build up that section, creating a balance in the development on each side of the Capitol. They drew up their vision of the Avenue of the States for East Capitol Street. They advanced their plan for a stadium at the foot of the street in Anacostia Park. Now, as the nation entered the second year of the administration of his nephew, President Franklin Delano Roosevelt, Delano forwarded a bill to construct a stadium to members of both the Senate and the House of Representatives.

The NCPPC support for the stadium and sporting area reflected its larger planning purposes. As the map on the following page illustrates, the sporting complex fit within the proposed development east of the Capitol building. East Capitol Street ended at a plaza which had a tennis and track stadium flanking it. Behind these three features sat a reviewing ground and polo field. A baseball stadium and a football stadium sat on either side of that area. Twin bridges carried traffic over the Anacostia River.

The Senate version proposed by Senator William Henry King a Democrat from Utah, authorized the Secretary of the Interior to build a stadium at the end of East Capitol Street. An attorney and professor, King had served for the last few Congresses on the Committee on the District of Columbia and supported many of the projects that District residents sought. The Senate leadership referred the bill to the District Committee for hearings.

The federal city work force moved behind the scenes to create a favorable impression of the stadium bill. Delano and members of the Department of the Interior had conversations about increasing federal government support for the plan. Members of the department drafted a letter supporting the stadium for their chief, Secretary Harold Ickes. Through the National Park Service, Delano wrote Ickes asking for him to sign this draft letter in support of the stadium and send it to Senator King for his committee hearing. Delano noted that the work could be finished quickly as part of the process would be included in anticipated winter construction.

On the same day in late April 1934, Representative Mary Theresa Norton, a Democrat from New Jersey, introduced a similarly written bill. The first woman elected to Congress from an eastern state, by the Democratic Party, and without a political lineage established by a husband, Norton became the first woman to serve as chairman of a committee. Nicknamed "Battling Mary," she was considered by her colleagues a sagacious "politician" with opinions grounded upon common sense and dictated by the best of motives. A feminist, she began her activity in the political world focusing on social welfare work like many women of her generation. In Congress she retained this focus,

Opposite: **Proposed development of East Capitol Street, NE, c. 1930s (National Archives and Records Administration).**

PROPOSED·DEVELOPEMENT·EAST·OF·THE·CAPITOL
JANUARY 1, 1936 ·WASHINGTON·D·C· CASS GILBERT, INC.

enjoying helping the people lined up outside her office door waiting to discuss their daily problems with her.

As the chairman of the House District Committee, Norton long advocated for both improvements and home rule for the District. She sought to sacrifice federal city and her own power to strengthen the power of the local city and District residents. Appearing at a celebration of Catholic University's greatest football team, Norton declared her vital interest in sports and gave her full approval to the movement for a huge municipal stadium in Washington.

Congresswoman Norton thought the Stadium bill would be referred to the Public Buildings and Grounds Committee. Battling Mary must have thought her bill stood an excellent chance with this set of lawmakers, though it was not her own District Committee. The legislation authorized the Secretary of the Interior to borrow the funds for construction from one of the federal government relief organizations or from private sources. The loan would be paid back through the admission charges to enter events. Delano informed the media that the 40-acre tract between Twenty-First Street and the Anacostia River, NE made an ideal location. The stadium would serve multiple purposes, including athletic contests and civic and patriotic demonstrations. Despite the efforts of the parties nothing came of the bills in either chamber.[13]

After the derailing of the latest federal city government members' effort, many local city residents looked elsewhere. A prominent businessman and a noted architect designed their own vision for a stadium in the District. Washington Redskins owner George P. Marshall and local architect Jules Henri De Sibour announced an alternative vision for the new Washington stadium, one that would be useable in all seasons, regardless of weather.

A Domed Stadium

George Preston Marshall's father moved from West Virginia and opened the Palace Laundromat in Washington. Marshall inherited the business and with his flair and innovation expanded the operation to 57 outlets. A friend of Chicago Bears owner and National Football League (NFL) leader George Halas, Marshall and three other men purchased the Boston NFL franchise in 1932. After buying out the others, Marshall created a successful team in Boston.

Despite the team's success on the field the franchise did not gain respect in Boston. After a few years of disappointments with both the city's fans and its media, Marshall brought his football team "home," according to the *Washington Evening Star*. Washington had the second best team in football and a

second chance in the NFL. Ever the innovator, Marshall received credit for creating half time, and for exploiting the forward pass. His team fight song, "Hail to the Redskins," continues to be used to this day. (However, the additional lyrics penned by his wife, actress Corinne Griffith, including "fight for old Dixie," and "Scalp 'em, Swamp 'em. We will take 'em big score," have been retired.)[14]

That Marshall looked to make improvements on the typical stadium design was part of his personality as an innovator. Once established in Washington, Marshall made the association of a descendant of Louis XI of France. Architect Jules De Sibour attended colleges in both the United States and France before settling in Washington, D.C., in 1901. The consulting architect for the U.S. Naval Academy, among others, he designed a few buildings that presently stand in Washington, including the Crowne Plaza Hamilton Hotel on 14th and K Streets, and the Jefferson Hotel at 1200 16th Street. De Sibour also played sports and belonged to racquet clubs in Washington and New York City.

The sportsman and the architect received a patent for their all-weather stadium in June 1936. The 70,000-person stadium featured a retractable roof made of steel-supported glass that could slide open and closed over the entire playing area. The place included heat and air conditioning for the spectators' comfort and had an estimated cost of $2 million. The pair claimed that their invention offered several other innovations, including a design for the tiers of seats that offered greater capacity yet maintained their proximity to the playing field. These good views would be maintained whether ice sports, track, baseball, swimming, or boxing occurred upon the playing field.

The illustration on page 112 shows the design of the stadium. This horizontal section shows the entrances and exits for the various users of the stadium, including male and female players, all fans, and the referees. The regulation-size football field could be converted into a track and field area. The area could also become a swimming pool (the number fours on the diagram). The central island in the pool area (number fives on drawing) could be covered with sand and reached via bridges (number sixes).

The roof's design and mechanism for moving represented its key elements. The men preferred that the roof be formed of eight panels constructed of frames, four to each side of the longitudinal center. The panels would be mounted on rollers on the fixed inclined roof of the stadium. This enabled each section to move independently of the other, such as via an electric motor. The roof sections could be adjusted into various positions that either completely or partly enclosed the stadium. On very sunny days, folding the sections back exposed the entire playing field to the open air. The design provided

Aug. 25, 1936. J. H. DE SIBOUR ET AL 2,052,217
 ALL WEATHER STADIUM
 Filed June 20, 1933 7 Sheets—Sheet 1

Horizontal section of retractable roof stadium (U.S. Patent and Trademark Office).

for heating the stadium in a suitable manner, such as arranging pipes under the seats that enabled the stadium to be used for playing ice hockey while the spectators remained comfortably warm.

The illustration on page 114 includes two figures. The top portion (Figure 8) depicts a detail section showing the construction of the meeting ends of the various sliding roof frames. The gutter and weather stripping hold a position that enabled them to form a tight joint when these two sections moved into contact with one another. The bottom portion (Figure 7) por-

trays a vertical section through a portion of the fixed roof with two of the abutting movable roof frames.

The two figures in this illustration share a similar numbering system. The areas numbered 8 represent the roof structure. The rollers (numbered 9) are aligned on a suitable track (numbered 10) running along the fixed roof (numbered 3). The areas numbered 11 show a skylight structure that enclosed the roof frame in glass. The gutters (numbered 12 and 13) slid into one another. They shared a suitable packing that enabled them to form a tight joint between adjacent sections while providing for them to move independently. The gutters (numbered 14 and 15) sat on the opposing end of the roof sections. They also contained a packing material, such as leather, that enabled them to form the tight joint upon contact after the roof sections moved to enclose the field.

The large problem that the stadium faced involved the playing surface. The designers needed a substitute for turf. At a press conference no one harped on the potential difficulties. The pair emphasized why they thought the stadium ought to be constructed. De Sibour informed the gathering, "The Army-Navy game certainly belongs to Washington, headquarters of the two Services. It may not be available for several years because of previous commitments, but there can be no valid argument against staging the contest here with proper facilities."

Several other government officials joined the chorus of support for building a stadium in the District in order to hold the Army-Navy Game. Senator Robert Rice Reynolds, a Democrat from North Carolina, made the construction of an all-weather, all-purpose stadium the center of his address to the American Legion in March 1938.

> Washington is the economic center of the entire world and yet in stadiums it stands forty-second in the United States alone. We have never been able to hold the annual Army-Navy football game here because of seating facilities. Chicago has an athletic plant that seats more than 100,000 people; Buffalo, New York, a stadium that will seat 90,000.

The senator aimed to construct the entire recreation center at the foot of East Capitol Street. He called for a new National Guard armory. The armory should be equipped also for expositions, ice skating, roller skating, swimming and other sports. Rice complained that Congress had thus far failed to appropriate any funds for the stadium construction.

District local government officials also offered opinions that supported the location of the stadium at the end of East Capitol Street. William A. Van Duzer, the District of Columbia's director of traffic, advocated locating the national stadium at the end of East Capitol Street. He believed that this would

Aug. 25, 1936. J. H. DE SIBOUR ET AL 2,052,217

ALL WEATHER STADIUM

Filed June 20, 1933 7 Sheets-Sheet 6

Sectional view through portion of fixed roof structure and a movable frame for retractable roof stadium (U.S. Patent and Trademark Office).

be the opening wedge in a program of development which eventually would do much to restore this area to its rightful position as a vital part of a balanced capital. He argued that the site was the only location in which adequate traffic could be handled and that would permit the stadium to be large enough for events such as the Army-Navy football game.

The consulting architect for the NCPPC used a different platform to promote the stadium. Born a year after the end of the Civil War in Washing-

ton, D.C., William Partridge received traveling scholarships and taught architecture at Columbia University and later at George Washington University. After serving as the principal assistant for the 1901 McMillan Commission's replanning studies, Partridge continued his efforts to put those plans into action. Partridge formulated development plans for areas ranging from the federal triangle to the Watergate area, and of course, the NCPPC's plans for East Capitol Street as the "Avenue of the States" with a stadium and sports complex at its foot.

Partridge contributed a series of articles on the future development of Washington to the *Washington Evening Star.* He observed that an area providing not only accommodation for the spectators but for the parking of their cars proved to be a definite need for a stadium in the District of Columbia.

> The increasing popularity of the annual football games between the Army and the Navy has forced the authorities to hold this contest between the rival service academies where there is sufficient room for the ever-increasing crowds assembled for this climax of the football season. There is also a feeling that, for sentimental reasons, the game should be held in the National Capital.

Within months, the NCPPC took action to solidify the placement of the stadium at the foot of East Capitol Street. The group ordered the condemnation of the remaining unimproved properties in the proposed national stadium site. This order included proposed sites for seventeen row houses, six of which already had permits to allow them to begin construction. NCPPC estimated that their action would save at least $165,000 in the purchase price for these properties facing on C Street, NW, east of Nineteenth Street.[15]

Whatever momentum might have been gathering to construct a stadium site in Washington diminished as the threat of involvement in the expanding European war increased. In the two years before the United States joined the fight, and then during the rest of World War II, the Army-Navy football game rationale for building a stadium did not appear. Other reasons did. When the Army-Navy Game arose in conversations regarding the construction of a stadium in the District of Columbia, it did so as a complement to another rationale. The purpose that gained the most traction as World War II approached its end, and in the immediate postwar era, was for the stadium to serve as a memorial to veterans of the recent world wars.

4

Utility in Concrete
Monuments and Memorials

Throughout the world, the capital cities of nation-states took shape as a reflection of that culture and nation. In most instances, these cities existed prior to their nomination as the nation's capital. Washington was one of the first cities to be formed with the knowledge that it would be the nation's capital. Decades earlier, Russian rulers chose St. Petersburg, and in more recent years, Brazil chose to create Brasilia as the capital city in 1957. These cities planned as national capitals had the unique opportunity to completely shape their environments.

The original planner, Pierre L'Enfant, envisioned Washington as the capital of a great democracy. Its landscape needed to remind Americans of their history so he conceived of a city that would contain symbols of the national experience. These symbols included buildings, statues and neighborhoods intended to project how the nation wanted others to see it and how it wanted to see itself. The monuments and memorials appeared on federal government property.

As described in the previous chapter, the Office of Public Buildings and Public Grounds maintained the responsibility for building and supervising construction on federal land. The Commission of Fine Arts served as an advisory board for all building that occurred on federal land. These organizations viewed the development of Washington's landscape through the prism of the City Beautiful movement. They believed that making changes to beautify the environment would alter behavior and thus improve life for all residents. For these organizations, the creation of parks and recreational opportunities, grand avenues, and monuments to a heroic past were vital portions of making over this cityscape.

Both government agencies usually worked with commissions that Congress created and charged with the responsibility to develop a specific mon-

ument. The city had a small number of monuments at the end of the nineteenth century. The Congress and private organizations added monuments to the city very slowly. In his annual report for fiscal year 1906, Superintendent of Public Buildings Charles Bromwell observed that Washington had 26 statutes, even after a spate of building.

There would be the occasion to build many more monuments and memorials during the next fifty years. During the discussions regarding several memorials, members of Congress and citizen groups raised the option of building a stadium in the District of Columbia. This type of memorial would have added something distinctive to the federal city portion of Washington. The memorial would have provided federal employees and the workers and residents of the local city with a new entertainment site and numerous spectator activities.[1]

A Stadium for Honest Abe?

The earliest instance of a stadium as a memorial emerged as one of several alternatives being considered in the halls of Congress. Shortly after his assassination, an association formed to create a memorial for Abraham Lincoln. The group debated concept and location. The McMillan Plan established an area in the new West Potomac Park as the location for the memorial in 1901.

Others advocated for different types and locations for a Lincoln memorial. A group of Maryland and Pennsylvania citizens and some representatives in Congress pushed for a Lincoln Memorial Highway from Washington to Gettysburg, Pennsylvania. Other groups thought that the location for an appropriate memorial would be in Meridian Park on Sixteenth Street and Florida Avenue, NW, beyond the boundary of the city. Others advocated for a million-dollar memorial north of the Capitol Building. Over a number of years, Americans' desire to build a memorial for Abraham Lincoln in Washington increased.

Almost ten years after the McMillan Plan's site designation, two members of Congress joined forces to create a memorial which honored Lincoln. Speaker of the House, Joseph G. Cannon, a Republican from Illinois, united with Senator Shelby M. Cullom, another Republican from Illinois, to push the Lincoln Memorial Bill through both the House and Senate. The bill created a Lincoln Memorial Commission to decide on the appropriate monument. President William Howard Taft signed the bill into law on February 11, 1911. The bill created the Lincoln Memorial Commission to oversee the project and set aside $2 million in funds.

The debate about an appropriate memorial for the sixteenth president

continued. The latest suggestion came from members of Congress and centered on a plan for a great stadium in Washington. Designs for the stadium were drawn up by architect Ward Brown so they could be shown to the Lincoln Memorial Commission. According to its advocates the stadium, as a memorial to Lincoln, should be a most magnificent structure like the Coliseum of the Roman Empire. The proposed stadium would enable Washington to hold pageants and expositions. The structure was 650 feet long and 550 feet wide, elliptical in shape and had a height of 120 feet. While the seating capacity topped out at 87,000, another 15,000 could watch from standing room.

The small group of federal city representatives who advocated for the Lincoln Stadium combined the desire to memorialize the sixteenth president with practical concerns. They observed that the stadium would help generate the potential to host the Olympic Games. The stadium solved the problem of the location of the Army-Navy football game as well. The stadium would also provide an ideal place to host state expositions. For these advocates, sports held a position in society that allowed for a stadium to serve as a memorial site for an assassinated president of the country.

This viewpoint for sports and stadiums may not have been widely shared at the time. The proposal for a Lincoln Memorial Stadium attained little consideration. Letters to the editor in the local Washington newspapers discussed the Lincoln memorial quandary. While some proposed new ideas, such as a memorial bell, most sided with one of the alternatives already being considered. No one mentioned the stadium proposal. As we know, the Lincoln Memorial Commission selected the site near 23rd Street, NW, on the axis with the Washington Monument. They placed there the Henry Bacon shrine, modeled upon a Greek temple, and the Daniel Chester French sculpture of Lincoln as the memorial.

To Honor the Veterans of the First World War

After the end of World War I, a group of Washington citizens resumed the effort to move Congress to approve the construction of a stadium for the District of Columbia. The chairman of the House District Committee, Representative Benjamin K. Focht, informed the city that, "There is no reason in the world why Washington should not have the largest and best stadium in the country." Perhaps reflective of the previous considerations for the Lincoln Memorial Stadium, the Pennsylvania Republican thought the stadium needed to equal anything that Rome had and be of ample proportions to seat thousands of persons.

By the summer of 1921, superintendent Colonel Clarence O. Sherrill of

the Office of Public Buildings and Grounds resumed the organization's efforts toward building a stadium. Sherrill joined forces with Walter C. Johnson, the head of the Army Athletic Activities under General John J. Pershing. The pair met with citizens in the District and created an organization in charge of building a great stadium in Washington. With William F. Gude, a prominent florist who was president of Gude Brothers Co., and Ben J. Summerhays, a certified public accountant, as the driving force, the group created the District Athletic Association. This combination of federal city workers and local city residents sought a solution to the matter of how to get the stadium built.

In mid–December, the District Athletic Association members formed the National Amateur Athletic Federation of America. The organization intended to promote all amateur athletics in every portion of the United States. Its promoters expected to conduct a national campaign for a great memorial stadium for Americans killed during World War I. They planned for local, sectional, national and international competitions to be staged there. Summerhays and others noted that they needed to create branches of the organization in every state in order to be national in scope. The federation would accomplish this simultaneously with the promotion of the stadium. For the first time, a group interested in building a stadium in the District looked to the national citizenry to come to the aid of the residents in the nation's capital and help them fund the building of a stadium.

Within months the group issued a prospectus as a key step to prepare for the launching of the campaign to raise funds. They consulted with the Fine Arts Commission to hear their ideas with regard to the kind of stadium to be erected in Washington. They determined what locations met with the approval of the Commission. The new federation received the endorsement of local and national organizations and prepared to begin the fundraising campaign for the stadium in the summer of 1922.

The first year culminated with the annual convention of the National Amateur Athletic Federation of America. The delegates created commissions to carry on the work of the federation. They also adopted standards concerning measuring physical ability. During a keynote address Lieutenant Colonel Walt C. Johnson, speaking on behalf of the Army, promised close cooperation between the military forces and the federation. He advocated the erection of a huge stadium in Washington, with a seating capacity of 80,000 or 100,000 for the purpose of staging the annual Army-Navy football game and other notable athletic contests in the national capital. Captain C.R. Train, representing the Navy, agreed with Johnson.

The private fundraising efforts did not go as well as planned. The delegates met two years later for their annual meeting and made decisions regarding amateur athletics and the status of the U.S. Olympic team. The appeal to

the national citizens to fund a stadium in Washington as a patriotic act or to improve their nation's capital did not succeed. The federation returned to a more usual stadium appeal. It passed a resolution urging Congress to appropriate not less than $1.5 million and to provide the necessary land for the erection of a memorial stadium in Washington to American soldiers, sailors and marines killed in the World War. The Congress might have heard about the resolution but that did not motivate them to take action.[2]

Characteristic of Theodore Roosevelt

As the efforts of the National Amateur Athletic Federation ended, a new opportunity appeared on the horizon. After Theodore Roosevelt died in 1919, Congress passed a law that formed a Memorial Association to perpetuate the legacy of the former president. The Association decided that the best way to promote his memory involved creating an appropriate memorial for the late president to be built in Washington, D.C. However, this group, under the leadership of Roosevelt's former Secretary of State, Elihu Root, announced its decision that the most fitting memorial would be "in no way a utilitarian structure." The Association sought to construct a monument comparing in grandeur and impressiveness with the memorials to Washington and Lincoln.[3]

The Association first proposed the construction of a lion with a reflecting pool in Rock Creek Park. However, the Office of Public Buildings and others determined that this monument would violate the law that established the Park. Two years later, the Commission chose a location in Potomac Park for a monument. The site was bounded by 15th and 17th Streets, SW. The governmental agencies responsible for planning and buildings in the District balked. They did not want to give up what they considered the only remaining cardinal point of the great central composition around which the capital of the United States was developing. The Memorial Association's leadership held a contest for the best design of a monument and selected a fountain for one million dollars. Their choice sparked a dispute.

Several members of Congress and residents of the District thought the area on the Mall ought to remain as documented on the McMillan Plan. Some preferred to keep the location open for a monument to Thomas Jefferson, the nation's third president and the author of the Declaration of Independence. The proponents of the location for a Jefferson memorial asserted that Jefferson had been dead for over one hundred years. Theodore Roosevelt had died less than a decade earlier. They believed that it was questionable judgment to erect on this august quadrangle a memorial to Roosevelt so soon after his death. Many objected particularly that the Roosevelt Memorial Association's

proposed plans would place Roosevelt on the same level as Abraham Lincoln and George Washington, promoting them as the outstanding triumvirate of Americans. Others argued that building a memorial to Theodore Roosevelt required the building of a memorial to the recently deceased former President Woodrow Wilson.

These objections revealed the importance of memorials in the minds of the decision makers and citizenry. Despite their differences in how they envisioned its development, the Mall had powerful resonance for everyone in the debate. All thought that only certain memorials belonged in that space. Whether those structures were restricted to those mentioned in the McMillan Plan, or could only include a memorial to a president of the stature of Washington and Lincoln, appeared to be debatable.[4]

The dispute over the Roosevelt memorial also showed that the Congress and the public perceived presidential memorials in terms of political parties and sectionalism. The advocacy for memorializing Woodrow Wilson along with Theodore Roosevelt illuminated the importance attached to memorials through the desire to grant one memorial to "your" president if a memorial was granted to "our" president. And who were the two sides in this instance? Surely, one set of sides centered on the two political parties, for Roosevelt was a Republican and Wilson a Democrat. But also the sides focused upon each man's birthplace, for Roosevelt came from New York City and Wilson from Staunton, Virginia, reflecting that in the mid–1920s, sectionalism and memories of the Civil War remained vibrant.

Other sources of objection to the Association's memorial plans arose. The chairman of the Fine Arts Commission opposed the fountain and the planned location. This advice against the memorial did not stop some members of Congress. By early 1925, both chambers considered a bill allowing for the Association to permit the Roosevelt Memorial Association to procure plans and designs for a memorial in the area near the Tidal Basin. It struggled to work its way through the Congress. Enough members of the House of Representatives and Senate held reservations about the Roosevelt Association's fountain memorial that the bill to construct the proposed monument sat in a dormant state in the Congress.[5]

The Roosevelt Memorial Association expressed its frustration. They complained that resolutions in the Senate and the House were permitted to lie dormant while tongues and pens inside and outside of Congress advanced negative claims. They detailed how they had been able to create memorials in other cities and towns across the country. However, in the federal city of Washington they had not received permission approving of the plan and design.

One member of Congress seized the opportunity to propose legislation

that promoted his version of an appropriate Roosevelt memorial. Represen-
tative Hamilton Fish Jr. a Republican from New York, proposed a bill author-
izing the erection of a great stadium on the speedway (Potomac Park) as a
memorial to Theodore Roosevelt. A football player at Harvard University
who served with distinction during World War I, Fish claimed that his sta-
dium idea served as a more fitting monument to the former president.

The son of a representative and grandson of a senator argued to his fel-
low congressmen that the stadium would pay for itself with two or more of
the Army-Navy football games. The stadium could also hold other sporting
events, music and theater performances and pageants, as well as great patri-
otic and fraternal assemblies. The properness of a stadium memorial to the
late President's character served as the most important factor to Fish: "[Of]
other memorials none is more appropriate to his character or a more fitting
tribute to those qualities of sportsmanship, fair play and love of physical
exercise which were predominant in the life of Theodore Roosevelt."

Fish asked for an appropriation of a first $100,000 to initiate a construc-
tion project. The congressman, like the members who supported a Lincoln
Memorial Stadium a decade earlier, viewed sports as an appropriate method
for remembering a former president. In this case, Fish thought a sports sta-
dium memorial was especially appropriate as it embodied the character and
interest of the late president.

Support for the Roosevelt memorial stadium bill came from many of the
usual sources. The local newspaper editors praised the idea, as much for the
stadium as for the memorial. One editorial board noted, "Such an institu-
tion is needed here as part of the equipment of the city." Several of the city's
citizens' associations joined the fray. The Dupont Circle Citizens' Associa-
tion endorsed the Fish stadium bill at their year-end meeting. Despite these
efforts the bill did not get reported out of the Committee on Rules. Within
a year another attempt to establish a commission to study the feasibility of
constructing a stadium in Roosevelt's honor also languished in committee.

One of the local city's interest groups stepped in to resume the focus on
a Roosevelt memorial stadium. During 1926, the Washington Board of Trade's
Committee on Public and Private Buildings focused their efforts on securing
an armory and stadium for the District of Columbia. Founded in 1889, the
Board represented businesses and marketed the Washington area to prospec-
tive employers. The Board had a civic mission as well, including participat-
ing in community-building projects.[6]

While the committee held discussions with the chairman of the Fine
Arts Commission and some members of Congress, they emerged with no
specific resolutions. They began initial planning activities, including starting
an inquiry about the type of structure needed, and the uses to which the sta-

dium would be put. The committee endorsed the idea of a stadium and favored further study as to its location and character. A year later, the Board of Trade created a special committee within its Community Affairs Committee to focus on a Theodore Roosevelt memorial.

The Board of Trade took the initiative. Their stadium plan garnered support from the major planning organizations in the city. Major Carey Brown, then both the assistant director of Public Buildings and Public Parks and engineer of the National Capital Park and Planning Committee, declared himself in favor of the stadium proposal. He added that Potomac Park would no longer prove a viable site due to the necessity of having 20 to 25 acres for the stadium and an additional 25 acres for parking. He noted, "A site on the axis of East Capitol Street as it connects with Anacostia Park would be the most artistic setting."

The newspaper editors also advocated the plan. One editorial board pled with the Roosevelt Memorial Association that they allow the memorial to take the form of a coliseum in the northeastern section of the city. The editorial noted, "The plan to put it in the Northeast section of the city is to further development of that section of the city which never has been properly developed as originally intended." The Board of Trade plan also gained the support of the Chamber of Commerce, the Merchants and Manufacturers Association and the Federation of Citizens' Associations.

With all the momentum in the city toward memorializing Theodore Roosevelt through a stadium, the Executive Committee of the Washington Board of Trade acted. The Executive Committee appointed a special committee to confer with officials of the Roosevelt Memorial Foundation in New York. The special committee received authorization to interest them in building a $5 million stadium located in Washington. The plan called for the stadium to occupy about 75 acres in Anacostia Park. The trade group accepted the recommendations of the regional planning organizations and others regarding the location and size of the stadium.

The group of three men chosen to make the visit included the chief officer of the area's largest planning group. Grandson of the famous Union Army General Ulysses S. Grant, Colonel Ulysses S. Grant III served as the superintendent of Public Buildings and Public Parks and Executive Officer of the NCPPC. The executive secretary of the Board of Trade, Robert J. Cottrell, an attorney and newspaper reporter, and the chairman of the Committee on Roosevelt Memorial, Claude W. Owen, rounded out the group. A former prominent attorney, Mr. Owen owned and served as the president of the E.G. Schafer Company.

The trio adopted the perspective of Representative Fish regarding the fit between the Roosevelt memorial and a stadium. They went to New York City

armed with their belief that since there had never been a President as intensely interested in athletics as Colonel Roosevelt, a great national coliseum would be the most fitting kind of memorial to him. The delegation met with the Roosevelt Memorial Association's vice chairman, William Loeb Jr., Roosevelt's secretary when he was president. Mr. Loeb was very favorably impressed with Colonel Grant's maps and presentation of the case. Grant argued that the chosen location, at the east extension of East Capitol Street, would perfectly balance with the Lincoln Memorial, being almost exactly the same distance from the Capitol. The group also presented the commissioner letters from civic organizations that supported the stadium to indicate the desire of the people of Washington to have the stadium.

Colonel Ulysses S. Grant III, 12 superintendent of Public Buildings and Public Parks, 1926–1932 (Office of History, U.S. Army Corps of Engineers).

Owen assessed the meeting during his annual report to the Board of Trade. He observed that four obstacles remained to the realization of a stadium as the Roosevelt memorial. Roosevelt had died only ten years earlier and some believed that sufficient time had not yet elapsed since his death for the erection of the memorial to him. The location selected for the memorial happened to be in an unimpressive condition, requiring imagination to visualize the possibilities of its development. Some members of the Roosevelt Memorial Foundation believed that the memorial should be monumental and artistic, rather than utilitarian. Owen countered that Colonel Roosevelt had expressed himself as favoring a utilitarian memorial, and the artistic fountain had failed to obtain government approval. The entire project carried an estimated cost of $3 million and the Board of Trade's Commission had only $1 million. The difference would have to come from further public subscriptions or from a government appropriation.[7]

The trip did spark the interest of a few of the Roosevelt Commission members. Its secretary, Hermann Hagedorn, asked for permission to keep the

stadium materials. The Washington group responded that they were pleased that the committee had shown interest. U.S. Grant wrote Hagedorn that the NCPPC foresaw the coliseum at the end of East Capitol Street as one of the best options for a memorial, with Analostan Island being the second. City planner Charles W. Eliot II also promoted the East Capitol option as his first choice that "seems the best opportunity."

The movement for the memorial stadium generated interest among others in the District. Other federal city workers offered their help. A member of the Judge Advocate General's Office in the War Department wrote to Colonel Grant asking him about what he might take up with anyone on the Roosevelt Memorial Association Board of Trustees. Grant advised that he needed to emphasize the coliseum as a place for important events, such as the Olympic Games, and that there was a memorial character to the site of East Capitol Street.

Members of the local city offered their support. The editors of the local newspapers observed that the Roosevelt Memorial Association's projects proposed for the District had not been completed. Local city residents' sentiment and Congress's inaction illuminated their opposition to the project for a memorial on the Tidal Basin. They argued that the stadium was appropriate to Theodore Roosevelt's character. They noted that the Board of Trade's coliseum idea added significantly to the city's landscape as a monument entrance to Washington for traffic coming in from the north and east.

The Board's memorial plan drew support outside the city. The Amateur Athletic Union at its convention passed a resolution that suggested no more suitable form of commemoration of the late chief executive could be created. The resolution urged for this stadium to be of sufficient size to make possible the holding of Olympics and other big national athletic contests in Washington, D.C.

The Board of Trade seized on this momentum. They contracted with the Allied Architects of Washington to draw up plans for a gigantic coliseum at the eastern entrance to the city. These plans would provide visuals to help the directors of the Roosevelt Memorial Foundation and removed that obstacle to their agreeing to the memorial stadium. Local newspapers trumpeted the decision as the most definite step which had yet been taken by the citizens of Washington toward securing a great athletic arena and forum.

The drawing on the following page includes two sections. On top, a map shows the end of East Capitol Street. It is labeled as the Avenue of the States, after an NCPPC plan to feature buildings from the then forty-eight states. Two stadiums flank the memorial plaza, which is directly in line with the Capitol. Behind the plaza is a single bridge over Kingman Lake and the River. The lower portion includes a rendering of the Theodore Roosevelt Memor-

ial Plaza and the two stadiums. The plaza was divided into three sections and a circular path behind the plaza provided a contemplative place.

The Allied Architects formed in 1924 to advance the science and art of architecture, and to aid in designing of public buildings in the District of Columbia. The bylaws provided that one-fourth of its net proceeds advance architecture and educate the public in architectural appreciation. Membership consisted of the leading architects in the city including the organization's top leadership, Frank Upman as president, and Louis Justement as vice president. The two men happened to be at the height of their influence. The pair served as the principal architects for the Longworth House Office Building in 1933. Upman also designed the Avalon Theater on Connecticut Avenue in Chevy Chase, while Justement designed both the Howard University Medical School and Sibley Hospital. A drawing of their neoclassically-influenced stadium has been included below.[8]

The NCPPC discussed the stadium at their monthly meetings. They looked at the proposed designs that the Board of Trade commissioned in late

Theodore Roosevelt Memorial Stadium, 1932 (National Archives and Records Administration).

September, a month before the stock market crash. Four meetings later they looked at other designs that emerged from the local city professionals. The designs came from small firms and groups, such as members of the George Washington University faculty. The NCPPC Board carried a motion to thank the designers "for their very interesting contribution on the subject."

Despite the range of new plans and enthusiasm the Roosevelt Memorial Association remained unconvinced. Reports leaked to the Washington newspapers that the Roosevelt Commission was negotiating for the purchase of Analostan Island as the site for a statute to be erected in honor of the former president. The president of the Washington Gas Light Company, the owners of the island, confirmed the association's interest. (Coincidentally, the island figured in Washington's sports history. The Columbia Athletic Club, the sporting wing of a men's club, used to practice football and track on the island during the 1890s.)

The Roosevelt Memorial Association purchased the island at the end of September 1931 for $364,000. Secretary Hermann Hagedorn announced that they would not erect a stadium or coliseum on Analostan Island. The geological contour of the island made it unsuitable for a stadium. Days later, the Washington Board of Trade voted to push the effort for Roosevelt Stadium. Its leaders did not appear disheartened by the recent announcement that the association had definitely decided not to build such a structure. One month later, a reporter for the *Christian Science Monitor* observed that Analostan Island remained in its wild natural state. The Association had still not chosen what form the memorial would take and a stadium or museum was being discussed as a substitute for a formal memorial.[9]

The members of the Board of Trade and the reporters in the *Monitor's* bureau shortly discovered that they were wrong. For over half a decade, federal city workers and local city organizations, newspapers and citizens attempted to convince the Theodore Roosevelt Memorial Association of the appropriateness of building a stadium in the District to remember the former president. Despite the impressive array of business, planning and architectural support summoned for this task, the Washingtonians proved unsuccessful.

The Allied Architects remained involved in the effort to construct a national stadium. During the early 1930s, the group submitted a few new designs. They located the stadium on a direct axis with the Capitol. The architects envisioned East Capitol Street as a boulevard with a variety of large office buildings lining each side up to the stadium. As depicted in the nearby drawing, the stadium traffic used a series of rotaries or came from the twin bridges that spanned the Anacostia River.

A Thomas Jefferson Stadium

During the discussion of the Roosevelt memorial, the advocacy of a memorial to Thomas Jefferson reemerged. The Commission of Fine Arts repeatedly advocated for a Thomas Jefferson memorial in Washington. In January 1934, President Franklin Delano Roosevelt sent the Fine Arts Commission a memorandum about the issue. The commissioners advised that three locations for a memorial seemed most appropriate to them. Their first choice centered on a statue or other memorial in front of the new National Archives building looking out toward Pennsylvania Avenue and Seventh Street, NW. As a second choice, they advocated for a memorial on the opposite side of the building, peering out toward the Mall. The third choice was a small triangle on the east front of the Apex Building.

Congress also offered its perspective on a Thomas Jefferson memorial. The legislature formed a Jefferson Memorial Commission with legislation approved in June 1934. They were authorized to consider and formulate plans for the construction of a memorial where Constitution and Pennsylvania Avenues meet in northwest Washington. The commission's 12 members elected Representative John Boylan as chairman. The Tammany Hall Democrat from New York City had long advocated for a Jefferson memorial. The commission began meeting and originally focused on erecting a simple statute at the intersection of Constitution and Pennsylvania Avenues.

Soon, more locations and types of monuments received consideration. Charles Moore of the Fine Arts Commission offered five major points for consideration. His major argument focused on the need for the memorial to be vitally related to the great plan of Washington. Secondarily, Moore stated that the character of the memorial must be determined before entering on any work. The commission considered four potential sites. The four were: Tidal Basin, the Mall, Lincoln Park, and Anacostia Park.

Another federal city group took an active role in providing its evaluation of the initial plans for the Jefferson memorial. The NCPPC hired consultants to review the principal technical aspects of the various sites receiving consideration. The NCPPC Board received this information in a preliminary discussion in June of 1935. They requested that two of their regular consultants, local District architect William T. Partridge and renowned landscape architect Frederick Law Olmsted, create sketch studies and review them.

A few months later the NCPPC Board reviewed these sketch studies for the six sites. The consultants preferred the location around the Mall. They observed that the proposed site around the Archives placed the memorial in the midst of departmental buildings. This seemed incongruous to them. The Lincoln Park option had the advantage of being the "only important remain-

Drawing of National Stadium Project, 1932 (Library of Congress).

ing site on the central axis between the Lincoln Memorial and the Capitol extended east to the Anacostia River." The consultants thought the site too close to the Capitol Building and expensive because an extensive amount of private land would have to be acquired in order to erect a suitable memorial to a figure as great as Jefferson.

The esteem felt for Jefferson might have also influenced the consultants' opinion of the site at the foot of East Capitol Street. Despite being the second location that the group evaluated, the Park received little space as a potential location. In a small paragraph the group deemed the site a terminal. However, the NCPPC designated the location a place for a stadium, armory and athletic fields. The consultants viewed this usage as manifestly inappropriate as a location for a memorial to Jefferson. "An appropriate memorial demands a dignified surrounding, and the contemplated development in this vicinity precludes the quiet, restful, and peaceful setting required."

The consultants' comments regarding the East Capitol site reveal a lot about their perspectives on memorials. Since they did not mention the possibility, it appeared that they did not consider making the memorial a stadium. The idea had been advanced only a few years earlier for the Theodore Roosevelt memorial. Their mind-set seems similar to that of the Theodore Roosevelt Memorial Commission when Elihu Root headed the organization. Each appeared not in any way inclined to view a memorial as a utilitarian structure. Instead, appropriate memorials existed within a highly prescribed location that created dignity, which they defined as only possible within quiet, restful and peaceful surroundings.[10]

The Jefferson Memorial Commission made one of its first public relations errors in late 1935. They did not appear to acknowledge the work done by the NCPPC. The commission also did not hold any form of design competition. Instead, in late 1935, they met with architect John Russell Pope and discussed the four sites. Pope had designed numerous buildings in Washington. His Mason's Temple of the Scottish Rite went up on Sixteenth and S Streets, NW in the early 1910s. His public buildings included the National Archives Building on Pennsylvania Avenue, NW, completed in the 1930s, and the National Gallery of Art on Sixth Street and Constitution Avenue, SW, finished in 1941.[11]

The Memorial Commission received the requested drawings early in 1936. The members met with President Franklin D. Roosevelt and discussed the plans for the memorial. At the commission's next meeting they directed the chairman to introduce a resolution in the House of Representatives. The resolution would authorize the commission to select a site and build a memorial at a cost of no more than $3 million. That resolution passed and the commission soon adopted its own resolution appointing Pope as the architect to build the Jefferson Memorial at the Tidal Basin site.

The group made its choices for location and monument without achieving unanimity. Several took their positions to the media. Senator Charles L. McNary of Oregon, the Senate Minority Leader and the ranking Republican on the 12-man commission, claimed he would try to stop the huge marble

monument from going up on the south bank of the Tidal Basin. "To erect the memorial there would mar the beauty of that portion of the city. I find nothing in the Tidal Basin plan that commends itself to me." Some commission members advocated for a memorial on East Capitol Street in Lincoln Square.

A few commission members had a different location in mind. While McNary preferred a location near the center of the Mall, others advanced plans for the memorial to sit at the foot of East Capitol Street. It is possible some would use the location for a memorial in the form of a sports stadium. The majority of members believed that this was a fortuitous site. The site would also help spur the development in a neglected part of the city. Senator Elbert D. Thomas, a Democrat from Utah, argued for East Capitol Street as the most effective location.[12]

The chairman buttressed the commission's position regarding the location and the type of memorial. Boylan responded to the members who wanted a stadium. "It is the universal experience that in such memorials the utilitarian side soon dominates over the commemorative, even to the extent of completely effacing it." Additional support came from President Roosevelt. He announced that he supported a nonutilitarian form for the Jefferson Memorial.[13] Once again, a sitting president refused to support the construction of a stadium in the District.

The minority voices of the Memorial Commission's members represented one sector of the federal city that expressed a degree of unhappiness. Other federal city members felt greater dissatisfaction. The Commission of Fine Arts expressed disapproval of the location of the Memorial. In response to the dissatisfaction of the Fine Arts members, the Jefferson Memorial Commission met and requested changes be made to the plans. The architects moved the Jefferson Memorial a few hundred yards, placing the memorial on the south bank of the Tidal Basin. The architects also diminished the expanse of the memorial. These actions preserved the informal beauty of the area. This did not stop the commission members and others who objected completely to the location.[14]

The compromise represented only one portion of the Memorial Commission's struggle with the Fine Arts Commission. The Fine Arts group disliked the Pantheon design. Members claimed that the Pope design was merely a replica of the center of the National Gallery of Art. They cited that each had the same number of columns across the front, the same façade, and the same low dome, each with four rings circling the base. The Fine Arts Commission submitted a design for consideration. However, the Jefferson Commission viewed their proposal as a modified version of the Theodore Roosevelt Memorial from 1926. Further, they claimed that this memorial would cost $15 million to build.[15]

The Memorial Commission balked at making any more changes and submitted a bill to Congress requesting an appropriation of $500,000 for the beginning of construction of the memorial. The House of Representatives voted the appropriation down 116 to 50. Representative Allen Towner Treadway, a Republican from Massachusetts, led the opposition to the Jefferson Memorial Commission. A Berkshire Mountains man who started in the hotel business, then worked his way up through state politics, Treadway became a resident of the District. He advanced a resolution to prohibit the construction of a memorial on the Tidal Basin site selected by the Jefferson Memorial Commission.[16]

Many local city residents also made their dissent from the Jefferson Memorial Commission's plans heard. The Southeast Business Men's Association voted their opposition to the $3 million proposed Jefferson Memorial, which would stand at the Tidal Basin. Instead, the members urged for the erection of a Jefferson Memorial Stadium which would stand at the end of East Capitol Street. The Southeast Citizens' Association, at their monthly meeting, adopted a resolution for a $3,000,000 Thomas Jefferson Memorial Stadium located at the foot of East Capitol Street. The Federation of Citizens' Associations asked that the Thomas Jefferson Memorial Fund be used for the construction of an auditorium or stadium on some other site than at the Tidal Basin. Seventeen of the city's Citizens' Associations opposed the Tidal Bain memorial and fifteen believed that the most appropriate memorial would be a stadium in the northeast.[17]

Other citizens expressed their opposition through letters to the editor. Many of the letters that appeared in the local newspapers opposed the memorial on the grounds of the "destruction" of the cherry trees along the Tidal Basin. A few advanced the argument for a utilitarian monument to Jefferson, usually a beautiful municipal auditorium or a stadium on some other site than at the Tidal Basin. One letter writer carried the argument further, observing that building the memorial utilizes funds that could well be wisely used elsewhere. He argued that the expenditure be used for improving undeveloped areas for playgrounds and parks and for the construction of a badly needed auditorium and stadium. The local city residents who sought a Jefferson Memorial Stadium presumably took hope with the Treadway resolution and other activities to stop the current memorial plans.[18]

The resolutions of the local citizens did not pose the greatest threat to the decision of the Jefferson Memorial Commission. The group attempted to work out their situation with the Commission on Fine Arts. They submitted four additional designs but could not obtain the Fine Arts' approval. In the spring of 1938, the Jefferson Commission proceeded to recommend the Pantheon design to Congress.

As the Congress prepared to act on the dispute, things grew worse for the Jefferson Memorial Commission. A member of the Committee on the Library, Representative Kent Ellsworth Keller, a Democrat from Illinois, submitted a report on the activities surrounding the Jefferson Memorial Commission. The witnesses who appeared before the committee unanimously complained about the site and the lack of an open competition to select the design.[19]

The Committee on the Library introduced bill House of Representatives 10217. This bill would instruct the Thomas Jefferson Memorial Commission to provide for the competitive selection of the design for the memorial. The eventual design would have to receive the approval of Congress. The bill would repeal the law under which the present commission acted and create a new three-person commission to secure appropriate plans and design. Keller observed that the architect Pope had died in 1937, and the chairman of the commission, John Boylan, lay ill, and believed this to provide additional justification for the need to change commissions.

The Committee on the Library's bill did not pass. The Thomas Jefferson Memorial Commission won in the struggle. Their design for the memorial received approval from the Congress. The firm of Eggers and Higgins assumed responsibility for the construction of the Jefferson Memorial. President Franklin Roosevelt laid the cornerstone in 1939. That year the world erupted into World War II and the issue of a stadium in Washington simmered down for a few years.

Memorial for World War Veterans: Bilbo's Behemoth

As the prospects for the war's end neared, another stadium effort began. Congressman Jennings Randolph, a Democrat from West Virginia and the chairman of the House Committee on the District of Columbia, reintroduced enabling legislation that had lain dormant since 1940. The bill would provide for the federal government's development of a great stadium and other recreational facilities at foot of East Capitol Street. Sentiment on Capitol Hill favored building a stadium, according to Senator Arthur Capper, a Republican of Kansas and a veteran member of the Senate District Committee. "The Capital needs a big stadium. We should have had one here long ago. The benefits that would result from such a project are obvious."[20]

Both federal city agencies and local city nonprofit organizations that previously fought unsuccessfully for a stadium joined this new effort for a stadium. The Washington Board of Trade organized a rally and the National Capital Parks and Planning Commission wholeheartedly supported a 100,000-person stadium. Irving C. Root, superintendent of National Capital Parks of

the National Parks Service, said, "If we had a stadium such as this we would be eligible for the Olympic games. The national Capital is the logical place for a competition of this kind." District religious figures, such as Dr. Frederick E. Reissig, executive secretary of the Washington Federation of Churches, said he believed plans for a national stadium constituted a step in the right direction. The estimated initial outlay ranged from $3.5 to $6 million.

Meanwhile, the National Capital Parks and Planning Commission took steps toward a reevaluation of their old plans for an armory-stadium and sports center at the foot of East Capitol Street. They included this plan with a few others in the Anacostia flats and hired Olmsted Associates to perform an evaluation of landscaping. The evaluation observed that elimination of the railroad bridge upstream permitted tree planting over a larger area. This widened the vista from the sports field stands. They suggested that the roads between Kingman Lake and Anacostia River should be eliminated since this would make the outlook from the stands much better.[21]

The local newspapers joined in with their support for the project. After observing that most cities of Washington's size already had stadiums, they argued that the issue was bringing the capital into line with its potential. "[T]he stadium should be a self-liquidating Federal undertaking, suitable to accommodate the Olympic Games and great national celebrations that can appropriately be held only in the Nation's Capital."

Congressional leaders created a special commission of nine members to work out all the preliminary details for the proposed Capital City Stadium. The chairman, Senator Theodore Gilmore Bilbo, believed Washington should have "the best and the largest" stadium in the country, one with a seating capacity for at least 100,000 persons. The son of a farmer, Bilbo taught in public schools, and then obtained his law degree. He served two nonconsecutive terms as Governor of Mississippi. Bilbo ran for a seat in the U.S. Senate in 1934. He won by running a campaign that highlighted his anti-elitism and white supremacist attitudes. During his last months before dying of mouth cancer in 1947, he answered with ethnic epithets the letters of protest he received from people with Italian or Jewish surnames.[22]

Representative Samuel Weiss, a Democrat from Pennsylvania, introduced a bill creating a commission to survey sites and plan for a stadium to seat 200,000. There would also be a large indoor area built to hold 50,000 persons, all part of a memorial to American war veterans. Weiss was a Jewish lawyer who practiced in Pittsburgh. He shortly resigned from the House to serve as a judge in the Allegheny County court system.[23]

The Weiss bill generated significant positive response from groups within the local city. The veterans' organizations supported the idea immediately.

The citizens' associations from all around the city offered their support. Letters endorsing the memorial idea poured into the offices of the Stadium Committee from these organizations and individual city residents. The American Legion's senior vice commissioner in the District said the organization felt pleasure over the proposal that the stadium be dedicated as a living war memorial for the nation's fighting men in this war. "The movement to build a stadium should deeply interest all veterans' organizations." The national American Legion as well as the Veterans of Foreign Wars and the Disabled American Veterans joined in their backing. The District of Columbia's Recreation Board said the stadium was "an appropriate memorial to service personnel."[24]

Agreement on the need for a stadium constituted only the first step. The competing versions of how to begin discussions on building a stadium had to be reconciled in the Congress. Senator Bilbo's bill created a commission that included representatives from the local citizens. Neither of the bills in the House provided for their inclusion. Others worried that no matter what bill was chosen, it would get bogged down in Congressional subcommittees as had happened in the past. Congress decided that the best way to select between the competing stadium bills was to establish a national stadium committee to study the question and provide a recommendation.

Meanwhile, groups of local supporters of the memorial stadium held a mass meeting to demonstrate the support for its construction. Over 300 groups had representatives in attendance at Anacostia Park that night in mid–November. Attendees came from the entire city. They included members of the Washington Real Estate Board and the District Building and Loan League, the Georgetown University Alumni Association, Howard University, and the Phyllis Wheatley YWCA. Thomas Settle, the secretary of the National Capital Parks and Planning Commission, stated that Washington should have the best, not the biggest, stadium in the world. "I believe that the District's stadium will rate a top priority in building in the postwar world."

The most influential person in the federal city provided his support. President Roosevelt now took a different perspective on utilitarian monuments than he had when considering a memorial for Thomas Jefferson. He told the 1600 people attending a rally at the Labor Department's building, "Such a stadium, if designed to be of general utility in order to house the above activities, could then become a fitting memorial to our men and women now in the armed forces and could be dedicated to the youth and freedom of our country." This was the first time that the president of the United States had supported the construction of a stadium for the District.[25]

Building a stadium as a memorial to servicepersons was already a twenty-five-year-old idea in the country. Since the early 1920s, colleges and univer-

sities had constructed football stadiums to memorialize their alumni who died in the armed conflicts of the U.S. From Clemson, South Carolina, to the University of California at Berkeley with stops in Illinois, Kansas and Nebraska in between, stadiums honored the sacrifices of students and university members who served in the Civil War, Spanish-American War, and World War I.

The buildings marked the location of the memorial in similar ways. Most had a plaque with a listing of the names of the deceased. A few created other methods for paying tribute. The University of Nebraska included text in the four corners of the stadium. The Berkeley stadium claimed that the hills in the background and vista to San Francisco Bay offered landscaping to honor the dead in simple dignity, beauty, and strength.

A few cities engaged in this building process. Ashville, North Carolina, constructed a memorial in 1927 to citizens who had served in World War I. Both Little Rock, Arkansas, and Baltimore, Maryland, would soon begin to build their own memorial stadiums. The memorial stadium in the capital of the country would need to appear significantly different from similar edifices around the nation in order to satisfy the monumental requirements of having an aura and evoking responses of legitimation and social memory.

National Stadium Commission Hearings

The National Stadium Commission that Congress established promptly decided to endorse Jennings Randolph's stadium bill. That bill established a commission of nine members to plan for a stadium with a minimum capacity of 100,000 persons. The membership consisted of three members from the U.S. Senate and three members from the House of Representatives. The remaining three members came from the local city. The local city politicians had a representative, Commissioner John Russell Young. The private sector had the president of Riggs National Bank, Robert V. Fleming, and the nonprofit representative was from the Washington Board of Trade, Floyd D. Akers.

The bill sought the development of more than a stadium. The project included additional facilities and/or space for a museum of athletics, and exhibition space for items of national interest and memorials to the men and women who had served in the armed forces. The bill called for an appropriation of $25,000 to provide for the immediate preparation of the plans, designs, and estimates. It also preferred the stadium be constructed through private finances through the government would make a conditional grant of the land for the site for the stadium. The final stipulation, an exemption from all federal and local taxation, carried the expectation that it would encour-

age private capital to invest, resulting in the construction project's receiving a favorable interest rate.

The compromise incorporated one important element from the Weiss bill. They believed that the stadium would be a real memorial to the veterans of both World Wars. On December 20, 1944, the House and Senate passed a joint resolution. The National Memorial Stadium Commission considered a suitable site for a stadium and procured plans and designs. They also made estimates of the stadium's cost and formulated a method of funding the building on a self-liquidating basis. Individual subcommittees would study one of these areas and then combine to write a preliminary report to Congress.[26]

At the organization session in February 1945, the members elected Senator Bilbo as chairman and Representative Randolph as associate chairman. In Washington and other places around the country, consideration was given to new types of memorials that would honor the World War II dead. Stadiums led the field of options for memorials. Cities took a variety of approaches to the construction and funding of the stadiums.

The commission opened its hearings and witnesses expressed concern about the proposed location. Major Richard Thompson, a War Department public relations officer, reiterated what he had told the Interfederation Conference, a local city nonprofit organization that supported the stadium construction. Thompson stressed that a stadium must entertain numerous events in order to keep from being a "white elephant," and advocated placing the proposed national stadium in a more central location. He suggested Constitution Avenue between 17th and 20th Streets, or between 23rd and 26th streets, or 12th to 14th streets, in northwest Washington.[27]

One of the architects involved in the development of Anacostia Park and the stadium for over a decade testified next. Local architect Francis Paul Sullivan expressed concern about access to the stadium. Sullivan pointed out that the larger the stadium the greater the need for transportation and even then it would take an enormous number of streetcars to transport people. He stated that a budget of $6 to $8 million was more in line with probable costs, including appropriate parking facilities.

Some other witnesses expressed a widely different concern regarding transportation. The members of the Aero Club of Washington stated they would submit a clear-cut plan for an airfield near the stadium. Senator Bilbo supported the idea. "A landing field will be most essential. A few years after the war ends nobody will be driving automobiles except poor white folks and some others." The Senator's statement illuminated an imaginative, inaccurate, and impractical vision that also showed Bilbo's attitude toward the citizenry, particularly non–Caucasians.[28]

Another architect entered the Commission's consideration through a

member from the Senate. The junior senator from Ohio, Harold Hitz Burton, received a letter from a constituent. The Osborn Engineering Company in Cleveland, Ohio, wrote to express their interest in receiving consideration for designing and building the stadium. The company had an established reputation in stadium construction. Osborn had supervised the building of the stadium in the District after the fire burned most of the old stadium in 1911.

The testimony of a Texas architect, Walter W. Cook of Dallas, sparked Mr. Randolph's imagination. Cook told the commission that placing a roof over the athletic field of the stadium would be feasible. Cook said the stadium could be planned so as to support a copper sheet roof with a span of as much as 500 feet. The sides of the upper part of a roofed-in stadium could be of non-glare glass which could be opened in warm weather. Randolph urged serious study of these possibilities. As noted in the previous chapter, Washington architect Jules DeSibour presented drawings of a stadium with a retractable roof during the late 1930s, when Washington hoped to build a stadium for the Army-Navy game.

Despite the domed stadium idea's origination with a local architect, the committee named Cook's company, Pettigrew, Cook and Associates, as stadium consultants. Their vision of the stadium appeared in the drawing featured on the following page. Senator Bilbo opined, "The stadium as a national memorial to the veterans of World War II must be the finest, the biggest and most beautiful of any in the country." Two local engineers in private industry testified that the domed stadium would be 265 feet high and the structure would be so big it could contain the Capitol dome and building. General Ulysses S. Grant III of the National Capital Parks and Planning Commission criticized the idea as too big to give customers in the back seats their money's worth and that such a place was unnecessary.[29]

The general remained one of the chief leaders in the federal city government on development in Washington. He continued to support the NCPPC position on the stadium's location and on its size. As he wrote to Senator Bilbo, Major Richard O. Thompson withdrew his suggestions for locating the new memorial stadium in the Mall or on Theodore Roosevelt Island, thus "there seems to be no occasion for further discussion of the said obviously impracticable sites."

Thompson shifted his support to Lincoln Park as a site. This necessitated a comparison between Lincoln Park and East Capitol Street. Grant supplied the senator with details regarding acreage, assessed value of the land to be purchased, automobile parking and traffic issues. On almost every value East Capitol proved superior. Whenever the site did not, Grant added an aside that questioned the numbers for the Lincoln Park location.

The comparison between the locations also consisted of an explanation

National Memorial Stadium for military personnel who died in World Wars I and II,
1945 (Library of Congress).

of the negatives associated with the Lincoln Park site only. Grant listed seven
objections to the site. These ranged from having a large building too close
to the Capitol through the anticipation of traffic to the need to acquire an
extensive amount of valuable residential property.

The senator and the general had less agreement regarding the size of the
stadium. While Bilbo sought a large edifice, Grant remained essentially in
the same ballpark as he had been with the Theodore Roosevelt Memorial Sta-
dium in the late 1920s. The position was the same one that the NCPPC held
as well. The NCPPC "very seriously recommends against further considera-
tion of a capacity greater than 100,000."

The general provided another list of objections to the larger size sta-
dium. The top reason included providing a number of seats with poor views
of the field. The next three reasons focused on the difficulties of moving a
large number of spectators around the city. He completed the presentation
with the response that a stadium of 200,000 would necessitate finding a loca-
tion outside of the District of Columbia.

Bilbo remained interested in the potential for aviation as a means of
transportation. He requested that the report include that possibility of air-
plane travel. Grant noted that the Washington Municipal Airport would bring
in 7,500 people without any interruption of routine commercial service. The

issue of the development of a landing field for privately-owned planes awaited a report from the Civil Aeronautics Administration (CAA) and the district engineer.

The local city government also contributed to the stadium issue. The District of Columbia's Recreation Department conducted a survey of stadium reference materials for the commission's consideration. The survey of stadiums in thirty-three large cities in the U.S. showed that Washington lagged behind twenty-four cities that had stadiums, auditoriums, or both. More of these cities owned auditoriums despite their smaller seating capacity and higher maintenance costs. Most of the stadiums were financed by bond issues. However, their revenues varied considerably, with football being the most important, followed by concessions, track, baseball, civic events and musical affairs. The Recreation Board supported the East Capitol Street location, and stipulated that the stadium should be oval, have a capacity of 100,000 and be multi-purpose.[30]

The preliminary report of the National Memorial Stadium Commission gave a unanimous recommendation that the site be the East Capitol Street area in Anacostia Park. The report argued that this location had traffic facilities, appropriate size, and parking. They hired Pettigrew, Cook and Associates of Dallas to make necessary designs and plans for a stadium. The size had to accommodate the largest national events of the present and the future, including Boy Scout jamborees, military competitive activities, veteran's programs, the international Olympics and other mass gatherings. Their recommendation leaned toward private funding to build the stadium with the government making a conditional grant of the land and exempting the stadium from taxation.[31]

The commission knew this and its report also suggested that Congress act immediately. They called on the legislature to authorize the Federal Works administrator to advance the necessary funds to pay for the architectural and engineering surveys of the site. The Federal Works Administration began in July 1939 with the responsibility to manage most of the federal buildings and construction projects, and lasted until the creation of the General Services Administration in July 1949.

Bilbo and the Senate

Before the end of World War II, the Congress passed the War Mobilization and Reconversion Act of 1944 to aid in the economic changes expected in the immediate postwar period. The Congress enacted the Independent Offices Appropriation act of 1946 for the purpose of enabling the Federal Works agency to expend funds on development projects in the United States.

This established the groundwork to carry out the expectations of Title V of the War Mobilization Act.

After the hearings, the Ohio Democrat Burton and the junior senator from New York, James Michael Mead, introduced the joint resolution the Stadium Commission sought. The Burton, Mead, and Bilbo Bill (S.1174) viewed the National Memorial Stadium as a postwar development project. The bill authorized the District of Columbia's Federal Works administrator to make as much as $600,000 in reimbursable advances to the commission appointed for the stadium. The athletic field and stadium would be a memorial to the men and women who gave their lives while serving as members of the armed forces during World War I and World War II. The bill stalled almost immediately.

A month later Bilbo tried a different approach. He opted for a joint resolution rather than a bill. They both make law and require a presidential signature, so there is little difference between them. The senator made changes to the content as well. The new resolution reduced the amount of the funds for the development of the plans from the original $600,000 to $150,000. The senator from Mississippi took the floor to describe the resolution. Bilbo observed that the provisions of the Reconversion Act of 1944 provided for appropriation to states, D.C., Alaska, Hawaii and Puerto Rico to create drawings for postwar projects. He noted that this was an advance that the federal government made to help get the project started and make acquiring the private loans easier. The private funds would pay this advance money back to the federal government and would also build the stadium.

Senator Harry Flood Byrd, a Democrat from Virginia, asked Bilbo a question. A former newspaper publisher and farmer, Byrd moved through state elected offices before becoming Governor of Virginia. Known as "The Pay-As-You-Go Man" for his approach to road building, Byrd wanted to see where in the resolution the statement that the stadium would be built with private funds appeared. Bilbo answered that he did not have the measure before him but assured him that the stadium would be self-liquidating. After other senators asked about other portions of the resolution, Byrd rose and requested that the joint resolution be passed over temporarily. The Senate agreed.[32]

Meanwhile the commission had contracted with an engineering company to complete a stadium study. In late September the commission received the report from H.A. Kuljian & Company, an engineering and architecture firm that had a Washington office, making them a member of the District's local city. The firm made the intensive study of this proposal in the hope and belief that they would receive equal consideration and opportunity to compete for the design.

The evaluation began with the site. They noted that the NCPPC's "Plan for Sports Center with Site for National Memorial Stadium" chose a site that would comfortably hold a stadium with 80,000 spectators. They observed that, if moved 100 feet to the east, the stadium would permit a practical stadium for 100,000 spectators very comfortably. The firm also considered a large site bordering on Kingman Lake as the only potential location for a very large stadium, such as Biblo's desired 200,000-seat version. They determined that there were numerous objections to using this Parade Ground as a stadium site, including the soft soil and low surface level.

Before discussing their proposed designs the firm noted that the statements had proclaimed this memorial stadium was to be the best and largest in the world. They asserted that they could create the best but not necessarily the largest, because the largest would not make the most satisfactory. Their proposal argued for a circular stadium to maximize sight lines, particularly for football games. This would also allow for the elimination of intervening posts and columns, creating a clear unhampered "line of vision" for every spectator. They advocated for a grass playing field and thus at best would accept a retractable roof, as opposed to a dome. They preferred an open-air stadium that could seat between 81,000 to 100,000 people. Their conclusion pleased some commission members while disappointing the chairman.[33]

After the short setback in the summer of 1945, commission chairman Bilbo returned to the Senate floor in the fall. He introduced the preliminary report of the National Memorial Stadium Commission to his colleagues. Before reading the report for the record he observed that the commission had gone as far as it could. Bilbo called for a positive decision on funding to create the stadium plans. He linked the memorial with the Olympics in an argument that said if the plans were completed soon Washington could host the Olympics in 1948.

The stadium's association with Bilbo proved to be a mixed blessing. When he introduced the report he shrewdly disarmed opponents who derided the memorial as a local or District affair. Bilbo insisted, "This monument is to be erected here only because Washington is the Capital of this Nation and one great show place of the Nation as a memorial to the soldiers of these two great world wars." The Southern senator also carried baggage, such as his opposition to the creation of the Fair Employment Practices Commission (FEPC). This opposition and the stadium became linked when Senator Dennis Chavez requested the floor to ask Bilbo a question.

As a child, the Democrat from New Mexico had suffered family circumstances that forced him to quit school and join the work force. He taught himself at the Albuquerque Public Library and eventually worked for the election of Democratic politicians in the state. When Andieus Jones won the U.S. Sen-

ate seat, he procured a clerkship for Chavez in the U.S. Senate. Chavez won a seat in the House of Representatives in 1930 and soon followed Speaker John Nance Garner's advice of being "an errand boy for the people who elected you." He carried this same perspective after being named as an interim senator in 1935 before winning the seat in his own right the next year. A firm New Dealer, Chavez advocated for the average person both in his state and in the country.

After accepting the floor, Chavez agreed with his fellow Democrat about the stadium. Chavez stated, "[A] dead wall built of marble for the purposes of a stadium, and for the purpose of showing respect to the men who fought the war, is proper and in keeping with that we do in our country on such matters." He asked Bilbo whether fair treatment under the Constitution and laws of the country would be more of a benefit than any stadium. Bilbo responded that the FEPC would not accomplish what Chavez expected.

The Republican Senator from North Dakota asked for the floor to pose a question to Bilbo. An attorney and former governor, William Langer survived an attempt to refuse him his seat after the election of 1940. Langer asserted that there was a shortage of building materials. He wondered if Bilbo believed that before a stadium was built, the slums of Washington should be cleared. Bilbo stated that the bill for $20 million to make Washington the cleanest city in America had already passed the Senate. "Having done that, let us do something else." Langer asserted that the country did not have the building materials. The debate on the issue ended as the Senate moved on to other business.

A month later, Senator Bilbo tried to present the stadium again to his colleagues. He received the floor on the condition that the interruption of the previous speaker not last long. As soon as the chief clerk read the proposed Senate Joint Resolution to authorize the money for the stadium plans, Senator Langer objected on the basis that the slums in the city had not been taken care of yet. When Senator Joseph Lister Hill, a Democrat from Alabama, rose to state that the joint resolution would be explained, Langer withdrew his objection. The attorney and former school board president built a reputation as a strong advocate for federal involvement in health care. Hill continued to aid Bilbo throughout this presentation.

Bilbo then asked for the unanimous consent of the Senate to proceed to the consideration of the joint resolution. Senator Joseph F. Guffey, a Democrat from Pennsylvania, objected. This New Dealer made his money in the oil and coal businesses and expanded his wealth through speculation. Guffey enjoyed a reputation as a pap-grabber, a man who nourished himself from the government trough.

The bipartisan interruptions bode poorly for the resolution. Hill derailed

this objection when he suggested that Bilbo explain the bill. Hill coaxed out clarifying statements that the bill would not cost the federal government any money, and that the bill provided for an advance not to exceed $150,000 to create architectural plans. Langer asked for details regarding the financial scheme. As Bilbo provided these responses, the Senator who initially yielded the floor now objected to the length of the discussion. A resigned Bilbo yielded the floor as he noted, "The Senator from Pennsylvania [Mr. Guffey] informs me that he will object...."

Over the next three months, Bilbo, President Harry Truman, and others pushed for the funding to draft the plans for the stadium. Citizens' groups throughout Washington, from American University Park to Anacostia, joined in with their support. The stadium supporters experienced continued internal divisions over the size of the stadium. Bilbo warned everyone that he would not stand for a "dinky affair," a stadium that seated fewer than 100,000 persons.[34]

By late November, several Stadium Committee members expressed their exasperation over the inaction of the legislative wing of the federal city. They decided to finance the architectural and engineering plans for the national memorial stadium privately rather than depending on a grant from Congress. Harvey L. Jones, Chairman of the Washington Board of Trade's Public and Private Building Committee, said that private capital should both plan and construct the stadium. Commission member Floyd D. Akers agreed: "It's time for us to wake up. We can work faster and more efficiently under private funds." Neither the federal government nor the local city provided funding for a national memorial stadium. Despite the tremendous momentum, once again an attempt to build a stadium in Washington, D.C., stalled.[35]

Little progress toward choosing a plan for the stadium occurred over the next year. Senator Bilbo stuck to his plan for an all-weather stadium with an aluminum top and marble-faced with grand proportions. The stadium also would contain permanent exhibition space of a size similar to the items shown at world fairs. The $150,000 loan from the federal government to accomplish the development of his stadium plans remained stalled in the legislature.

Meanwhile, new opinions regarding the general concept of a memorial emerged from the federal city. The Fine Arts Commission asserted that a war memorial had a threefold intention: to promote feelings of gratitude, to provide inspiration, and to encourage recollection. After suggesting types of memorials appropriate in the modern community, including arches and chapels, they suggested a war memorial structure, "provided it unmistakably proclaims the purpose for which it was erected...." They did not recommend the construction of civic projects as war memorials and suggested, "If such a project is adopted ... it should be amply marked with tablets, archways,

[and] sculpture ... [and be a space] where annual memorial services may be conducted."[36]

Memorial for World War Veterans: Harris's Heavy Lifting

After lying low for a year, memorial stadium proponents renewed their efforts in the beginning of 1947. This on-again, off-again nature would categorize the memorial stadium process over the next decade. The process received a kick start when the Speaker of the House of Representatives, Joseph William Martin Jr., a Republican from Massachusetts, announced the three members of the House who were served on the supposedly defunct stadium commission. The commission members, minus the late Senator Bilbo, began discussions to find common ground regarding the appropriate size of the stadium.

Proponents expressed concerns over certain assumptions that the commission had made two years earlier. John A. Reilly, president of the Second National Bank, a citizen member of the commission, mentioned that the project required great care. "We should explore all the possibilities. These would include financing, location and many other factors...." Representative Sidney Elmer Simpson, a Republican from Illinois, also an original member, noted that "it would be fine if Washington could have a stadium." However, he expressed caution: "It is quite a proposition to establish it on a self-liquidating basis." He seemed to be unwilling to accept a memorial stadium if that facet could not be successfully incorporated as he stated, "If that self-liquidating feature can be worked out, such a place would be a great thing for the National Capital."[37]

One voice emerged to rally the forces behind building a memorial stadium. As chairman of the House District Committee, Representative John Lanneau McMillan, a Democrat from South Carolina, had long been familiar with the plight of the stadium-deprived Washington. McMillan announced, "You need a stadium here, and you need it badly...." He echoed the sentiments expressed in the last chapter, saying that it would be wonderful to hold the Army-Navy football game right here in the nation's capital. His argument for the stadium picked up the currency of the times in which he lived. "Already we have enough formal memorials to look at. Why not build a memorial to the veterans that will be useful?" McMillan advocated working in conjunction with the Senate on the bill in a joint committee in order to save time and effort for both congresspersons and the people who testified.

Little came of this effort. In April 1949 Representative Oren Harris, a

Democrat from Arkansas, prepared a bill for a District of Columbia memorial stadium, H.R. 4325. In typical bureaucratic fashion the measure created a District of Columbia Memorial Stadium Commission, again made up of nine city residents. This commission received the broad powers to find a site, and contract for design and construction to build a memorial stadium. They could not name for whom it would be a memorial; this would be the right of a future Congress.

Harris envisioned a particular stadium, site and financial arrangement. Built at the foot of East Capitol Street, the stadium would hold 60,000 seats at a cost of $40 each to construct. The legislator financed a $2.5 million project with bond issues bearing not more than 4 percent that would be paid off from gate receipts. Government assistance would come in the action of the Reconstruction Finance Corporation's purchasing $500,000 of the bonds. The measure also carried the stipulation that the armed services would commit to a contract requiring that they play at least one game a year in the stadium. "This is neither a fantastic idea nor a costly one. If the people of Washington really want a stadium, I am simply giving them the opportunity to put across this project as a public service venture."[38]

The Harris Bill did not get a significant amount of local newspaper coverage beyond its introduction. The bill was referred to the House District Committee. Chairman McMillan sent it to the subcommittee on Health, Education and Recreation headed by Representative Thomas Gerstle Abernethy, a Democrat from Mississippi. Months passed. Harris informed the media that his subcommittee had several bills slated to consider, including a bill to authorize a national memorial stadium in the District. Meanwhile, in the Senate, a bill languished in a subcommittee while they considered what needed to be done about a national memorial for veterans.

Meanwhile several groups within the federal city questioned the need for Harris's new legislation. The Bureau of the Budget of the Executive Office of the President asked the chairman of the Commission of Fine Arts and the heads of the NCPPC and the General Accounting Office, among others, what views they had toward the project and the bill. The acting executive officer for the NCPPC agreed with the development of the stadium as part of a sports center. However, he saw no need to create a new commission as this bill would do. Instead he recommended that the Stadium Commission already established by reactivated. The chairman of the Commission of Fine Arts, Gilmore D. Clarke, called their attention to Public Law 523, 78th Congress, which created the Stadium Commission. "It would seem that all that is necessary is to have members appointed to serve on the 'National Capital Stadium Commission' and for Congress to provide the appropriation needed to carry out the purpose of the Act."[39]

After months of waiting on a reluctant Congress, the private citizens in Washington voiced their support of a memorial stadium. Between Christmas and New Year's Eve, the executive committee of the District Legion passed a resolution urging for stadium construction in memory of the nation's World War II dead. The chairman of the District Legion's civic relations committee, Charles T. Bell, explained that a 60,000- to 100,000-seat stadium could be financed by contributions from each state, Alaska, Hawaii and the District. Each state would be represented with an individual niche in the stadium, similar to the design of the Lincoln Memorial. The national office spokesmen said Bell's proposal was "favorable news. Certainly we could be interested in helping."[40]

The local city government joined in the support for a memorial stadium with its own suggestion of a site. The District Highway Department conducted a study to determine the best location for a bridge over the Anacostia River. This led them to comment on the stadium issue. The study recommended that the stadium be located at the grounds of the National Training School for Boys in the northeast corner of Washington at the Maryland/District of Columbia boundary where New York and South Dakota Avenues intersect. The report argued that this site offered excellent transportation facilities, providing eighty-one acres for parking that provided space for 14,500 vehicles. The Pennsylvania Railroad serviced the area and brought in another 18,000 people. The department expressed concern over the possibility that the stadium could become a white elephant, similar to the concern that Major Thompson had had five years earlier. Its study observed that the new location enabled the stadium to be constructed alongside an auditorium with exhibit rooms under the seats in one corner and a gymnasium in another with seating for 6,000. One final corner provided the space for a swimming pool.[41]

The memorial stadium situation stagnated again. One of the few instances of discussion of a national memorial stadium in Washington came from President Harry Truman. The president announced, in the spring of 1951, his support for a $50 million art and sport complex built through funds raised from private sources. Truman and Representative Arthur G. Klein, a Democrat from New York, both thought private funding would be necessary because they doubted Congress would provide federal funds. Despite this active support from the sitting president, neither Congress nor the private sector took action. The support of the single most important person in the federal city had failed for the second time to generate the movement of the Congress.[42]

The National Memorial Stadium Commission contained three vacancies in the early 1950s. By early 1954, Senator William F. Knowland submitted a

bill to disestablish the commission as he perceived it to be useless. In a letter to the *Washington Post* a local citizen claimed the senator would be better off spending his energy on providing Washington with the facilities it really needed and every other capital city in the world had: a stadium, convention hall, and art, theater and music auditorium. The writer implied that what the government did was more important than what it said, commenting that the prestige of the United States would climb more in the world if they spent their money on building cultural and recreational facilities in Washington rather than on academic information programs (presumably, Voice of America).[43]

Much as congressional inaction enabled the commission to become dormant, that inaction allowed the Knowland Bill to not shut down the commission. In the summer of 1956, Oren Harris again introduced a bill related to a potential stadium in Washington. This time Harris had a cosigner. Representative Frank Thompson Jr., a Democrat from New Jersey who had received three combat decorations for action at Iwo Jima and Okinawa, became the latest congressperson to join the battle. Simultaneously, South Dakota Republican Francis Case introduced a similar bill in the Senate. The bills picked up the mantle of the District Highway Department and required that the National Memorial Stadium Commission place the stadium on the grounds of the National Training School for Boys. Meanwhile, McMillan's House District Committee approved legislation to revive the National Memorial Stadium Commission. The bill gave the commission instructions to make cost estimates and plan for a stadium on the property of the National Training School for Boys if the Justice Department abandoned the site. The law gave the commission until December 31, 1957, to make its report.

The firm commitment to this location dissolved within months. Thompson withdrew support for the Training School grounds as the site for stadium and suggested the area around Griffith Stadium might be the proper location. He wrote to the leadership of the Redevelopment Land Authority (RLA) regarding their study on the potential of the area as an urban renewal site. The RLA proposed an 80-acre tract as the site of a Seventh Street, NW urban renewal project. This proposed project included the area around Griffith Stadium, and the area of mid-city once known as Howardtown.

The owners of the Senators and the Redskins were not pleased with this plan. Calvin Griffith and George Marshall each preferred a central location for the new stadium. The National Capital Planning Commission, which took over for the NCPPC in the summer of 1952, offered their perspective in the "Preliminary Report On Sites For National Memorial Stadium," in November 1956. The writers concluded that the National Training School site was adequate for either a large or medium-sized stadium; the East Capitol Street

site was adequate for either a large or medium-sized stadium in the area between Benning Road, Oklahoma Avenue and Kingman Lake. The East Capitol Street area opposite the National Guard Armory was a suitable site for a medium-sized stadium. In these conclusions, the writers minimized several advantages that the Training School site offered. The site offered more area in total and for parking, and there would have been no requirement to purchase additional land as there was with the site opposite the Armory. The location created no traffic and crowd issues for the surrounding neighborhood because it was sparsely populated. Most intriguingly, the Training School site offered an elevation and openness that the writers admitted provided the opportunity for the new stadium to become a monumental landmark.[44]

In January 1957, Representative Harris again put in a bill calling for a 50,000-seat stadium across from the Armory. For one of the first times since the discussions in late 1944, the bill and the news media did not refer to the project as a "memorial stadium," but simply called it a "stadium." Despite the continuing existence of the National Memorial Stadium Commission, a District Stadium Commission emerged to pass judgment on the plans for the stadium. Each chamber of Congress passed different versions of a stadium bill; the chances of the authorization of a stadium in the District remained in doubt. What seemed certain was that the animating rationale for building a stadium in Washington for the last twelve years had disappeared. This proposed stadium lost its connection to a memorial to the veterans of the two world wars. Another rationale spurred on the drive to construct the stadium and it would be reflected in the stadium's name.

5

Five-Ring Circus
Olympic Dreams and Delusions

The First Olympic Dream

As the close of the previous chapter showed, the rationale that once motivated the participants' drive to build a stadium in Washington could change. Even people who had long held that rationale as the reason why the city needed a stadium could switch. They could adopt a new reason for promoting the city's need for a stadium. Sometimes, another person adopts their proposal as part of advocacy to build a stadium for another motivation.

For the third straight year, Colonel Harts submitted a proposed plan for the creation of the recreation center in East Potomac Park to his superiors in the War Department. The Chief of Engineers, U.S. Army received the comprehensive plan for its development of East Potomac Park with a letter of support for the project. The Army bureaucrat noted the value of public recreation facilities. The facilities were widely recognized as essential in laying the foundations for good citizenship and for the healthful moral and physical development of the people. "It has become the duty of municipalities to provide wholesome outdoor recreation for the public in such form as may be readily available for those who cannot otherwise have such opportunities."[1]

The plan included a drawing of the island and descriptive information. The right side of the park was devoted to the golf course and groves of trees. A boat harbor faced the channel side and would include a boathouse. A field house with locker rooms and a luncheon facility overlooked the golf course. The left side included a parade ground and a series of sporting fields. The stadium sat in the top left hand corner and overlooked the parade grounds.

Opposite: **Plan for East Potomac Park Recreational Center, 1913–1917 (Office of History, U.S. Army Corps of Engineers).**

The back slopes featured trees that furnished shade to a large group of spectators.

The members of the Commission of Fine Arts and local city residents supported the development of East Potomac Park as an Olympics Recreational Center. The commission asserted that the development would be excellent. Washington would have a beautiful island park like the one in Paris. Similarly, a group involved in a protest against the erection of a proposed power plant for Congress argued that the location would ruin the vista along the Potomac. They mentioned that East Potomac Park was to be developed as the people's playground: "It is capable of forming one of the four great island parks in the world."[2]

The Secretary of War submitted the request for the appropriation to the House of Representatives. The first-term congressperson, George Murray Hulbert, introduced the portion for the East Potomac Park as a separate bill in the early spring of 1916. A lawyer who practiced for fourteen years before joining Congress, Hulbert represented "a renegade to political tradition," because he spent one day a week available to his constituents in his office on 125th Street.

A tall and portly gentleman who suddenly shifted his glance from one thing to something else, the Democrat was an avid sportsman. He represented the New York City district that included the Polo Grounds and enjoyed a friendship with the owners of the New York Yankees. His interest in athletics also included serving as director of the Irish-American Athletic Club and as honorary president of the Harlem Athletic Club. Hulbert also enjoyed a position as a representative to the Amateur Athletic Union (AAU), the most powerful body in amateur sports in the country.

The Congressman's main reason for supporting the recreational area and stadium soon became apparent. Representative Hulbert addressed the newspapers during the introduction of the bill. He declared that if favorable action were obtained upon the bill, a concerted effort would be made by the athletic clubs of the country affiliated with the AAU to have the Olympic Games in 1920 held in Washington. Hulbert pointed out that in every country ample accommodations were afforded in the capital city for national athletic events. Every country, that is, except for the United States.

At his first opportunity, the congressman transformed the rationale for building the stadium in Potomac Park. The project originally began as part of the City Beautiful perspective on recreation and municipal government. The inclusion of the stadium emerged as a location for the staging of the Army-Navy football game. As the proposal came into the House, Representative Hulbert interpreted the stadium and other recreational facilities as the chance to convene the Olympic Games in Washington, D.C. This marked the

first occasion that the Olympics served as a reason for the construction of a stadium in the District of Columbia.

The Speaker of the House, James Beauchamp "Champ" Clark, a Democrat from Missouri, assigned the Hulbert bill to the House Appropriations Committee. Hulbert promised that he would urge Chairman John Joseph Fitzgerald, a fellow New York Democrat, to hold hearings on the bill soon. The Hulbert Bill sought an appropriation of $1,545,397. The local newspapers noted that the bill more popularly known as the Harts Report mirrored that work. If passed, the bill would also enable the city to host the Army-Navy football game. The inclusion of the services' football game as an additional purpose suggested the relative greater popularity of the game compared to the Olympics.[3]

Fitzgerald granted Hulbert's bill the early hearing. In the early part of May, Congressman Hulbert gathered the witnesses he wanted to appear before the Committee on Appropriations' House Subcommittee on Sundry Civil Appropriations. Many of these people came from the congressman's past associations with organizations involved in amateur athletics. Witnesses ranged from the top officers in the AAU to many ethnic athletic organizations in New York City.

Meanwhile, the organizations attempted to generate a ground swell of support for the bill. The AAU generated a letter-writing campaign in favor of the appropriation. The Office of the Secretary-Treasurer of the Amateur Athletic Union of the United States sent out a four-page letter dated May 8, 1916, to members and other groups interested in outdoor sports. The mailer requested the receiver's cooperation in a movement for a public recreation ground and stadium in East Potomac Park, Washington, D.C.

The letter described and provided a copy of the Hulbert bill. The document pronounced that the bill would be a credit to our country and would provide a place for holding national championships in all sports. It noted that the bill called for city car lines to be extended into the grounds with loops at the stadium, at the boat harbor and near the field house, and offered parking for 500 cars. The document ended with a push for the receiver to write or telegraph his congressman and senator immediately, and urge them to give a favorable vote upon the bill.

The letter writers sent their pleas to the members on the committee particularly. A letter from the president of the National AAU went to John Francis Carew, a Democrat from New York. The Irish-American Athletic Club from New York also sent a letter to Representative Carew that said that the group unanimously endorsed and commended Mr. Hulbert for his bill to create a national stadium in East Potomac Park that would remain under the supervision, direction and control of the national government. The same let-

ter went to Representative Fitzgerald and Representative Thomas G. Patten of New York.[4]

While these letters arrived, the members began hearing the testimony for building the stadium. The men who arrived to testify on Capitol Hill had worked for the amateur sporting world and Olympic movement for many years. They forged the American Olympic teams, teams coined with the term "America's athletic missionaries," because they promoted the idea of American civilization. The teams advanced the idea that the civilization ought to be copied if a nation wanted progress, democracy, and social equality. These proponents of the Games determined that a nation's strength could be shown on the athletic field against other nations. They believed that as products of the melting pot, American athletes could beat anyone in their ancestral homelands.[5]

Interested congressmen offered remarks to their brethren in the House of Representatives prior to the beginning of testimony. The Honorable Frederick C. Hicks, a Democrat from New York, extended his remarks into the Congressional Record. Hicks averred that he supported the bill and had a remarkable editorial in the *New York Sun* brought to his attention. The article favored the erection of a stadium. "Other lands, some of them having but one-tenth as many athletes as we have, and athletes of far less ability than ours, have built such structures, and have also paid training and traveling expenses for their Olympic teams." The editors observed that the athletes of the United States understood that they were not in those other countries. However,

> they feel that this one request of theirs should be granted, and that the Government should signify its appreciation of the luster reflected upon America by the achievements of its world-mastering knights of track and field, by rearing in the Capital City a fitting site for great contests.[6]

Congressman Hicks entered into the record the challenge that the newspaper editors laid on Congress. Could the men who came to testify before the committee successfully amplify the case that the newspaper editors made? AAU president George J. Turner started the statements with the declaration that the erection of this stadium would be of great interest to all athletes and all lovers of athletic sports in the United States.

Next to testify, the Honorable Bartow S. Weeks, justice of the New York Supreme Court, declared, "[Building the stadium and recreation grounds] is manifestly a most proper and suitable development of a property here in Washington...." The Justice maintained affiliations with the AAU and the American Olympic Committee and provided details about the size and work of these private organizations. The AAU membership included about 550

clubs with over 500,000 men. The clubs invested millions of dollars in the development of a competitive desire in the improvement of physical manhood. That manhood development tended "to the general improvement of the man in the belief that thereby you generally improve his citizenship."

Justice Weeks shared a similar belief with the military men who made the argument to transfer the Army-Navy game to Potomac Park. Weeks believed that amateur sport had positive character building attributes. The men playing sports engaged in competition that improved their physical manhood. The improvement of manhood in turn improved the man and this changed reflected positively on his role as a citizen and thus that man's value to the nation.

During his testimony Justice Weeks argued that the building of the stadium had another advantage. Weeks interpreted the stadium as important in developing the athletic improvement that would enable the United States to host the Olympiad. "[Hosting the Games in the Capital] will afford an opportunity for the warring nations to meet in friendly rivalry in a neutral country and there we can have a stadium, if this park is developed, that would be an incentive to all the nations of the world...." The benefit that Weeks believed that competitive sport provided to the individual man and nation came from participating in the Olympics Games as well. The justice believed that Washington could host the Olympiad and provide a place of peace for the nations embroiled in World War I.[7]

Despite the poetics of the witness the committee members did not ask any inspired questions. Chairman Fitzgerald asked the justice if any municipality had a publicly financed stadium like the one requested in the bill. Judge Weeks responded that the capitals in other countries had them.

The chairman of the Advisory Committee of the Intercollegiate Athletic Association (IAA), Gustavus T. Kirby, testified next. Kirby stated that this bill was important because it reserved the ground for the recreational purpose. He observed that the layout Colonel Harts designed was splendid. Kirby saw a value to sport that was similar to that seen by Justice Weeks but had greater inclusiveness. For him all citizens, little boys and little girls, older men and older women, benefited from the furnishing of an opportunity to have wholesome and well-directed play. The IAA chairman also held a sense of the importance of Washington, D.C. He claimed that the Congress owed the stadium to Washington's citizens and the construction of the stadium would affect the entire United States. Kirby envisioned Washington as the city where people from all over the country would come, and when they were here, seeing the stadium and recreational area would provide them with an object lesson.

The stadium would bring more gain to Washington. Kirby praised the creation of a location for sport. "If I may speak from the standpoint of the

college athlete, I say to you that there is a great demand for an athletic field of this kind for Olympic Games and for games of the AAU." He all but guaranteed that the city would receive tangible benefits from the construction of the stadium: "I can assure you that the Intercollegiate Athletic Association will be only too delighted to be able to hold its games elsewhere than at the two places open to it...."[8]

After hearing the IAA Chairman place himself in the position of a current athlete, the Committee heard testimony from a current athlete. That athlete, Everet Jansen Wendell, proclaimed "that if the Olympic meeting should be held in America there is nothing that would be nearer to the hearts of all of us than to have it held in Washington."

Wendell noted that having men visiting from other countries see the representative side of our country brought joy. His focus was not the individual citizen but the leaders and important persons of the country. In the European capitals he had the experience of participating in games that were graced with dignified presences. Wendell stated, "We should want the games [here] under those dignified auspices." The stadium in Washington would result in placing the United States within the pinnacle of nations. Only in the capital could the U.S. place on display to the rest of the world the country's highly dignified personages.

The athlete's personal relationships enabled him to keenly perceive the importance of the stadium and of hosting the Olympics in the nation's capital. At the close of his testimony, Wendell strove to provide the committee members with a sense of this importance. He told them that "If this admirable bill and plan should go through, I think it would lay the foundation for a much more successful meeting if it should ever be held in America...." Wendell's statement became more intense while he told the men what the Games in Washington would mean: "[I]f you realized how tremendously the American athlete is admired on the other side, if you realized how all the other nations looked up to us here as representing athletics, you would appreciate very keenly the importance of this thing." Wendell believed that the Washington Olympic Games would enable international athletes to compete with the American athletes they so admired in the place that defined America and Americans. These athletes would then see the greatest of America.[9]

If the concerns of the views of foreign athletes were not foremost to some of the congressmen, the next testifier argued that the stadium provided a different benefit. Colonel Robert M. Thompson, president of the American Olympic Games Committee, testified that no athletes from below the Mason-Dixon Line had represented America during the 1912 Stockholm Olympic Games. Thompson argued that this would not happen again as athletics were more national in scope. Clearly, congressmen south of the line could

justify their vote for the stadium as the way to involve their men in the Olympics.

The next portion of the colonel's testimony returned to the theme of the stadium's providing the stage for the Olympics, which would help improve the country's manhood. "[Preparation for Olympic teams] means years of making the best of one's physique; it means living a sober, chaste, and active life, and that is the example you will be setting the young men of the country by the establishment of such as place as is here provided."

Certainly, part of this appeal shared similarities the argument Justice Weeks had advanced previously. However, Thompson's argument about the men south of the Mason-Dixon Line enabled the committee members to extrapolate the notion that the improved manhood would consist of new groupings of men. Many of these men had frequently been left outside of the improved citizenry. The president of the American Olympic Games Committee challenged the congressmen to determine what this improvement would be worth. "The expenditure [for the stadium] seems to be a great item," Thompson acknowledged, "but, after all, what is it? It will send ahead the whole of the United States; and think what it means to our young men."[10]

Anthony J. Barrett testified that the presence of the stadium in the national capital would lift the country's men and their sense of patriotism. "[The stadium would] instill in the minds of young men coming from all over the country ... a spirit of broad Americanism ... an appreciation of the greatness of the country and the need for an intense national feeling." The chairman of the Athletic Committee for the Irish-American Athletic Club foresaw an interesting melting pot as he noted, "[N]o place could be more appropriate for the meeting of the different elements that compose our population than a national playground under the shadow of the National Capitol, where they know there could be no antagonism, but only the rivalry to excel...." The leader of an ethnic group's athletic wing clearly saw, like Justice Weeks, an improvement to manhood in competition. In addition, like Weeks and Wendell, Barrett perceived that participating in athletics in Washington would show the participants the greatness of the United States.

The Irish-American athletic club leader completed his testimony with an appeal to the congressmen's magnanimity. He provided them an argument to offer the home district. Barrett noted, "[T]he young man ... from any part of the country [meeting] competitors in the national stadium at Washington, can look back on a long series of national championship meetings held here and can feel a pride in realizing that he knows the great national champions of America...."[11]

The final testimony came from Frederick W. Rubien, the AAU's secretary-Treasurer. Rubien requested permission to submit the remarks of Hon-

orable Charles Pearce Coady, a Democrat from Maryland, for the record. Chairman Fitzgerald gave it to him. The secretary-treasurer read the words of Coady to the Chamber.

> There is a pretty good prospect that the world games of 1920 may come to this country. The event hinges largely upon the success of a measure introduced in Congress ... which provides for the erection in Washington of a stadium of proportions and construction befitting the Capital city of the great Republic of the Western Hemisphere.[12]

The Congressman provided his colleagues with his view of the ranking of the rationales for building the stadium. "Not only will the Government have a fitting area for the staging of such contests as the Army-Navy football game, but, which is of vastly greater import, it will be able to play house in proper style to all of the nations of the world where athletics is encouraged." Akin to the views of the other men who testified, Coady noted that the construction of the stadium would, through housing the Olympiad, promote world peace. "If this should come to pass ... the athletes of the now warring lands of Europe would find upon this side of the water in 1920 a common meeting ground, a field of athletic reconciliation."

Rubien, who was based out of Chicago, continued his testimony. He introduced a letter written to his office from that city's mayor. Mayor William Hale Thompson offered his congratulations to the AAU on having interested Congress to consider the building of a stadium. Thompson valued the stadium for the encouragement of athletics. He stated his belief that the federal government had been rather slow in recognizing this value of the stadium. The AAU official noted that he had received hundreds of letters from all over the country which praised the AAU and expressed the hope that the organization's stadium efforts would be successful.

The committee members asked the men testifying before them a wide range of questions related to international relations and public financing of stadiums. John Joseph Egan, a Democrat from New Jersey, asked Colonel Thompson if holding the Olympics in Washington would result in more Latin American countries coming. Thompson responded yes, unquestionably they would come. He noted that they had no idea how many countries sent representatives to past Olympiads. Representative Frederick Huntington Gillett, a Republican from Massachusetts, and Frank Wheeler Mondell, a Republican from Wyoming, both wondered if it was necessary to host the Olympics in the capital city. While the Colonel said no, he observed that the only time they hadn't been was when St. Louis hosted the Games. Thompson asserted that those Games were not a very successful affair.

Congressman Hulbert expressed concern to the chair about the short amount of time left before they suspended for the day. He asked to address

a previous issue regarding public stadiums. Hulbert asserted that the city of Tacoma, Washington, had a publicly financed stadium. Mr. Kirby added that the stadium was beautiful and very successful. Representative Eagan asked if the stadiums in Berlin and Paris were municipally owned. Kirby stated that the buildings in Stockholm and Berlin were and that there was a newly erected stadium in St. Petersburg, Russia, as well.

District local citizen opinion joined in the chorus of support for the Hulbert bill. The editors of the *Washington Star* observed that Washington had long needed a stadium for athletic uses: "[I]f provided with one it would now have been the scene of important national and international contests." They concluded that the park was ready for use and the appropriation should be provided as soon as possible to permit the beginning of this work in the good season.[13]

The committee adjourned. After a vote, the committee favorably reported the bill onward for the consideration of the full House of Representatives. The House and later the Senate approved of funding for a small portion of the development of the recreational project. The stadium did not receive the necessary allocation of funds. The Congress provided the money to create the bathing beach and to design the golf course. The golf course was completed in 1921 and remains there to this day. The decision to establish tennis courts at the site eventually led to the creation of the Tennis Center at Haines Point.

Congressman Hulbert left Congress shortly after. Colonel Harts remained in his position as superintendent in charge of the Office of Public Buildings and Grounds. Harts did not stop trying to create a recreational park out of the East Potomac location. Months after the appropriation came through for a few items, Harts looked to several private sources to improve the transportation network to the area. He wrote to the presidents of two streetcar companies in the city, the Washington Railway and the Capital Traction Company, asking them about the feasibility of establishing ferry connections from the 7th and M Street, SW wharves to the Island. Both replied that they could not create the network, viewing the ferry business as too dissimilar to their present activities.

The War Department planned the first recreational site in a federal portion of the city. Some members of Congress and amateur athletic groups, mostly from the northeast section of the country, viewed the site as an opportunity for Washington to host the Olympics. The congressmen and sporting leaders perceived of the Olympics in the District as a chance to promote their version of Americanism. Hosting the Games in the nation's capital would demonstrate the superiority of America's representative democracy and pluralism of the "melting pot." The Olympics as "pure" sport would help develop

"proper" muscular Christian character and manhood, further enhancing in their minds American superiority.

Within the year the United States deepened its involvement in World War I. Before departing with a corps of engineers for service in Europe, Harts explained his plans for a great stadium, large enough to host the Olympic Games: "These projects seem like children of mine. I hate to leave them." As mentioned in the earlier chapter about the Army-Navy football game, World War I completely disrupted the War Department's efforts toward building a stadium in Washington. However, soon after the end of that war, Colonel Harts again scheduled speaking engagements that included the promotion of his idea for a stadium and recreational facilities in Potomac Park.

Harts' Children in Other Hands

After a few years several newspapers returned to the prospect of the District's needing a stadium to host the Olympics. The opinion-makers in the local city, such as the editors of the *Washington Post*, discussed proposed municipal improvements. They argued that a great athletic stadium of a class to meet the need in the District must command the attention of Congress. They noted this need already existed and the United States would soon be looking forward to staging another Olympic meet. They proclaimed, "There could be no more fitting place to hold the great international athletic carnival than in Washington."

Others outside the District also envisioned an Olympics being held in Washington. Like the proponents of the Hulbert bill, these supporters came from the northeastern United States. *The Courier* from Buffalo, New York, ran an article titled "The New Washington of Tomorrow." The article mentioned that the boosters of the city supported a stadium to bring in the big games: "A stadium which would attract the Olympic Games as well as the biggest American athletic events."[14]

The federal and city bureaucracies took steps to issue plans for the construction of a new stadium. Lieutenant Colonel Clarence O. Sherrill took the mantle from Colonel Harts. The native of North Carolina served as a junior aide to President Theodore Roosevelt before becoming an instructor in the Army service schools. An author of several mapping and military topography books, Sherrill served as the chief of staff for two divisions of the American Expeditionary Force in France, and then co-wrote a history of the United States in World War I.

The new superintendent of public buildings and grounds authorized Colonel George Vidmer to carry out the plans for a great stadium in East Potomac Park so the 1928 Olympic Games may be brought here. Vidmer and

the Superintendent thought private funding seemed the best option. One option focused on a request from the sportsmen of the country. The plan called for the horsemen of the country to donate 10 cents for every horse they owned, and ball teams to contribute the receipts of one game to raise the funds for a stadium to seat at least 100,000 people. Three years later, in 1926, James G. Langdon, District of Columbia city planner, led an effort to draw up plans for Potomac Park improvements. His plans were similar to those the Army issued in 1913 and again in 1916. The Fine Arts Commission granted their approval to the new plans.

Again the newspaper editors viewed these activities as movements toward bringing the Olympic Games to town because, "when the Olympic Games are held in the United States, Washington would be the proper place for them." A newspaper article advocated for an Olympic Games in Washington because a series of festivals, repeated every third or fourth year in the nation's capital city, would bring Americans together. "Our best are momentarily met in the city common to all. America is in Washington. It becomes an institution of our civilization.... National unity could be promoted in no better way."[15]

A National Capital Park Recreation Center

A new federal city governmental organization became involved in the effort to build a stadium in Washington. The Presidential Executive Order 6166 from June 1933 abolished the Office of Public Buildings and Grounds. The order transferred its responsibilities to the National Parks Service (NPS). Based in the Department of the Interior, the NPS began in 1916. The agency's administrators spent the first years corralling the formerly independent parks into a cohesive unit. Throughout the 1920s, the parks system held only one park east of the Mississippi River. The establishment of all federal park lands in the District under the NPS gave the agency a national scope and increased its bureaucratic influence.

The NPS sought to organize its new areas. They created the National Capital Parks to manage the lands and memorials in the District's federal city. The new superintendent of the National Capital Parks, C. Marshall Finnan, came to the area from Mesa Verde National Park in Colorado. The Baltimore native brought with him expertise in civil engineering, road and trail work and southwestern archaeology and botany. He also brought the agency's focus on making the national parks into vacation spots and knowing the value of commercial ventures.[16]

The National Capital Parks soon increased its holdings. The U.S. Engineer's Office finished its work reclaiming the wetlands from near the Anacostia River. It transferred 208 acres of land at the end of East Capitol Street

to the NPS's jurisdiction. NPS officials hoped to obtain a Public Works Administration allocation for the building of the stadium in the area. The NPS viewed the site as a public works project to provide amenities to residents and promote city development. Their vision concurred with other urban planning activities of the era, including those of Robert Moses in New York City.

The NCPPC worked with the NPS on developing a stadium construction plan. The two federal city representatives formed half of the stadium committee. The U.S. Engineer's Office sent a representative to aid with technical building issues and the District commissioners sent a representative to work with the group to represent local city interests. National Capital Parks Superintendent Finnan served as chairman of the advisory committee studying the project.

The preliminary plan for the National Sports Center appears below. The plan shared some of the features that appeared in the East Capitol Street Development plan discussed in Chapter 3 and with the Roosevelt Memorial plan discussed in Chapter 4. East Capitol Street ends at a plaza with two athletic fields on either side. A stadium stood on the right side while an

Preliminary plan, National Sports Center, 1934 (National Archives and Records Administration).

armory that would hold indoor sporting events sat on the left. Behind them was a polo field and parade grounds. A road encircled these grounds and fed into the bridge spanning the Anacostia River.

The map contains notation on the far right side designating an area as the "Colored People School Center" and the "Colored People Sport Center." This illuminated the segregated nature of Washington, D.C. in this era. The facilities that the federal government was designing would provide recreational opportunities for Washington, D.C., residents. However, those residents would have to have white skin pigmentation. The lack of any drawing of this school and sport center for the city's black residents illustrated the fallacy of the "separate but equal" doctrine, used to excuse segregationist policies.

The superintendent shared the committee's preliminary plans for the development of the stadium site with the NCPPC Board in mid–June 1935. The original plans provided for the stadium, the sports area, and a large water park formed by Kingman Lake. Necessary modifications reduced the water park and included a fully equipped area for competitive sports, recreation and national demonstrations. The Stadium Committee proposed a list of twelve projects for the area. The first few included a drill field of at least 40 acres; a stadium with seating for 100,000; and stadiums for national and international tennis, swimming and diving. In addition, the plans called for an exhibition hall, an outdoor theater, an armory and a warehouse for equipment storage.

The plans for all these projects revealed the limitations of the original layout. The NPS found that the property lines would not provide sufficient area for everything. The Stadium Committee and the consultants on the project offered specific recommendations to provide sufficient grounds for the sports center. The NPS requested the approval of the NCPPC on three recommendations. They asked for a set of proposed land acquisitions, allocations of areas to the uses indicated in the plans, and a decision as to whether the axis of East Capitol Street should be continued across the river by means of a bridge.[17]

In late 1935, the stadium committee submitted four plans for the construction of the complex to the NCPPC and NPS leaders. Each plan again proposed a sports complex at the foot of East Capitol Street. The stadium would have a minimum seating capacity of 100,000 spectators. Inside this massive building would be armories and part-time barracks for the District National Guard and local units of the United States Marine Corps Reserve. Indications also pointed toward including gymnasia of sufficient size for complete indoor track meets, distance races, ice events and water sports. This complex required 300 to 500 acres. The federal city agencies made it known that those portions

that could not be purchased through direct negotiations with the present owners would be sought through legal condemnation proceedings.

The NCPPC Board wrestled with several considerations. They expressed concern over the location of enough parking for the 15,000 to 20,000 automobiles they expected to come per event. They were unsure of the validity of building a 100,000-seat stadium because of one or two games a year that could fill it. They wondered about the cost inherent in the acquisition of the necessary land. They accepted the special committee's determination that the 100,000-seat stadium would cost nearly $5 million.[18]

With the acceptance of the report, the stadium proposal moved up the chain of command of the federal city. Finnan submitted the stadium plan to the Secretary of the Interior. Harold Ickes approved the NPS's plan, allowing them to hire an engineer, an architect, and a landscape architect to work on the plans for the proposed stadium. The Chicago politician was the sort of progressive Republican that Roosevelt sought to incorporate into his administration. His management of the Public Works Administration and unimpeachable integrity corruption earned him the name "Honest Harold." Ickes often presented projects to President Roosevelt for his personal approval.

The NPS named local architect Francis Paul Sullivan to design their plan. Sullivan received his bachelor of arts from Georgetown University in 1904 and attended George Washington University for five years afterwards. Sullivan started the firm Wyeth and Sullivan with Nathan Wyeth. Their best known work was the wing of the Russell Office Building built in the early 1930s. The NPS's stadium plans received NCPPC approval and the Planning Commission planned on putting workmen on the grounds immediately to accomplish the necessary grading for the project. Sullivan's testimony regarding the National Memorial Stadium appeared in the previous chapter.

Finnan generated increased media interest in the park and the sports complex project. He announced that after his organization completed work on the national Mall, it would start on the projected stadium. He did not provide any timetable for the preliminary development. He sent the model of the football stadium, the District Armory, and the auditorium and exhibition hall that comprised the end of East Capitol Street to Congress for display in the Capitol Rotunda.

The proposed stadium plans reached the point of final consideration in the federal city. Superintendent Finnan approached Congresswoman Norton to guide the legislation that enabled the NPS to create a recreational area that could host the Olympic Games. Mrs. Norton submitted the stadium bill to the House of Representatives. The legislation authorized construction of a

stadium, a parade field, swimming pools and other recreational facilities and approaches in Section F, Anacostia Park in Washington, D.C.

This legislation shared facets with the bill submitted two years earlier, examined in Chapter 3. Both measures enabled the Secretary of the Interior, acting through the National Parks Service, to construct everything. The costs would be covered with funds from the Public Works Administration of the Works Progress Administration. The recreational center would remain under NPS direction, but the agency was authorized to enter into contracts with "any individual, organization, association or corporation" for its operation. Receipts from any fees or charges collected for the use of the facilities must be deposited in the Treasury to the credit of miscellaneous receipts. The intention was to have the deposits within 20 years equal to the government's investment in the area, both as to cost of construction and maintenance. The NPS's leadership believed that the turnstiles from the game and other events would raise the money for the outlay advanced to build the stadium.

Observers noted that this sizable complex would place the District on the map in the sporting world. The measure would provide the facilities for the city to play host to the Olympic Games in some recent future year. With the appeal and focus that sports had in the United States during the mid–1930s, and given how significantly the role of sports in the culture expanded afterwards, the measure would have given the District of Columbia and the federal, regional and local cities a great boost.

The Speaker of the House exhibited his support for construction of the sports center in Anacostia Park. He directed the bill to Norton's committee. Congresswoman Norton brought in a number of favorable witnesses to testify. They offered a vision of a sports center that might conceivably attract future Olympic contests or championship prize fights. They urged the subcommittee of the House District Committee to issue a favorable report to the larger body. Representatives with the NCPPC provided the subcommittee with detailed plans and they estimated the ultimate cost at between $18 and $20 million dollars. The District Commissioners informed the subcommittee that the District would not oppose the project so long as it is financed by the federal government.

A local nonprofit citizens' group took an interest in the stadium construction issue. The Recreation Committee of the Junior Board of Commerce established a group to perform special studies of the proposed government stadium for Washington. The committee intended to use these studies as information to help the full organization launch a campaign of support for the bill. The previous week members had attended a presentation where Marshall Finnan energized members with a presentation and the display of a

model of the stadium. The Junior Board Committee pointed out that if the stadium were constructed the city could hold the Olympic Games and the Army-Navy football game.

Other citizens' groups continued the effort of promoting the stadium bill. The Washington Board of Trade sent its president, John Saul, to the offices of Frederic A. Delano. The chairman of the NCPPC met the representative. The Board of Trade promoted a plan that supported the stadium facilities for the Olympics and they also requested that exhibition space be included as well.

The local enthusiasm did not spur Congress on to taking positive action on the bill. The subcommittee postponed action on the Norton bill to authorize construction of a stadium and sports center in Anacostia Park at the foot of East Capitol Street. The subcommittee of the District Committee postponed action on the bill. Thomas S. Settle, the Secretary of the NCPPC, admitted that the budget bureau disapproved the bill. The executive branch's controllers of the funds believed the spending did not conform to the president's financial program.[19]

Despite Chairwoman Norton's support the bill died in Congress. However, the plan had a long institutional life. Two years later a bureaucrat in the local government advocated for a stadium. A former president of the American Road Builders Association, William A. Van Duzer became the District director of traffic in 1931. He advocated for locating the national stadium at the end of East Capitol Street, convinced that this represented an ideal location. This was the only location in which adequate traffic accommodations could be provided. The site permitted the construction of a stadium with adequate size for such international events as the Olympic Games, and outstanding events such as the Army-Navy football game.

Van Duzer stated that a stadium large enough to host the Olympic Games would be the opening wedge in a program of development for the eastern side of the capital. Similar to the federal city workers in both the Parks Service and the NCPPC, the director sought to build a stadium and other facilities to host the Olympic Games not solely for the sport. These professional city planners strove to build up the eastern side of the capital. As one of the local city's top planning officials, Van Duzer sought the stadium in a larger effort to help eastern Capitol Hill assume its "rightful position" as a vital part of a balanced capital. As important, placing the stadium in that location would promote the widening of East Capitol Street. According to Van Duzer, widening the street would provide a great American equivalent of the world-famous Champs Élysées.[20]

The NCPPC continued its efforts toward bringing sporting facilities to the city. It issued a revised study of the Sports Center Armory and Stadium

drawings completed four years earlier. The drawing was much more detailed than the earlier version. The stadium had a capacity figure provided (70,000), and lengths and widths were given for the Sports Field and Parade Ground as well as the Armory and Sports Building. The necessary transportation systems appear with the inclusion of the major roadways, parking for buses and automobiles, and the train system.

The sports area appeared more compact than in the earlier proposal. All the major sports facilities fit within the horseshoe shape. The prongs, B Street, SE and C Street, NE, began at 19th Street and continued down to form a circle at the bridge behind Kingman Lake. The labels for the separate and unequal centers written on the right side of the preliminary map were replaced. On the top portion was the label "Langston Terrace Housing Project" and on the lower part were the words, "Golf Course." The construction of the housing project had been finished in 1938, and the location served as a community and highly functional society for working class minorities. The Public Works Administration, a New Deal agency that contracted with private companies to construct public works projects, built the housing project. The stadium advocates, including other federal agencies, had wanted to use the PWA to construct the National Sports Complex and fuel the city's Olympic possibilities. However, in this instance, the need for housing of the lower-income population came before the need for sports.

The Langston Golf Course offered blacks a facility where they could play. As mentioned earlier, the city's black population faced restrictions on their use of the East Potomac Park Golf Course. Ironically, the course became a stumbling block to the plans of those who wanted to build a stadium in order to keep the Redskins in the city during the late 1980s and early 1990s. This will be discussed in Chapter 6.[21]

As we discovered earlier in this chapter, some local city and federal workers compared Washington to Paris. Paris was not only the capital of France but had a reputation as a great and sophisticated city. Twenty years earlier, members of the Commission of Fine Arts and local residents who foresaw the development of East Potomac Park as an Olympics recreational center had the opportunity to turn that space into one of the third or fourth greatest island parks in the world. Now, the District's traffic director foresaw the development of Anacostia Park for the Olympics as the opportunity to create a great boulevard in Washington.

Several businessmen and other notable local city residents resumed their effort under the banner of a new organization. In the winter of 1939, the Touchdown Club of Washington, a group of "sports-minded" citizens, sponsored a committee to present the organization's stadium ideas. Assembled in the ritzy Hamilton Hotel, the group devised a three-point plan. First, they

Sports Center revised study, 1938 (National Archives and Records Administration).

adopted a resolution calling upon Congress to appropriate funds to build a stadium with the capacity to accommodate 120,000. This large a stadium would host the Olympic Games and other events such as the Army-Navy game. Second, they appointed a representative of the Real Estate Board to meet with the NCPPC to gain approval for their stadium plans. Finally, they

created another committee to investigate sites, including the area of Fifteenth and H streets, NE.

The platform of the group indicated that they took a different approach from the earlier work of the Washington Board of Trade. The Touchdown Club had fewer members, less history, and less bureaucracy. They formed specifically to share their enjoyment of sports. Their plan to consider other locations for the stadium indicated that they did not necessarily share the opinion of the Washington Board of Trade and other organizations regarding the foot of East Capitol Street. Unlike the earlier efforts, the Touchdown Club did not work much with the federal city planners. They did not use U.S. Grant III or Frederick Delano during the formation of their plans or site choices.

As with the other citizens and the federal bureaucrats the Touchdown Club found themselves back at the drawing board the following year. They modified their tactics. The group planned to launch a petition throughout the city to amass 150,000 names requesting that the stadium be constructed. The club officers and District Commissioner George W. Allen signed the document, then set about circulating it throughout the government departments. The petition declared that "Washington, as the Capital, should lead the world not only in political ideology and intellectual attainment, but also in the promotion of wholesome competitive athletic development."

The Touchdown Club's renewal of its appeal to Congress for an outdoor stadium in Washington came in conjunction with another bill beginning in the House of Representatives. Chairman Jennings Randolph of the House District Committee introduced a bill to authorize construction of a national sports center in Anacostia Park. Anticipating the 1944 Olympics, Randolph asked authority for the Secretary of the Interior to construct and maintain a stadium, parade field, swimming pool, and other recreational facilities in Section F of the park. The bill authorized whatever appropriations may be necessary from the Treasury for construction and maintenance. Sponsors of the sports center had hopes that a WPA or PWA grant may be obtained once the project was authorized by Congress. The substance of this bill shared much with the bills that Congresswoman Norton had submitted earlier.

The local city politicians, residents and groups with involvement in the efforts over the last few years provided the Randolph bill with organized support. The publishers of the four Washington newspapers, District Commissioner George Allen and other public officials, and numerous citizens' associations all promoted the bill for a municipal stadium and sports center in Anacostia Park. These groups crafted an appeal to Congress that requested them "to take early and adequate measures for the erection and maintenance of a municipal stadium, in the District of Columbia, capable of accommodating athletic events of both national and international importance."

The Congress appropriated the funds for the project's first unit, an armory for the National Guard. The District commissioners then sought permission to use the new National Guard Armory as an indoor sports arena. They planned to use the profits the Armory made to build a fund for the construction of a municipal stadium. However, they had to stop pursuing their effort as the country joined the Allies' side in World War II.[22]

During the 1944–1945 planning for the National Memorial Stadium discussed in Chapter 4, the issue of the sports center arose again. The local architectural and engineering firm that provided an analysis of the stadium's size and plan also provided a few pages devoted to the sports center. R.O. Marsh, the Washington manager of the firm of H.A. Kuljian and Company, noted that the memorial stadium would seat 100,000 spectators and could fit within plans for hosting the Olympic Games.

Marsh observed that the plans for the sports center segued nicely with Olympic plans and the city's existing infrastructure. He noted that there would be ample parking spaces and plans for the extension of the streetcars raised the ability of mass transit to aid in moving visitors around. Marsh stated that everything could be accomplished for the 1948 Games if given a year's notice. He based this decision on a flexible approach to the types of buildings required of a host city. "Such structures, for such an occasional event as the Olympic Games, would seem to call for temporary economical installations until and unless experience demonstrated the justification for permanent installations on such a large scale."

The engineering firm manager may not have been correct. Perhaps the IOC would not look favorably upon such structures and would not have granted Washington the Games. However, his attitude revealed that the Games did not necessarily warrant the expenditure of money and manpower on buildings.

The federal city work force combined with local city residents to present a vision of this sports center. The NCPPC and the Corcoran Gallery combined for an exhibit. Titled, "Washington After the War," this two-month show during September and October of 1945 put on display plans, models and drawings of the vision of the "improved" city environment. The plans for the sports center appeared as one area of the reimagined city. Some members of the federal city retained this vision despite the building of only the Armory during the first twenty years. The National Capital Parks staff continued viewing the plan as a way of bringing the Olympics to the District. The plan retained power through the late 1950s, as will become apparent in the next chapter.[23]

The Letter Writer

Over the next few years an individual raised the issue of building a stadium so Washington could host the Olympics. During the National Memorial Stadium efforts, a letter to the editor described a conversation between letter writer David Darrin and the NCPPC's Ulysses S. Grant III and city planning expert John Nolen. A frequent contributor to the editorial pages, David Darrin had his thoughts published on a wide range of subjects. He advocated for District home rule, for more playgrounds and recreational spaces, and for the liquidation of the United Nations, to be replaced by a world state with a strong constitution that reflected our country's constitution.[24]

In the first of his letters regarding a memorial stadium, he argued that the East Capitol Street site for the stadium was far short of adequate. Darrin stated that East Potomac Park Island had more to offer. While Grant objected that the location had a golf course and Nolen pointed out that the site lacked transit facilities, the writer stated that East Potomac was more accessible, more scenic, more capacious and topographically superior to the East Capitol Street location. East Potomac Park, in his opinion, would be superior as the site of an Olympic stadium and outstanding national athletic plant as track, swimming and other facilities could be added to this location.

Darrin categorized Grant's vision as focused on present-day needs while a National Memorial Stadium needed to serve a larger purpose. He proposed that the city host the 1948 Olympics. Serving as host would create a historic event that would provide the stadium with the larger purpose that a memorial required. Darrin argued that creating an appropriate stadium required the involvement of architects and engineers in a nation-wide design competition. Their buildings would create a national sports plant worthy of the nation at a site more scenic, central and accessible than the proposed East Capitol Street location. Proponents of a stadium in Washington had sometimes linked two rationales for building a stadium, generally the Olympics and the Army-Navy football game, or a memorial and the football game. Darrin's proposal represented the first to link of the Olympic Games to the memorial purpose. The results of the letters were negligible.

A few years later a sportsman argued for the Olympics in Washington. Bill Henry, the man instrumental in building the war memorial stadium for Los Angeles in the 1920s, provided his view. "If Washington had a stadium or had a chance of getting one by 1960, the International Olympic Committee would leap at the chance of holding the games here. It's the Nation's Capital and, you might say, the capital of the world." As the successful director of the Olympic Games of 1932, Henry had an opinion that carried influence.

"Except for lack of a stadium, Washington is ideal for the Olympics. The National Guard Armory is perfect for indoor games like wrestling, boxing, basketball and fencing, and the lovely countryside nice for the equestrians." This ringing endorsement from an expert sparked little official reaction.[25]

Regional City Ideas

Others among the local city residents agreed with Darrin about the potential for the Olympics and the inability of Anacostia Park to be the focal point. Unlike the letter writer, they advocated for regional sites. The efforts of Representative Harris to pass a stadium bill, discussed in the last chapter, sparked comments. The city's chief highway planner, Douglas S. Brinkley, active in regional planning since the late 1940s, looked at the issue from a regional city approach. Noting the movement of the population into the suburbs surrounding the District, Brinkley objected that the Armory location lacked adequate access roads to handle spectators who drove to the stadium.

The local city planners agreed. The District of Columbia's Highway Department supported the site of the National Training School for Boys for the stadium. They observed that the training school property provided 200 acres for a stadium and supporting facilities, a size that could handle an Olympic meet. In addition, major access roads, including the Baltimore-Washington Parkway and Route 495, ran nearby.

The District budget officer added a new and bigger site to those under consideration for the District's proposed sports and civic stadium. Walter L. Fowler suggested the mammoth stadium be placed on the 906 acres now occupied by Bolling Field and the Naval Air Station. He called on city planners to think in terms of a self-liquidating federal undertaking suitable for Olympic Games and great national celebrations. Fowler noted that the site on the east banks of the Potomac and Anacostia Rivers would support the construction of the largest stadium in the country, suitable for Army-Navy games and Olympic competitions. The area could also contain a civic auditorium with seating for 20,000 persons. Bolling offered adequate parking, natural sites as appropriate background and better access than any other site via existing and proposed bridges and superhighways.

The two proposals illuminated a perspective reflecting changes in the city and the surrounding areas. Each proposal came out in the late 1950s when large portions of the District previously undeveloped now contained buildings. The two sites lay near the outskirts of the city, beside the new expressways. The focus on the access and parking for cars reflected both the large amount of the population that had moved into the suburbs and the expansion of automobile ownership that had occurred during the recent decades.[26]

These sites envisioned a different development purpose behind the stadium. The purpose of developing the eastern side of the Capitol Building to create a balanced local city had disappeared. The plans for creating a grand avenue that matched the Mall and provided the District with a triumphant boulevard worthy of Europe had vanished. Instead these proposals focused less on the local city of Washington as they acknowledged the increased number of residents and businesses located in southern Maryland and northern Virginia. These Olympic Stadium proposals began envisioning the regional city.

Rise and Fall of the Greater Washington Exploratory Committee

The discussion of Washington, D.C., hosting the Olympic Games rarely appeared for the next forty years. Similar to many of the country's oldest cities, Washington lost population, businesses and tax ratables to the suburbs, to cities in the southwestern part of the U.S., and to international competition. The city did not realize the advantages projected from the massive urban renewal project that reshaped the local city's southwest quadrant. The local city's Shaw and Columbia Heights sections in the northwestern quadrant suffered tremendously during the rioting after the assassination of Dr. Martin Luther King Jr. in April 1968. Twenty years later the city earned the unwanted sobriquet of the "murder capital" of the country.

The District government had its home rule curbed in April 1995. Congress established a five-person Financial Responsibility Authority, better known as the financial control board. The control board oversaw the budgets and operation of the city government because the government had a budget deficit of $722 million dollars. The municipal bonds for the District reached one of the lowest ratings they could have with both Standard and Poor's and Moody's rating systems.

In the spring of 1997, Mayor Marion Barry of the District of Columbia announced the city's intention to bid for the 2008 Summer Olympic Games. The Greater Washington Exploratory Committee (GWEC) sent a nonrefundable application fee to the U.S. Olympic Committee. "We want the Olympics. We are going to go all out," said Mayor Barry. However, city officials were unable to authorize any expenditure toward the Olympic Games without the Control Board's approval.

The Mayor could be taken for his word. He had made a remarkable comeback to capture his fourth term as the city's top official. The son of a Mississippi sharecropper and founder of the Student Non violent Coordinating Committee (SNCC), Barry first won election in 1979 promising to promote

social justice and balance the city's fiscal affairs. As mayor, Barry achieved
development across the city and forged programs benefiting a small number
of black professionals. Barry oversaw the mismanagement in many of the
city's agencies and a government laced with corruption. He experienced that
corruption on a personal level as well in the late 1980s and early 1990s. Within
three years, Barry reestablished himself in southeast Washington, D.C. He
won the ward's City Council seat two years before achieving reelection to the
mayoralty in 1994.[27]

Mayor Barry noted that the Olympic Games were lucrative. He listed a
number of economic benefits that the city would gain. He deduced that the
GWEC seemed the best method to afford the District the opportunity to enter
the Olympics host city fray. Local public relations executive Elizabeth Ganzi-
Ejjam headed GWEC.

Ganzi-Ejjam had designed promotions and events at the Atlanta Sum-
mer Olympic Games of 1996. "I kept coming back to our city [the George-
town part of Washington] thinking 'Why can't we have the Olympics in our
nation's capital?'" She realized the Olympic bid demanded a lot of work. "My
dad taught me I could do anything I wanted to...." Ganzi-Ejjam informed
the media that the down payment came entirely from private sources. They
wired the money to the United States Olympic Committee (USOC) headquar-
ters three hours before the deadline. "The Olympics are going to eventually
come back to the United States, and when they do we want them in Wash-
ington," said Brad Dockser, of the GWEC.[28]

Ganzi-Ejjam observed that she "knew the Olympics wasn't going to fix
our city. But I always said that it would bring our region together in a way
that had never been done before." The promoters' attitude revealed the enor-
mous power that sports held in the late twentieth century. The Olympic
Games seized the world's attention. They aired on television for hundreds of
hours and occupied millions of pages in the print media of the world. The
sporting event provided the opportunity for a city to showcase itself in a
manner that few other events can. Sports supplied a unique platform for a
city and country to show its prowess and advance itself among the world's
cities.

Weeks after receiving the bids from the interested cities, the USOC made
a dramatic announcement. They would not offer a U.S. city as a potential host
for the 2008 Olympics up to the International Olympic Committee (IOC) for
its consideration. The United States had already had the 2002 Winter Games
in Salt Lake City. The group thought that they stood a better chance of win-
ning the recognition of the International Olympic Committee if they waited
another four years before advancing a U.S. city for consideration as host of
the Summer Olympics. The USOC decided that all the submitted bids would

instead be considered for the 2012 Olympics, including the ones for Washington and for Baltimore. The USOC's executive director Dick Schultz stated, "I think 2012 is a very viable bid, much more viable than 2008."[29]

The method of determining Olympic Games host cities for 2008 and 2012 illuminated the increasingly centralized and bureaucratic nature of the Olympic sports. As we saw earlier in the chapter, the U.S. Olympic effort consisted of a small group of amateur athletic groups. These men, like those who testified before Congress for the Hulbert bill, represented organizations, generally local sporting and ethnic clubs, that worked in conjunction with each other in the loosely federated five districts of the AAU. They promoted sport as part of a larger effort consisting of economic and social opportunities as well as educational, reform and Americanization activities.

Certainly others participated in the effort. The colleges and universities both assisted in coordination and provided players, and the spaces for holding sporting tournaments. As the number of competitive sports in the Olympic Games grew, a number of specific groups formed and vied for control of the sport. These groups not only had different personnel and perspectives but often chose differing methods to determine the composition of the teams over the years.

In 1950, the non profit United States Olympic Committee incorporated through an act of Congress. The charter enabled this private non profit, then known as the United States Olympic Association (USOA), to solicit tax-deductible contributions. This organization differed significantly from its predecessors. The group had a national scope and served premiere athletes perceived as Americans rather than as members of a single ethnic-based constituency. The year-round mission focused singularly on sports, to coordinate amateur athletic activities in the country. The guiding idea was to sustain U.S. athletes in their efforts toward sporting excellence. After the passage of the Amateur Sports Act in 1978, the mission became more explicit, with the USOC's main goal to be obtaining for the United States the most competent amateur representation possible in each event of the Olympic Games.

The original charter did also provide another mission for the organization. The USOA/USOC would work to sustain Olympic ideals to inspire all Americans. The statement and its sentiment would resonate with the Americanism of the Hulbert bill proponents.

By the end of the twentieth century, the USOC expanded to include Paralympics athletes in their mission. The organization spent over 100 million dollars annually and retained nearly 300 million dollars in assets. The USOC ran three sophisticated training centers for athletes with its management staff of 48 people and an enormous staff of professionals and experts.[30]

This USOC network of professionals prepared for a greatly expanded

and intensified Olympics. The Olympic Games expanded from the 102 events in 1912 to 163 in 1964 and 301 in 2004. The number of participants expanded nearly four times from over 2,500 to over 10,400 over the same span. A host city needed a wide range of venues in order to stage all these events. This required a significant investment in constructing new stadiums and modifying existing locations.

Even with sufficient corporate and charitable funding, the GWEC and city officials still had to convince the USOC that the District could accommodate the Summer Olympics. The local city could not build new stadiums and facilities to host events. They could not afford to expand existing public transportation systems. They could not count on significant aid from the federal city, which had already instituted a check on the local city's ability to spend. Cynics noted that the campaign to bring the Summer Olympics to the city was a hope to make the District known for something other than abundant potholes and substandard schools. "That they might spend money for the infrastructure to build all that stuff is unbelievable to me," said Delabian Rice-Thurston, who serves as director of a group working for quality education.[31]

The Olympic host city contest appeared tantalizing to many cities in the United States and around the world. Washington was not even the only local city bidding for the Olympics. The city of Baltimore made its bid with the support of the Maryland Sports Authority. Mayor Kenneth Schmoke viewed the Games in a similar way to that of his Washington counterpart.

The two groups continued their efforts to bring the summer Olympic Games to their respective cities for 2012. The GWEC, under Ganzi-Ejjam's leadership, recruited additional corporate sponsorship. The organization also gathered information on financing, fundraising, communications, and infrastructure. Additionally, GWEC obtained venue and feasibility studies on where Olympic events could be held. In October 1997, Ganzi-Ejjam responded to conversations with Kenneth Sparks of the Federal City Council and shared the information that the GWEC maintained.

Groups and individuals expressed concern that two cities 40 miles apart had made competing bids. John A. Moag of the Baltimore group talked to two dozen area executives and they supported a joint bid. The USOC strongly recommended that the two groups join forces. Less than two months later, Ganzi-Ejjam and the GWEC met with Sparks, Katherine Graham, Mary Junck and other business leaders of both Baltimore and Washington. Both John Moag of Baltimore's organization and Ganzi-Ejjam gave presentations. The Business Steering Committee decided to combine the two cities into a single bid.

Shortly thereafter, Ganzi-Ejjam alleged that the USOC defied its prom-

ises to her and the Greater Washington Exploratory Committee. The USOC had begun conferring with the Business Steering Committee regarding a joint bid. Others in the Washington contingent expressed displeasure over this action. Mayor Barry said that he did not see his city supporting a bid if it was not considered the host city. Laleh Rafiee, a project manager with the GWEC, argued that Washington was the choice because it was a city the rest of the world recognized. Other organizers rolled their eyes when they heard about early attempts at naming the new regional organization.[32]

On February 1, 1998, Ganzi-Ejjam met members of the Business Steering Committee. Under the belief that the organization required her consent to combine the bids of the two cities, Ms. Ganzi-Ejjam listed her requirements. She requested that GWEC receive the majority of the seats on the new board of directors, and that the Greater Washington Exploratory Committee be designated as the company to continue the Olympic effort. Finally, Ms. Ganzi-Ejjam requested that she receive a salaried position. The committee members rejected her terms.

Meanwhile, the Business Steering Committee acted to solidify their position. On March 20, 1998, the group established a board with members limited to those willing to make a $500,000 contribution to the effort. They wooed the mayors of the two cities in order to receive their consent to represent the cities in dealings with the USOC. Ganzi-Ejjam received an offer to be on the board and a waiver of the contribution requirement, which she declined. In April 1998, the USOC acknowledged a letter from Mayor Marion Barry and Mayor Kurt Schmoke designating the 2012 Coalition as the official representative of the joint bid of their two cities. Ganzi-Ejjam and the GWEC had officially lost their position.[33]

The executive and the GWEC took the former Business Steering Committee, now named the 2012 Coalition, to court. The plaintiff filed her suit on federal racketeering charges under the Racketeer Influenced and Corrupt Organizations (RICO) provision of the Organized Crime Control Act of 1970. Ganzi-Ejjam and the GWEC charged that the defendants conspired improperly to wrest control of the District of Columbia's "Official Bid" to host the 2012 Olympic Games from the GWEC. The plaintiffs used the RICO law to charge Barry with not honoring his commitment to the GWEC because of promises of a strong personal financial future from the 2012 Coalition.[34]

The court reached its decision in the spring of 2000. The judge dismissed Ganzi-Ejjam case without prejudice because the plaintiffs failed to state a claim upon which relief could be granted with regard to the RICO provision. Judge June L. Green decided that the case involved a single scheme that lasted a relatively short amount of time and had two victims and a single injury. A single scheme designed to frustrate a small number of victims failed to meet

the requirement of the RICO provision of a pattern of racketeering activity. Ganzi-Ejjam also asserted a number of common law claims (promissory estoppel, unjust enrichment, conversion, fraud, tortuous interference with business relations, and conspiracy), but theses were dismissed without prejudice because the court was not the proper place to have them tried. A year later, the 2012 Coalition and Elizabeth Ganzi-Ejjam reached a settlement. The terms were not released.[35]

Regional City for 2012 Coalition

During the GWEC's short existence, changes occurred to the District local city and government financial situation. The chief financial officer for the "Control Board" ran for mayor and defeated city council members in both the Democratic Party primary and general elections in 1998. The revitalization and gentrification of many neighborhoods throughout the city increased. The new and rehabbed housing, retail and corporate businesses filled in and brought vibrancy to these areas. The changes also raised property values and generated different jobs while helping Washington become a world-class city in the arts, sports, entertainment and restaurants.

The local city government's fiscal circumstances also improved. The District government balanced its budget in fiscal year 2002 for the sixth year in a row. They even created a small surplus that year of 27.4 million dollars. The general fund balance rose from being in the hole for $518 million dollars in fiscal year 1996 to a surplus of over $865 million by fiscal year 2005. However, the surpluses came with major reductions in spending that might be required in future years as well.

These overall positive fiscal changes might enable the District local city and government to provide some funding toward an Olympic Games effort. However, any contribution would have to be balanced against knowledge that the city still suffered with major long-term problems. The U.S. Government Accountability Office issued a report in May 2003 that detailed several structural issues that the District faced. These core problems included the city's having the highest tax burden in the nation. Yet, the city government could provide only sufficient public services; those services were expensive due to high levels of poverty. Other cornerstone difficulties included a high cost of living and too much crime. The city government faced a substantial structural deficit and a structural imbalance that was determined by factors beyond the government's direct control.

The Chesapeake Region 2012 Coalition came the closest to making the Olympics in Washington a reality. The businesspeople running the Coalition realized that neither Washington nor Baltimore had the finances to manage

an Olympic Games bid alone. The group also realized that a regional effort would include those businesses and residents based in the suburbs of northern Virginia and southern Maryland. The regional city approach was the first of its kind and enabled them to utilize the buildings and funding sources across the area to forge a united effort. The Coalition sent off its bid entitled "Connection Communities, Hosting History."

The 2012 Coalition needed a substantial amount of assistance from organizations throughout the region to complete the bid. The 2012 Coalition consisted of four paid staff and two ongoing volunteers, and later added one Olympian. This small group spent a significant amount of time soliciting financial and in-kind donations to develop the proposal. The participants in shaping the bid and process included area colleges and universities, local and state governments and their agencies, the U.S. Navy, private enterprises and nonprofits. These groups constructed the nineteen themes addressed in the proposal, ranging from the official program and sports to bid city characteristics, climate, media and accommodation. The effort required attention to many obscure details, a myriad of unwritten Olympic rules, and the understanding of the "Olympic" foreign language. A featured image of the Olympic Stadium appears below.[36]

The 2012 Coalition faced off against seven other cities. The USOC received bids in December 2000 from Cincinnati, Dallas, Houston, Los Angeles, New York City, San Francisco, and Tampa Bay. The Baltimore-Washington bid had several advantages and a few disadvantages. The area had presence on the international stage and raised almost all of the $9 million required for the bid. Most importantly, like San Francisco and New York, Washington had international appeal, something the USOC considered a key to winning the approval of the International Olympic Committee (IOC). However, the Olympic events were spread out over a larger area than the ICO usually liked. In addition, the area was not known as a sporting powerhouse.[37]

After a few weeks the Coalition learned that it had received the nod. The other cities making it to the semi-final round included Houston, New York City and San Francisco. Each of the groups representing these cities faced a new challenge: they needed to prepare for the upcoming USOC site inspection in early summer 2001.

Meanwhile, the 2012 Chesapeake Coalition organization needed to fulfill another USOC requirement. Their leadership urged the Maryland and Virginia legislatures and the D.C. City Council to help move bills to commit each government to providing the backup financial guarantees the USOC required from bid cities. Each of the three bodies passed bills providing for their portion of the $175 million dollar government guarantees. The District government provided for $49 million, or 28 percent of the total. The contribution

Stadium and East Capitol Street Olympic bid, Baltimore–Washington, 2000–2002 (Washington-Baltimore 2012 Coalition and HNTB Architecture).

figure was based upon the percentage of revenues from hosting the Games that each city or state would receive.

The Coalition predicted a $1.3 billion dollar positive economic impact for the region. They also estimated that hosting the Olympic Games would generate over 15,000 jobs. In addition, the Olympics would provide the opportunity to make transportation improvements and would serve as an amazing showcase for the area to be seen worldwide. The Games would also serve a philanthropic end as well. A portion of the costs of hosting the Games included a $200 million Olympic Legacy fund.

Mayor Williams issued press releases and wrote editorials supporting the campaign to bring the 2012 Summer Olympics to the Baltimore-Washington area. The mayor stated the Games would grant the District a newfound prominence on the world stage. They provided the city and region the incalculable boost of a staggering $5.3 billion in overall economic impact and a massive boost to tourism and hotel industries. Sport as represented by the

Olympic Games equaled business opportunities. The Games were projected to generate enormous economic gain for the regional city. They would lead to an influx of expenditures and visitors to the city and jobs for area residents.

Sports also offered the opportunity for new development. As noted in the last paragraph, the Games provided the change to build transportation improvements. Hosting the Olympics would accelerate the city's efforts to transform Anacostia into a thriving waterfront. While claiming that twenty-four of the thirty-three venues existed or were under construction, the mayor admitted the need for support to build the remaining stadiums along the Anacostia waterfront. A high-speed magnetic levitation train would be built to whisk people within the corridor of the Games.[38]

The photograph below shows the plans for the development of a sports complex along the Anacostia River. The plan used the existing Armory (vaulted roof southwest of the stadium) for the boxing matches but replaced RFK Stadium with a new 40,000-seat Olympic stadium that could be expanded to hold 80,000 spectators. (See Chapters 6 and 7 for the story of the RFK Stadium's construction.) The Olympic Plaza bridged the space between the stadium and the end of East Capitol Street. At the other end of East Capitol Street, in the top of the photograph, sits the Capitol. New buildings included the hospitality pavilion and a beach volleyball venue in the lower left hand corner. The aquatics facility and the main media center fill the bottom right half of the image. Across from the armory is the sponsor

OSC Site Plan_043002. The Capitol and the Mall are in the top center of the photograph (Washington-Baltimore 2012 Coalition and HNTB Architecture).

pavilion and to the west of that are another two new facilities, the handball facility and a training track.

The USOC representatives visited Washington in June 2001. The Coalition described the capital city as a single piece of a cohesive metropolitan area. Its governments supported the bid as Mayor Williams made it known, "The District of Columbia fully supports the great effort underway to host the Olympic Games in our region." Its people supported the effort as over 82 percent of adults said they would like to see the region host the Games.

The visitors knew that hosting the world's largest international sporting event would help create a richer athletic legacy for the entire region. The area would attain note as a sporting city, and infrastructural improvements would include new competition venues and community facilities. The Coalition members assured the USOC that 30 of the 33 competition sites were located with a 30-mile radius of the Olympic Village and that two-thirds of them required only a minor "Olympic overlay." They redefined the regional locations to only include a corridor from Baltimore in the north to Fairfax, Virginia, in the south.

The 2012 Coalition emphasized that they would hold monumental, meaningful, and magical Games. The opening and closing ceremonies would inspire and celebrate the Olympics as they occurred on the National Mall. The organizers expected that by using the Mall and Baltimore's inner harbor, they could enable 500,000 or more people to experience the ceremony. As the image showed, the plan to incorporate the four-mile long "monumental core" from the Lincoln Memorial to the Olympic Sports Complex provided a "processional approach" to the carrying of the Olympic torch. The Mall would be in use throughout the Games and would offer visitors entertainment modules that included videos, live entertainment, concessions and other activities. The plan showed the space to its fullest potential.

There were some questions surrounding the 2012 Coalition's thoughts regarding competition sites. The bid addendum's venue form listed six new stadiums and arenas that required construction, including the Olympic Stadium, Anacostia Waterfront Park, the Olympic aquatics facility and the beach volleyball areas in the Olympic Stadium Complex. In addition, the D.C. Armory required major modifications. That does appear to be more significant than the minor "Olympic overlay" and would presumably require funds from the District. Two more areas, the William H. Fitzgerald Tennis Center and the National Mall, exist within the control of the federal government. The 2012 Coalition would need to obtain the permission and cooperation of the federal city in order to use and adapt either of these areas for the use in the Games.

The requirement to spend more on stadium construction might have

brought the financial assumptions into question. The budget devoted $287.2 million dollars for capital investments in sports facilities. The figure appeared inadequate for the need to construct six venues, let alone perform modifications on twelve to fifteen other locations. In addition, while the costs might be associated with the operations, the budget did not clearly demark potential costs associated with the "repair" to the National Mall after its use.

The costs for using the Mall and other areas of Washington grew after the attacks on the Pentagon and the World Trade Center on September 11, 2001. Charles H. Moore, the chairman of the USOC panel making the choice among the U.S. cities, immediately announced that the attacks would not damage the area's bid. Moore added that Washington scored high because of its status as a major international center and its rail system. He added that the committee would discuss the attacks' effect on the international appeal of Washington and New York City. The president and chief executive of Chesapeake Region 2012 Coalition, Dan Knise, announced that the group took its lead from the USOC and continued to move forward in the bid process. "Long term we need peace in the world. One of the ways to bring about that is sharing with the rest of the world, and that's what the Olympics allows us to do."[39]

The 2012 Coalition made an additional submission after the visit of the USOC representatives. The 100-page submission supplemented the 600 pages provided to the USOC in December 2000. The effort required 36 people over three months. Knise explained why he required the effort from his staff. ""If we don't win this now, it's likely to be at least another 30 years before we would have a chance at hosting the Games."[40]

As the USOC announcement of the two finalist cities drew closer a few groups emerged and raised questions about the effort. The Coalition for Smarter Growth strongly opposed the use of Great Meadows for the equestrian competition. The group agreed with the ability of sports to lead to development. They argued that some members of the Coalition used the Olympics as a method to push a development program that local citizens did not want and had stopped from happening earlier. The D.C. Statehood Green Party opposed the bid plans, expressing concern over how the Olympic site would look in the future. Some local residents wondered what the "legacy" in the 2012 Coalition's bid would mean. "All of the local priorities are being pushed aside for the Olympics," said one resident in the northeast section of the city. A resident in the area around RFK Stadium said, "The committee shouldn't put the venues in residential areas to disrupt people's homes and neighborhoods."[41]

Two of the regional city's largest daily newspapers served as part of the 2012 Coalition. A daily regional city newspaper not involved raised questions about the effort. A *Washington Times* editorial noted that Mitt Romney, the

head of the Salt Lake Organizing Committee, wondered whether the Games were really worth the cost. "My own position is, the Games make sense not as a money-making enterprise but as a statement for peace." Salt Lake City's hospitality industry suffered overall from the Games because locals left town or refused to go downtown, while visitors did not add significantly to the businesses' revenues. Most worrisome, the stadiums built for the Olympics are usually rarely used after the Games despite their $400 million price tag and $10 million annual operation costs. Sports columnist Thom Loverro argued that the Games do not lead to money. Atlanta, though it was host to the 1996 Olympics, is not drawing more visitors and could not get corporate sponsorship for the Georgia Dome. Sydney was considered a glorious success and yet taxpayers there lost $110 million hosting the Games.[42]

One of the newspapers involved in the Coalition carried a columnist who also questioned the effort. A commentator on the business of sports, Evan Weiner expressed his disbelief that Washington spent so much time, energy and money on a costly event that does not live up to its billing. Weiner observed that Montreal's citizens were still paying for the 1976 Olympics. Atlanta's residents put up with snarls in city traffic during the years of construction and its local businesses never reaped the promised benefits. Weiner observed that the Olympics are now more of a business bazaar than an athletic competition.[43]

The commentator on the business of sport had a unique vision of the role of sport. The role of sports moved past athletics, past a business from which to simply extract profits. Sports were neither primarily a place for community building, nor to expand one's main business. Sports at the beginning of the twenty-first century became a gathering place for business. Corporations placed their logos all around. They promoted their connection to the U.S. Olympic Team. They informed all of us about how they flew the athletes to the places they needed to go, or how they would provide them with meals.

The site team members in the days before the official USOC announcement praised the Washington-Baltimore bid for overall excellence, strong leadership and international strategies. The top leaders, Dan Knise and John Morton, sat in the front row of the televised news conference in late August as the USOC prepared to make its choices known to the public. Chairman Charles H. Moore said the group chose New York and San Francisco. The leaders of the Chesapeake Region 2012 Coalition appeared stunned and speechless.

Moore discussed the group's thinking. "We felt Washington made an outstanding candidate. It was very close — very, very close.... We were looking for the city that could win the international competition." The choices reflected split votes. However, the group considered that the IOC might harbor resentment toward Washington on political grounds, particularly the pos-

sible U.S. invasion of Iraq. Though he believed the process fair, Knise expressed disappointment that political considerations played such a significant role: "I'm disappointed only in the sense that it is something outside of my control."[44]

The area political leaders expressed their disappointment at Washington's not being a finalist. Maryland Governor Parris Glendening issued a statement that he felt "extremely disappointed." Baltimore Mayor Martin O'Malley, while feeling similarly, did note that the effort brought the area together. Mayor Williams felt particularly frustrated because he viewed the Olympics as a critical component of his economic development platform. Council member Harold Brazil also viewed the decision as a missed economic opportunity. "You're bringing in money, creating jobs. It affects the image," he said.[45]

One of the major strengths of the Coalition also carried a weakness. The regional city's association with the federal city provided the area with its international relevance. However, the link to the federal city bound the regional city and its effort to host the Olympic Games to everything the federal government said or did. Thus, the Washington-Baltimore bid became linked with the federal government's recent unpopular choices. Meanwhile, its primary opponents in the bid to host the Olympics did not share this same weakness. The city of San Francisco benefited by the perception that it is a city on the progressive cutting edge of America. New York City benefited from its undisputed international status that positioned it above the choices of the federal government.

The director of the proposal operations for an organization that volunteered their services to the 2012 Coalition offered a postmortem about the effort to win the Olympic Games. They included a number of lessons learned. One lesson was that the bid process took a long time and cost a lot of money. A second was that politics was woven into every thread of the Olympic fabric. Finally, a third was that playing by the rules may not be the way to win the Olympic "game."[46]

The observations from the member of the Coalition were interesting and probably indisputable. Indeed, the Chesapeake Region 2012 Coalition's activities to bring the Olympics to the District provided an invaluable window into sports in the beginning of the twenty-first century. The effort originated in the plan of a nonprofit formed for the single purpose of undertaking the effort of have the District host the Olympic Games. The size and the money involved with the Olympic Games at the end of the twentieth century represented such a business bonanza that an organization and other people could earn livings from the attempt to win the right to become the host city.

The Games have such an exalted position that their ruling bodies expect

the completion of an extensive list of requirements in order to consider a bid to serve as the host city. Completion of this list required over a decade from conception to hosting and demanded much more than any single organization could accomplish. A host city must raise $10 million to bid. The Coalition fund raised over $12 million between 1999 and 2000. The host city needed a proposal that must address nineteen themes and then several others in supplemental information. The proposal required extensive research into obscure facts and figures. The Coalition needed the services of area governments, educational institutions, and private and nonprofit organizations to write the three volumes, 800 pages and 200 copies of the first proposal submittal. The Coalition needed this support to create 75 copies of the same size for a second submittal and 40 copies of one volume for a third submittal. The Games' numerous events required the use of the federal, local, and regional city portions of Washington to conduct. Once a city won, it would spend over a billion dollars, such as Atlanta did for the 1996 Games.

The ninety years of attempts to have Washington, D.C., host the Olympic Games resulted in the creation of three elaborate plans for stadium complexes. The first two sets of plans developed during the course of one part of a federal agency performing a larger task. However, a group solely created for the single goal of making Washington the host city for the Olympic Games created the third set of plans. The influence of the sporting world in U.S. culture has grown to the extent that the Games created a large national organization to run the Olympic efforts. The Games generated the market for smaller businesses to emerge in their wake as a city makes a choice to bid for the right to host. The Games presented at least the perception of enormous economic gain that potential host cities would spend millions of dollars on the hope to be the one city selected.

The increase in the number of Olympic events has had an intriguing effect as well. In the first two plans the Games were viewed as support for necessary urban development. The increased number of events in the twenty years between these two sets of plans made it necessary for the second plans to cover a larger area and include more venues. The enormous increase in the number of events over the sixty years between the second and last plans led to a tremendous expansion in the area needed to host the Games. Most importantly, the Games stopped being part of a larger urban development project that directly benefited all Washingtonians. Instead, the sporting event proved to be sufficient reason for building venues and making infrastructure improvements. Some opponents and residents in the most deeply effected neighborhoods wondered if the Games also provided a device to mask unpopular development projects and changes to specific residential areas.

6

If We Build It
Keeping the Team in the District

Prelude to a Move

Since the peace among the National and American League owners detailed in Chapter 2, baseball's franchises wedded themselves to their communities. Under Clark Griffith, Washington's team won the World Series in 1924 and lost in 1933. Other seasons proved unmitigated disasters. The fifty years of inviolate bond between community and team in major league baseball ended. The Boston Braves moved to Milwaukee, Wisconsin, for the start of the 1953 season because of declining attendance and a decrepit home field. Next year, the American League owners allowed the St. Louis Browns franchise to shift to Baltimore and rename their team the Orioles.[1]

The role of sports in U.S. culture had climbed significantly since the era when team owners had to build their own stadiums. Sports had panache and cities across the country sought a major league team so that they could move into the ranks of notable places. Milwaukee hired Osborn Engineering to construct the Braves' new home, County Stadium, for $5 million. Baltimore renovated Memorial Stadium, despite its being only four years old, for the arrival of the Orioles. Los Angeles, San Francisco, Minneapolis and Houston all sought major league baseball teams to build the prestige of their cities.[2]

The presence of another team within 40 miles of Washington raised the concern of the Griffiths. Since 1933, the team had finished in the lower half of the eight-team AL 17 out of 21 seasons. After drawing the second highest attendance during that championship season, the team had finished in the top half of the league's attendance figures on three occasions over the next two decades. While a relationship existed between field performance and attendance, other factors influenced the attendance figures as well.[3]

The stadium the team owners constructed after the fire in 1911 (described

in Chapter 2) was outmoded when built. Within a decade, new owner Clark Griffith expanded upon the stadium after two seasons of having to create a "standing-room only" section. The addition of new grandstands and double-decks to existing stands created a seating capacity of 20,000. This helped on the occasions when the stellar attractions of the league, including Babe Ruth, came to Washington. The capacity increased again over the next decades to hold over 27,000. The team accommodated the day game record of 31,728 for April 19, 1948, against the Yankees and 30,728 for the night of June 17, 1947, versus Cleveland.[4]

Even one of the most successful franchises in major league baseball experienced declines in attendance. As political scientist Neil J. Sullivan observed the Brooklyn Dodgers experienced a small decline in attendance due to population movement and the location of their stadium. A large number of people moved out to the suburban areas surrounding the older cities, resulting in their need to travel significantly greater distances to attend a game at Ebbets Field. The stadium offered very limited parking spaces for automobiles and had poor access to the public transit that suburbanites used to get to the games. The author noted that the changes in population in the country also offered sports teams new markets and opportunities.[5]

The Senators faced similar circumstances. Griffith Stadium was miles from every highway that led to the ever-expanding regional city. The mid-town site also received poor coverage from the existing mass transit system. The regional trains stopped at Union Station, several miles from the stadium. The streetcar that serviced the area had disappeared, leaving buses as the most viable alternative for city residents and for the increasingly larger number of people coming in from the suburbs. The local city of the District's population peaked at over 800,000 in 1950 and began its descent toward 600,000 in 1970. The District's regional city population climbed from 200,000 in 1940 to 1.7 million people in 1970.

The area surrounding Griffith Stadium suffered from the perception of being run-down. Congressional interest in a site for a national memorial stadium picked up momentum during the mid–1950s. As discussed in Chapter 4, Congressman Frank Thompson Jr., a Democrat from New Jersey, asked the Redevelopment Land Authority (RLA) to perform a preliminary survey of the Griffith Stadium area. Thompson wondered if the area could serve as a viable site for the new stadium. Others in the local city government disagreed with this option. "The area is generally not considered to be one of the worst deteriorating or blighted areas," announced the District commissioners' Citizens' Advisory Urban Renewal Council.[6]

The Senators' ownership saw the opportunities of the market as well. Los Angeles congressman Pat Hillings even tried to spur the city fathers to

make overtures to the Senators' owners regarding moving. As newspaper columnist Shirley Povich wrote, the Griffiths said no. The family turned a profit of $4600 on their operation in 1955.[7]

Going, Going, Gone

The federal city politicians and local city residents both thought the construction of a new stadium would be necessary to keep the Senators in the District. But Congress adjourned for the summer in 1956 without authorizing the legislation to provide $10,000 for a feasibility study of stadium sites and design. As Congress's newly funded National Memorial Stadium Commission studied how and where to build the stadium, the Redskins' flamboyant owner George Marshall offered to build one himself if given the site and the money. Meanwhile a group of prominent local city residents formed a "Keep the Nats" Committee that planned on "talking to stockholders and, if necessary, to the American League," to make certain that the team stayed in Washington. President Eisenhower joined this chorus, stating, "[W]hile I could hope that Washington would have a better team than it does I still like to go out when I get a chance."

The local newspaper editors joined in the support for a new stadium. After insisting that the club must improve its performance on the field, they asserted that the community must follow through on its pledges for a better or expanded stadium with improved parking. They postulated that slum clearance would be the most practicable approach. It would make room for parking and step-by-step enlargement or rebuilding of the stadium itself. They thought that the value of the land for parking ought to be nearly great enough to defray the cost of acquisition and clearance.

The focus on urban renewal reflected the perceptions of the times. The definition of slums, unquestioned faith in urban planning, and designed cities had already appeared on Washington's horizons. An enormous portion of the southwestern quadrant experienced this phenomenon and would suffer the consequences. Other groups expressed support for this idea. The Urban Renewal Council modified its position and decided after a closed-door meeting that a stadium, an auditorium and other public facilities may legitimately be provided under the city's urban redevelopment program.[8]

The federal city politicians and government workers remained focused on the Anacostia Park location that had energized them for thirty years. Congressman Oren Harris sent a bill to Congress to establish an authority with private financing powers to build a stadium. The stadium would be situated directly north of the District of Columbia Armory. The Armory would be authorized to take possession of federal government property in the area for

a 50,000-seat stadium. As examined in the previous chapter, the NCPPC issued a report in late 1956 that supported the Armory area as the best location but also acknowledged the National Training School for Boys as a possibility.[9]

The National Memorial Stadium Commission issued a series of announcements of their various decisions regarding stadium development. First, they agreed with locating the building within Anacostia Park. Next, they declared a five-point plan. A subcommittee would determine the final location for the stadium within the park and its capacity, which shifted between 50,000 and 65,000. Then, the decisions regarding capacity for parking, financing and maintenance would be determined.

The Anacostia Park location bordered the Kingman Park neighborhood to the south and west. Dating back to the mid–1920s, the area started as the development project of the Charles D. Sager firm. They constructed forty homes near Benning Avenue and Twenty-Fourth Street, NE, near the Anacostia Park and the Anacostia River. After slow initial sales, the company sold the homes to blacks. During the early years of the Great Depression, Sager acquired more land and announced the erection of another 350 homes in his "exclusive colored and fully modern home community." Kingman Park, like neighboring Lincoln Park, suffered from the historical neglect of the Congress and commissioners regarding the delivery of infrastructure and government amenities.

The citizens' association of Kingman Park interpreted the construction of the stadium differently from the federal groups. Many of the long-time residents did not seek the stadium. The neighborhood group did not appear to expect the impetus to greater city services and development for their area. Instead, they focused on ending segregation in the nearby city parks and other public locations during the late 1940s and 1950s.[10]

The National Memorial Stadium bill went to the House. The site subcommittee of the newly established Stadium Commission unanimously approved of the location of the stadium. The National Capital Planning Commission (NCPC) called this area the best location because of the approaches to the East Capitol Street Bridge. Future plans called for this bridge to connect with the projected Woodrow Wilson Bridge and expressways leading to areas in Maryland.

One member of the federal city work force disagreed with the approach in the Harris bill. Edward J. Kelly, superintendent of the National Capital Parks, harked back to the plans of both the NCPPC and the National Parks Service (NPS) from the 1930s. Kelly described the stadium plan as "a complete departure from the concept of a national sports center." He called for rewriting the bill to develop the project along the lines of a long-standing com-

prehensive plan for the area. The NPS argument demonstrated that advocacy for the stadium included institutional and personal motivations and benefits for many of the stadium proponents. If the plan chosen followed their recommendations, their institutions would gain by receiving a larger budget or additional responsibilities.[11]

Both the local city government and residents expressed disagreement with the location and size of the stadium. The District Recreation Board unanimously recommended that the Stadium Commission consider their vision for a combined indoor-outdoor sports center. "A stadium should be of sufficient size to accommodate the Olympics, Army-Navy football games and many other national and international attractions." The Federation of Citizens' Associations supported the National Training School site. An editorial writer listed the nine advantages that the organization observed. These members of the local city suggested that the new stadium be located on federal city property near the edge of Washington's local and regional city. They viewed the size, beauty, and transportation network at their site as offering specific advantages over the East Capitol Street location. What the area in Fort Lincoln lacked was a direct line to the Mall and the heft associated with thirty years of being the focus of the planning community.[12]

The opinion leaders in local sports supported the perspective of Harris and others in Congress. The dean of the sports columnists, Shirley Povich, argued that the Recreation Board asked for too large a stadium. He claimed that a stadium of that size had four problems: too big, impractical, unwarranted and unwanted. Povich expressed concern that the result of pushing this large stadium would be the construction of no stadium and Washington would lose both its baseball and football franchises. He asserted that neither team had sold out the 34,000 seat Griffith stadium in years so they didn't want a stadium of that size. Despite the arguments from its supporters that the Army-Navy game would generate $600,000 gate receipts and the Olympics would come to Washington, Povich noted that a stadium built to seat 100,000 couldn't pay for itself.

The stadium proponents did not want to lose any momentum so they moved the bill through the House quickly. The Harris House bill provided that the Armory would issue 30-year tax-free bonds at an interest rate set by the Secretary of the Treasury. It capped expenditures for the stadium at $6 million. The stadium's rental fees would generate the income to pay off the bonds. The National Memorial Stadium Commission endorsed this bill.

Representative Harold Royce (H.R.) Gross, a Republican from Iowa, opposed the bill. The farm boy and sergeant in World War I had embarked on a career as a journalist. Years later, the antiwar and isolationist Gross became inspired to enter the political fray himself. Characterized as "a wearer

of loud neckties and a permanently worried expression," he treated his fellow House members to constant choleric barbs against everything, even bills that had the unanimous consent of the chamber. Gross, who frequently derided legislation aimed at the District, pushed through an amendment to the bill. Gross's amendment required the Armory Board to reimburse the federal government for the land that it would provide in order to build the stadium.[13]

The Senate pushed through their version very quickly. They heard the reservations from the Parks Services' National Capital Parks Superintendent Kelly about the size and control over the stadium. Kelly's statements regarding the stadium size found an echo in a local citizen. Douglass E. Bullock, a real estate operator, urged for a stadium that would be much bigger than 50,000 seats. The Senate wanted early approval of the bill and the leading proponents, Senator Bible and John Stennis, a Democrat from Alabama, engineered its passage.

Congress expressed disagreements over the others' version of the stadium bill. Each chamber assigned representatives to a conference committee to iron out the differences. The major differences concerned three amendments that the House version contained. They involved banning the sale of beer at the stadium, limiting the interest rate and requiring that the District pay back the cost of the government land. The conferees emerged with a near compromise close to the Senate version of the bill. The House voted and resoundingly rejected the Senate version 234 to 134.

The Senate and House conferees once again devised a compromise bill. The conference committee maintained the provision to sell beer from the Senate version. However, they removed the provision providing that the federal government would make a donation of the land needed for the stadium to the Armory Board. The committee sent the bill back to the individual chambers. Each passed the revised legislation before adjourning for the summer recess. Representative Gross denounced the bill as "another beautiful giveaway." President Eisenhower signed the District of Columbia Stadium Act of 1957 after Labor Day. The Act provided for the funding of an engineering study to determine the feasibility of the East Capitol Street site for the construction of a stadium.[14]

The legislation appeared to have the desired effect. The ownership of the Washington Senators rejected bids to move to Minneapolis or St. Paul, Minnesota. Calvin Griffith, nephew of deceased owner Clark Griffith, and C. Leo De Orsey, member of the Senators board of directors, met with a three-man delegation from Minneapolis. Gerald Moore, chairman of the Minneapolis Metropolitan Sports Commission, said he had not abandoned hope of landing the Senators. Minneapolis politicians guaranteed the Senators the receipts

from one million in attendance. Since the team had led the majors in lowest attendance for the past three seasons, this guaranteed income must have seemed appealing.[15]

The Senators' ownership informed the public about the team in a series of newspaper articles. Team president Calvin R. Griffith explained his dissatisfaction with the choice for the location of the new stadium. Griffith complained that the Armory grounds seemed woefully inadequate to handle stadium traffic and that planned highway improvements had a history of running into problems. He noted that he held positive inclinations toward two previously considered stadium sites, preferring the site to be the National Training School or West Potomac Park. Griffith called the school site spacious and beautiful and at the hub of a very fine new highway network. Potomac Park was pretty and ideal because of its location near the center of the metropolitan population ring. The owner finally suggested that the team could remain at its current grounds with the city creating additional parking through the use of its development plans for the Florida Avenue and Seventh Street corridor.

Another board member echoed these sentiments. Lee De Orsey also wrote an article for the newspapers and stated that Calvin Griffith had authorization to spend money to develop the team. The board met and De Orsey joined in the majority vote against the Armory site for a new stadium. His greatest concern centered on the "plans" for larger highways to this new site. Griffith wondered if the highway would ever happen. He believed that improved parking for the present site would be a better choice. Griffith announced after the 1958 board meeting, "The team will not be shifted out of this city in my lifetime."[16]

While the engineering firm of Praeger-Kavanagh-Waterbury planned to inform Congress that they could build the stadium at the Armory site, Shirley Povich changed his mind. Povich referred to the Armory site as an inaccessible corner of the District of Columbia. The columnist definitely stated that Griffith would't move his team to the stadium at the Armory site over his disappointment with the location. The stadium was dependent on the rental from the ball club and both could lose. "The tragic result of a stadium at the Armory could be the defeat of the very purpose that inspired the stadium [keeping the Senators in Washington.]" Povich noted that the site on the cusp of the local and regional city did not represent a good choice.

The two powers of the federal city, the Congress and the president of the United States, remained focused on the Anacostia Park location for the stadium. In the budget for fiscal year 1959 that he sent to Congress, President Eisenhower requested an appropriation of $1.2 million ($8 million in 2005 dollars) for the acquisition of land for the stadium in the District. Within a

month, the House denied the funds, handicapping the project's choice of location. The associate superintendent of the National Capital Parks, Harry T. Thompson, said:

> It was distressing that the House Appropriations Committee refused to grant a NPS request for funds to purchase the land. The Park Service has opposed the District Armory Board's preference for building the stadium on the oval bounded by the approach roads to East Capitol Street Bridge.

The NPS did not want the stadium built on a direct line with the Capitol, the Washington Monument, and the Lincoln Memorial.

William E. Finley, the director of the National Capital Planning Commission, countered that his agency would approve of a stadium at the oval site. He said he saw no objection to building a stadium in line with the Capitol if it were properly designated. A stadium in keeping with the "monumental" structure of federal buildings could be "a beautiful terminus for the East Capitol Street Development." The Senate Appropriations Committee ended the issue of location when it refused to grant the NPS request for funds.[17]

The finalization of the location sparked the owners of the local sports franchises to comment. Redskins owner George Marshall expressed pleasure over having a larger stadium but did wonder about the viability of the location. The Senators' ownership continued to express misgivings. Calvin Griffith asserted that if the Senators used the stadium, the team stood to lose $150,000 through the loss of rentals, concessions and parking. Griffith was believed ready to insist on an annual cash guarantee regardless of stadium revenue to ensure him a profit in bad as well as good years. Griffith repeated his concern over the traffic. "They tell me they'll have new approaches and freeways by 1965. But that's a long time away." He would prove prescient and the neighborhoods of Lincoln Park and Kingman Park would bear the brunt of the traffic problems and disruptions.[18]

At the end of March the engineering firm provided Congress with the Engineering and Economic Study, District of Columbia Stadium. The report offered three potential sites within Anacostia Park. The first one placed the stadium on line with the Capitol. The second scheme put the building across from the Armory building. The last scheme placed the stadium slightly behind and to the east of the location that was in line with the Capitol. A line-item report for all the elements to construct the stadium and related facilities indicated that the second and third locations appeared over $1 million less expensive than the first option. The cost for each of the three stadium options totaled more than the original budget of $6 million.

The economic section of the report explained why the additional expenditure ought to be accepted. Graphs illustrated projected climbing of the Dis-

trict's local and regional city populations. In addition, the per capita incomes of this population would also increase greatly. The report argued that the stadium needed to be built as there would be many people interested in attending games and many other events at the new stadium.

The three proposals did not receive the same treatment in the report. There was clearly an advantage to appearing as the first option. The presentation enhanced the advantage as it referred to the other site locations as alternate schemes. Despite each of the two alternates costing significantly less than the first option this conclusion was not stated. The final paragraph of the section itemizing the costs of construction simply pointed out that each option exceeded the original $6 million total. The maps for all the sites greatly enhanced the advantage for the site located on line with the Capitol. Its map appeared in color while the others did not. The area surrounding the stadium included landscaping. The islands surrounding Kingman Lake appeared lushly landscaped, providing a nice backdrop for the stadium. The other two schemas lacked both the landscaping around the stadium and the lush backdrop.[19]

Both chambers of Congress quickly moved to send the authorization for funding to the president for his signature. The bills added an amendment that required the Treasury Department to advance to the District commissioners money to cover interest payments on stadium bonds if Congress failed to appropriate sufficient funds. The legislation lifted the $6 million limit on costs and allowed the National Park Service to lease the stadium site to the Armory Board for 30 years. The House of Representatives approved the measure on a voice vote. Several representatives objected that the stadium authorization would not be put to a roll call vote so that taxpayers would see how their congressman voted. Representative John McMillan, the House District Committee chairman, defended the bill against the protests.

The most vocal critic, Representative Alvin O'Konski, a Republican of Wisconsin, claimed that it was improper to use federal property for a facility that would benefit a private organization. The farm boy had worked as a teacher, school superintendent, educator, journalist, and lecturer before winning a seat. O'Konski objected especially to free transfer of the government-owned site to the Armory Board under a 30-year lease as provided in the bill. McMillan claimed that the federal government retained the ownership of the land. O'Konski labeled the stadium "an 8.5 million memorial to Calvin Griffith and the wetbacks he passes off as baseball players and bamboozling the public."[20]

The O'Konski comment drew only a few reactions. Perhaps because the event occurred near the end of the season, few of O'Konski's fellow politicians commented. Representative Charles McKevett Teague, Republican from

California, referred to the comments as uncalled for and ridiculous. The attorney and decorated Air Force veteran added that the Nats always put up an interesting game, showed lots of hustle and frequently looked like a real good ball club. After defending the team's honor Teague added that he was "entirely confident that all [players] are either good citizens of the United States, or are here perfectly legally as visitors from friendly countries. They in no sense are wetbacks passing off as baseball players, here illegally."[21]

Calvin Griffith provided an immediate set of comments. He stated that he considered the slurs about his ballplayers unwarranted and resented them on behalf of his ballplayers. "Mr. O'Konski's remarks were a careless slap in the faces of fellows like Roy Sievers, Eddie Yost, Albie Pearson, Rocky Bridges and all the rest of my players who try their best on the field every game...." The team president did not mention the derogatory word or specifically defend his players from Latin American nations.[22]

The pair of comments illustrated attitudes of the era. The derogatory word that the representative used drew little comment. At best, some people did not discuss the matter because they would prefer not to deign to it. At worst, it was indicative of commonly-held perspectives. It seemed Representative Teague objected to the misuse of the word rather than the word itself. Interestingly, not only did Griffith not mention the word but he named several Caucasian players.

The responses revealed the esteem the men bestowed upon sport, particularly the local team. The team's president, as expected, supported his team against the comments. His concern focused upon their integrity as ballplayers first. More telling, a representative from California made public comments defending the team as the primary focus. His comments reflected that his greatest concern centered on the sports team, not the individual players, illustrating that sports meant so much that their integrity needed immediate defending.

The Senators' boss soon had other concerns. Two minority stockholders brought individual suits against him and the team leadership. H. Gabriel Murphy brought suit in United States District Court against Griffith. The former director of athletics at Georgetown University had owned 40 per cent of the team since 1950. Murphy expressed increasing frustration with the Griffiths and the other stockholders who sided with Calvin and his sister to form the majority on the team's board. He offered to purchase an additional 12 percent of the club's stock at $605 a share. Unable to obtain a controlling share, Murphy went to court seeking to stop any conversations about moving the Senators to Minnesota or other potential cities.

Murphy claimed in his suit that under the 1954 District of Columbia Business Corporation Act, the Senators were required to do business in Wash-

ington. The Act stated "no corporation may be organized under this chapter unless the place where it conducts its principal business is located within the District of Columbia." Meanwhile, the attorneys for another minority stockholder, Robert R. Rodenberg, asked Federal Court for a temporary restraining order to prevent Griffith from even discussing a transfer. Two days earlier, Rodenberg had requested the court to eject Griffith and other officers, assess $500,000 damages and place the club in receivership.

A dean of the New York sportswriters offered his opinion on the Senators and their legal battles. Arthur Daley stated that the Senators had no farm system worthy of the name and the team had approximately two dozen members of the Griffith family on the payroll. As bad as the team was, it still made a little money. Calvin Griffith complained that Griffith Stadium had no parking facilities. But the federal government voted to build a new stadium that the Senators could use. Daley believed that the team would not be allowed to move because Major League Baseball needed friends in Washington to avoid antitrust legislation.

Within days, Calvin Griffith announced a change of his mind and decided not to move the club to Minneapolis. His consideration of moving had represented a change of mind from his promise earlier in the year not to leave Washington. The latest change came after meeting with the American League's realignment committee, who presumably were prepared to block Griffith's request. The change of heart occurred before U.S. District Court Judge David A. Pine ruled on the Murphy suit. Pine decided that the Business Corporation Act of the District of Columbia did not prohibit the franchise from moving to a new city. After Griffith's recent decision Pine could state, "I don't believe there is any urgency in this case now. From what I've been reading there is no longer a burning issue."

Two months later, Griffith changed his mind again. He wanted to reverse a club resolution barring discussion of shifting the team. The president would approach the board of directors about changing this decision in an upcoming meeting. Murphy openly denounced Griffith for considering moving the team to Minneapolis.[23]

The federal and local city workers responded to the threat of losing the team with renewed effort to build the stadium. The NCPC gave unanimous approval to the proposed National Stadium within the highway loop at the west end of the East Capitol Street Bridge. This idea had long been a plan of the agency, whose leaders argued that the stadium extended the Mall from the Capitol to the Anacostia, twinning on a smaller scale the Mall west of the Capitol. The area would also include parking for 12,500 automobiles, plus buses and taxis. The cost for the stadium rose to $9 million.

The D.C. Armory Board began putting together the plans for the stadium

construction. The board established a four-man committee to negotiate contracts with the professional sports teams. The talks with the Redskins went more smoothly than those with the Senators. The board took its design subcommittee's recommendation and asked four architectural firms to form a syndicate to draw plans for the stadium. They included the consultants, Praeger-Kavanagh-Waterbury of New York City, the company that had rebuilt the stadium after the 1911 fire; Osborn Engineering Company of Cleveland; and the firms of George L. Dahl of Dallas and Ewing Engineering Corportion of Washington, which joined forces.

The preliminary plans led to reconsideration of assumptions regarding building the stadium. The Armory Board requested consideration of financing the construction through loans from banks rather than through a bond issue. They believed the change would save them on interest costs. The initial circular design with removable seating to enable the change of the field for the two different sports displeased Griffith. The board, architectural consultants, and two team owners met and the board announced that they would consider a new design for the stadium. The new plan would flatten one side to enable construction of partial double-decker seating to make the arena more suitable for baseball fans. The board announced the chosen location to be in line with East Capitol Street because they would not need to purchase additional lands and this site maximized parking space.[24]

They showed the initial designs to the Commission on Fine Arts membership to obtain their approval. The Commission on Fine Arts disapproved of the site two miles from the Capitol and directly in line with that building. The members felt the site should be reserved for possible future use for a monument. They proposed that consideration be given to the remaining two sites proposed in the engineering and economic study for the stadium.

The Armory's chairman returned a month later to convince the commission members to change their mind. The chairman of the Commission of Fine Arts wrote a detailed response after the first. David E. Finley asserted that the members wanted to maintain the site in line with the Capitol Building as a possible location for a monument comparable to the Lincoln Memorial. The first director of the National Gallery of Art, Finley served as the right-hand man to Andrew W. Mellon. He quietly helped found the National Trust for Historic Preservation to save important buildings throughout Washington and the country. The consummate modest man had an iron will. Finley suggested that either of the other sites mentioned in the study for the stadium also provided advantages in parking and beauty. He suggested the stadium be shifted to the third site because the land was already purchased so there would be no delay. The commission approved of the circular design and asserted that the stadium was an important and needed facility in Washington.[25]

The Armory Board remained firmly committed to the location in line with the monuments. George F. Shea, the chairman of the Armory Board, told the Fine Arts Commission that if the primary site for the stadium was not utilized, it could be the "kiss of death" for the project. Shea argued, "We are on a tight schedule and to change our site now would mean we would have to start all over again. It would not be possible to build the stadium by the target date of early 1961 and, perhaps, be the kiss of death." Many thousands of dollars had been spent on or committed to plans for the site already.

Members of the local city opinion makers issued their public response on the stadium location. A local newspaper editorial board stated:

> The Fine Arts Commission's objections have been offered in good faith and merit consideration but since they are based largely on nebulous notions that the preferred track might some day be wanted for a memorial or monument, they do not seem compelling. The stadium itself could be a monument — and surely so large an area in so strategic a location ought to be assigned a utilitarian role.[26]

The Congress made additional modifications to the Stadium Act to facilitate the construction and operation. In May, Representative Harris offered an amendment to the Act that added parking areas to the Armory Board's area of control. The vote on the bill before the entire House offered Representative O'Konski the opportunity to protest against the expenditure. He complained that the "advocates of the stadium know just as little about the ramifications of what they are getting into as they did when the original Stadium Act was passed." He asked if both teams had made final commitments to play in the new stadium and received a no response. The Wisconsin representative's complaint about the expenditure of money prompted a strong defense from Representative Harris. Harris noted how funds were spent on stadiums elsewhere in the country and to send teams to represent the U.S., "but when the Nation's Capital is involved there seem to be no funds available...."[27]

Representative Harris might be accused of hyperbole except new roadblocks to the spending appeared. Representative Michael Joseph Kirwan, a Democrat who ran a trading business in Ohio, used his position as chairman of the Interior subcommittee to erect one. He banned the Interior Department from spending any money on erecting parking for the new stadium for the fiscal year 1961. This occurred despite the fact that the committee only had fiscal year 1960 in its purview. The Park Service planned to ask for the money in the future and Kirwan thought the parking facilities should be handled without federal expense. After clearing that hurdle, the next item that the Appropriations Committee on the Interior Department balked over involved the necessary road construction. The debate on the legislation

stopped after Representative Gross objected to the form in which the District Committee report on the bill came to the floor because it did not show how an amendment to the stadium act was related to the original law.[28]

The Congress appropriated the funds to construct the stadium. Other cities did likewise. With the development of new cities interested in having a professional sports franchise and the Dodgers and Giants vacating New York City for the West Coast, a new league seemed possible. William Shea, chairman of the New York baseball committee, announced the formation of a Continental League to begin in the 1961 season with teams in New York, Houston, Toronto, Denver and Minneapolis–St. Paul. Allies in Congress, including Representative Emanuel Celler, a Democrat from Brooklyn, and Senator Estes Kefauver, a Democrat from Tennessee, supported the news and announced their activities to apply antitrust laws to professional sports.[29]

The owners of the American and National League franchises faced the first battle in their industry in over forty years. They initially offered what Continental president Branch Rickey called a pledge of "unqualified acceptance." Soon the owners announced that they had never committed themselves to a third league as the method of expansion. The hopes for the new league hinged on the passage of the antitrust legislation that would be introduced in Congress in 1960. The bill would forbid any club to own or control more than 100 players and require the major league clubs to offer at least sixty players once a year for unlimited draft.

The local city residents faced a more immediate concern. Senators president Griffith issued a series of complaints about the situation for his team in Washington. He complained that he did not draw at least 700,000 people to the stadium despite a gain of over 130,000 from 1958. "We're not making the money we should in Washington and if we can get a better proposition, we'll certainly have to look it over." The District citizenry understood that baseball was a business and the team needed to make money.

Some local citizens observed that, as landlord, Griffith owned and operated his own stadium and concessions. However, the new stadium had a much larger capacity so he should think bigger. Griffith remained unconvinced. The changes he proposed months earlier regarding the stadium's design did not occur. "I'm not a bit happy with the new stadium," Griffith said. "It's going to be built for football not baseball. Of the 50,000 capacity, only 10 percent will be under cover and those seats will be away back."[30]

Griffith expressed no concern regarding Murphy's and Rodenberg's latest lawsuits against him. Murphy appealed the decision of the Court of Appeals on his suit to stop Griffith from moving the Senators to the Supreme Court. Murphy requested that Chief Justice Earl Warren order the team to stay put at least until the Supreme Court decided whether to review Mur-

phy's case. Warren rejected Murphy's plea, refusing to hear the case. Murphy immediately followed with another suit, this time charging that Griffith had sold off the team's minor league teams and assets without the consent of two-thirds of its stockholders.[31]

As the threats from Griffith's internal opposition waned, the exterior forces against a possible move expanded. A growing opposition to a move continued within the ranks of American League owners. One unidentified owner claimed that "Washington was too good a franchise to lose." In addition, congressmen had expressed their concern both about losing the franchise and about any action detrimental to the creation of the new Continental League. William Shea noted that the League would be faced with extinction or all-out war with major league baseball if Congress failed to pass the controversial Kefauver bill.

The timing of the bill could not have been worse. The bill reported out of the antimonopoly subcommittee that Kefauver chaired during the spring of 1960. The Senate Judiciary Committee reported the bill to the Senate floor without recommendation. The demands of the election year resulted in Kefauver's absence, since he was campaigning in his home state when the bill reached the floor in late June. Thoughts on many minds went to the upcoming political party conventions to nominate the candidates for president. Before the legislation reached the floor, a second bill emerged that offered the other sports the same antitrust protections that baseball received. The bill passed and the group supporting Kefauver's bill knew they would lose if it came to a vote.[32]

In the summer the magnates of the National League voted unanimously to expand to ten teams. The owners established a four-person panel to discuss the possibility of expansion with members from the American and Continental Leagues. The New York franchise's moving into the National League appeared ironclad. The leaders of the Continental League knew that without a franchise in the largest market they would not stand a chance of surviving. One month later, the American League owners announced that they would also expand to a ten-team structure. The potential additional cities included Toronto, owned by Jack Kent Cooke, Minneapolis–St. Paul and Houston.

Many of the local city workers and residents focused on other baseball news besides expansion throughout the 1960 season. Columnist Bob Addie anticipated Calvin Griffith's signing to have his team play at the new stadium a few times over the first four months. First, he figured that since C. Leo De Orsey worked the stadium deal for the Redskins, the Griffiths' family lawyer would surely do the same for the baseball team. The columnist awaited the announcement when the team returned from spring training, and a month later when Griffith attended the Touchdown Club luncheon. Even the news

that the most important city resident, President Eisenhower, spent a lot of time following the team failed to help the negotiations. The Armory Board members mentioned that they had not been able to discuss tenancy with Griffith.

The construction of the new stadium began and representatives from the city's franchises attended. By late October, the latest and last Murphy suit to enjoin the Washington Senators from taking any action without approval of two-thirds of stockholders failed. District Court Judge George L. Hart Jr. dismissed the suit. He told Murphy's attorney, "You are trying to do in this case what you tried to do in the previous suit."

The Armory Board and local sports figures stated that the dismissal of the suit removed any obstacles Griffith had to negotiating. Griffith left the city for a meeting with the American League's expansion committee. Two days later, Calvin Griffith announced that he was moving the Senators to Minnesota with its guarantee of a million fans entering the stadium. The action involved such secrecy that it surprised the Griffith family members who ran the stadium's concessions and grounds. Baseball's salve to Washington featured an expansion franchise.[33]

Back to Back

The newly created Minnesota Twins, much like the old Senators used to do, finished in seventh place during their inaugural year in 1961. Despite the team's position in the standings, the state feted Griffith like a hero. The news covered the family in their home on the shores of Lake Minnetonka, a wooded, affluent suburb situated minutes from downtown Minneapolis. Griffith became the honorary chair of the state's Christmas Seals campaign. The personal plaudits only increased as the team improved on the diamond. The Twins finished either first or second in seven of the next ten years, including a World Series appearance in 1965 and two more league championship series. They drew over a million people every one of those years.

The construction of D.C. Stadium did not serve as the impetus for any of the visions that federal planners advanced. As Edward J. Kelly, superintendent of the National Capital Parks, had stated a few years before, the construction of the stadium itself would derail the vision for a recreation center in Anacostia Park. The stadium at the foot of East Capitol Street did not lead to the development of the grand boulevard that the National Capital Planning Commission leadership envisioned, either.

The stadium brought change to the Lincoln Park and Kingman Park neighborhoods. Immediately upon its opening, local residents protested the enormous increase in traffic on their local roads as spectators headed to the

stadium. Since the freeways were of limited capacity, as Calvin Griffith had noted in one of his protests against moving the Senators to the stadium, cars had to use the city's surface roads. The Kingman Park neighborhood struggled with the effects of the parked automobiles and noise that the stadium generated.[34]

The tenants in the new stadium fared little better than the neighborhood. The expansion Senators shared many of the tribulations that befell the franchise when it started in the American League in 1901. As detailed in Chapter 2, that franchise played in a new stadium in the northeast part of the city that many local city patrons considered inconvenient. The team finished near the bottom annually and had five managers in ten years. Also like the team from the turn of the century, the new Senators had several owners over that period, none with the monetary resources to develop a winning franchise. The total attendance for the period only broke the 750,000-a-year barrier once.[35]

The Senators, second edition, soon performed in a sequel to the franchise that got away. The expansion Senators did not leave Washington after the 1971 baseball season because of the lack of a "modern" stadium in the District. The stadium in the photograph nearby appeared quintessentially modern. The departure of the expansion Senators to Arlington, Texas, happened because of the existence of another viable city and the negotiations over the stadium deals.

D.C. (RFK) Stadium, 1967 (Historical Society of Washington, D.C.).

The expansion Senators' owner Robert Short inherited the deal the Armory Board management gave the expansion Senators. The team received 7 percent of gate receipts and 20 percent of concessions during the baseball season, with this dropping to 15 percent of the concessions on all other events. They paid rent for the facility of 7 percent of gross receipts, less federal and local taxes and less about 40 cents a ticket for expense. Short knew the average ticket brought $1.80 and the rental cost broke down to about 10 cents per ticket. The deal was not sweet enough for the last team owner, Robert Short. Short wanted for his team to not pay rent until they reached one million customers for the year.

The Washington Redskins received significantly less and paid more. The team's deal with the Griffiths at their stadium involved paying 15 percent of the first $400,000 of annual gross receipts and 10 percent of anything above that mark. After months of negotiations the Armory Board and the Redskins set the rental fee at 10 percent of the first $500,000 and 15 percent of any amount over the half-million mark. The Armory Board expected the team to earn at least $750,000 annually. The team received no share of the parking, scoreboard advertising or concessions revenues.[36]

Cooke's Stirrings

The ownership of the Redskins suffered through a series of questions and changes for a decade from the mid–1960s. George Preston Marshall suffered a stroke and became legally incompetent to manage his affairs in December 1963. Three team stockholders and members of the board petitioned to become the conservators of his $450,000 estate and also the team, valued at $5 million. While battling with the Marshall family over control, the club directors, which included former Griffith family lawyer C. Leo De Orsey, turned down numerous offers to sell the team.

Three years after Marshall's death in August 1969, the three adult children received equal shares of their father's assets. The Marshall estate retained 260 shares of the team. However, the majority ownership included Jack Kent Cooke, who owned 250, Edward Bennett Williams and Milton W. King, who each owned 50 shares. Williams continued as the team's president and operating head.[37]

The turmoil in ownership continued throughout the 1970s as the team accumulated financial losses. After the 1973 season when the team went to its first Super Bowl, Cooke, Williams, and King purchased the 43 percent of the team stock that the Marshalls owned for about $6 million. Meanwhile, the minority owner of the old Senators, now the Minnesota Twins, Gabriel Murphy, tried to acquire interest in the team from Cooke. Cooke responded,

"I am not interested in selling." However, Cooke's health raised questions and the team lost an estimated $750,000 during the season. Rumors of potential sale of the team resurfaced again in the summer of 1978. The splitting of his assets after his divorce from Los Angeles resident Barbara Jean Cooke prompted a flurry of concern over the Redskins' possible relocation to Los Angeles. Instead Mr. Cooke moved to Virginia and eventually took the team's reigns when Williams became the owner of the Baltimore Orioles.

One of the first news stories in this new era focused on a new stadium. Reportedly, two groups approached Cooke about a domed stadium between Baltimore and Washington to house the Redskins and Baltimore's teams, the Orioles and the Colts. "A domed stadium is a very attractive idea, a very good one and there has been an awful lot of talk about one being built lately," Cooke stated. However, Cooke promised to wait until the lease on RFK Stadium ran out in 1990. Months later, Cooke talked about building the stadium with his own money.

Fresh from losing two baseball franchises to the whims of team owners, the local city opinion leaders pounced on the musings of this sports team owner. They opposed the move. The *Washington Post* editors acknowledged D.C. Stadium's (renamed RFK Stadium, for Robert Francis Kennedy, in 1969) small capacity and inconveniences but noted that it was served by the subway and had 12,500 parking spots. They proposed renovating RFK in order to keep the Redskins in the city. These changes included additional box seating and possibly building a done. The editors noted that the Redskins belonged in Washington, not Laurel. Congress had only recently enacted legislation that paid off the $20 million bonds used to build the stadium in 1961.

Businesses in the Baltimore-Washington metropolitan area argued that a common stadium for the cities' franchises might make sense. Some argued that the region really was a single market. Others pointed to the size of the combined cities which made the region the fourth largest media market. Since teams derived approximately 20 percent of their revenue from media, this would be a boon to the Orioles, Colts and Redskins. However, Orioles owner Edward Bennett Williams argued that building a stadium required public financing: "I don't think it'll wash economically. I don't think it's possible in the private sector." The local city workers and residents wanted each team to stay in their respective cities. A spokeswoman for Mayor Marion Barry stated, "The mayor does not want to see the team leave, and he will enforce the lease [at RFK Stadium]."[38]

The threat proved not to be very effective. Cooke might move the team after buying out his lease obligation to RFK Stadium. Estimates placed the construction of a domed stadium at three years and $125 million but Cooke

had recently spent $82 million on the purchase of the Chrysler Building in New York City. As one reporter noted, Cooke dreamed big dreams.

The article noted that appealing to Cooke's dreams might be an effective method to convince him to stay. The city could allow the team owner to run the stadium operation. The stadium floundered over its twenty years under the control of the Armory Board. It was as if the city had little to lose by making such an offer. Within short order, Mayor Barry and Cooke met to discuss whether RFK Stadium could be managed better. The proposal being debated centered on the city's turning over control of the stadium to Cooke for $500,000 a year in rent. However, the city would be responsible for the installation of additional seats and building skyboxes.

The public-private arrangement between local city government and residents regarding the operation of RFK Stadium did not occur. However, concern over the stadium and keeping the Redskins in the city diminished for a few years. All discussions about upgrading the stadium centered on bringing major league baseball back to the city. The District's City Council held hearings to discuss a bill that would establish a nine-member commission on baseball. This group would study how much the franchise would cost, how much revenue it would generate, and how the city would obtain a team. The general manager of RFK Stadium testified that the stadium would need to be upgraded to house a new team. However, making these changes would not be simple. The requirements to convert the park from baseball to football took thirty days so an investment of $7 million would install sliding stands that made the conversion take only a single day. The construction of skyboxes required another $5 million and other necessary adaptations added $3 million to make the total for "necessary" renovations "$15 million, easy" according to a member of the D.C. Commission on Baseball.[39]

During the mid–1980s the regional city became the focus regarding stadium construction. The ownerships of both Baltimore teams appeared interested in moving their franchises. Colts owner Robert Irsay expressed dissatisfaction with the city's proposal to fund a refurbishing of Baltimore's Memorial Stadium. The areas around Laurel and along I–95 between Baltimore and Washington received significant consideration as potential sites. Arguments were made for the strength of the regional base for attendance and revenues. Washington baseball fans considered the potential relocation the end of their efforts to bring a franchise to reside in the local District. However, the departure of Irsay's Colts for Indianapolis aided in providing the impetus for the city of Baltimore and Maryland's governor to eventually construct new stadiums in that city.[40]

Restless Redskins

As Washington's professional football team began its training camp for the 1987 season its owner returned to the issue of a new stadium. Jack Kent Cooke reiterated his dissatisfaction with Robert F. Kennedy Stadium and announced that he would like to see a domed football stadium for his team in D.C. that could accommodate 75,000 spectators: "The area deserves a far better facility than it presently has. It deserves to get into the swim of big cities regarding stadiums. It seems to me we are bringing up the rear." Almost anticipating potential critics the owner removed the responsibility of moving from himself by asserting that the fans in the District merited a better facility.

Some members of the fandom in the local and regional city responded. A District resident suggested, tongue in cheek, to let the market decide: Mr. Cooke should simply double the price of the tickets. That would let him operate and a profit and also produce an inviting investment that would enable him to finance a new stadium through private capital: "It is very unfair of people in this area to take advantage of Mr. Cooke in this way." One Virginian observed that before considering a new stadium, authorities ought to take better care of RFK Stadium: "If you want comfort of a plush, thermostatically controlled, glass-fronted apartment from which to view the game you can sit in one's family room and watch." Cooke, of course, failed to mention that those suites generated income that he kept without having to share it with the other team owners in the league. Perhaps that might have softened the Virginian's response.[41]

If the local and regional city residents were not accepting the gift of a new stadium the politicians for these locations certainly were interested. Cooke argued that a domed stadium would enable Washington to host the Super Bowl and that would generate hundreds of millions of dollars to the area. The role of football in the U.S. culture had grown enormously in the twenty years between the first Super Bowl and the time of Cooke's announcement. The game brought a large number of visitors to the host city over the weekend. The first Super Bowl drew about 62,000 and the 1986 version drew over 101,000. Being the host city also generated a great deal of business for local merchants. The media coverage of the game for the entire week prior to its kickoff added the bonus of the host city being in the spotlight. Mayor Barry met with Cooke to discuss the stadium and his spokesperson stated, "The Mayor has expressed a real commitment for keeping the team in D.C." Five suburban county governments would also invite him to talk about building a new stadium for the Redskins.[42]

The potential competition among these locations played to the benefit

of the team and the league. "The stadium issue for local jurisdictions is one of business retention versus business attraction. It is an economic issue that springs from a businessman's desire to improve the profitability of his business enterprise." Cooke set as his stadium goal a building similar to the Silverdome in Pontiac, Michigan, or a complex like the Meadowlands in New Jersey. Thus, at the least, Cooke sought concessions from the District or some other local jurisdiction as part of spending his own money to build a stadium.

The larger role of sports in society had led to the public financing of stadiums during the preceding twenty-five years. This created examples of public stadiums that could be used in the debate of a new stadium in the District. A sports reporter in Detroit requested that everyone stop the idea of building a domed stadium in D.C. The grounds for his request were aesthetic, sporting, and financial. He decried that the domes were ugly, unnatural and unnecessary. The Silverdome had a 10-acre roof that blocked out the elements, but trapped in smoke and noise. The athletes complained that artificial turf hurt their knees and fans grumbled about the shopping-mall ambience. The city-owned stadium cost $55.7 million to build but would cost $107 million including interest when paid off in 2004. It had been profitable in only two of its twelve years and the roof collapsed one day, adding $9 million in damage to the costs.

Local and regional city politicians did not heed the view from afar. Cooke discussed the domed stadium with Fairfax County board chairman John F. Herrity, who claimed his major concern involved keeping the team in the Washington area. The District hired consultants to explore options aimed at satisfying Cooke and the Redskins. Cooke's new vision featured a retractable roof and a natural grass stadium, such as the one being built in his native Toronto for $ 240 million Canadian. Mayor Barry told Cooke that a new stadium could be built at Langston Golf Course in northeast Washington, near the present RFK Stadium. Built in 1934 for blacks to play golf in the then-segregated city, Langston was now owned by the National Park Service, which leased the operation of the course.[43]

As noted in the last chapter, during the late 1980s the District suffered from large debts and a reputation as the nation's capital for murder. The mayor explained that the Washington Redskins were "one of the most unifying forces in the region" so he wanted to build a new football stadium in the city and was "prepared to support some subsidy" to do so. "There's no logical reason why a private owner ought to demand that a government should subsidize their existence. On the other hand, it's understandable why that would happen." Barry noted that financing possibilities included revenue bonds which would use the income from the stadium to pay off inter-

est and principal; a one-time contribution from the federal government; and contributions from suburban governments.

One of the local city's many public interest groups entered the discussion. The Citizens for a Sound Economy, formed to advocate for free-market policies effectively in Washington, decried publicly-financed stadiums. An economist on its staff argued that publicly-owned stadiums rarely lived up to the revenue potential conjured up by the team owners and local politicians. Using the history of the last three decades, he stated that the Silverdome and the New Orleans Superdome required regular public funds to cover their deficits. Additionally, he observed that stadiums and sports franchises, rather than stimulate local economies, diverted jobs and resources from manufacturing and other industries.

The economist hailed recent activities in the state of Florida. Voters rejected a tax-financed stadium and Miami Dolphins owner Joe Robbie responded by building a stadium with private funds. "The stadium is a monument to a free, competitive enterprise system and showed that anything government can do, we can do better," Robbie declared when the stadium opened in August. Robbie raised money via bank loans. The owner's guarantee that he would have the funds to pay off the loans came from requiring season ticket holders and renters of skyboxes to sign 10-year leases. The economist argued that with 20,000 people on the waiting list to get Redskins season tickets and a city full of lobbyists looking for glamorous ways to entertain influential policy makers, surely the Redskins could work a similar deal.

The viability of the private option increased as the suburban communities that composed the Washington regional city united behind the local city on the issue of hosting the stadium. Not only did these governments pledge to forgo a bidding war, they joined with the District government to collaborate on a study to determine the desired capacity for a new stadium, the types of events that could be held there and possible sites. Next they could examine the possible financing mechanisms for the stadium's construction.

However, two days later the son of Cooke met privately with a Loudon County developer about building a football stadium near Dulles International Airport. John Kent Cooke, vice president of the Redskins, met with developer Robert DeLuca and Loundon County Supervisor Steven W. Stockman. A largely rural locale twenty miles from the District, the county lacked the major highways and expressways. While stating that the District was his first choice, Jack Kent Cooke noted that "if the District of Columbia fails to build what Redskins fans deserve, I have no other choice than to go to one of the surrounding counties." He backed this talk with a discussion of an Ultra-Dome surrounded by a shopping mall, a luxury hotel and a convention center near Dulles Airport.

The letter-writing public remained unconvinced. One noted, "In a city where you can get a pizza delivered to your house faster than a paramedic can arrive to save a life ... it is amazing that Jack Kent Cooke, one of the country's richest men, wants to drain the budget to build a new, domed stadium so he can make more money." The city opinion leaders echoed the sentiment, asking the city leaders to allow Cooke's June 30th deadline to pass and instead commit the resources to paving roads and paying teachers.[44]

Off the Course

Two consulting firms worked on proposals for a refurbished RFK and for a new stadium. After pushing the deadline back two months, the consultants and the mayor leaned toward a choice of a new 75,000-seat stadium on the nearby Langston Golf Course site. Cooke and Barry emerged from a meeting with "a definitive plan for the future new stadium." Soon after Cooke expressed frustration, stating,

> I'm surprised and disappointed to hear that Mayor Marion Barry has turned thumbs down on the use of Langston Golf Course as a site for the Redskins' proposed stadium. I thought the mayor was in concert with my suggestion that the golf course on Langston be replaced with a new 18-hole course on Children's Island, which is immediately adjacent to Langston.

The Mayor backed away from Langston for several reasons. He had received negative reactions from golfers who played on the course. They and other city residents viewed Langston as a historic site. The former landfill became the first place where blacks could play golf regularly in the segregated city. Among the first cadre of top black golfers who played on the Professional Golf Association (PGA) tour, Lee Elder, Jim Dent and Jim Thorpe played the course regularly.

The local city residents living in the black middle-class Kingman Park neighborhood expressed their protest. Carolyn Gibson, a congressional staff assistant commented, "They seem to be taking everything in the neighborhood. We will be in a circle of cement by the time they finish, all in the name of progress." Local city politicians objected to the location too. D.C. City Council member Nadine P. Winter attacked Barry's approach. "I am very angry with the mayor. He doesn't touch base with me or the residents on plans like these. It shows a total disrespect for the community."

Cooke soon proposed a new stadium proposition. The owner announced at the "Welcome Home" luncheon for the team he would pay for a new 78,000 seat, open-air, natural-grass stadium. Cooke asked that some organization or some business lease him the land and provide the parking. While the local

politicians offered no comment, local city opinion makers praised the choice, and cited how Cooke built the Forum in Los Angeles. Cooke proposed that the construction of the stadium would cost in the range of $125 to $150 million.

As everyone had discovered during the effort to create D.C. Stadium, any development in Anacostia Park would face hurdles. The area existed in the federal city, thus came under control of the Interior Department and ultimately Congress. The transfer of land rights required congressional approval. The law governing the stadium facility, the D.C. Stadium Act, also limited what the local city and the federal agencies could do in Anacostia Park.

Cooke took his plan to the head of the federal city agencies involved with managing Anacostia Park. He proposed to Secretary of the Interior Donald P. Hodel that if the department provided the land Cooke would extend the golf course if needed. Hodel requested that the National Capital Region staff investigate the matter. City officials scrambled to assess Cooke's surprise offer to finance a new Redskins football stadium. They focused on a site that might require taking a part of Langston Golf Course or filling in part of the Anacostia River for parking. "The Mayor is kind of caught between [preserving Langston] and the reality that Jack Kent Cooke is meeting him halfway and is willing to pay for the stadium," noted a city official. It appeared that RFK parking lots were not large enough to accommodate both the new stadium and the necessary parking areas.

The local city government paid $176,000 for the report from the consultant team, composed of architects from the major firms that construct stadiums. The team examined six locations and vetoed Langston Golf Course and four others. The group advanced the site northeast of RFK as the best location, despite the requirement to fill in part of the Anacostia River. Like Cooke's plan, the city plan envisioned an open-air facility. However, the cost ranged closer to $225 million. The city included a three-level parking structure in their stadium plans, increasing estimated costs by nearly $70 million.

City officials advanced the plan of the consultants. A $230 million offering of tax-exempt bonds would finance the stadium and a parking ramp/garage. The city officials pointed to the portion of the original Tax Reform Act of 1986 which granted the District a $225 million exemption from a prohibition against this method of stadium financing. However, the amount was the result of a typographical error. The House had voted the month prior to the city's announcement of the stadium plan to approve technical corrections to the 1986 legislation. This vote included altering the $225 million typo down to the intended figure of up to $25 million to refurbish RFK Stadium.

One congressional committee staffer responded to the city government's

stadium announcement very quickly. "There is not a snowball's chance in hell Mayor Barry is going to get $225 million for that stupid stadium.... I was offended, and I think everybody else on the Hill was offended, he was that presumptuous." If the funding news did not dampened the possibilities of the city's plan, Cooke referred to the garage as a "motorcar madhouse," and insisted on using Langston for parking. He warned that "perhaps the time has come for me to look for another site for the stadium" in the regional city.[45]

The mayor and staff dropped the planned bond issue. They pledged support to Cooke's offer to build the facility in return for leasing him the land and providing the stadium with parking. City officials increased their outreach on the issue. They met with the National Park Service to discuss the stadium in Anacostia. They visited the Kingman Park neighborhood to discuss the existing situation with residents. The NPS informed the mayor that the existing legislation, facilities and agreements drove their conclusion to oppose using Langston Golf Course or a filled-in portion of the Anacostia River for parking facilities. Cooke stated he would wait for word from Secretary Hodel.

Over half a year passed. Cooke said that he wanted the stadium on the city's fast track but little occurred. Then, two federal city oversight agencies and local city residents with environmental concerns entered the fray. The Environmental Protection Agency, the U.S. Army Corps of Engineers, and environmental groups opposed the stadium's location. The groups demanded that Cooke be denied the right to fill in the river if there was any alternative site for the stadium. Cooke stated he would meet with the city officials but declared he would continue to appraise other locations for the new stadium. Washington, D.C. General Counsel Artis Hampshire-Cowan wondered about Cooke's intentions: "If he doesn't want to build here, he can say, 'I need to fill in the river,' and he knows he can't do it. Then he says it's impossible to build a stadium here and he can build elsewhere."[46]

The leadership of the local city came under a cloud. After years in which two deputy mayors received convictions for misuse of city funds, extortion, and other activities, Mayor Barry was indicted and convicted for cocaine possession in January 1990. He had to step down as the city's mayor. Since the local city residents mostly register as Democrats, the winner of the 1990 Democratic Party primary would presumably become the next mayor of Washington. Four candidates ran, including three current members of the City Council and a corporate lawyer upset with the decay of her hometown, Sharon Pratt Kelly. Kelly won election on the promise of reforming the city's inept and oversized bureaucracies.

Kelly and the Entertainment Complex

The graduate from Howard University faced several daunting tasks. Mayor Kelly struggled to provide more and better city services while trying to reduce a large budget deficit. She battled with the city's high crime and high unemployment rates. Her efforts to attain statehood for the District created significant opposition and rattled her coalition of supporters. Amidst this, Kelly moved to address the activities required of the city in order to convince the federal agencies to enable them to build the stadium near RFK.[47]

Kelly built upon former Mayor Barry's groundwork. Barry established a Stadium Advisory Committee composed of about forty local city government officials and residents. She embraced the group's decision to hire a national environmental planning firm to evaluate sites in the District. The consultants compiled a list of those locations with more than twenty acres of vacant space, then eliminated parks and parkways. A set of sites for potential stadiums similar to the earlier study emerged, ranging from three locations in Anacostia Park to Ft. Lincoln and Bolling Air Force Base. The consultants rated the sites on a scale of zero to four, with zero as unacceptable to four as excellent. The five groups of criteria that received ratings included land configuration, access, planning considerations, site preparation concerns and necessary land acquisition. The team sent the results to the Stadium Committee and to the mayor.

The local city officials decided to publicize the stadium construction effort. The Armory Board produced a publication called *Starplex News*, to provide information about the new stadium project. With the first issue in September 1991, Mayor Kelly advanced the idea that the stadium serve as part of an entertainment complex. The new stadium would join with the D.C. Armory and the Convention Center to host the biggest and best of shows and events.

The publication presented the results of the consultants' study. The parking lots northeast of RFK Stadium finished highest in the first round of evaluation, with the RFK/Armory and Bolling Base sites tied for a distant second. In the secondary criteria evaluation of judging these three sites on a more qualitative basis, the parking lot/northeast section triumphed again. Even though presenting the local city officials with a clear choice, the study left them with the realization that the site existed in the federal city part of the District. The location left the city officials without actual control over the area that they observed had the best prospects for housing the stadium. The local officials would need to negotiate with the agency that managed this land in order to use it for a new stadium.

The board commissioned a new study detailing the economic impact of

the stadium. Released during the winter of 1992, the report claimed that the construction would inject $240 million in the Washington economy. In addition, direct and off-site expenditures related to the stadium would add $23.8 million annually to the District economy. While the local city politicians promoted the possible gains to their constituents, the three-pronged negotiations among the local and federal city officials and the team proved daunting.

The most significant problem involved space for parking. Since the last attempt to use a portion of Langston Golf Course, local city residents and groups moved to nominate it to the National Park Service's National Register of Historic Places. The official listing occurred in October 1991. Despite a mention in an article in the *Starplex News* that only 26 of the 215 acres would be used for a possible parking lot, making that happen would be more difficult than even a few years earlier. The District offered a plan to build a parking garage to replace the 9,000 parking spots lost to the new stadium. However, Cooke balked and insisted on surface parking that would require filling in part of the Anacostia River. Local city residents threatened to sue on environmental grounds. Cooke advocated for a quick environmental impact study but the Secretary of the Interior, Manuel J. Lujan, would not offer that option. Instead the secretary made a statement about giving the project preferential treatment that assured the process would take at least one year.

Cooke then announced that he had expanded his search for sites and six locations existed as possible locations for a new stadium. He negotiated with Governor Douglas Wilder of Virginia and several county officials regarding locations in Fairfax County and the city of Alexandria. The team owner had feelers out for a location in Prince William County off Interstate 66 beyond the intersection with I-495, known as the "Beltway." While several private interests in this area expressed their interest in the project, some powerful public officials made a new stadium in that county highly unlikely. Ed King, the chairman of the board of Prince William County Supervisors, stated, "I personally don't want it in Prince William.... It's already overcrowded now out here. I think Loudoun County is a good site for him.[48]

Football in the Yards

Cooke's exploration of other options brought fruition. His meetings with Governor Douglas Wilder resulted in a deal. The Redskins would move to the Potomac Yards in Alexandria, Virginia. At a news conference at the hundred-year-old railroad switching yards running near the Potomac River, Cooke, Wilder, and NFL Commissioner Paul Tagliabue announced the stadium deal. The 400-acre plot of land offered ample space for the stadium and

parking, along with a relatively close mass transit connection. District Mayor Kelly called Cooke a "billionaire bully" in response.

Members of Congress took action. Representative Jim Moran, a Democrat from Virginia, proposed a rider to the appropriations bill for the Veterans Administration, Housing and Urban Development and various other agencies. The provision required that the Environmental Protection Agency undertake an environmental impact study for the Potomac Yards Project. The appropriations bill passed the House of Representatives.

The rider would not last. Considering the action unusual, Senator John Warner, a Republican from Virginia, contacted members of the Senate Appropriations Committee and took the Senate floor to comment about the provision and ask that it be removed from the spending bill. Warner argued that he chose not to take a specific position regarding the Washington Redskins in Virginia. Instead, he asked for the removal of the provision on the basis of allowing the debate on the merits of the use of the site to happen and dictate the action that needed to occur.

Many of the opinion makers in the regional city sided with the Senator in the split between the two members of the federal city. The newspapers argued that everyone ought to wait for the facts before deciding to support or oppose the Potomac Yards stadium. Others stated that the Redskins and their location were simply no business of Congress. Another noted that the leader of the District's northern Virginia (NOVA) regional city, Governor Douglas Wilder, handled Jack Kent Cooke in a more successful way than had the leader of the District's local city, Mayor Sharon Pratt Kelly: "Mr. Cooke wants to be treated with the admiration due a bowl-winning quaterback.... A little pandering to the ego is cheap compared to losing a national football team." The senator had bested the representative in the Battle of the Rider.

The deal displeased several contingents in the NOVA portion of the regional city. The Alexandria city leadership had only recently approved of a new zoning and development plan for the Potomac Yards and Greens. They observed that the stadium might not conform to those regulations. The city officials had plenty of help from the residents in the neighborhood near the Potomac Yards. After the unsuccessful attempt of their congressman, the citizens took direct action. The Del Ray Citizens' Association held an emergency meeting. Always known as a political force in Alexandria, this economically and racially diverse citizenry living in the bungalows and expensive brick homes were a formidable opponent for Cooke and his Redskins.

Working with their City Council members and government officials these citizens set about to destabilize the stadium effort. They discovered that neither the team nor the state government had done the requisite economic, transportation or environmental impact studies. One council member

responded that the stadium proponents should expect the kind of delays on their plans that they had faced in the District. Some of the proposed plans showed weaknesses. The accompanying new subway station for the area would have linked it to the rest of the region on the blue and yellow lines. The original estimate of $22 million left the station "incapable of handling the estimated stadium passenger loads either physically or operationally," according to the subway officials. Expectations involved an extra expenditure of $12 million. The stadium project in the deserted area came to a screeching halt as the opponents exploited the weaknesses in their team and state government's plans.[49]

Cooke resumed negotiations with the local city government of the District. The team announced in a press release that the parties reached a deal at the end of 1992. Cooke would pay the costs for the construction of the stadium, estimated at $160 million, and the city would issue bonds to cover the $46 million in infrastructure improvements. The team paid for the ten percent financing of the bonds for each of the thirty years through a series of taxes. Mayor Kelly expressed her delight with Cooke's decision and noted that this would result in jobs and money for citizens of the District. Cooke chose not to mention the mayor during his wry statement, "I am glad we wound up where I wanted to be in the first place."

Environmental Impact

The consultants the Armory Board hired to review stadium options submitted their report to the local city government. They evaluated three options, eliminating Bolling due to new development, and the Ft. Lincoln area of the city. They settled on the parking area north of RFK because of the existence of the subway and highway accessibility, and because it had been long planned as a location for a sports stadium. The decision to select the same site generated all the problems that had plagued the stadium project since the mid–1980s, including the federal control over the land, the strong citizen opposition, and the environmental sensitivity of the area.

The federal control issue initially appeared to be much less of a difficulty than it had been in the past few years. The congressional portion of the federal city took action to pave the way for the building of a stadium. A number of representatives from both major political parties supported the stadium project. They proposed a bill that would amend the District of Columbia Stadium Act of 1957 to allow the construction and maintenance of a new stadium to occur. The bill went to two committees, the Committee on the District of Columbia and the Committee on Natural Resources, to be discussed in joint hearings. Meanwhile, the Senate advanced a similar bill and

sent it to the Committee on Energy and Natural Resources for the hearing process.

As the hearings began some members of the Senate objected to the approval of a stadium for the Washington Redskins. Senator Ben Nighthorse Campbell, a Democrat turned Republican from Colorado, introduced legislation in the Senate that would derail the bill to enable the District to build a new stadium. The Air Force veteran and one-time Olympian, who had represented the United States in judo in the 1964 Games, objected to the team's name. A member of the Council of Chiefs for the Northern Cheyenne Nation, the Senator proposed a bill that would deny assistance for the construction of a new stadium for use by any person or organization using certain racial or ethnic designations. As the co-sponsor of the legislation, Senator Paul Simon, a Democrat from Illinois, noted, the name and the mascot for teams like the Redskins were "one of the last vestiges of racism in the United States...."[50]

The stadium consultants and the District Armory officials tried to dampen the local opposition. They began a process of promoting their decision regarding the stadium by holding a series of public meetings to explain their positions. Two public meetings occurred during April 1993, one in the neighborhood and the second at the city convention center. The local city residents and groups protested against the process instituted by Cooke, the local city government, represented by the Armory Board, and the federal city government, represented by the National Park Service. They asserted that these chose incorrectly when they opted to perform the brief Environmental Assessment (EA) rather than the more in-depth Environmental Impact Statement (EIS).

The local city opposition achieved its goal. The National Park Service and the Environmental Protection Agency evaluated the area near RFK Stadium using the EIS approach. They discovered lead contamination at the site, presumably the result of the U.S. Corps of Engineers' dredging of the Anacostia River years earlier. The project would cost an additional $12 million and would be unable to begin until after the remediation of the lead. The federal bureaucracy began a long battle over a decision regarding who would pay to remove the lead.[51]

The Congress held hearings on two stadium construction bills. The bills before the Subcommittee on National Parks and Public Lands of the House of Representatives were identical except that one held the Campbell prohibition on the use of certain designations. Members of the federal city work force supported the bills. Director Robert Stanton of the NPS's National Capital Region appeared in support of the bills, stating that Congress had long established that the area be used for stadiums. Stanton argued that the bills

did not require the use of additional lands within the park. The stadium would be built without intruding upon Langston Golf Course or Kingman Island or requiring the filling in of the Anacostia River. Therefore, if adequate mitigation measures described in the EIS were finalized, the NPS would support the bills. Stanton added that the Department of the Interior deplored the use of language, names or symbols offensive to any racial or ethnic group. "Our responsibility as to these bills relates to the use and protection of parklands. Therefore we take no position on [the prohibition section] at this time."

Several organizations of local city residents opposed the stadium construction. The Committee of 100, a long-time local citizen planning organization, testified that the proposed stadium destroyed valuable park land. In addition, they argued that the location violated the *Comprehensive Plan for the National Capital* that the District City Council had adopted in 1989. Group Chairman Dorn McGrath Jr., the director of the Institute for Urban Development Research at George Washington University, added that the stadium reports were tendentious, that Kingman Park residents would suffer, and that few District citizens would receive financial benefit from the new stadium.

McGrath expressed his group's concern over the action of one federal city agency toward the proposed stadium. The membership of the Committee of 100 called into question the National Capital Planning Commission, an organization that until recently they regarded as the last bastion of comprehensive planning in Washington. McGrath claimed that the NCPC, through focusing only on the draft EIS, sidestepped addressing the long-term costs and consequences of the proposed stadium project. The NCPC's actions offended many citizens and the Committee of 100 membership urged the Subcommittee to observe carefully how the NCPC carried out its responsibilities when considering the proposed stadium project.[52]

The Congress did not follow the local citizens' suggestion regarding the NCPC. However, the subcommittee did not report the bill out to the full committee. The bill languished, providing the opponents of the new stadium with a victory. The local District government officials faced a dead-end for the year regarding gaining permission to construct a new stadium.

Despite signing a memorandum of agreement with District local city officials, Cooke resumed looking for another site. One year after announcing the new stadium near RFK, the Redskins announced negotiations to build a $150 million stadium in Laurel, Maryland. Cooke portrayed himself as a martyr. "For almost five years, I have struggled to obtain permission to build the new Redskins Stadium in the District of Columbia. I now know I cannot overcome the forces against me. So I have decided to build the stadium elsewhere."

The news sparked negative reactions from a variety of parties. Mary-

land's governor William Donald Schaefer announced he would not support the move because "it could slam the door on any effort [for Baltimore] to get a [football] team." Perhaps as a method of achieving his goal or out of respect for a fellow politician, this regional city leader announced he needed to speak with District mayor Sharon Kelly before he communicated with the Redskins owner. The Maryland City Civic Association worried about traffic congestion and the lack of benefits to local residents. The president of the association said, "Mr. Cooke is not well liked in the communities that surround him, and we will fight him all the way to the courts." These stadium opponents met in Laurel with local politicians and other groups, including Citizens Against the Stadium, to plan their course of action.

The team moved to mobilize supporters. They established a liaison office in Laurel, and referred to the team simply as "The Redskins." Cooke granted a ninety-minute interview. He declared that the area could become a multi-sports mecca with the Bullets and Capitals moving to an arena nearby. He harked back to one of the long-time arguments for building a stadium in the District. He observed that the new stadium would help draw other major events, including the annual Army-Navy and Navy-Notre Dame football games. The owner also advanced a new argument, stating that the stadium could unite the area, including the cities of Washington and Baltimore. He stated that this regional city would be the fourth largest metropolitan area but could not effectively support two teams. Pooled as a regional unit, the pair of major cities and their surrounding suburban areas would support all teams extremely well, enabling the team owners to build excellent teams.[53]

Cooke became the first individual among advocates for building stadiums to promote the Washington regional city. His advocacy predated the plan of the 2012 Chesapeake Coalition Olympic bid discussed in the last chapter by a decade. The Redskins' owner acknowledged the exalted position of sports in U.S. culture in his talk about the ability to "unify" the area through everyone's supporting a single team in each sport.

With this, Cooke denied the identification and community that residents of every local city obtain from having a professional sports team use the name of their city. His assertion that the market could at best bear only a single team ignored several factors. These positive aspects that Cooke denied included the Redskins' having 20,000 fans on the waiting list for season tickets; the Baltimore area's having a wealth of people interested in supporting a football team; and the large numbers of citizens of the entire region who were more casual fans interested in occasionally purchasing tickets for individual games.

The team had the support of most business interests and many state politicians. However, a group of Laurel citizens faced off against these inter-

ests before the zoning board over the use of the land for a stadium. These citizens took the name "Citizens Against the Stadium — Part 2" (CATS2) in recognition of the Alexandria, Virginia, group that had kept the team from using the Potomac Yards. They worked hard the days before the hearing to summon up support among their neighbors. Many of the local politicians opted to stay silent. The zoning hearing on the stage at Fort Meade High School had the feel of a "reality" television show. The run lasted three months.

After spending the entire summer of 1994 in battle, the Anne Arundel County hearing officer made his announcement and released a 64-page opinion. "This was not a close case," wrote Administrative Hearing Officer Robert C. Wilcox. "Simply stated, the property is too small for the proposed use." The Redskins suffered a stunning defeat. The Redskins had proposed building 20,077 parking spaces and county law insisted that the size of the stadium required over 24,000 spaces.

The team responded in a few ways. They immediately filed papers to appeal the ruling with the county's Board of Appeals. However, the process would take months. The team's project manager for the stadium announced that the Redskins would study whether making road improvements could create a high rate of car-pooling to address the parking space requirements. CATS2 observed that Wilcox did not rule on the many issues that they raised, including how much the stadium would effect the area with noise pollution and other issues. However, they left pleased with the announcement.[54]

The setback did not immediately cause Cooke to abandon the northern section of the regional city. The recent victory of Marion Barry in the Democratic Party primary for mayor made circumstances look brighter for a stadium in the local city. However, in the spring of 1995, Cooke expressed interest in a 300-acre parcel of land in Prince George's Country, Maryland. County officials had yet to decide if they would purchase the Wilson Farm for $6.2 million. It was one of three areas county officials proposed to Cooke and his stadium project manager, though some county and state politicians as well as private groups intended the farm to serve as open space and a recreational center.

Prince George's County officials purchased the Wilson Farm. Had they purchased it for the original purpose or to sell to Mr. Cooke? Perhaps portions of the two purposes could be met simultaneously. The County Council met to discuss an expedited land use review process that would enable them to change the zoning on the property. The hearings occurred over sixteen days and generated thousands of papers and documents. The result: the Council changed the zoning, enabling the stadium to move forward. However, the Council added the requirement that they review the site plan before the change became final.

County Executive Wayne Curry made a proposal to allow Cooke to purchase the land necessary for the new stadium. Cooke thanked Curry for the offer but found it unacceptable in its present form. The pair struggled to find a compromise on who would spend the millions of dollars necessary for infrastructure improvements on the property. The governor of Maryland, Parris N. Glendening, offered to pay $50 million for the roads and other improvements around the site. However, the estimated cost for the improvements on the site totaled $23 million. Cooke declared he would not build the stadium unless one of the governments paid this bill. Meanwhile, Curry opposed issuing bonds or using the tax revenue expected from the stadium to pay for the improvements.

This new disappointment prompted Cooke to address the team's fans. At his Redskin Park office, Cooke promised that the Redskins would remain in the metropolitan Washington area: "I am dedicated to keeping it here." The owner described the actions of those franchise owners in the National Football League who had recently switched cities as vagabond moves that he deplored. Cooke explained that he had lost over $40 million during his 21 years of majority ownership of the team so he needed to move out of RFK Stadium.

Before the holiday season at the end of December, a three-pronged deal brought an end to the impasse between Curry and Cooke. Cooke purchased the land for $4.1 million and would provide another $4.6 million to help the county build a community recreation center and assist a charitable foundation. Only recently, Curry had slashed spending, laid off workers, and raised taxes to cover the county's $108 million deficit. He did not commit county tax dollars to the project. Governor Glendening announced that the state would contribute $78 million for the roads, parking lots and other facilities around the stadium. This contribution needed the approval of the Maryland General Assembly. Ever the codger, Cooke announced his happiness over the signing while stating, "I wish [Curry] would've signed it weeks or months ago when he should have...."

The regional city politicians and residents opposed to the project began lobbying the Prince George's County Council. Walter H. Maloney, a Democrat from the First District, pronounced, "This is just round one. I think this is still a long way off." The Council aired their debate over the stadium proposal during the first week of February 1996. After placing fifty conditions on the proposal, the council approved the plan for the 78,600-seat football stadium in Landover with a 6 to 2 vote. While the team's chief lobbyist informed the press that none of the requirements was fatal to the project, stadium opponents announced that they would challenge the council's vote.

The project remained tentative until the state of Maryland's officials

approved of the financing for the infrastructure. Team representatives, state political leaders, and county officials negotiated final contributions to the costs for the stadium, recreation center, and roads and parking lots. Maryland Assembly leaders offered to spend $58 million for the roads and parking lots in addition to $5 million for the recreation center. Cooke contributed $7 million for that center and $177 million to construct the stadium. Prince George's County leaders allocated $12.5 million of their share of the state highway funding to the project. The funding faced critics in the General Assembly in the month before the vote on the spending packages for fiscal year 1997.

The state lawmakers voted on funding initiatives for the Redskins and the new Baltimore Ravens stadiums. Opponents proposed measures to eliminate the public monies from each bill. Both attempts fell short, 81 to 57 on the Baltimore stadium and 80 to 58 on the Prince George's County site. The stadium funding for Baltimore and for the Landover roads and parking lots won swing voters with promises of millions more dollars going to school construction and other proposals. Ironically, two more members of the Prince George's County House of Delegates supported the Baltimore expenditure than the project in their own jurisdiction; the vote was twelve to eight, against a ten-ten split vote on the Prince George's County stadium.

Cooke's victory in acquiring a new stadium carried subterranean costs to the football team owner. Two former campaign aides of Maryland politicians each worked for the Redskins at a cost of $1,000 per week apiece. The government watchdog group Common Cause of Maryland stated that this raised the appearance of a conflict of interest. The two politicians, Prince George's County Executive Wayne Curry and State Senator Decatur W. Trotter, a Democrat from Prince George's County, both expressly denied any involvement. The individuals that the team hired were on the team's payroll to provide help in generating pro-stadium responses in the area.

The responses to the stadium were mixed. Supporters promoted the new interchange built on the "Beltway" at the site and all the new road improvements. Detractors refer red to the traffic as "horrendous," and the fans called it "a pain," observing that many did not take their seats until halftime. The estimated time for clearing the parking lot of the cars after a game ranked as one of the highest in the National Football League. After a revision of the plan's traffic, the surrounding roads cleared after games within an hour.

The stadium's promised economic boon is still uncertain. According to one person focused on the economics of sports, "City officials on FedEx Field: 'huuuge [sic] economic impact!!!' Local businesses and residents: 'where — at the tailgate parties in the parking lot ten times a year?'" Studies have been completed on a few aspects of the stadium's effect on the neighborhood's

financial circumstances. One discovered that a completed stadium did raise the value of area housing. However, as one commentator succinctly observed:

> While some have justified public "investments" in professional sports franchises on the grounds that they will stimulate the local economy, this is hardly the case. In order to assume economic growth from the mere presence of a sports franchise, one must also assume that people not only would spend money on events at the sports venue, but also would continue to spend just as much on other forms of entertainment.[55]

The new stadium might not generate an economic windfall to the surrounding area. The predictions from a 1997 report estimated that the new "Jack Kent Cooke Stadium" (FedEx Field) would generate $6 million in taxes a year: $2 million in property taxes and nearly $4 million in admission and sales taxes. In fiscal year 2006, the stadium provided the county with $10 million, with more than $8 million in admission and amusement taxes. However, that figure fell $2 million short of the estimated revenue. This despite the fact that the revenue came from a stadium that has more seats and charges more for those seats than the stadium featured in the earlier report.

However, it offered numerous opportunities for making money for the team. The stadium's large size (originally 80,116 seats) enabled the team to become one of the richest in the National Football League. The team earned $50 million a year from the sales of over 200 luxury boxes, 2,000 loge seats and 15,000 club seats. Under the leadership of the Cooke family, the Redskins did not maximize the stadium's marketing value.

In late 1999, the Cooke family sold the franchise. The new ownership under Daniel Snyder maximized the opportunities that the stadium offered. Snyder expanded the seating to over 91,000, the largest in the league. The organization charges high prices for concessions. They sold the naming rights to the FedEx Corporation for reportedly over $200 million. The Redskins created a number of new team-owned radio and television shows, and "sell ads across myriad platforms to such sponsors as Nextel, Home Depot and E-Trade. 'We don't just sell stadium signage,' Snyder likes to boast."[56]

Since the mid–1950s, the District of Columbia faced two protracted struggles to build a stadium in an effort to keep the city's professional baseball and football teams. Despite the construction of a new stadium in the first instance, the Senators moved. The inability to build a stadium in the second instance also resulted in the team's moving. The link between a stadium and maintaining a sporting team proved tenuous at best. The team owner always maintained the ability to locate the team wherever he or she deemed fit. The construction of D.C. (later RFK) Stadium did not keep the Washington Senators' owner Calvin Griffith from departing to Minneapolis/St. Paul, Minnesota. The Twin Cities offered a great deal. The city leaders guaranteed one

FedEx Field, 2007 (author's photograph).

million fans. They offered a strong location in a new region for major league baseball.

The District federal and local city officials did not help the situation. They connected the stadium with their city building plans. The Anacostia Park location represented the base to a long-time plan for a "grand" East Capitol Street, or part of a recreational complex as yet not built. Although located far away from the area's population centers, the stadium predated the necessary mass transit rail and highway network by several years. Calvin Griffith knew this and his frequently expressed dislike of the stadium plans went unheeded.

The Redskins' owner Jack Kent Cooke frequently expressed the details of the stadium he wanted in the District. During this ten-year saga, the federal and local city officials faced a great deal of daunting problems, let alone eventual competition from the efforts of various regional city politicians to lure the team to their area. However, those officials left certain options underexplored. More might have been done with the opportunity to refurbish and expand upon RFK Stadium, or they might have negotiated a fair deal to remove the environmental waste discovered on the site in Anacostia Park.

Ironically, recent actions between the Bush administration and the District's top officials may enable the local city to take the Redskins back from the regional city. The Bush administration has been trading U.S. government-owned land for areas of District land. They aim to enable these swaps to pro-

vide the city with a larger tax base and allow the federal government to reduce its annual "rental" payment to the city.

The Federal and District of Columbia Government Real Property Act of 2005 would swap Anacostia Park for the St. Elizabeth's Hospital area. The bill languished in Congress in 2005 and 2006. The possibility of passing this law spurred discussions between city officials and representatives for Redskins owner Daniel Snyder over a plan to enable the team to build a new domed stadium on the site of the RFK Stadium. The team would pay for the stadium and receive development rights around the stadium as an incentive to build there. The local city would lose parkland and public space. The city would gain a stadium that could host the Super Bowl once in a great while and tax ratables from the new development. The regional city has a humongous stadium in Landover that might be converted into a shopping mall.[57]

The federal, District, and many of the regional city politicians underestimated the strength of the local groups and residents who opposed having a stadium built in their area. This proposed new domed stadium may again prove this to be true. The residents knew the size and scope of the undertaking and questioned the expenditure and planning, something very easily underestimated, as will be seen in the last chapter on the building of one stadium in the local city District.

7

Building a White Elephant
Corruption, Mismanagement, and D.C. Stadium

The Congress gave the Armory Board the responsibility to oversee the construction of D.C. Stadium. However, the federal city workers responsible for overseeing public construction in the District and surrounding areas rejected the initial design of the D.C. Stadium. The Commission of Fine Arts members disapproved of the site two miles from the Capitol and directly in line with it. Members felt the site should be reserved for possible future use for a monument and suggested the stadium be shifted to one of two alternative sites in the 180-acre plot.

As noted previously, George F. Shea, Armory Board chairman, told the Fine Arts Commission that if the primary site for the stadium was not utilized, it could be the "kiss of death" for the project.

The Commission vote was decisive. Six of the seven-member commission spoke against the site on esthetic grounds. However, the Fine Arts Commission held no veto power over the project. They also could not win the battle of persuasion. The local city public opinion leaders observed that the objections had been offered in good faith and merited consideration. Still, as noted earlier, the arguments against the location were not "compelling."

Local city resident support for a utilitarian monument had existed in the past. Residents sought a Theodore Roosevelt and a Thomas Jefferson Memorial Stadium during the late 1920s and late 1930s, respectively. However, as the opinion shapers wrote their thoughts, they would know that the D.C. Stadium lost its original moorings to the idea of a national memorial stadium for the veterans who served in the two World Wars. D.C. Stadium lost its memorial purpose and to purport that it could be a monument or memorial was a disingenuous expression. The site would be given over to a sports sta-

dium, no more or less. This choice clearly reflected the growth in the significance of sport in U.S. culture.

One year later the Fine Arts Commission again had the opportunity to comment on the stadium. Members reviewed the proposed design for the stadium. Two architect members registered complete dissatisfaction with the stadium. Members felt unhappy with the roof design, which they described as "roller coaster," and "whoopsie-doodle." Armory Board member and District commissioner Robert E. McLaughlin told the Fine Arts group that the District Stadium may become a prototype for twin-use designs. The commission responded that it planned to look the other way when the stadium was built.[1]

Escalating Costs

Besides the president of the District of Columbia's Board of Commissioners, the Armory Board included the commanding general of the District National Guard. The third member was a political appointee chosen by the chairman of the House and Senate District Committees. The board represented a unique combination of federal city workers, local city workers, and area residents. During the first year of the stadium's construction, the board consisted of Commissioner Robert E. McLaughlin, Major General W.H. Abendroth, and a long-time District citizen Floyd D. Akers. Arthur J. ("Dutch") Bergman served as the Armory manager.

An appointee of President Eisenhower in 1955, McLaughlin endeared himself to locals for his constant crusade for District home rule. Often resented by members of the House District Committee, McLaughlin also battled for an end to the many ways in which the city residents experienced racial discrimination. General Abendroth took over command of the District of Columbia National Guard in 1949, after the native of South Dakota had served in the active military since 1916. His Guard became the first to desegregate.

The local citizens on the board included individuals who had battled for the construction of a stadium in the District for many years. Floyd Akers had served on the Stadium Commission during 1944 and 1945. He maintained his interest in the project and remained active, joining the Armory Board during 1960. However, after Calvin Griffith removed the Washington Senators to Minnesota, Akers took an interest in the expansion Washington Senators. The ownership stake required Akers to leave the Armory Board because of its negotiations with the new baseball team over the stadium rental.

A new local citizen took his place. Jim Reilly assumed the position on the board in March 1961. An attorney, he made a name for himself in the legal

profession but also within the local city trade, civic and sporting worlds. He received high praise from both the chairman of the congressional District Committees and in the local city newspapers as a man who brought legal experience to the necessary contract negotiations.

As administrator, Dutch Bergman held the largest responsibility for the management of the stadium construction. The former Notre Dame quarterback had arrived in the District to assume the position of Catholic University football coach and athletic director before the 1930 season. The protégé of Knute Rockne became the Armory manager in 1949 and his $20,000 salary at the time of the stadium's construction represented the highest paid to any public official in the city. Some in the congressional circles referred to him as glib.

As noted in the last chapter, the stadium started as a $6 million project. This matched the original cost to construct Milwaukee County Stadium and the additional expenditure to increase the stadium's seating capacity to over 43,000 in the 1954 season. Milwaukee County was the first stadium designed to be dual purpose. The baseball diamond became the Green Bay Packers' gridiron when the bleachers behind the left field wall were moved into the playing area in left field.

However, D.C. Stadium's cost reached the $10 million plateau when the Fine Arts Commission chose to voice its objections to the building in early 1960. This put the price tag beyond what the District's nearest neighbor had spent on its public stadium. Baltimore officials allocated $2.5 million to the initial construction of old Memorial Stadium. A few years later, they issued a $6 million bond to add an upper deck and new seats, increasing the capacity to over 47,000.[2]

After tabling the Fine Arts Commissions' objections, the stadium's proponents received the green light. The Armory Board officials requested bids for the construction of the stadium. The bond issue to finance the construction of the new stadium followed. Bidders for the $19.8 million issue knew the bonds received the top ratings from the financial industry. Moody's Investors Service gave them a triple A while Standard and Poor's rated them A-1 plus. Congress directed that both principal and interest on the stadium bonds be guaranteed by the U.S. government. The bonds matured in twenty years. Meanwhile the Congress passed and the president signed a bill appropriating another $2.6 million to the National Park Service for them to put in infrastructure at the stadium site. The board reportedly accepted the lowest bid, which came from McCloskey & Company of Philadelphia, but totaled over $14 million.

The Armory Board leaders discovered that their original bid lacked a great deal of specificity. They ordered 236 changes in specifications that cost

$3 million more. If the number of necessary changes did not raise concern, some of the reasons for these changes did. The Armory Board officials had neglected to provide for the cost of equipment for concessions in the original contract. Armory Board manager A.J. Bergman explained the board had not decided what to do about the concessions at the time invitations to bid were sent out: "While it was thinking about it, the Board omitted from its specifications such essentials as water piping and electric wiring for refreshment stands as well as drink dispensers and sinks." The omission accounted for $1.3 million of the $3 million increase.

The contract for building the stadium cost $17.3 million as the first spade broke ground in the summer of 1960. McCloskey & Company followed up their winning of the bid with a request for an additional $1 million to make the facility ready for football in 1961. Building industry sources noted that change orders brought a profit of 10 percent to the builder compared to a typical six percent return for work in the original competitive bid. The McCloskey contract rose through the changes an astounding 21 percent.[3]

The Congressman and the Insurance Agent

As the stadium construction moved toward the final stages the first scandal erupted. Representative John L. McMillan, a Democrat from South Carolina and the chairman of the House of Representatives District Committee, introduced family friend Donald B. Reynolds to the chairman of the District Armory Board, Jim Reilly. Reynolds's insurance firm submitted a proposal to insure the new stadium and the D.C. Armory Board. The South Carolina congressman defended his intercession in behalf of the Silver Spring resident because Reynolds, a fellow South Carolinian, was a "constituent" and a longtime family friend. The contract, for $20,000 annually, meant $4,000 in commissions to the company that won the bid to become the insurer.

The congressman and the stocky and dapper insurance salesman had a history of interesting activities between them. Reynolds had purchased a $5100 automobile for the congressman. McMillan stated that he paid Reynolds for the car. He executed the transaction through a friend in order to avoid seeming to be seeking favors from auto dealers by virtue of his political position in the District.

With this as a backdrop, the question of attempted congressional influence would not disappear. McMillan defended his activities and denied any attempt to influence Reilly. Reilly initially pledged that the insurer would be selected solely on the basis of the bids. Within a month, perhaps because he could not freely exercise his legal expertise in these contractual negotiations, Reilly resigned his position with the board.

The two District Committees needed to make a new appointment to the board. McMillan and Senator Alan Bible, a Democrat from Nevada and the chairman of the Senate District Committee, jointly announced that Washington businessman Francis J. Kane would join the Armory Board to replace Reilly. Francis Kane presided over the city's biggest general hauling firm, a company he built himself. Known for his sprinklings of Irish wit and for having the energy of a buzz saw, Kane joined the Armory Board in mid–1961.

As suspicions swirled, Armory Board manager Arthur J. Bergman stated that the stadium insurance question would not be discussed. He refused media requests to see the bids from the more than twenty firms that proposed to insure the stadium and Armory. The bidding went public in October. Bergman informed the media, "The members of the press could have taken down the information as [Assistant Corporation Counsel Milton] Korman read it." It was believed that Reynolds submitted the third lowest bid. Kane revealed that when he took his position on the board, he raised some questions about the bids submitted by two out-of-town insurers who were considered the lowest bidders.

The insurance fiasco soon ended. The Board chose one of those "out-of-town insurers." The Reliance Insurance Company of Philadelphia won the bid. The company offered a low rate. In addition their policy provided "umbrella" coverage, protecting the board against damage claims up to $1 million.

The House District Committee chairman involved himself in other stadium matters. McMillan recommended two of the city's largest parking lot businesses to run the stadium parking areas. In a letter to Reilly, he praised the work of Leonard B. Doggett Jr. and Harry A. Swagart Sr. in developing downtown parking facilities. Reilly noted that the letter expressed the congressman's belief that the concession should go to a local firm so that the stadium would get local support. Doggett submitted one of sixteen requests for permission to bid for a contract to operate the parking spaces around the D.C. Stadium.

Deeper in Debt

While the issues of who received the contracts to provide insurance and parking services created controversies, the fallacy of the self-liquidating stadium quickly became apparent. The costs that spurred the insurance policy and stadium debates amounted to small change compared to the costs associated with the stadium. Projections before the first game occurred in the stadium anticipated annual operating expenses of $400,000 a year. The cost of paying the interest on the bonds alone added $832,000 to the expense sec-

tion of the accounting ledger. As the time to make the first interest payment approached, the Armory Board waited until very late to let the District commissioners know that it lacked the funds to make the payment. The commissioners needed to get a loan from the Department of the Treasury for over $400,000 that they were obligated to repay in little over one year.

A member of the federal city expressed his concerns. After one year of play with the Redskins and the Senators, the chairman of the House District Appropriations Subcommittee argued that the stadium had produced little more than $200,000. A Democrat from Kentucky, William Huston Natcher practiced law in Bowling Green before serving in the Navy during World War II. He presided over a committee with authority over each line in the District budget. Natcher calculated that the District government would be forced to pay the nearly $1 million in interest payments. He declared that "this stadium will be a losing proposition, and some arrangement must be made immediately to take this burden off the taxpayers of the District of Columbia."

The first House member to support Natcher on the floor was Congressman Gross. The long-time opponent of the D.C. Stadium argued that the stadium could have been built for far less than $20 million and served the purpose adequately. Other congressmen used the example of the stadium in a variety of ways during other debates. During the consideration of a bill to fund the creation of an aquarium in the District, Senator Frank John Lausche, a Democrat from Ohio, reminded senators that a strong argument was made for the construction of the stadium, yet now it was a $20 million white elephant. The former governor of Ohio's fiscal conservatism flared often, and he voted so frequently with the Republicans that fellow Ohio Democrat Howard Metzenbaum demanded that Lausche switch parties. The stadium had proved a fiasco that was used to persuade other members of both chambers to vote against bills involving large public projects in the District. Opinion shapers in other cities wrote editorials against these same projects.

The federal city leadership often left the local city leaders in a financial position that made paying for the projects difficult. While maintaining ownership of over more than 80 percent of the District's land, the federal government contributed only twelve percent of the District's budget during the early 1960s. Those more familiar with the city's financial straits often recommended greater contributions and lost those struggles. Natcher's subcommittee provided the House with a budget estimate for 1964 of $50 million and the House passed a bill authorizing only $30 million. After the Senate passed a bill for $45 million, the conference committee settled on $37.5 million, a drastic difference between estimated need and available funds.

Members of the local city public opinion shapers agreed about the sta-

dium. They argued that the Commissioners needed to find a way to make the stadium into a paying proposition. Interestingly, these opinion shapers did not place the responsibility clearly where it belonged, with the Armory Board. Other opinion shapers proposed a different solution. They advocated that the operation of the stadium be removed from the District to relieve the city of the burden. They proposed that the Department of the Interior become the new manager, or another department of the federal government.

Despite talk of the Department of the Interior's becoming more involved, no action occurred. However, the federal city representatives advanced other ideas. President Kennedy entered the fray with a plan for moving the responsibility of running the stadium to the District Commissioners. His plan achieved as little success as the idea of moving it under the Interior Department.

The House of Representatives proposed their own solution. They voted to increase the size of the Armory Board. These two new members would provide additional abilities to address the work that managing the stadium had brought to the Armory. While Representative Thomas G. Abernathy, a Democrat from Mississippi, hoped that two businessmen, able to deal with the stadium's financial problems, would be appointed, Representative Gross from Iowa provided his usual caustic anti-stadium remarks. Gross declared that the two new members would oppose "saddling the taxpayers of the Nation with this 20-million-dollar white elephant."[4]

The Armory Board did realize the financial quandary in which the new stadium found itself. The Board met with C. Leo De Orsey, acting chief of the Washington Redskins, in late 1963. The Board sought to find a way around a provision in the Redskins' lease that blocked college games the day before a professional game was scheduled in the stadium. De Orsey did not volunteer to give up the contract clause. He said that the three service academies and other colleges could submit to him the dates they wanted to play in Washington in the next three years and he would examine them: "I'll see then where we stand." Armory Board chairman Francis Kane said after the meeting that he believed this pledge of cooperation solved the college game problem and offered the stadium another method of raising revenue.

Unfortunately, in mid–November, it became obvious little had changed. Secretary of the Department of Interior Stewart L. Udall and "Dutch" Bergman, Manager of the D.C. Armory Board, both expressed their concern that Navy-Pitt game and annual Interhigh championship contest were lost to the stadium because of the Redskins' lease. Udall said it was high time that the stadium accomplish two purposes. First, it had to maximize public use and second, it had to maximize the amount of revenue it earned. It was the responsibility of the Armory Board to accomplish these ends. Bergman said

he hoped to work together with officials of the Redskins to open up and ease the contract.

Armory management tried to accomplish the goal of bringing more games to the new stadium. They fought to land the Navy-Duke football game in 1964 and Army-Air Force in 1965. The Army-Navy game had three more years in its contract with Philadelphia to play at the JFK Stadium with its 100,000 seats. Bergman met with officials from Notre Dame and the three service academy teams to formulate long-range plans for playing football games of national importance in D.C. Stadium. He planned to map out a 5-year schedule among these teams, with each playing a game a year at the stadium.

In the midst of attempting to formulate the five-year plans, the Armory lost the chance to host the All-America Bowl game. The original plan called for the game to shift from Buffalo to Shea Stadium in Flushing, New York. D.O. McLaughry, executive secretary-treasurer of the American Football Coaches Association, which produces the contest, stated that the American Broadcasting Company (ABC) would pay more for the television rights if they played the game in New York City. ABC held a five-year option to televise the game, $75,000 if the game returned to Buffalo but $105,000 if the game moved to New York City. The promoters of the game ruled Washington out because of the high humidity in June and because there was no suitable place for the players to live and train.[5]

While the promoter made a valid point about weather and circumstances, money served as the central issue for both promoter and broadcaster. The promoter observed that the Downtown Jaycees, the group working to bring the game to D.C. Stadium, "wanted too much of a share of the net gate receipts." McLaughry sought to maximize the profits he received for his game from both the stadium and television.

By the early 1960s, television played a larger, significant role in sports, opening up large audiences for games and commercial sponsorship opportunities. Technological advances enhanced the ability to show games and made the presentation significantly more improved. Sports Network offered an economically feasible arrangement using AT&T land-lines. The advent of videotape and portable cameras enhanced these broadcasts and widened their appeal to audiences and advertisers. The larger viewership and advertising space enhanced the price tag for individual games and made those games increasingly valuable to broadcasters as revenue generators.[6]

College football and individual games were not the only potential users of D.C. Stadium. In the fall of 1965, a local city group sought to rent the stadium for the use of a professional football team. Half a decade earlier, a few millionaires, unable to obtain a franchise in the National Football League,

had started the American Football League (AFL) with eight franchises. The AFL consisted of the Boston Patriots (later known as New England), the Buffalo Bills, the New York Titans (later the Jets), the Denver Broncos, the Houston Oilers, the Oakland Raiders, the Dallas Texans (later the Kansas City Chiefs), and the Los Angeles Chargers (later known as the San Diego Chargers). All struggled to draw attendance and fight the battle that the National Football League teams waged against them. The difficulties subsided with the AFL reaching an agreement with the National Broadcasting System (NBC) television network to broadcast their games for the 1965 season. The infusion of $36 million enabled the team to compete for the top players.[7]

The Washington group approached the Armory Board about renting the stadium for an AFL team. The group's chairman, Norman F. Hecht, proposed a 20-year lease to use D.C. Stadium at a cost of either a $100,000 guaranteed fee or 12 percent of gross receipts. A local banker who became one of the first proponents of computer-based financial services, Hecht and two others assembled the financing. They approached the AFL leadership to receive a franchise for the 1966 season. The board attorneys and officials decided that their lease agreement that provided the Redskins with exclusive use of D.C. Stadium during the football season.

The local city groups' decision stirred a member of the federal city into action. Representative William Beck Widnall, a Republican from New Jersey, immediately wrote to Secretary of the Interior Stewart L. Udall in support of Hecht's group. An attorney and state politician before serving in the House of Representatives, Widnall suggested that Udall end the exclusive lease that the Redskins held in order to make the stadium possibly self-supporting.

Within a month, the Interior Department solicitor ruled that the Redskins' exclusive use of the stadium for professional football violated the Sherman Antitrust law. Secretary Udall followed with a statement that he favored the leasing of D.C. Stadium to the backers of the proposed AFL franchise for Washington. "In view of the financial condition of the stadium, the city could only benefit as a result of more football and more use of the stadium." The Department hoped to negotiate a beneficial settlement on the lease issue.

The good offices that the Interior Department hoped for did not occur. The management of the Armory Board took a passive position. Bergmann stated that the board felt it must live up to the terms of its contract with the Redskins. They proposed that the Hecht group needed to negotiate with the Washington Redskins first, then the board would be willing to sit down with the group. Given that the NFL and AFL were still at war, such a meeting seemed incredibly unlikely to occur.

The Department of the Interior observed that the situation appeared unlikely to be resolved through negotiations among the three parties. The

Department released its legal opinion that the lease violated the Sherman Antitrust Act. The solicitor for the Department noted that the restrictive covenant in the lease was a contract in unreasonable restraint of trade. They concluded that this was an act of monopolization in violation of Section 2 of the Sherman Act.

Members of the local city responded to the decision of the federal city officials. Originally, the office of the Corporation Counsel for the District prepared a draft reply regarding the lease and the use of D.C. Stadium. However, upon instruction from D.C. Board of Commissioners President Walter N. Tobriner, the D.C. Armory Board hired a private law firm to address the case. Tobriner explained that the Corporation Counsel's office was not equipped to handle antitrust law as technical as appeared to be the case. The D.C. commissioner said that he knew "[Francis] Shea to be a highly qualified specialist in the antitrust field." The local city reached a decision that supported the lease as it currently existed, losing out on the additional revenue opportunity. Almost two months later, Shea determined that the lease was legal.[8]

The next year the football group tried another approach in their effort to use D.C. Stadium. Hecht testified before the House Budget Committee for the District in early spring. He said he would guarantee to pay $200,000 to the District "if only the stadium could be opened up to someone besides the Redskins and the Senators." Again, the politicians in the federal city responded positively to Hecht. Representative Glen R. Davis, a Republican from Wisconsin, said the committee intended to look into the stadium's lease policies.

Chairman Natcher of the District Committee responded that he would like to give the stadium back to the Interior Department now rather than wait until 2007, as originally planned. Before any member of Congress could act on the stadium lease, another professional football concern needed their attention. The AFL and the NFL proposed a merger. Congress and the president needed to review the proposal to determine that it did not violate antitrust regulations. They approved the merger and Hecht lost his chance to have a team. The banker and the other group members filed suit for $25 million.[9]

Cracks in the Façade

Difficulties with the construction of the stadium appeared even before the opening. The District commissioners received a report that listed several major deficiencies in the safety facilities for the stadium. These items included a lack of exit lights and signs. Other detriments included incomplete handrails

and protective rails in the stands and combustible construction material sitting in piles around the stadium. In addition, they discovered that the parking areas would not be finished in time for the first Redskins game.

These issues lingered. A baseball fan plunged through a plaster board that covered two ramps and fell forty feet. The man broke his pelvis. District local opinion makers cited the accident in their declamation that the Armory management needed to take action. The board could not allow a recurrence of this accident or anything similar. Additional costs came with the approval of the creation of a practice field. Armory management realized that the Redskins needed one and the new field would save wear and tear on the stadium's sod.

These problems paled beside the difficulties that emerged before the stadium reached its third year. The stadium concrete showed cracks. The Armory Board ordered an investigation. Meanwhile, Walter Tobriner stated that the board had decided to rope off sections of seating where doubts about the condition of the overhead structures existed.

The report proved that the problems were known before construction. A Canadian study printed in *The Engineering Journal* mentioned the problem in the fall of 1955. Two years later, three scientists of the Aluminum Company of America published a report in which they referred to the Canadian report. In their conclusion they urged further research into the problem.

The company scientists discovered that a combination of structural steel, aluminum electrical conduits and calcium chloride could play havoc with concrete. Salt had been used in situations where there was a desire to make the concrete set faster, such as in damp environments and during winter construction. In Washington and other places where the temperature frequently drops below freezing in the winter, it is almost routine to add two per cent calcium chloride to concrete to speed up setting. This salt acted as an electrical conductor between steel and aluminum, corroding the aluminum. This set up the concrete-smashing chemical reaction that created a new chemical that, in turn, cracked the concrete.

Reports of buildings with the problem began in the year the stadium started construction. One college dormitory had cracks while its twin had none. This proved the perfect test for scientists to determine how that had happened. As of early 1964, five buildings in the Washington area experienced this problem. A Reynolds Metals Company engineer warned in 1960 — before work started on D.C. Stadium — that precautions should be taken if aluminum conduit were used in such a structure. In the January 1960 issue of *Concrete Construction*, R.I. Linberg warned that "when dissimilar metals are in contact with aluminum in concrete, the aluminum will suffer accelerated

attack; however, inexpensive paints are available to prevent this type of attack."

The task of assigning responsibility began in earnest. A Reynolds Metals Company spokesman stated that while Reynolds aluminum conduit was used in the stadium, "We did not know at the moment whether all the conduits used in the stadium were manufactured by Reynolds or whether other manufactures and distributors also supplied conduit." The Osborn Company of Cleveland had the responsibility for the specifications on the above-ground part of the stadium. A partner in the firm, H.T. Borton, said he had not been aware of the cracks in the stadium until he saw an article about them in a technical journal earlier in the month.

The aluminum corporations and construction companies created a repair procedure. They advised that the cracked concrete be chipped away so that the conduit could be cleaned with a wire brush. After the conduit and concrete had been coated with a bonding compound, the area would be replaced with a salt-free concrete. The Armory Board faced miles of cracks that were a fraction of an inch wide with conduits awaiting this procedure. The repairs, if mandated, would be time-consuming and expensive.

The Armory Board received the special engineering panel report in the summer of 1964. The panel's report indicated that cracking of the concrete at D.C. Stadium warranted a special repair job. However, the report provided no evidence of whether any significant hazard existed and offered no analysis of expected costs for the repairs. The engineers noted that construction specifications for the stadium prohibited the use of calcium chloride without written permission from the architect-engineers hired to design it. However, the report stated that they made no attempt to collect evidence of whether anyone had provided written or verbal permission to use the chemical during the stadium's construction.[10]

Fast Food Service

As the building cracked, the Armory management and the stadium concession provider faced off over expenses. Sports Service Incorporated refused the Armory Board's demand to pay half of its water and electric bill. The District's assistant corporation counsel, C. Francis Murphy, argued that the Armory Board's contract with Sports Service mandated that the concessionaire pay for the amount of water and electricity it used. The problem became determining how much of the utility the company used when there was only one electric meter at the stadium.

The lack of ability to specify usage led to the disagreement. While they received a bill for $20,000 each year, Sports Service's executives asserted that

they should pay half that amount. They made payments of $10,000 to the Armory management. The water and electricity bill for the entire stadium averaged slightly above $30,000 yearly. The company paid the Armory over $140,000 for the concession operation in fiscal year 1963, or roughly one-third of its gross income. The dispute continued throughout the summer as Sports Service's last offer generated a response of unacceptable from the Armory management.

While the Armory Board grappled with the cracking façade and the unco-operative concessionaire, the Congress opened up an investigation into the stadium construction. In late 1964, the General Accounting Office published a report that questioned a variety of choices that the Armory Board had made. Foremost, they asserted that the board should have obtained congressional approval before going ahead with building D.C. Stadium at more than double its original estimated cost. The investigators observed that smaller deci-sions, such as financing the purchase of the stadium scoreboard, added $120,000 in interest payments to the original cost of $412,000.

The GAO reached the conclusion that local city politicians had arrived at two years earlier. The stadium probably would never earn enough to pay for itself. The investigators claimed that a significant portion of this deficit occurred because of the unexpectedly low attendance at baseball games. These watchdogs of the federal city offered no effective solution to the problem. Instead, they recommended that the Armory Board and the District commis-sioners jointly review the stadium's financial position with a view toward developing a plan for retiring the bonds at the earliest feasible date.

The Clerk, the Ambassador, and the Insurance Man

The Armory Board proved to have been the least organized of the groups involved with the stadium's construction. A series of congressional investi-gations revealed that other interested parties had used the stadium construc-tion as an opportunity for personal and professional gain. Insurance agent Don Reynolds reappeared, this time accompanied by clerks in Congress and the builder of the stadium.

In 1963, the disgruntled owner of Capitol Vending Company felt angry over losing a yearly contract for $350,000. He brought suit in the U.S. Dis-trict Court against Robert G. ("Bobby") Baker. Ralph L. Hill's suit alleged that the Senate majority's secretary had conspired to cancel the contract, despite having been given $5,600 in cash from Hill's company. The Federal Bureau of Investigation (FBI) began examining the ties between Baker, his

wife Dorothy, and the company that received the new vending machine con-
tract.

Simultaneously, a Republican senator from Delaware, John J. Williams,
spent the summer investigating the activities of Baker. A man fellow senators
deemed a stalwart of "moral principle and integrity," Williams took the floor
and called for an immediate inquiry into "charges of questionable transac-
tions." The Senate leadership opted for an intermediate step. Majority leader
Mike Mansfield and minority leader Everett Dirksen arranged for a meeting
with Williams and Bobby Baker. Baker chose to resign rather than take the
opportunity to explain his activities.

The Senate voted to start an investigation into Baker's activities in early
October 1963. Williams testified before the Senate Rules Committee for three
hours providing "information that ought to be checked out." The Commit-
tee appeared divided along partisan lines on the next approach. Republicans
and one Democrat felt an outside counsel needed to handle the inquiry rather
than a Committee counsel. The chairman of the committee was a Democrat
from North Carolina. B. Everett Jordan agreed with this request in order to
"keep the inquiry above question." Nearly all the Senators agreed upon lim-
iting the inquiry to Baker and rule changes to the Senate's employees, keep-
ing the senators themselves outside of the scope of consideration. The changes
left the senators themselves untouched. Williams determined that the com-
mittee was more interested in containing than investigating the scandal.[11]

The Rules Committee hired a retired FBI agent as chief investigator and
received two General Accounting Office auditor-investigators on loan. The
Senate provided only $50,000 to pay for staff salaries and expenses for a total
of six investigators. Despite the small staff, the investigators discovered that
for a man earning $20,000 annually in salary, Baker had extensive assets. He
owned a home in Spring Valley worth $129,000; a townhouse in southwest
Washington worth $28,000; and a large portion of stock in Mortgage Guar-
anty Insurance Corporation, which then saw a dramatic increase in its vol-
ume of business.

As the inquiry continued into early 1964, insurance salesmen Donald B.
Reynolds appeared before the committee. The South Carolinian told the com-
mittee behind closed doors stories about his friend, Mr. Robert Baker.
Reynolds claimed that Baker set up meetings during the negotiations for the
insurance policy that then Senate Majority Leader Lyndon B. Johnson pur-
chased. Baker also established meetings with Reynolds for the insurance con-
tract for the construction of the District stadium. At the completion of the
testimony, Chairman Jordan told the media that this witness "brought up
some things we did not know about." Jordan acknowledged that the investi-
gation would be ongoing.

Later in the month Reynolds returned to testify. He explained that he had paid $4,000 to Baker and $1,500 to William N. McLeod Jr., the former clerk of the House District Committee. The money acknowledged their work in helping Reynolds get the commission on the performance bond for the construction of the stadium. According to Reynolds, he, Bobby Baker, McLeod, House District Committee chairman John L. McMillan, and Matthew McCloskey met in Baker's office in early 1960. Months after this meeting occurred, McCloskey's firm won the contract to build the stadium and Reynolds received a $10,000 fee for his services in writing the performance bond for McCloskey & Company's work constructing D.C. Stadium.

The men implicated in Reynolds's testimony responded with quick denials. McLeod stated that Reynolds paid him for "legal services." McLeod completed his statement with a refusal to discuss the nature of those services to the media. Representative McMillan remembered meeting in Baker's office. However, he asserted that the meeting occurred after McCloskey won the bid. "I don't think that we even sat down. I just looked over the plans and then left as I think the House was in session." The president of McCloskey & Co. issued a short statement, referring to the building of the stadium as "a fairly routine business deal."

McCloskey offered no response himself. Since the 1950s, he had served as the Democratic Party treasurer and a major fundraiser for the party's candidates for office. After John F. Kennedy's election as president in 1960, McCloskey received the appointment to become the ambassador to Ireland. Since he left in early 1962, McCloskey was in Ireland when the testimony occurred.

The committee continued its investigation. After hearing the testimony of McLeod behind closed doors, the committee Republicans moved to bring presidential aide Walter Jenkins in to testify in the case. However, the six Democrats on the committee voted against requiring Jenkins to appear. The voting continued to follow this 6 to 3 pattern, as the majority Democrats refused to require either Matthew McCloskey or Charles Baker, Bobby Baker's brother, to testify. Senator Carl T. Curtis, a Republican from Nebraska, stormed out of the meeting. Senator Hugh Scott, a Republican from Pennsylvania, declared that the inquiry was "a whitewash."

The investigation into Bobby Baker gained attention from both local and national media outlets. The national outlets generally featured stories on the key personalities, particularly Senator John Williams. Newspapers generally supported Williams's efforts to uncover the situation behind Baker. The *New York Daily News* referred to the senator as the "Walter Mitty of Muckrakers," whose triumphs were real." The *New York Times* made Williams the main feature in its Sunday magazine section in February of 1964. The news

President John F. Kennedy throws out first ball at 32nd All-Star Baseball Game. Left to right (starting under the *Washington Post* banner): Speaker of the House John W. McCormack, Dave Powers, Vice President Lyndon B. Johnson, President Kennedy, Commissioner of Baseball Ford C. Frick, Lawrence O'Brien; in foreground, Dennis Marcel and Frank Brown, members of the Washington Boys Club. Washington, D.C., D.C. Stadium, 07/10/1962 (National Archives and Records Administration).

weeklies also featured Williams and mentioned the brazenness of Baker, and the possible gift from Reynolds to then Senator, now President, Lyndon Johnson. They noted the irregularities in the contract for the Washington Stadium and stated it was fair game for the Republicans in an election year.

Several local city opinion makers offered editorials. One called for the Senate to start a probe into the stadium. The piece asked why the stadium cost so much to build and stated that the public interest demanded that the investigation be continued. Upon discovery of the cracks in the concrete, an article written by a local city opinion shaper complained about the presence of the cracks. The writer used the problems to discuss the Baker payoff.

Williams took the floor of the Senate and read another article. The piece included a discussion of McCloskey's charge that his company was owed another $1 million for their work on the stadium. Williams implored his colleagues to act, stating:

> The manner in which these negotiated contracts are being given to favored con-
> tractors on the basis of their ability to contribute to or raise contributions for the
> political party in power, and then the manner in which the same contracts are
> boosted from 10 to 20 percent, through convenient specification changes, is a dis-
> grace, if not actually illegal.

Williams then added that he had been trying to prod Attorney General Robert
F. Kennedy into initiating an FBI probe into another questionable govern-
ment contract that McCloskey had received. The senator had not had much
luck in that regard.

The Senate Rules Committee issued its reports in May of 1964. Essen-
tially, the committee made its decisions based on party affiliation. The Democ-
rats issued a majority report that essentially exonerated everyone involved.
The majority report found no real wrongdoing on the part of Bobby Baker,
McLeod, Reynolds, or McCloskey, let alone Baker's long-time sponsor, Lyn-
don Johnson. The Republicans disagreed with the findings.

Senator Williams continued his investigation into the McCloskey stadium
contract on his own. He pursued particular channels to attempt to acquire
new information. Eventually, he received a copy of the check the builder had
sent to Donald Reynolds Associates, Inc., along with a copy of the bonding
agreement. The Senator noted that while the check amounted to $109,205.60,
the cost of the insurance was $73,631.28. The photograph of Williams hold-
ing the payoff check made the front pages of newspapers around the U.S.[12]

With this new evidence Williams took the Senate floor in early Septem-
ber. He made his assertions about how the principals, including McCloskey
and Baker, had used the stadium to advance their political aims as well as per-
sonal aims. Williams told the Senate:

> Mr. McCloskey could, first, circumvent the law, which prohibits political contri-
> butions in excess of $5,000; second, charge this item off on his books as an expense
> of doing business, and thereby deduct it for income tax purposes; and third, in
> effect charge it to the American taxpayers by adding this on as a cost item of a
> Government contract.

The revelation of the extra payment provided new life to the Baker affair.

In the House of Representatives, H.R. Gross took the floor to raise the
issue of the stadium, the contracts, and the extra $35,000. Gross recounted
how he objected to the federal government payment of $2.6 million for the
infrastructure around the stadium. Yet through machinations the secretary
and leadership of the majority party had pushed the funding through. Gross
thundered, "I did not know at that time that the human vultures were col-
lected ... in an office in the Capitol waiting to begin picking the bones of the
stadium even before a shovelful of dirt had been turned."

Gross yielded the floor to Durward Gorham Hall, a Republican from

Missouri. The physician had served in the Army through the Korean War, then became involved with Republican politics in his state. The social moderate had won a seat in Congress in the early 1960s. Hall earned the nickname "Dr. No" for his consistency in voting against spending bills. Hall declared that $25,000 of the extra money went into the Kennedy-Johnson campaign treasury. That campaign's manager was Bobby Kennedy, whose prowess and knowledge of campaign financing was unquestioned. The attorney general had been slow to investigate the stadium affair. Now he planned to resign and run for the Senate from New York.[13]

These usual suspects among the federal city leaders were not the only people who believed in reopening the Baker and stadium inquiries. Local city opinion leaders complained about the execution of the last Baker inquiry: "The Senate Rules Committee did not look beyond this surface of interested parties handing out money to promote legislation to the possible conspiracy involving a campaign contribution."

The majority leader, Michael Mansfield, a Democrat from Montana, heard Williams's statement regarding the extra payment to Reynolds. He asked for the time to confer with the Democratic Policy Committee. A week later, the minority leader, Senator Everett Dirksen, a Republican of Illinois, requested that the senate resolution to authorize a continuing investigation of Bobby Baker be considered. Mansfield responded that the proposed resolution was on the floor and he hoped either it or some other resolution would be shortly adopted. Williams took the floor and requested an amendment to the proposed resolution. The Delaware senator wanted to have the Committee on Government Operations, or a duly authorized subcommittee thereof, investigate Baker and the stadium.

The proposed amendment set off a long debate. Republicans continuously stated how the stadium funds needed to be investigated and that it must be done well. They proposed how good and effective Senator John Little McClellan, a Democrat from Arkansas, would be as the chairman in this investigation. A quiet, unassuming man, he was deeply respected by his colleagues, who imagined that his investigation might be more judicious. Most of the Republicans carefully avoided openly stating how poorly the senator from North Carolina had run the last investigation. However, they asserted their support for the Williams amendment to move the hearings to the Government Operations committee.

The Democrats did not support the Williams amendment. McClellan stated his belief that the Baker inquiry should be reopened and that a further investigation should be made. He suggested that the Rules Committee needed to be allowed to continue the investigation it started. Other party members took the same approach.

The Senate Republicans than tried a new tactic. They suggested that a separate select committee be created to investigate the Baker and stadium affair. They knew that this committee would not be under the same Rules Committee restriction of requiring a majority of members' consent in order to call a witness. The committee would again have six Democrats to three Republicans, almost assuring that the Republicans would be limited in what they could accomplish. Mansfield rose and refused to accept the establishment of a select committee, stating, "There are no volunteers on this side of the aisle [the Democratic Party Senate members], so this issue is clear."

The debate over the details of the committee and its investigation continued. Mansfield asked the presiding officer for a statement of the question before the Senate. The issue centered on the Williams amendment only. The legislative clerk called the roll for a vote. The vote was 37 for the amendment and 50 against with 13 absent. All the Republicans and four Democrats voted for the amendment. While the defection of Ohio's Lausche and that of Virginia's two senators did not surprise, the very liberal Paul Douglas from Illinois also left the party ranks. Still, the Senate handed the stadium investigation back to the Committee on Rules.[14]

After the vote Republicans attempted to influence the operation of the Senate Rules Committee through putting the spotlight on them in the media. Senator Williams said he would not support another whitewash. Senator Carl T. Curtis, a Republican from Nebraska, complained that the six Democrats on the Rules Committee repeatedly rejected Republican demands that McCloskey be called as a witness.

The former ambassador did issue a statement. Matthew McCloskey said he paid Reynolds only the amount Reynolds billed him and nothing more. President Johnson ordered the FBI to look into the charge made by Williams and said he favored a "thorough investigation and study of any indication that Federal law may have been violated." Williams complained that FBI representatives who visited him were more interested in how he had obtained a copy of the McCloskey check than in where the money went.

The second round of Senate inquiries into the stadium and financial dealings began in early October. While Congress used to end their sessions early so they could enjoy the summer off, since the mid-twentieth century they have remained in session through the end of September and later. During presidential election years, such as 1964, the year of the second Baker hearings, both chambers usually completed the sessions early in October so they can campaign. Everyone knew the committee had a limited amount of time in which to conduct the investigation before the Congress adjourned in this election year.

The public hearings started with testimony from the District Armory

Board members and architects for the stadium. The questions focused on the details about the construction of D.C. Stadium. The most significant issue was Senator Williams's charge that Matthew McCloskey had made a $35,000 kickback payment on the performance bond and that Reynolds had told him that $25,000 of this was channeled into the 1960 Kennedy-Johnson campaign fund through Baker.

One of the first to testify was District Buildings and Grounds superintendent James A. Blaser, the contract officer on the stadium project. He provided a detailed explanation of the choosing of architects and engineers and the subsequent $3 million in change orders that made the stadium's cost skyrocket. Blaser then admitted that he had approved payment of $100,000 to D.C. Stadium contractor Matthew H. McCloskey for a performance bond that cost the builder only $73,631. He thought Mr. McCloskey intended the payment to include not only the bond cost but some of his initial expense on the project.

As the local city employee testified, only one Republican member of the committee attended. Senator John Sherman Cooper, a Republican from Kentucky, expressed his impatience with the inquiry. He complained about the plodding pace. He claimed that the six Democrats intentionally proceeded in this way to stall the hearings until after the 1964 presidential and congressional elections. The committee was not sure whether the hearings would continue after Congress adjourned but the Republicans hope to force such a decision.[15]

In the 1964 elections Lyndon Johnson won election as president and Robert Kennedy became the junior senator from New York. The investigation of Baker, D.C. Stadium, and potential political kickbacks resumed. Senators Williams and Curtis attacked the committee counsel for his handling of former ambassador Matthew McCloskey and staff. The Counsel accepted the former ambassador's statement that he had overpaid, but that it was a "goof." The committee's counsel did not push for McCloskey to provide the General Accounting Office a list of his business's federal government contracts. The two senators questioned the lack of an explanation for the overpayment and all the costs associated with McCloskey's federal buildings, including the House of Representatives' new Rayburn Building, a $100 million structure some worried would come "unstuck." The Rayburn Building remains standing as of the publication of this book.

The hearings extended into early 1965. McCloskey called the insurance man a "liar," and insisted the overpayment was a "goof." Reynolds held to his testimony and refused to surrender his personal financial records unless he was assured that L.B.J. and Walter Jenkins were being investigated. The Johnson administration worked overtime attempting to discredit Reynolds

though having a variety of federal agencies leak derogatory statements and stories about him to the media. Shortly thereafter the hearings came to a close.[16]

While the Senate investigations of the stadium and Bobby Baker ended, the interest in these issues remained. The General Accounting Office performed a review of the change orders and other D.C. Stadium construction issues. They submitted their report to Congress during the fall of 1966. The report noted that the change orders had added nearly $3 million to the total cost. These 234 change orders did not even go through the process of having the District local government's building chief evaluate them. While not assigning any blame to a person or group, the report implied that the Armory Board had been lax. The report's conclusion offered a lesson that construction contracts should never be allowed before plans are completed and reviewed by governmental regulatory agencies.[17]

The report perhaps represented an appropriate finish to the investigations related to the construction of D.C. Stadium. Neither very harsh nor very edifying, the central statement in the report made discoveries but limited the amount of light shone on the deficiencies that it uncovered. Would the reaction be as sedate today with the new Nationals stadium? Indeed with the cost overruns involved in the construction of D.C. Stadium and the discovery of leaks in FedEx Field after one winter, what types of additional costs will be associated with the stadium for the Nationals? With the malfeasance of Baker et al., and the questionable consultant hiring in Prince George's County during the building of FedEx Field, what may the revelations of the new stadium be?

Conclusion
A Big League City

Having the Right Vibe

The focus on the Potomac Yards Stadium in 1992 left one local city columnist bemused. Tom Knott stated his ownlack of interest in the stadium issue. He felt perplexed over the coverage. After all, neither Cooke nor any of the politicians had accomplished anything profound, such as finding a cure for cancer.

Knott proposed, then debunked, two possible reasons for the coverage the media provided. Did the coverage occur because the stadium was the topic of interest for the average person? Knott stated that people talked about interest rates on home loans and vacations, not the stadium. Did the coverage result because the average citizen in the area received an economic boon from its construction? He observed that the masses would not receive a tangible benefit, such as free suds or tax break. Even the merchants of Alexandria, should they really dance in the streets over the prospect of eight busy days a year? He asserted that the Buffalo Bills played football in Orchard Park, New York, and the people of that area still await all the football-related economic development.

Having disproved the first two possible reasons, Knott asserted his explanation for stadium stories. He concluded that stadium stories were the journalistic trend of the early 1990s. "The stadium story is way overdone.... [A]t a certain point, you ask, 'Am I really supposed to care about this?'" The columnist thought there was nothing wrong with the owner getting his deal and the politicians getting their decorative piece. However, since one knew that they would, where was the news in this?

The examination of this history of stadiums in Washington, D.C., confirms that stadiums have resulted in a building's going up in one area of

the city. As sports have attained expanded significance in the culture, the requirements for the stadiums have grown, necessitating expenditure of more money. This has expanded the economic benefits that emanate from stadiums, although the prime benefactors remain the team owners and those involved in the real estate and construction deals. In certain cases, such as the Olympic Games host city bidding, the process has become so enormous and elaborate that the planners can make a livelihood without winning the bid or constructing a stadium.

This book has revealed that stadiums have meant a variety of things to residents and power brokers in Washington, D.C. In the late nineteenth and early twentieth centuries, stadiums enabled Washington to enter into different professional sporting leagues. This offered the city inclusion in the network of northeastern cities, a group that Washington struggled to stay in. Throughout the early to mid-twentieth century, the construction of a stadium promised the District the possibility of hosting the big football game between the two armed services. This would have resulted in the District's joining the ranks of a city that hosts an annual sporting spectacle.

From the second decade of the 1900s until after the Korean War, Washington conceived of a stadium as a memorial. This would have enabled the District to memorialize in a different manner from the statues and monuments already dotting its landscape. Since the mid-1900s until early in the twenty-first century, members of the city and surrounding cities and towns perceived of the stadium as one of many buildings that made up a sports complex to host the Olympic Games. This would have placed Washington to be in a league with the European capitals that had previously played host to the Games. Beginning in the 1950s through today, residents and politicians believed that a new stadium would enable the District to keep its professional sports franchises in the city. The record has not proved this to be at all certain.

Citizens and politicians in other cities and nations have shared some of these rationales. The Italian leaders during the 1930s constructed a stadium that was to "truly reflect the genius of the regime and the greatness of the era." Universities constructed stadiums that memorialized the students who died serving in the country's wars. A number of cities in the U.S. built or promised to build stadiums in an effort to woo a big league franchise.[1]

Advantages to the City

These rationales for stadiums illuminate that interest in the building of stadiums has more often had symbolic and cultural motivations than materialistic and economic aims. The gains that both the city and its residents realize come from the symbolic and cultural realm as well. The stadium and

associated professional sports team placed the city in the "big leagues." As the complaints over Washington's acquiring a minor league baseball team in the late 1980s and the battles for getting an expansion team show, having professional sports franchises provide a city with the cachet of belonging in the majors. This provides it with the opportunity to proclaim itself as one of the top urban areas in the country.

There are other related advantages that come from having a stadium with a big league team. The stadium as a building generates evaluations. Is the stadium interesting architecturally? Is it new and exciting, or a "knock-off" of another? Is the stadium aesthetically appealing? Does the stadium fit within the context of the area? How do the ballpark's environs look? In the early 1990s, Camden Yards reinvigorated the architecture of stadiums, baseball stadiums in particular. Its use of the neighboring warehouses also made a statement for the environs as well. Stadiums develop identities that then enhance the stature of their host cities. Yankee Stadium's identity, bound to items such as Monument Park and the right field façade, remains attached to New York City.[2]

The city that has a big league stadium and team receives the media coverage that comes from hosting big league sports. The number of games broadcasted in general and on the numerous national stations has increased significantly since the flowering of cable and digital television. Since the majority of the time focuses on the game at the stadium, an attractive modern stadium presents a positive impression of the city as a hip and desirable place to be. The broadcasts also include other images of the city where the game is played. These images of the locations and people in the city are almost always upbeat, showing the city in a good light. The influence of these city images is difficult to measure but surely adds to the positive perception of the city.

There are certain limits to the coverage of games and consequently the exposure that they provide for a city. There are fewer games broadcasted on over-the-air stations than during the 1970s and 1980s. Thus, viewers of many of the games need to have cable television, which eliminates certain viewers. More games are shown on subscription channels, reducing the number of viewers by a significant amount. The subscription channels do offer the viewers a variety of choices and sometimes the ability to see any game. The cable and over-the-air channels usually choose the game(s) they perceive to be the "best." This television coverage results in teams with the biggest stars or best records appearing much more frequently than other teams, limiting the exposure that certain teams, and as a result their cities, receive.

The last advantage to the city involves being identified with the team. As an academic who specializes in the area of sports facilities observed, "[A] stadium is one piece of a total community revitalization or identity process."

The most obvious link between team and city comes from the team's wearing the name of the city on their uniforms. The sports pages and broadcasts further the team and city association as they use the city name in the standings and box scores. Less directly but similar to the creation of a link between a city's main industry and its identity, a city's identity is associated with its professional sports teams. Thus, Washington earned the identity summarized in the phrase, "First in war, first in peace, and last in the American League."

Advantages to the Residents

The stadium provides residents with a few benefits. It represents a venue for entertainment and serves as another place to go in the city. Like theaters, museums, nightclubs and bars, stadiums host a specific type of entertainment event. However, unlike the other locations, which are multiple, a city usually only has one stadium providing its spectacle at any one time.

The form of entertainment in the stadium has different characteristics from many of the other entertainments. Venues such as movie theaters show a pre-recorded form of entertainment that does not change. Others, such as museums and art galleries, present curated shows that remain static throughout their run. Theatrical stages present live shows but they have been scripted. Nightclubs sometimes presented scripted live shows. More frequently, they present musical performances that are live and have the ability to be variable.

Like nightclubs, stadiums sometimes host the largest tours of musical groups and concerts that perform such live and new shows. This quality of new entertainment every night is what is inherently different about the entertainment that regularly appears at the stadium: the sporting events that stadiums host. The game does not involve the same players each night. The combination of the number of actions that define the game and the order in which they occur is astronomical. In fairness, it must be noted that fewer people can afford the cost of attending a game at the newer stadiums. The price of tickets has climbed and there are fewer inexpensive seats available. In addition, the person needs to also pay for the cost of traveling to the game and for any food that they consume while at the stadium, and each of these costs has also risen significantly.

The stadium and team offer the general city resident the advantage of being able to attend an event. However, a smaller group of residents gains more than something to do from having the stadium. The fans of the team gain a regular activity to become engaged in monitoring the team throughout the sporting season and into the off season. The person can think about

and discuss the circumstances of the team and/or the sport. This focus enables him or her to build identification with the team. The fan gains an identity as a supporter of the team.

This personal identity that the individual fan gains is part of a larger entity. The fan becomes linked with the team, or more accurately with the team's other fans. This grouping of fans forms an entity with a specific size and composition. It has shared activities and behaviors and over the years, so the entity forges a reputation. Frequently, the entity of a team's fans is both global and variable. Rather than a single entity it would be more useful to understand the teams' fans as comprising thousands or even tens of thousands of smaller groupings. The experience of being in one or more of these small groups provides every fan with the sense of belonging. This gives these fans the feeling of community.

The number of people who receive this experience increases greatly when the team wins regularly. The casual fan joins the ranks of the team's supporters when the team reaches the playoffs. The incidental resident becomes swept up in the excitement of a team's winning when the team reaches the World Series or Super Bowl. If they win, the city experiences a championship celebration, which encompasses a euphoric feeling of pride and other good vibes throughout the city.

This vibe and the celebration are special because teams do not become the champion of their sports very often. A team certainly needs luck but it also must commit its resources to make this happen. The market in the city for the professional sports team needs to be large enough to enable the team owner to earn the resources to commit to the team. The owner needs to be willing to commit the resources to the team.

This book demonstrates that Washington's professional sports teams have been hampered at times by one or both of these difficulties. The Hewetts, father and son, and the Wagner brothers sought profits and exhibited little commitment to expend their resources on the team either in quantity or wisely. The new stadiums that the Hewetts and Wagners had for their teams exerted little influence on the behavior of either set of owners. The new stadiums for the bicycle and baseball teams in Washington during the beginning of the 1900s could not provide enough of a market to enable the teams to overcome the sizes of and the distances from the northeastern and Midwestern cities.

The Griffiths, father Clark and son Calvin, displayed mixed results on the issue of team resources. Over the first fifteen years, from the late 1910s until the early 1930s, Clark Griffith added onto the stadium to expand his market. He spent his resources wisely in fielding two Senators teams that played in the World Series. However, his and his son's limited resources, frugality,

nepotism, and inability to expand the market for their team led to his team's descent into the cellar for many of the next twenty years. The Griffiths rarely joined in the efforts to bring a new stadium to Washington. While Griffith Stadium provided a major source of the team and family's income, a larger stadium with better seating and concessions could have generated more revenue for the team. Calvin Griffith acknowledged the need for a new stadium but opposed the specific effort to build one. He disapproved of its location but also sought guaranteed income from the stadium, which he received from Minneapolis and St. Paul's leaders.

Washington's professional football team owners usually allocated the resources to the team but only one achieved great results. George Preston Marshall had one winning team over the last fifteen years at Griffith Stadium. He experienced only losing teams at D.C. Stadium. The increased resources from the new stadium did not result in increased success for his team. Under the same circumstances, owner Jack Kent Cooke had a Super Bowl entrant and several winning squads. After he began grumbling over the RFK Stadium, his team made the Super Bowl twice. He won a Super Bowl after the first five years of his negotiations for the construction of a new stadium to increase the team's resources. The stadium was eventually built. New owner Daniel Snyder made that stadium the largest in the National Football League and maximized the team's income sources. Despite spending more resources on the team, his football team achieved winning seasons only twice in seven years.

What can the city and its residents expect from the Washington Nationals and the new stadium the city built for the team? The construction of a new stadium can not provide more than a short-term lift to a franchise. During more than a decade of new sports stadiums, fifteen in baseball alone, teams received an immediate spike in attendance. The Milwaukee Brewers almost doubled their attendance when Miller Park opened in 2001 but sank to slightly over the amount they drew in their previous stadium when the team played well below .500 baseball. The Seattle Mariners topped three million fans at Safeco Field but as their play sank so did attendance figures. The argument: winning is essential to boosting revenue.[3]

The District knows the validity of this from its experience with D.C. Stadium. The Washington Senators that left for Minnesota for the 1961 season had drawn the smallest crowds in the American League at Griffith Stadium. The team drew almost 750,000 during the 1960 season, their last in the District. The American League replaced the old Senators with an expansion team that began play in 1961. The team drew fewer than 600,000 their first year while they played at Griffith Stadium. With the move to D.C. Stadium the team drew almost 730,000 fans and ranked eighth of ten teams in attendance.

However, the stadium can not be the sole draw. As the team played mediocre baseball, the number of fans dropped. In the two seasons when the team's prospects rose on the field, the fans came to watch. The 1969 team drew over 900,000 and ranked 6th best in the twelve-team league.

The professional sports leagues in the country realized the need to have most of their teams be competitive in any given year. This serves as the best way to ensure the health of the franchises and the league. With the differences in stadium and city sizes, the larger city teams always enjoy a financial advantage that could translate into acquiring the best players and winning regularly. Sharing the gate has long been a part of major league baseball and the NFL. However, the home team always receives a higher percentage, providing the larger markets with an advantage. The NFL also shares the revenue from its television contracts equally. Since this amounts to nearly 66 percent of the sport's income, this money plays a key role in the health and activities of the smaller market franchises and enables all teams to have a good opportunity to create a winning squad.

Major league baseball changed its revenue circumstances. The owners and players recently made attempts to generate income distribution through revenue sharing and a luxury tax. The bargaining agreement between owners and players included a requirement that the team owners spend the revenue sharing money on their teams. Despite the changes, from 2002 to 2006, the same eight baseball teams each averaged a payroll of over $100 million, while the same four teams averaged a payroll under $50 million.

How have teams that received public funding for stadiums performed with these new approaches to revenue? After the nation's entry into the twentieth-first century, new baseball and football stadiums emerged in Pittsburgh, Cincinnati, Milwaukee, Philadelphia, Seattle, Detroit, Arizona and other locales. The public in these local and regional cities paid an average of 80 percent of the cost for the construction of these stadiums. As small-market baseball teams, the Pittsburgh Pirates, Cincinnati Reds and Milwaukee Brewers all received money under the new system. While the Pirates remained cash-strapped and the Reds stayed tight-fisted, the Brewers cut their payroll in 2003 and 2004, but stated that they spent the money on player development. The Brewers spent the 2003 and 2004 seasons playing just above .400 baseball, but became playoff contenders in 2007. Perhaps Milwaukee is getting its value after six years, but what about the other two cities? There are several new stadiums for NFL teams and while Pittsburgh, Philadelphia and Seattle have seen the playoffs, Detroit and Arizona have not.[4]

The Detroit NFL franchise stood apart from the other teams with publicly built stadiums who have shown futility. The Lions had a 23–71 record over the first years of the twenty-first century, the worst of any six-year stretch

in NFL history. Lions fans and the local media have waved placards at games attacking the Ford ownership for their ineptitude. However, they have effected little positive change. One blogger recently suggested that the only recourse the fans have is to band together and take action. The fans, he suggested, needed to stop spending money going to the games. This would deprive the team ownership of money and would embarrass them as images of the empty station appeared on television around the country. In addition, the other NFL owners would not be thrilled about the Lions' generating little income for them and might apply pressure for the team owners to sell.

The blogger approached the situations with his team using consumer logic. The expectation was that the team sold a product and that if no one purchased the product the team would suffer financially. The team owners would endure a loss of a great deal of money. In addition, their brethren in the larger corporate entity to which the team belongs, the National Football League, would also suffer financial losses.

While sport is entertainment, the game of a professional sports league today is not a typical consumer product. Unlike a foodstuff or appliance, a game requires the presence of two companies (member teams in the league) in order to be produced. The corporate franchiser, such as the National Football League or major league baseball, needs to have all the games played to keep its schedule and maintain the integrity of its franchise. Thus, a rejection of a team's games can not drive the product from the market as it might any other consumer good. Unlike a typical consumer product, a new game or product is exceedingly difficult to introduce as an alternative. Most sports leagues are monopolies that control their markets. The corporate franchisers and member companies control the number of teams in the league and dictate who can own a team. The cost of establishing an alternative league would be prohibitive and in recent years such attempts have not been successful.

The boycott of a team's product has not had the desired effect of driving a miserly owner or an owner with poor judgment from control of any team in the past. An individual team in a sports league maintains an "exclusive" geographic market. When team owners face decreases in attendance due to fan dissatisfaction and lack of interest in the product, they do not blame themselves. Instead, they do something that no corporation producing a consumer product could ever get away with: they blame the consumers, complaining about the lack of support for the team from the area fans.

The team owners then embark on a process that borders on extortion. There are two tracks that their complaints travel. Track one involves calling the existing stadium antiquated. This has been followed by an expression of a need for a new building and the expectation that the local taxpayers will pay for it. The alternative track features a complaint about the area. The own-

ers use the low attendance figures to show that they are not making money in the geographical area. They petition their fellow owners for the right to move the company/team to a new geographical area. Then they move.

The moving of a team damages the culture and psychology of a city not as devastatingly but similarly to the dislocation of the company supplying the majority of the jobs in an area. These damages range from the loss of an entertainment event to the loss of feeling like a big league city. No place in the United States knows this experience as well as Washington, D.C. During the first three decades of the National League, Washington had the team owners sell out the franchise twice, eliminating the city's representative in the league. In 1960, Calvin Griffith transferred the team to Minneapolis-St. Paul, Minnesota. A decade later, Robert Short moved the Senators to Arlington, Texas. The city's first representative in the National Football League lasted one season in 1921. The city did gain from the transfer of the Redskins football team from Boston in the mid–1930s.

The past demonstrates that the best hope for fans and city residents is for the league franchiser and team owner to recognize the city's investment. The city invested public funds to build the Washington Nationals stadium, and the fans of the team and residents of the local and regional city expect a return on their investment. Event nights at the stadium recognize groups in the community and build goodwill with them while introducing the people to the game. Activities, including refurbishing baseball diamonds and holding clinics on the sport, give back to the city's residents. These activities also build the team's market through promoting fan interest. These activities also associate the team with serving the community and represent valuable public relations vehicles. These and other types of actions would expand the fan base and the interest in the sport and team within the geographical area.

Obviously, the fans and city view making the playoffs and winning a championship as the most significant returns for their investment. However, scholar Jeffrey Scholes argued that sports, and particularly baseball, offer a type of religious ritual experience that gives fans a tremendous dividend. Each season is a life-cycle vehicle with its beginning full of hope, a mid-season equivalent to mid-life, and the end that comes with death before the renewal of the next season. A religious ritual creates a whole from the integration of the moral impulses of our ethos into the "is" component of experience, our worldview. All would agree that sports are a business (worldview), yet they have values on the field of play, a fair competition summed up in the phrase "the integrity of the game" (ethos). The successful sport offers its fans a balance between the business and play on the field. Scholes observes that for the fans of most small-market teams, business overwhelms the reality of the play on the field. Their teams are perpetually also-rans with the realiza-

tion that they will not make the playoffs coming early in the season. This deprives fans of the ability to enjoy a rich and rewarding mid-life as the team's death comes prematurely.[5]

Scholes noted that the fans of small-market teams are not alone in this disillusionment. Fans of middle-market teams can feel similarly. If the ownership spends in a limited fashion and manages the franchise poorly, as with the aforementioned Detroit Lions, fans of big-market teams (Detroit ranks eleventh) can experience disillusionment. Players leaving teams for larger contracts and owners buying the latest all-star on the market and trading players because of salary considerations disrupts teams and promotes the disillusionment of fans of all sports in all markets. Washington, D.C., is the core of the eighth-ranked regional market. Here's hoping that the owners and their franchise provide the fans and the city with a deserved series of payoffs for their investment in the stadium.[6]

Ironically, even when a team follows much of this formula the city may not reward them. Washington has the franchise that has won the most major league soccer championships. The D.C. United has won four times since the origin of the league in 1996. RFK Stadium has hosted the championship game three times, drawing some of the largest turnouts. The team runs summer and winter academies for youth in the area. The team also has a nonprofit organization that operates four programs for community outreach.

Despite these championships and community activities, the team and city officials did not reach an agreement on building a new stadium. Poplar Point, a 150-acre parkland along the Anacostia River, had been under the control of the National Park Service. The Bush administration and city officials want to promote development in the city to increase the tax base and diminish the amount of federal subsidy to the District. The White House proposed the transfer of this area for a development project despite the opposition of its Department of Interior and the National Park Service.

The group that obtained the operating rights to the D.C. United in early 2007 proposed to build a development over the full extent of the park. They would build a stadium with private funds but expected the city to contribute the costs for infrastructure. The city reportedly balked at the costs for the roads and remediation and would not shoulder the $350 million estimated cost for the public financing of the stadium. City officials eventually issued a Request For Expressions of Interest (RFEI) to develop the area for projects over only 110 acres with 70 acres of that mandated to remain parkland. The D.C. United group chose not to bid because they determined the smaller area left not enough development opportunity to include a privately financed stadium in the mix.[7]

In late 2007, the responses to the RFEI for the Poplar Point area of the

city became public. Only two of the four private plans submitted for the area included a soccer stadium. The value of the stadium as an economic development engine must be quite conditional. This value appears to be dependent as much upon who seeks the new stadium and when they want it as upon where they want they stadium built. As mentioned at the end of Chapter 6, local city officials discussed the possibility of the Washington Redskins' moving back to the District. The team owner would be provided with either the development rights to a large amount of acreage or land ownership of that acreage in Anacostia Park outright in exchange for building a privately financed stadium.

The advocates encased the stadiums in development projects that would transform public parkland into privately owned space. These new private spaces carried the expectation that they would bring tax revenues to the District that would enable the federal government to reduce its annual payment to the city. These stadium/private development projects are emblematic of the exalted place of professional sports in U.S. culture. Professional soccer and football teams are private businesses. Yet, they are being provided with public land from which they will profit from commercial and residential development. In exchange for the land, they have the obligation to construct a stadium, from which they would also earn additional profit.

Both of these deals would represent another rationale for stadium building. The advocates for these stadium projects have linked them with two current trends: privatization and the movement to reduce public infrastructure expenditures. The rationale is similar to the economic development argument except that the public does not own the stadium and offers land rather than footing the bill for the stadium's construction and infrastructure. This new perspective is distinctly different from most of the rationales for building stadiums featured in this book. The stadium would not provide the area with a memorial to a president or to veterans who served their country. Nor would it bring the Olympic Games to Washington. It would be the opposite of the plans that placed a stadium within a recreation area open for the local citizens to use. But those plans represented either Progressive Era or New Deal ideals, or they were the high-minded aspects of the 2012 Chesapeake Coalition's vision.

Chapter Notes

Introduction

1. *Washington Post*, 30 September 2004, A1; *Washington Times*, 30 September 2004, A1; 19 December 2004; 22 December 2004, A1; *Washington City Paper*, 22–28 October 2004, 16–20.

2. Testimony of Natwar M. Gandhi, Testimony on Bill 15–1028, Ballpark Omnibus Financing and Revenue Act of 2004 (includes fiscal impact statement); Letter to Council Chairman Linda W. Cropp Regarding Building a New Baseball Stadium at the RFK Site; Letter to Council Chairman Linda W. Cropp Regarding Certification of a Private Financing Arrangement for a New Baseball Stadium*; Baseball Stadium Cost Re-estimation Study 30 March 2005; Fiscal Impact Statement and Letter Regarding the Ballpark Hard and Soft Costs Cap and Ballpark Lease Conditional Approval and Separate Development Authorization Emergency Amendment Act of 2006*; Letter to Council Chairman Linda W. Cropp on Actions Required for Parking at the New Stadium*; *Washington Post*, 5 December 2005, B1; 13 December 2005, A1; 21 December 2005, B1; *Voice of the Hill*, 12 July 2007, 1; "Parking at New Stadium Will be at a Premium," *WTOPnews.com* 3 August 2007.

3. Green; Walter F. McArdle, "Development of the Business Sector in Washington, D.C., 1800–1973," in *Records of the Columbia Historical Society*, 1973–1974; Bob Arnebeck, "The General and the Plan," DCPages website; http://dcpages.com/cgi-bin/jump.cgi?ID=18 634.

4. Howard Gillette, *Between Justice and Beauty: Race, Planning and the Failure of Urban Policy in Washington, D.C.* (Baltimore, MD: Johns Hopkins University Press, 1995), ch. 1.

5. Carl Abbott, *Political Terrain: Washington, D.C., From Tidewater Town to Global Metropolis* (Chapel Hill: University of North Car-

olina Press, 2000), 51–52; Kenneth R. Bowling, "From 'Federal Town' to 'National Capital': Ulysses S. Grant and the Reconstruction of Washington, D.C.," *Washington History* 14, no. 1 (Spring/Summer 2002): 14–15; C.M. Harris, "Washington's 'Federal City,' Jefferson's 'federal town,'" *Washington History* 12 (2000).

6. Bowling; Abbott; Arnebeck, "The General and the Plan."

7. Arnebeck, "The General and the Plan"; Gillette, 8–11.

8. Bob Arnebeck, "Finding a Place in Early Washington," paper delivered at 2005 D.C. Historical Studies Conference.

9. Gillette, 18–26.

10. Abbott, chapter 3.

11. Elena Guarinello, "The Promise of the Games: Imagination and the Washington, D.C. 2012 Olympic Bid," senior thesis, Bryn Mawr College, 2001.

12. Bowling; Joseph R. Passonneau, *Washington Through Two Centuries: A History in Maps and Images* (New York: The Monacelli Press, 2004), 60–85.

13. United States Navy, "Naval District Washington," at www.ndw.navy.mil/Navy-Yard/History.html; United States Marine Corps, "Marine Corps Barracks, Washington DC" at http://www.mbw.usmc.mil/Newmbw/; "The L'Enfant and McMillan Plans," in *The National Registry of Historic Places* http://www.cr.nps.gov/nr/travel/wash/lenfant.htm; Harpers Ferry Center of the National Park Service, *The National Parks: Shaping the System* (Washington, D.C.: Department of the Interior, 2005).

14. Public Law 92–578 (86 Statute 1266); http://www.nps.gov/archive/paav/pa_visit. htm; John Nolen, Jr., "Some Aspects of Washington's Nineteenth Century Economic Development," in *Records of the Columbia Historical Society*, 1973–1974; McArdle; Record Group

233, 68th Congress, Committee Papers, Various Subjects, Representative John W. Langley speech; *Report of Public Building Commission*, January 3, 1924; Miriam F. Stimpson, *A Field Guide to Landmarks of Modern Architecture In The United States* (Englewood Cliffs, NJ: Prentice Hall, Inc., 1985).

15. George J. Olszewski, *A History of the Washington Monument, 1844–1968* (Washington, D.C.: National Park Service, 1971).

16. American Federation of Government Employees, "AFGE At a Glance," http://www.afge.com/Index.cfm?Page=AFGEFacts; James B. Burns, "The First Ten Years, Depression and War," *Government Standard* (September 2001), Paul C. Light, "The True Size of Government," *Government Executive* (January 1, 1999); Congressional Budget Office, "Changes In Federal Employment: An Update" (May 2001); Randall G. Holcombe, "Federal Government Growth Before The New Deal," *The Freeman* (September 1, 1997).

17. Alan Lessoff, *The Nation and Its City: Politics, "Corruption" and Progress in Washington, D.C. 1861–1902* (Baltimore: Johns Hopkins University Press, 1994), 165–174.

18. Lessoff, 140–160; Information Please® Database, © 2007 Pearson Education, Inc.

19. Abbott, 110–124; *Washington Post*, "Post Sees Straggling Town Become Metropolis in 50 Years," 6 December 1927, D1-D9; Ed Hatcher, "Washington's Nineteenth-Century Citizens' Associations and the Senate Park Commission Plan," *Washington History* (Fall/Winter 2002); Michael R. Harrison, "The 'Evil of the Misfit Subdivisions': Creating the Permanent System of Highways of the District of Columbia," *Washington History* (Spring/Summer 2002); Cultural Tourism D.C., "The John A. Wilson Building," at http://www.culturaltourismdc.org/info-url3948/info-url_show.htm?doc_id=212986&attrib_id=7967; "Historic Neighborhoods" at http://www.culturaltourismdc.org/homepage2549/index.htm; Eric Niiler, "Mercury Contamination Plagues D.C. Schools," *Morning Edition* (National Public Radio, March 8. 2005); V. Dion Haynes, "Spending on Underused Facilities Saps D.C. Schools, Study Finds," *Washington Post*, February 7, 2006; "Bureaucratic Failure," *NBC-TV Nightly News*, October 23, 1970; National Association to Restore Pride In America's Capital, "Major Issues: Public Housing," at http://www.narpac.org/PWH.HTM; Henri E. Cauvin, "Pair Sentenced in Killing of Teen Witness," *Washington Post*, January 20, 2007.

20. Passonneau; *Washington Post*, 6 December 1927; Ronald M. Johnson, "From Romantic Suburb to Racial Enclave: Le Droit Park, Washington, D.C., 1880–1920," *Phylon*

45, no.4 (1984): 264–270; Audrey Elisa Kerr, *The Paper Bag Principle: Class, Colorism, and Rumor and the Case of Black Washington, D.C.* (Knoxville: University of Tennessee Press, 2006), chapter 3.

21. Nolan; McArdle.

22. Constance McLaughlin Green, *Washington Village and Capital, 1800–1878* (Princeton, NJ: Princeton University Press, 1962), 340–346; Green, *Washington Capital City, 1879–1950* (Princeton, NJ: Princeton University Press, 1963), 212–226.

23. Jason DeParle, "The Worst City Government in America," *Washington Monthly* (January, 1989); Matthew Cella, "D.C. Officials earn in the city, live in the suburbs," *The Washington Times* (July 19, 2006).

24. Cambell Gibson and Kay Jung, "Historical Census Statistics on Population Totals by Race, 1790 to 1990 and By Hispanic Origin" (Washington, D.C.: Census Bureau, September 2002); Campbell J. Gibson and Emily Lennon, "Historical Census Statistics on the Foreign-born Population of the United States: 1850–1990" (Washington, D.C.: Census Bureau, 1999); *Ancestry in America* (Millerton, NY: Grey House Publishing, 2003).

25. Kathryn Allamong Jacob, *Capital Elites: High Society in Washington D.C., After the Civil War* (Washington: Smithsonian Institution Press, 1995).

Chapter 1

1. *Washington Post*, August 1888.

2. *Washington Post*, 11 January 1903, 32.

3. Robert F. Burk, *Never Just a Game: Players, Owners and American Baseball to 1920* (Chapel Hill: University of North Carolina, 1994), 104–114; *Washington Post*, 10 October 1883, 4; 21 October 1883, 1; 13 December 1883, 2; 4 May 1884, 2; 11 May 1884, 2; 3 August 1884, 2.

4. *Washington Post*, 22 March 1885, 2; 25 June 1885, 1; 29 November 1885, 2; Sandborn Maps of Washington District of Columbia, National Archives and Records Administration, Microfilm of District of Columbia Building Permits, 1884, 1886.

5. Microfilm of Permits, 1886–1887; *Washington Post*, 21 January 1886, 2; 28 February 1886, 2; 24 August 1886, 2; 5 September 1886, 2.

6. Morris A. Bealle, *The Washington Senators* (Washington, D.C.: Columbia Publishing Co., 1947); "Irish Neighborhoods in Old Washington," at http://www.rootsweb.com/~dcgenweb/irish.html; Margaret H. McAleer, "The Green Streets of Washington: The Expe-

rience of Irish Mechanics in Antebellum Washington," in Francine Curro Cary, ed., *Urban Odyssey: A Multicultural History of Washington, D.C.* (Washington, D.C.: Smithsonian Institution Press, 1995); Howard Gillette Jr., and Alan M. Kraut, "The Evolution of Washington's Italian American Community," in Cary; Michael R. Harrison, "The 'Evil of the Misfit Subdivisions': Creating the Permanent System of Highways of the District of Columbia," *Washington History* 14, no.1 (Spring/Summer 2002): 27–38; LeRoy O. King, Jr., *One Hundred Years of Capital Traction: The Story of Streetcars In the Nation's Capital* (Washington, D.C.: Taylor Publishing Company, 1972), 1–15; http://www.ac.wwu.edu; http://chicago.cubs.mlb.com; *New York Times*, 11 August 1887, 3; *Washington Post*, 30 April 1889, 6.

7. *Sporting News*, 13 November 1886, 1; 20 November 1886, 4.

8. *Sporting News*, 31 December 1886, 1.

9. *Washington Post*, 23 January 1887, 2; 14 February 1887, 2; *Sporting News*, 3 December 1887, 1; *Sporting Life*, 5 October 1887, 7; 16 November 1887, 3.

10. City Directory of Washington, D.C. 1880–1900; *Washington Post*, 30 August 1888, 2; 31 August 1888, 6; 15 February 1890, 5.

11. *Washington Post*, 16 January 1889, 6; 27 January 1889, 2; 27 April 1889, 3; 14 May 1889, 2; *Sporting News*, 9 February 1889, 3; 11 May 1889; *Sporting Life*, 9 January 1889, 5; 5 June 1889; Players statistics are from the website: Baseball-reference.com.

12. Baltimore and Ohio Rail Road Company, *Guide to Washington* (Washington, D.C.: Charles O. Scull, Co., 1889).

13. *Washington Post*, 6 August 1889, 2; *Sporting News*, 25 January 1890; 8 March 1890, 1; *Sporting Life*, 11 December 1889, 3; 25 December 1889, 6; at National Archives and Records Administration, hereafter NARA, RG 21, District Courts: District of Columbia Equity Cases: Case #12612, Docket 31, Michael B. Scanlon vs. Washington National Base Ball Club, note on jacket that a copy was made for the Senate Committee. Scanlon & Mary C. Cronin v. Walter F. Hewett, Luther E. Burket, Frank E. O'Brien and Alvin W. Coleman; Case #12728, Scanlon vs. Snow; Case # 14,183 Docket 34: Charles, Walter Hewett, Laura G. Robinson, Edward L. Robinson and Rachel M. Hewett vs. Luther Burket, Walter F. Hewett and Rachel M. Hewett, Trustees of Robert C. Hewett Estate.

14. *Washington Post*, 8 December 1892, 3.

15. One year earlier, the players, through their "union" known as the Brotherhood of Professional Base Ball Players, negotiated with the NL and American Association (AA) own-

ers to make changes in the current operation of professional baseball. However, they gained little ground in their attempt to abolish the classification system and its ceilings on player salaries, and end the practice of selling players. The players decided to form a rival major league for the 1890 season. *Washington Post*, 11 September 1890, 6.

16. *Washington Post*, 23 August 1878, 4; 3 August 1881, 1; 8 September 1885, 4; 20 January 1891, 6; 26 September 1915, 12; Cultural Tourism D.C., African American Heritage Trail; *Baltimore Sun*, 6 August 1867; Wilhelmus Bogart Bryan, *A History of the National Capital*, vol. 2: *1815–1878* (New York: The MacMillan Company, 1916), 591; James M. Goode, *Capital Losses: Cultural History of Washington's Destroyed Buildings* (Washington, D.C.: Smithsonian Institution Press, 1979).

17. *Washington Post*, 15 May 1880, 4; 2 June 1887, 4; 1 August 1888, 6; 4 August 1888, 1; 5 August 1888, 1; 15 August 1890, 6; 21 March, 1891, 2; 6 December 1927, D1; Hopkins Map 41, Washington DC 1887; Ronald M. Johnson, "From Romantic Suburb to Racial Enclave: Le Droit Park, Washington, D.C. 1880–1920," *Phylon* 45, no.4 (1984): 264–270; Audrey Elisa Kerr, *The Paper Bag Principle: Class, Colorism, and Rumor and the Case of Black Washington, D.C.* (Knoxville: University of Tennessee Press, 2006), chapter 3.

18. District of Columbia Building Permits, No. 1568, February 16, 1891; *Washington Post*, 20 January 1891, 6.

19. *Washington Star*, 17 January 1891, 6; *Washington Post*, 15 March 1891, 6; 19 April 1891, 3.

20. *Washington Star*, 14 December 1891, 10.

21. *Washington Star*, 2 October 1892, 3; *Washington Post*, 2 October 1892, 6.

22. *Washington Star*, 21 February 1893, 6; *Washington D.C. City Directory 1900*.

23. *Washington Post*, 10 March 1893, 3.

24. *New York Times*, 28 February 1894, 6.

25. *Washington Star*, 10 October 1894, 6.

26. *Washington Post*, 2 March 1894, 6.

27. *Washington Star*, 20 October 1894, 4; *Washington Post*, 7 October 1894, 15; 9 October 1894, 6; 14 October 1894, 15; 17 October 1894, 7; 21 October 1894, 6; 12 November 1894, 6; *New York Times*, 19 October 1894, 3; Steve Holroyd, "The First Professional Soccer League in the United States: The American League of Professional Football (1894)," at www.sover.net/~spectrum/alpf.html.

28. *New York Times*, 12 October 1894, 6; 13 October 1894, 6; 14 October 1894, 7; 19 October 1894, 3.

29. *Sporting Life*, 28 March 1896, 5.

30. *Washington Post*, 8 April 1894, 15; 27

May 1894, 6; 10 June 1894, 12; Peter Nye, *Hearts of Lions: The History of American Bicycle Racing* (New York: W.W. Norton & Co., 1988).

31. *Washington Star*, 28 March 1896, 19.

32. *Washington Post*, 3 May 1891, 10; 14 April 1896, 12; 31 May 1896, 9; "Palisades of the Potomac" map in Palisades Folder Historical Society of Washington, D.C.; Sandborn Maps of Washington District of Columbia, NARA, Microfilm of District of Columbia Building Permits, 13 April 1896 Number 1407; Donald E. Gerrety, University of Maryland history course paper from 1979 titled "Palisades: An Early Suburb of Washington."

33. At NARA RG 21, District Courts: District of Columbia Equity Cases: Case Number 21152: Martha M. Read vs. Jacob P. Clark et al.

34. *Sporting Life*, 7 March 1896, 15; 4 April 1896, 23.

35. *Washington Post*, 19 April 1896, 20; 3 May 1896, 18; 25 May 1896, 9; 30 May 1896, 9; 31 May 1896, 9. The track drew many fans to the meet that served as the conclusion to the Racing Board's National Circuit races, which determined the top male rider of the year. The racing season continued that fall with a six-race card that also included local amateurs trying to break speed records and seven races under the auspices of the National Bicycle Club, one of the foremost African American organizations in Washington.

36. *Washington Post*, 11 July 1896, 8; 28 September 1896, 7; 4 October 1896, 9; 24 October 1896, 2; *Sporting Life*, 28 November 1896.

37. *Washington Post*, 10 January 1897, 8; 7 February 1897, 4; 28 February 1897, 9; 4 April 1897, 2; 5 June 1897, 12; 6 June 1897, 10; 22 June 1897, 10; *Sporting Life*, 1 May 1897; 5 June 1897; 17 July 1897, 21; *Washington Star*, 12 June 1897, 23.

38. *Sporting Life*, 24 July 1897, 21; 4 September 1897, 16; *Washington Star*, 17 July 1897, 13; 21 August 1897, 23; 18 September 1897, 20; 25 September 1897, 18; 26 February 1898, 20.

39. *Sporting Life*, 23 October 1897, 15; 13 November 1897, 14.

40. *Sporting Life*, 29 January 1898, 16; 26 March 1898, 16; 2 April 1898, 16.

41. *Sporting Life*, 9 April 1898, 14; *Washington Star*, 30 April 1898, 20; 14 May 1898, 7; 11 June 1898, 21 16 July 1898, 12; 19 July 1898, 9; 23 July 1898, 10; 30 July 1898, 10; 9 August 1898, 7; 13 August 1898, 8; 16 August 1898, 9. At this time other cities invested in bicycle tracks. Indianapolis built a new track for $20,000 and Baltimore's new track near Lake Montebello at eastern edge of the city seated 15,000 people.

42. *Washington Post*, 1 December 1898, 10; 11 December 1898; 26 January 1899, 8; *Sporting News*, 1 October 1898, 7; 29 October 1898, 7; 17

December 1898, 8; 18 February 1899, 8; *Washington Star*, 1 October 1898; 8 October 1898, 9.

43. *Washington Post*, 2 April 1899; 8; 29 June 1899, 8: 5 July 1899, 9; *Sporting News*, 15 April 1899; 29 April 1899; 27 May 1899, 8; 24 June 1899, 8; 15 July 1899, 8; *Washington Star*, 20 May 1899; 7; 10 June 1899, 7; 14 July 1899, 9; 5 August 1899, 8.

44. *Washington Post*, 23 September 1899; 7; 26 March 1900, 9; 11 December 1900, 2.

45. Gerrety, "Palisades: An Early Suburb of Washington"; District Courts: District of Columbia Equity Cases: Equity Case Number 21235, Hosea B. Moulton, trustee versus Jacob P. Clark and other Clark Brothers; District of Columbia Microfilm of Building Permits.

Chapter 2

1. *Washington Post*, 27 February 1900, 8; 4 July 1900, 8; 9 July 1900, 8; 22 July 1900, 9; 6 February 1901, 8; *Washington Star*, 21 March 1901, 9; National Archives and Records Administration, Microfilm of District of Columbia Building Permits, March 12, 1901, number 1262 (hereafter D.C. Permits).

2. Historical Society of Washington, D.C., Howard S. Fisk Bicycle Club Collection, 1887–1905, program from the Coliseum; *Washington Post*, 13 May 1901, 8; 19 May 1901, 9; 22 August 1901, 8; 7 September 1901, 6; 13 September 1901, 8; 19 September 1901, 8; *Washington Star*, 11 May 1901, 7; 26 June 1901, 9; 20 July 1901, 8.

3. *Washington Star*, 28 September 1901, 8; 6 October 1901, 9; 15 October 1901, 6; 24 February 1902, 9; 10 March 1902, 9; *Washington Post*, 6 April 1902, 24; 20 April 1902, 24; 7 May 1902, 9.

4. *Washington Post*, 26 May 1902, 8; 31 May 1902, 8; 25 June 1902, 8; 27 June 1902, 8; *Washington Star*, 4 April 1902, 7; 14 May 1902, 8; 17 May 1902, 22; 19 May 1902, 9; 21 May 1902, 9; 22 May 1902, 9; 23 May 1902, 22; 12 June 1902, 9; 15 June 1902, 6; 19 June 1902, 9; 26 June 1902, 2.

5. *Washington Post*, 8 July 1902, 8; 10 July 1902, 8; 16 July 1902, 8; 26 July 1902, 4; 7 August 1902, 8; 14 August 1902, 2; *Washington Star*, 7 July 1902, 7; 8 July 1902, 8; 16 July 1902, 7; 21 July 1902, 9; 24 July 1902, 9; 26 July 1902, 9; 4 August 1902, 9; 7 August 1902, 9; 8 August 1902, 9.

6. *Washington Post*, 20 April 1903, 8; 20 May 1903, 9; 10 June 1903, 8; 11 June 1903, 8; 17 June 1903, 8; 22 June 1903, 3; 27 September 1903, 8; *Washington Star*, 21 May 1903, 9; 23 June 1903, 9; 26 June 1903, 8; 8 July 1903, 3; 19 July 1903, 9; 26 July 1902, 9; 23 September 1903, 9.

7. *Washington Post*, 20 March 1904, S2; 20 November 1907, 5; *Boston Daily Globe*, 14 January 1904, 8; 17 January 1904, 21; 21 January 1904, 9; 22 February 1904, 4; 1 March 1905, 11; 8 September 1905; *Chicago Daily Tribune*, 11 February 1906, A4.

8. D.C. Permits, April 1905; 1907; *Washington Post*, 30 April 1905, S2; 22 September 1905, A1; 18 November 1905, 2.

9. D.C. Permits, 1907, Plat 1056; Washingtonia Room, D.C. Public Library, Baist Maps of Washington D.C., 1903, 1909.

10. Joe Santry and Cindy Thomson, "Byron Bancroft Johnson," in David Jones, ed.. *Deadball Stars of the American League* (Dulles, VA: Potomac Books, Inc., 2006), pp. 390–392; http://www.baseball-reference.com/bullpen/Ban_Johnson; Jerold Casway, *Ed Delahanty in the Emerald Age of Baseball* (Notre Dame, IN: University of Notre Dame, 2004).

11. *Sporting News*, 1 September 1900, 5; 22 September 1900, 11; 13 October 1900, 1; 2 February 1901, 1; *Chicago Daily Tribune*, 13 January 1901, 18; *Washington Post*, 22 December 1900, 8; 5 February 1901, 8; *Washington Star*, 10 November 1900, 7; 14 November 1900, 9; 30 November 1900, 7; 26 December 1900, 8; 30 December 1900, 8; 15 January 1901, 9; 17 January 1901, 8; 18 January 1901, 8; 21 January 1901, 7; 26 January 1901, 7.

12. *Washington Post*, 17 February 1901, 8; 9 March 1901, 8; *Washington Star*, 2 May 1900, 8; 6 February 1901, 8; 13 February 1901, 8; 18 February 1901, 7.

13. *Washington Post*, 21 March 1901, 8; 1 April 1901, 8; 2 April 1901, 8; *Washington Star*, 27 March 1901, 7; 30 March 1901, 7; 13 April 1901, 7; 21 April 1901, 7; *Sporting News, Sporting Life*.

14. *Washington Post*, 16 September 1901, 8; 30 September 1901, 8; 20 October 1901, 9; 22 October 1901, 8; 29 October 1901, 8; 30 October 1901, 8; *Washington Star*, 10 June 1901; 17 August 1901, 8; 30 October 1901, 9; 2 November 1901, 9; *Sporting News*, 28 September 1901, 5; 12 October 1901, 1; 19 October 1901, 2; 2 November 1901, 7.

15. *Washington Star*, 23 December 1901; 1 March 1902, 9; 24 April 1902, 9; 30 May 1902, 9; 25 June 1902, 9; 16 July 1902, 9; 1 August 1902, 9; *Washington Post*, 2 November 1901, 8; 2 February 1902, 24; 16 March 1902, 8; 17 March 1902, 8; 24 April 1902, 8; *Sporting News*, 2 August 1092, 7; 25 December 1902, 8.

16. *Sporting News*, 7 March 1903, 6; 21 March 1903, 7; 9 May 1903, 4; *Washington Star*, 28 February 1903, 9; 28 March 1903, 9; 2 April 1903, 9; 20 April 1903, 9; 23 April 1903, 9; 14 May 1903, 9; 2 June 1903, 9; 3 June 1903, 9; 5 June 1903, 9; 6 June 1903, 9; *Washington Post*, 4 January 1903, 28; 10 February 1903, 8; 20 February 1903, 10; 22 February 1903, 28.

17. *Sporting News*, 8 August 1903, 4; 15 August 1903, 7; 22 August 1903, 7; 10 October 1903, 3;17 October 1903, 7; *Washington Star*, 31 July 1903, 9; 14 August 1903, 3; 9 September 1903, 9; 29 September 1903, 4; 15 October 1903, 4; *Washington Post*, 8 August 1903, 3; 15 August 1903, 7; 16 August 1903, E12; 23 August 1903, E12; 30 August 1903, E12; 4 September 1903, 8.

18. *Sporting News*, 22 November 1903, H10; *Washington Post*, 24 January 1904, E12; 31 January 1904, E12; 20 March 1904, 8; 23 March 1904, 8; 24 March 1904, 9; *Washington Star*, 26 February 1904, 9; 9 March 1904, 9.

19. *Sporting News*, 12 April 1904, 7; May 1905; *Washington Star*, 13 April 1904, 4; 15 April 1904, 4; 3 June 1904, 8; 21 July 1904, 9; 31 July 1904, 9; 18 May 1905, 17; *Washington Post*, 15 April 1904, 8; 10 January 1905, 8; Tom Deveaux, *The Washington Senators, 1901–1971* (Jefferson, NC: McFarland & Co., 2001), 10–15.

20. *Washington Star*, 29 July 1909, 8; 9 September 1909, 8; *Boston Daily Globe*, 15 August 1909, 41; *Chicago Daily Tribune*, 31 July 1909, 10; 7 September 1909, 18; 28 September 1909, 12; *Washington Post*, 26 February 1906, 8; 22 September 1909, 8; 25 September 1909, 8; 1 October 1909, 8; 2 October 1909, 9; 3 October 1909, S1; 22 October 1909, 8; 5 November 1909, 8; *Atlanta Constitution*, 16 December 1909, 13; Deveaux.

21. *Washington Post*, 18 March 1911, 1; 18 March 1911, 6; 19 March 1911, S1; 21 March 1911, 8; 13 April 1911, 1; *Washington Star*, 18 March 1911, 1; 19 March 1911, 1.

Chapter 3

1. Annual report of the chief of engineers to the Secretary of War for the years, 1880 to 1905 (Washington, D.C.: Government Printing Office); *Washington Post*, 13 February 1881, 1; 14 February 1881, 1; 16 February 1897, 4; 25 February 1897, 9; 4 March 1897. 4; 28 July 1903; *Washington Star*, 10 December 1881, 4; 15 December 1881, 3; 13 April 1886, 4; 10 February 1887, 5; 16 July 1891, 1; 24 October 1891, 5; *Guide to Federal Records in the National Archives of the United States, 1789–1988*: Records of the Office of Public Buildings and Public Parks of the National Capitol; National Park Service, "Park Report: Potomac Park," Part 2, History at http://www.nps.gov; 11/10/2006.

2. "Col. Symons' Long Leave," *Washington Post*, 26 April 1904, 2; "Free Garden Grounds," 20 February 1905, 5; "Tasks For

Bromwell," 23 September 1905, S1; "Cosby Is Advanced," 15 March 1909, 1.

3. *Washington Post,* 5 December 1905, 8; 6 December 1905, 8; 10 December 1905; S2; "Cosby Is Advanced," 15 March 1909, 1; 14 November 1911, 2; *Who's Who in the Nation's Capital 1909.*

4. *Chicago Record-Herald,* November 1905; *Los Angeles Times,* 25 November 1907, 16; 23 November 1910, 10; *Atlanta Constitution,* 3 December 1911, A6; *Washington Star,* 1 April 1904, 3; 29 November 1908, 1; 22 November 1909, 6; 5 May 1910, 17; http://www.ncaa.org/about/history.html.

5. *New York Times,* 2 December 1902, 1; 8 November 1904, 6; 31 December 1905, 9; 30 June 1906, 10; 1 January 1908, 10; *Chicago Tribune,* 1 February 1908, 6; *Washington Post,* 2 December 1901, 8; *Washington Star,* 1 December 1910, 17; http://www.phillylovesarmynavy.com/; Robert M. Ours, "A Brief History of College Football," *College Football Encyclopedia* at www.footballencyclopedia.com/cfeintro.htm.

6. *Washington Post,* 4 September 1913, 3; *Washington Star,* 9 July 1913, 9; *Boston Globe,* 29 November 1913, 7; *New York Times,* 4 September 1913, 10; Washington Chamber of Commerce Annual Report, 1913, at Washingtonia Collection; Annual Report of Fine Arts Commission, 1914; Annual report of the chief of engineers to the secretary of war for the years 1913–1915 (Washington, D.C. Government Printing Office).

7. "Succeeds Col. Cosby," *Washington Post,* 7 August 1913, 3; "Free Baths In Park," 29 July 1914, 14; "Finer Capital Is Aim," 29 November 1914, 3: "More Beauty For City," 20 June 1915, 7; "Wilson Retains Col. Harts," 18 August 1915, 12.

8. *Washington Post,* 12 July 1914, R3; 25 July 1914, 14; 8 November 1914, E4; 30 May 1915, 9; 31 May 1915, 6; 4 December 1915, 4; 20 February 1916, R1; 31 March 1916, 5; 22 April 1916, 5; 9 February 1917, 2; Annual Report of Fine Arts Commission, 1914 and 1916; *Washington Star,* 13 January 1913, 11; 9 July 1913, 9; 19 February 1916, 2; 30 March 1916, 2; 23 July 1916, A10; 25 October 1916, 3; 3 June 1917; 22 February 1918; 24 July 1920, 3.

9. "District's Playgrounds for Grown-Ups," *Washington Post,* 15 May 1921, 60; *Who's Who in the Nation's Capital 1925.*

10. *Washington Post,* 25 August 1921, 9; 21 July 1925, 24; 14 October 1925, 22; 18 November 1925, 6; 21 November 1925, 1; 29 November 1925, 1; 3 January 1926, 1; 13 February 1927, 2; 11 May 1927, 1; 21 March 1928, 20; *Washington Star,* 4 January 1923, 21; 1 April 1923, 2; 27 February 1926, 2; Washington Chamber of Commerce, *Annual Report of President Albert*

Schulteis For the Year 1922 (Washington, D.C., 1923); Washington Board of Trade, *Annual Report for 1927, 1928, 1929* (Washington, D.C.); Seventieth Congress, Second Session, *Congressional Record,* Volume 75, Part 9 (Washington, D.C.: Government Printing Office, 1929).

11. *Washington Post,* 22 November 1931, M6; 21 November 1932, 18; 25 April 1934, 17; *Washington Star,* 4 January 1923, 21; 1 April 1923, 2; 27 February 1926, 2.

12. Seventy-Second Congress, First Session, *Congressional Record,* Volume 75, Part 9 (Washington, D.C.: Government Printing Office, 1932), 9444–45 *Washington Post,* 21 November 1932, *Chicago Tribune,* 17 March 1935; 9 April 1936, 27.

13. Letter from Frederic Delano to Harold Ickes, 9 May 1934; Records of Arno Cammer, 1922–1940, RG 79, National Archives, College Park; *Washington Post,* 22 November 1931, M6; 25 April 1934, 17; *Washington Star,* 13 January 1935, A2; 8 February 1935, B1; 15 February 1935, 1; 27 April 1935, A16; 29 June 1935, A16; "Mary Thersa Norton" in Commission on the Bicentenary of the U.S. House of Representatives by the Office of the Historian, U.S. House of Representatives, *Women in Congress, 1917–1990* (Washington, D.C. U.S. Government Printing Office, 1991).

14. *Washington Star,* 1 March 1936, A2; 1 January 1937, A9; 14 January 1937, A2; 24 April 1937; *Times,* 30 November 1937; http://www.haruth.com/RedskinsHailtotheRedskins.html.

15. *Who's Who in the Nation's Capital 1933*; "Application for Membership," Partridge, William, Washington, D.C. Chapter, 29 December 1921 from the American Institute of Architects, The Octagon House, Washington, D.C.; *Washington Star,* 6 January 1938; 3 March 1938; 22 May 1938, A5; 12 June 1938, C9; 28 August 1938, B1; 17 February 1939.

Chapter 4

1. Colonel Charles S. Bromwell, "Annual Report of the Office of Buildings and Grounds," *Annual Report of the Chief of Engineers United States Army 1906* (Washington, D.C.: Government Printing Office, 1906), 214.

2. *Washington* Post, 13 December, 1921, 12; 22 December 1921, 15; New York Times, 30 December 1922, 16; 1 December 1924, 26.

3. *New York Times,* 11 December 1920, 10; 6 April 1925; 6; 22 November 1925, XX1.

4. *New York Times,* 1 October 1925, 18; 22 November 1925, XX1; 4 July 1926, XX16; Letter from U.S. Grant III to the Librarian of the American Civic Association dated 1 December 1931, in RG 79, National Park Service, Entry

115A, National Capital Region Subject Files, 1924–1951, Box 36.

5. House of Representatives, "Plans and Designs For Roosevelt Memorial," *Report No. 1078*, January 6, 1925 (Washington, D.C. 1925); 68th Congress, Second Session, *Journal of the House of Representatives* (Washington, D.C.: Government Printing Office, 1924), 146.

6. RG 79, Entry 115A, Roosevelt Memorial Folder, Roosevelt Memorial Association Annual Report 1926; *Washington Post*, 30 November 1926, 22; 1 December 1926, 6; 7 December 1926, 24; Washington Board of Trade, *Annual Report 1926–1932* (Washington, D.C.: Washington Board of Trade); http://www.bot.org/about/who/; Sixty-ninth Congress, Second Session, *Congressional Record*, Vol. 68, 200.

7. *Washington Star*, 10 January 1926, 1; 26 March 1928, 36; 26 October 1928, 22; 4 December 1929, 17; *Who's Who in the Nation's Capital 1927* (Who's Who), 440; *Annual Report*.

8. Roosevelt Memorial folder, Lt. Colonel Joseph I. Mullen to Colonel U.S. Grant III, letter of 12 October 1929; Martin Muller, *AIA Guide to the Architecture of Washington, D.C.* (Washington Chapter of the American Institute of Architects, 2005); *Washington Star*, 3 April 1929, 8.

9. Roosevelt Memorial Folder, 36th NCPPC Meeting 29 September 1929; 40th NCPPC Meeting, 17 January 1930; *Washington Post*, 5 October 1931, 16.

10. "Memorandum with Reference to Proposed Sites for A Memorial to Thomas Jefferson in the National Capital," 8 August 1935, B143–145, Reel 105, Olmsted Associates Papers, Manuscript Division, Library of Congress (Olmsted Associates Papers in future references).

11. 75th Congress, 1st Session, House of Representatives Document Number 367, "Report of the Thomas Jefferson Memorial Commission" (Washington, D.C.: Government Printing Office, 1937).

12. *Washington Post*, 6 December 1936, M18; *Washington Star*, 10 December 1936, B1; Kay Fanning, "On Kimball and the Jefferson Memorial," Symposium at University of Virginia on November 19, 1995.

13. *Washington Star*, 13 February 1937; *Washington Post*, 13 November 1949, B6.

14. "Facts From the Fine Arts Commission," *Magazine of Art* 31 (May 1938): 348.

15. 75th Congress, 3rd Session, House of Representatives Document Number 699, "Report of the Thomas Jefferson Memorial Commission" (Washington, D.C.: Government Printing Office, 1938), 6–7; 75th Congress, 3rd Session, House of Representatives Document Number 2489, "Thomas Jefferson Memorial

Report," (Washington, D.C.: Government Printing Office, 1938), 2–3.

16. Frederick A. Gutheim, "Fools On All Sides," *Magazine of Art*, 30.2 (September 1937): 529–530.

17. *Washington Post*, 15 December 1936, X17; *Washington Star*, 6 January 1937, A13.

18. *Washington Post*, 18 April 1937, 22 October 1937, 2; *Washington Star*, 18 April 1937, A6.

19. "Thomas Jefferson Memorial Report," 3–5; "Jefferson Memorial raises stormy discussion," *Architectural Record* 81 (June 1937): 24–26.

20. *Washington Star*, 13 November 1944, A1.

21. *Ibid.*, 14 November 1944, 6; *Washington Post*, 14 November 1944, 1; Report dated 1 November 1944, B142–143, Reel 104, Olmsted Associates Papers.

22. Eleanora W. Schoenebaum, ed., *Political Profiles: The Truman Years* (New York: Facts On File, 1978), 36.

23. http://bioguide.congress.gov/scripts/biodisplay.pl?index=W000257.

24. *Washington Star*, 15 November 1944, A1; 16 November 1944, A1; 17 November 1944, A17.

25. *Washington Star*, 17 November 1944, A1; 18 November 1944, A1; 19 November 1944, M1.

26. 78th Congress, Second Session, "Joint Resolution To Consider A Site and Design For A National Memorial Stadium to be Erected In The District of Columbia," (Washington, D.C.: Government Printing Office, 1944).

27. *Washington Star*, 20 March 1945, B5.

28. *Washington Star*, 22 March 1945, B1.

29. *Washington Star*, 1 April 1945, B12; Letter from Osborn Engineering Company to Senator Harold H. Burton in National Memorial Stadium Commission for the District of Columbia, Box 40, Folder 17; The Papers of Harold H. Burton, Manuscript Division, Library of Congress (Burton papers in future references).

30. *Washington Post*, 11 April 1945, B9.

31. 79th Congress, First Session, *Congressional Record*, Volume 91, Part 6, (Washington, D.C.: Government Printing Office, 1945), 1945; "Senator Harry Flood Byrd of Virginia, The Pay-As-You-Go Man," http://www.fhwa.dot.gov/infrastructure/byrd.htm; Congressional Biography, Harry Flood Byrd.

32. 79th Congress, First Session, Report #466, "Preliminary Report of National Memorial Stadium Commission" (Washington, D.C.: Government Printing Office, 1945); Senate Bill 1174 in Burton papers.

33. H.A. Kuljian & Company, "Proposed National Memorial Stadium," 26 September 1945 in National Glass?National Memorial Stadium folder, Box 68, Office of the Secretary

Records, 1925–1949; RU46, Smithsonian Institution Archives, Washington, D.C. (Smithsonian Archives in future references.)

34. *Ibid.*, U.S. Senate, S.J. Resolution 83, "Authorizing the Federal Works Administrator To Advance Discretionary Apportionment Funds To Be Used For The Purpose Of Making Plans For the National Memorial Stadium As A Postwar Project" (Washington, D.C.: Government Printing Office, 1945); 79th Congress, First Session, *Congressional Record*, Volume 91, Part 8 (Washington, D.C.: Government Printing Office, 1945), 10253; Part 9, 11548; "Tough Cookie," *Time* 22 April 1940 at http://www.time.com/time/magazine/article/0,917,763843,00.html; *Hispanic Americans in Congress*, Dennis Chavez; Washington *Star*, 21 November 1945, A1; 22 November 1945, 5.

35. *Washington Star*, 21 November 1945, A1.

36. Commission on Fine Arts, "Report adopted at meeting of May 14, 1946."

37. *Washington Star*, 29 January 1947, A1.

38. *Washington Post*, 17 April 1949, M1; *Washington Star*, 17 April 1949, A1; 25 April 1949, A1.

39. Eighty-First Congress, First Session, H.R. 4325; Roger W. Jones to Gilmore D. Clarke letter of 12 May 1949; A.E. Demaray to Frank Pace, Jr. letter of 20 May 1949; Gilmore D. Clarke to Roger W. Jones letter of 25 May 1949 in the U.S. Grant III Papers.

40. *Washington Post*, 29 December 1949, 15.

41. *Washington Star*, 26 March 1950, A1.

42. *Washington Post*, 11 May 1951, B1.

43. *Washington Post*, 11 February 1954, 12.

44. National Capital Planning Commission, "Preliminary Report On Sites for National Memorial Stadium," 8 November 1956; *Washington Post*, 14 February 1955, 13; 28 June 1956, 1; 13 July 1956, 54; 4 August 1956, 19; 22 August 1956, 17; 84th Congress, Second Session, House of Representatives, "Amending Public Law 523 of the 78th Congress Entitled Joint Resolution To Consider A Site and Design For A National Memorial Stadium to be Erected In The District of Columbia," House Report Number 2615 (Washington, D.C.: Government Printing Office, 1956).

Chapter 5

1. Speech of Superintendent Harts, 22 June 1914 in Records of the Office of Public Buildings and Public Parks of the National Capital (Office of Public Buildings in future references), Box 10, Entry 97.

2. Fine Arts Commission, *Report of the National Commission of Fine Arts 1913–1917* (Washington, D.C.: Government Printing

Office, 1917); "An Appeal to the Enlightened Sentiment of the People of the United States For the Safeguarding of the Future Development of the Capital of the Nation," March 1916 in CLC F194.5 Washington D.C. Pamphlets Part 1 at Library of Congress.

3. 64th Congress, First Session, House of Representatives, "Development of East Potomac Park" (Washington, D.C.: Government Printing Office, 1916), Feb. 11, 1916: Letter on Improvement of East Potomac Park to the Chief of Engineers, U.S. Army.

4. Letter from the Office of Secretary-Treasurer of the Amateur Athletic Union of the US in Office of Public Buildings.

5. Mark Dyreson, "Selling American Civilization: The Olympic Games of 1920 and American Culture," *Olympika: The International Journal of Olympic Studies* 8 (1999): 1–4.

6. Hon. Frederick C. Hicks of New York, "Extension of Remarks: The Proposed Washington Stadium," in *Appendix to the Congressional Record 1916*, p. 817.

7. Testimony before the House Committee on Appropriations, House Subcommittee on Sundry Civil Appropriations, February 2 through May 16, 1916 on Bill H.R. 14905; 1701–1703.

8. *Ibid.*, 1703–1705.

9. *Ibid.*, 1705–1707.

10. *Ibid.*, 1707–1708.

11. *Ibid.*, 1708–1709.

12. Hon. Charles P. Coady of Maryland, "Extension of Remarks: Hulbert Stadium Bill," in *Appendix to the Congressional Record 1916*, p. 891.

13. *Ibid.*, 1709–1717; *Washington Star*, 25 April 1916, 6.

14. "The Washington of Tomorrow," *Buffalo Courier*, 1924, in D.C. Public Library Washingtoniana Room, Olympics Vertical File.

15. *Washington Star*, 4 January 1923, 21; 1 April 1923, 2; 27 February 1926, 2.

16. Harpers Ferry Center of the National Park Service, *The National Parks: Shaping the System* (Washington, D.C.: Department of the Interior, 1991).

17. National Capital Park and Planning Commission Minutes to June 27–29, 1935 Meeting at NARA, RG 79, National Parks Service, National Capital Region, Subject Files, Entry 115A, 1924–1951, Box 36.

18. Records of the National Capital Planning Commission, RG 328, A1, Entry 1; "Record of the 104th Meeting of the National Capital Park and Planning Commission," 20–21 December 1935.

19. *Washington Post*, 10 August 1935, B-1; 3 April 1936, 14; 21 April 1936, X24; Graham White and John Maize, *Harold Ickes of the New*

Deal: His Private Life and Public Career (Cambridge, MA: Harvard University Press, 1985); Jeanne Nienaber Clarke, *Roosevelt's Warrior: Harold L. Ickes and the New Deal* (Baltimore, MD: The Johns Hopkins University Press, 1996).

20. *Washington Star*, 22 May 1938, A5; *Washington Post*, 7 February 1939, 17; 9 February 1939, 18.

21. " 'Deserving' a Better Life at Langston Terrace," http://www.wam.umd.edu/~kaq/kathy2.html, accessed on January 18, 2008.

22. *Washington Post*, 17 November 1944, 6.

23. H.A. Kuljian & Company, "Proposed National Memorial Stadium," Smithsonian Archives; "Washington After the War," Corcoran Gallery Exhibit September 9?October 21, 1945, U.S. Grant III Papers, National Capital Park and Planning Commission Records, 1942–1946 folder.

24. *Washington Post*, 3 January 1940, 15; 4 January 1940, 17; 7 February 1940, 18; 18 January 1941, 13; 28 July 1946, B4; 15 August 1951, 10.

25. *Washington Post*, 19 June 1950, 11.

26. *Washington Post*, 30 June 1955, 22; 11 November 1956, C11; 18 November 1956, B4; 12 December 1956, C3; National Capital Planning Commission, "Preliminary Report on National Memorial Stadium," November 1956.

27. Gillette, *Between Justice and Beauty*, 190–211.

28. *Washington Times,* 2 May 1997; *Baltimore Sun*, 20 September 1998, 10; *New York Times*, 2 May 1997, A22.

29. *New York Times*, 16 May 1997, B16.

30. American Athletic Union, "History of AAU: From Olympic movement to grassroot sports," at http://www.aausports.org/default.asp?a=News-Stories/pg_News_archives.htm, 10/27/2007; United States Olympic Committee, *2003 Annual Report* (Colorado Springs, CO, 2004); Gerald R. Gems, *Windy City Wars: Labor, Leisure, and Sport in the Making of Chicago* (Lanham, MD: Scarecrow Press, 1997); 1978 Amateur Sports Act, 36 U.S.C. § 220501; Public Law 805, United States Olympic Committee Incorporation, 21 September 1950; "The United States Olympic Committee," http://www.usocpressbox.org/mediaguide/USOC/usoc_about.doc, accessed 12/7/2006.

31. *Washington Times,* 2 May 1997; *New York Times*, 16 May 1997, B16.

32. *Baltimore Sun*, 15 March 1998, 1A; 18 March 1999, 1.

33. United States District Court for the District of Columbia, *Civil Action 99-cv-3379*. Elizabeth Gazni, Greater Washington Exploratory Committee v. The Washington-Baltimore Regional 2012 Coalition, Kenneth R. Sparks, Federal City Council, Donald E. Graham, Mary Junck, Alfredo La Mont, The United States Olympic Committee, Marion Barry.

34. *Ibid.*; *Washington Times*, 9 September 2000.

35. United States District Court for the District of Columbia, *Civil Action 99-cv-3379*; *Baltimore Sun*, 22 May 2001, 2C.

36. Alice Ivey Snyder, "Washington's Bid for the 2012 Olympic Games," 20 October 2002 at apmp-nca.org/library/oct_20_Alice_Snyder/index.htm, 10/22/2007.

37. Government of the District of Columbia, Office of the Chief Financial Officer, "Comprehensive Annual Financial Reports," FY 1999–2003; *Washington Post*, 16 February 2000; 6 August 2000.

38. Mayor Anthony Williams, editorial, *The Current*, 20 March 2002; Williams, "2002 State of the District Address" on 5 March 2002, http://ww.dcwatch.com/mayor/020305.htm; *Baltimore Sun*, 15 December 2002, 1B.

39. Chesapeake Region 2012 Coalition, *Bid Submission for the 2012 Olympic Games* (Washington, D.C., 2000); Amy Shipley, "Olympic Bid Still Viable," *Washington Post*, 28 September 2001.

40. *Baltimore Sun*, 5 April 2002, 1C.

41. Elena Guarinello, "The Promise of the Games: Imagination and the Washington, D.C. 2012 Olympic Bid," senior thesis, Bryn Mawr College, 2001, 71–80; Reniqua Allen, "Olympics come in, residents pushed out," *Washington Afro-American*, 6 July 2002.

42. Thom Loverro, *Washington Times*, 12 June 2001; *Washington Times*, 14 February 2002.

43. *Baltimore Sun*, 27 August 2002, A15.

44. Amy Shipley, "D.C. Bid for Olympic Games Rejected," *Washington Post*, 28 August 2002, A1.

45. Serge F. Kovaleski, "Mayor, Area Lament Loss of Billions for Economy," *Washington Post*, 28 August 2002, A1.

46. Snyder, "Washington's Bid for the 2012 Olympic Games."

Chapter 6

1. *New York Times*, August 1953.

2. See various parks at the website http://www.ballparks.com/baseball. Lawrence S. Ritter, *Lost Ballparks: A Celebration of Baseball's Legendary Fields* (New York: Penguin Books, 1994).

3. Baseball-reference.com, Teams: Minnesota Twins Attendance, Stadium, and Park Figures, http://www.baseball-reference.com/teams/MIN/attend.shtml.

4. *Washington Star*, 20 November 1921, 29; Ron Smith, *The Ballpark Book* (St. Louis, MO: Sporting News Books, 2003); Michael Ben, *Ballparks of North America* (Jefferson:, N.C.: McFarland & Company, 1989).

5. Neil J. Sullivan, *The Dodgers Move West* (New York: Oxford University Press, 1987), 30–51.

6. *Washington Post*, 22 August 1956, 17; 19 September 1956, 15.

7. Joseph R. Passonneau, *Washington Through Two Centuries: A History in Maps and Images* (New York: The Monacelli Press, 2004), 160–164; *Washington Post*, 24 May 1956, 33.

8. *Washington Post*, 29 July 1956, A1; 6 October 1956, 1; 22 October 1956, A14; 21 November 1956, B1.

9. *Washington Post*, 8 November 1956, B1; 11 November 1956, C11.

10. *Washington Post*, 15 July 1928, R3; 15 February 1931, R1; 28 May 1948, 21; 6 May 1952, B1; 15 October 1952, 25; 8 September 1970, C2.

11. *Washington Post*, 2 July 1957, A1.

12. *Washington Post*, 6 January 1957, A1; 13 February 1957, B1; 26 February 1957, A18; 29 March 1957, A14; *Washington Star*, 7 January 1957, 1, 13 February 1957, A-13; 22 February 1957, B-1.

13. http://www.arlingtoncemetery.net/hr gross.htm, 11/3/2007; http://bioguide.congress. gov/scripts/biodisplay.pl?index=G000495, 11/3/2007.

14. U.S. House of Representatives, H.R. 1937, "An act to authorize construction, maintenance and operation by the District of Columbia Armory of District of Columbia Stadium in the District of Columbia" (Washington, D.C.: Government Printing Office, 1957); U.S. House of Representatives, Report No. 370 17 April 1957; Conference Report 16 August 1957; *Washington Post*, 22 June 1957, A1; 6 August 1957, B1; 21 August 1957, A1; *Washington Star*, 14 May 1957, B-3; 2 July 1957, B-1; 22 August 1957, A-27; 8 September 1957, A-1.

15. *Washington Post*, 22 October 1957, 44; *Washington Star*, 22 October 1957, 1.

16. *Washington Post*, 14 January 1958, A16; 18 January 1958, A18; 20 January 1958, A13.

17. *Washington Post*, 10 June 1958, A1; 21 July 1958, B1; 22 July 1958, B1; August 1958, B1; House of Representatives Bill No. 12612, 28 July 1958.

18. *Washington Star*, 23 April 1958, A-29; 17 July 1958.

19. Praeger-Kavanagh-Waterbury, "Engineering and Economic Study, District of Columbia Stadium," 31 March 1958.

20. 85th Congress, Second Session, *Congressional Record* Volume 104, Part 11 (Washington, D.C.: Government Printing Office, 1959), 14024.

21. *Ibid.*, 11316; *Washington Star*, 25 June 198, A-21; 8 July 1958, A-1; 17 July 1958, A-23.

22. *Ibid.*; Mitch Worthington, *Idaho Falls Post Register* 15 April 2007, B7.

23. *New York Times*, 5 September 1958, 31; *Washington Post*, 5 September 1958, A14; 9 September 1958, A20; 28 October 1958, A26.

24. *Washington Star*, 13 October 1958, B1; 12 December 1958, A-1; 20 December 1958, A-12; 16 January 1959, A-7.

25. David A. Doheny, *David Finley: Quiet Force for America's Arts* (Charlottesville: University of Virginia Press, 2006).

26. *Washington Post*, 6 March 1959, A1; 3 April 1959, 16 April 1959, D1; 19 April 1959, E4; David E. Finley letter to George F. Shea, 16 April 1959 in National Archives and Records Administration, RG 66, Fine Arts Commission, Entry 7 Central Files, Box 23.

27. 86th Congress, First Session, H.R. 6893, "to Amend the District of Columbia Stadium Act of 1957 with respect to motor-vehicle parking areas, and for other purposes," 5 May 1959; 86th Congress, First Session, *Congressional Record*, Volume 105, Part 12 (Washington, D.C.: Government Printing Office, 1960), 15352–53.

28. *Washington Star*, 22 March 1959, A19; 8 July 1959, B1; 13 July 1959, A1.

29. *New York Times*, 28 July 1959, 30; 28 July 1959, 1; 28 July 1959, 30; *Washington Post*, 28 July 1959, A17.

30. *Washington Post*, 3 October 1959, A1; 26 October 1960, 31; *Washington Star*, 3 October 1959, 1.

31. *Washington Post*, 4 October 1959, C1; 6 October 1959, A23; 13 October 1959, C1; *Washington Star*, 16 October 1959, A21.

32. Lee Lowenfish, *Branch Rickey: Baseball's Ferocious Gentleman* (Omaha: University of Nebraska Press, 2007), 570–574; *New York Times*, 13 May 1960, 35; 14 June 1960, 45.

33. *Washington Post*, 5 January 1960, A12; 10 February 1960, D3; 25 March 1960, A17; 23 April 1960, D7; 25 October 1960, 19; 26 October 1960, 32; 28 October 1960, C3.

34. *Washington Star*, 11 December 1961; *Washington Times*, 30 September 2004, B1.

35. http://www.baseball-reference.com/ teams/MIN/attend.shtml, 10/29/2007; http:// www.baseball-reference.com/teams/WSA/ 1970.shtml,11/3/2007; http://news.minnesota. publicradio.org/features/199910/20_wilcoxen w_griffith/, 11/5/2007; http://espn.go.com/ page2/wash/s/2002/0311/1349361.html,11/6/200 7; Deveaux, 208–239.

36. *Washington Star*, 3 September 1958, A1; 9 April 1959, C1; 19 May 1959, D1.

37. *Washington Post,* 14 December 1963, C1; 24 January 1964, B1; 30 April 1964, E6; 13 October 1964, D4; 17 May 1967, D4; 22 January 1972, E1.

38. *Washington Post,* 13 March 1979, D2; 12 August 1979, D7; 3 September 1979, A1; 21 December 1980, B1; 25 April 1981, D1; 7 December 1981, C1; 8 December 1981, A1, A20; 13 December 1981, D1.

39. *Washington Post,* 28 October 1983, D1; 12 May 1984, B3; 8 June 1984, D3; 2 December 1984, C1.

40. *Washington Post,* 11 February 1984, D2; 1 April 1984, 69; 1 July 1984, B1; 17 January 1985, D1; 19 January 1985, B6.

41. *Washington Post,* 22 August 1987, B1; 2 September 1987, A1.

42. http://sports.espn.go.com/nfl/playoffs 05/news/story?id=2315303,11/6/2007; http://news.bbc.co.uk/2/hi/special_report/1998/super_bowl_xxxii/49741.stm, 11/6/2007; *Washington Post,* 3 September 1987, E1.

43. *Washington Post,* 6 September 1987, A1; 15 September 1987, B3; 16 September 1987, B1; 17 September 1987, D1;

44. *Washington Post,* 19 September 1987, A1; 14 October 1987, B1; 16 October 1987, A1; 13 January 1988, B1; 9 February 1988, B1; 9 February 1988, A10, A22.

45. *Washington Post,* 14 July 1988, C1; 28 August 1988, D1; 30 August 1988, A1; 9 September 1988, A1; 17 September 1988, B3; 7 December 1988, D3; *Washington Times,* 13 September 1988; 13 November 1991; *Washington Business Journal,* 26 September 1988, 26; Cultural Tourism DC, "African American Heritage Trail Database: Langston Golf Course and Driving Range," http://www.culturaltourismdc.org.

46. *Washington Post,* 1 January 1990, B1; 4 January 1990, C1.

47. www.dc.gov/elections; http://en.wikipedia.org/wiki/Sharon_Pratt_Kelly, 11/16/2007; http://www.time.com/time/magazine/article/0,9171,971704,00.html; http://www.answers.com/topic/sharon-pratt-kelly, 11/16/2007.

48. District of Columbia Armory Board, *Starplex,* September 1991; February 1992; *Washington Times,* 10 July 1992; National Park Service, "National Register of Historic Places," *http://www.cr.nps.gov/nr/*; *Washington Post,* 6 December 1988; 9 April 1990; 8 September 1990.

49. *Baltimore Sun,* 4 June 1991, 7B; 8 December 1992, 3C; *Chicago Tribune,* 26 July 1992, 6; District of Columbia Armory Board, "Public Information Packet for the Public Meeting on the Environmental Assessment of the Proposed Construction and Operation of a Stadium in Washington, D.C.," 1993 (hereafter

Public Information Packet); City of Alexandria, *Potomac Yards/Potomac Greens,* 1992 Master Plan; Alexandria Planning Commission, "Development Concept Plan: Potomac Yards/ Potomac Greens," 15 June 1999; Alexandria Library, "Potomac Yards," January 2003; *Washington Post,* 12 August 1992, A16; *Washington Times,* 10 July 1992, B1; http://www.alexandria.lib.va.us/lhsc_online_exhibits/monthly/jan_2003.html, 11/18.2007; 102nd Congress, Second Session, *Congressional Record,* Vol. 138, Part 5, 21719–21721.

50. 103rd Congress, Second Session, *Congressional Record,* Volume 140, Part 5, 7041–7042, 8663, 10238, 10462; http://biogu ide.congress.gov/scripts/biodisplay.pl?index= C000077.

51. Public Information Packet; *New York Times,* 8 December 1992, B21; *Baltimore Sun,* 8 December 1992, 3C; "Nader Calls for D.C. Council Oversight on Stadium Project," *League of Fans,* 24 October 2005; http://www.league offans.org/blog/index.php?/archives/62-Nader-Calls-for-DC-Council-Oversight-on-Sta dium-Project.html.

52. Statement of Dorn McGrath Jr., Chairman of the Committee of 100, Before the Subcommittee on National Parks and Public Lands, House of Representatives Committee on Natural Resources, Concerning H.R. 2176 and H.R. 2702, Two Bills To Amend the District of Columbia Stadium Act of 1957 To Authorize the Construction, Maintenance, And Operation of a New Stadium In the District of Columbia, And For Other Purposes," 5 November 1993; Statement of Robert Stanton, Director, National Capital Region, National Park Service, Department of Interior. In Committee of 100 Papers at Special Collections, Gelman Library, George Washington University.

53. *Baltimore Sun,* 7 December 1993, 3B; 8 December 1993, 1A; 10 December 1993, 30A; 12 December 1993, 7C; 21 December 1993, 1B; 23 December 1993, 5B; 7 January 1994, 1A; 10 April 1994, 4B.

54. Price George Country, Maryland, County Councilman Tom Dernoga, at www. tomdernoga.org/about.html, 11/28/2007; *New York Times,* 13 October 1994; *Washington Post,* 13 October 1994, A1.

55. *Washington Post,* 14 April 1996, A19; 26 December 1996, E1; 12 September 1997, G13; http://www.epinions.com/sprt-Venues-Fed Ex_Field/display_~reviews, 11/28/2007; *Washington Times,* 14 November 2004; http://the sportseconomist.com/2004/10/cowboys-v-redskins.htm, 12/1/2007; Charles C. Tu, "How Does a New Sports Stadium Affect Housing Values? The Case of FedEx Field," *Land Economics* (August 2005): 379–395; Adam Sum-

mers, "Baseball Boondoggle," *Baltimore Sun*, 23 December 2004.

56. *Washington Post*, "Redskins Go to Market," 6 July 1999; 23 January 2008, B1; 25 January 2008, B4; BallParks.com, http://football.ballparks.com/NFL/WashingtonRedskins/index.htm, accessed 6 January 2008; "Redskins Close to Naming Rights Deal," 28 October 1999; MediaVentures; Brett Pulley, "The $1 Billion Team," *Forbes*, 20 September 2004.

57. H.R. 3699, The Federal and District of Columbia Government Real Property Act of 2005; Statement of Paul Hoffman, Deputy Assistant Secretary for Fish and Wildlife and Parks, U.S. Department of the Interior, Before the House Subcommittee on National Parks of the Committee on Resources, Regarding H.R. 3699, The Federal and District of Columbia Government Real Property Act of 2005, 3 November 2005; "Redskins Could Come Home to RFK," nbc4.com; 17 November 2006, http://www.nbc4.com/print/10330600/detail.html; accessed 16 January 2008; Marc Fisher, "Next 2 D.C. Stadium Deals Might Smell a Bit Sweeter," *Washington Post*, 11 January 2007, B1; "New Life for Good Old RFK?" *Port Halifax Gateway*, http://porthalifax.blgspot.com/2007/02/new-life-for-good-old-rfk.html, 20 February 2007, accessed 16 January 2008.

Chapter 7

1. *Washington Post*, 16 April 1959, D1; 19 April 1959, E4; *Washington Star*, 17 March 1960.

2. www.ballparksofbaseball.com/past, 10/18/2007.

3. *Washington Post*, 3 July 1930, 19; 16 June 1957, C12; 8 April 1960; 8 July 1960; 13 August 1961, E2; 7 November 1967, A20; 6 September 1970, 50; 30 September 1978, B6; 22 November 1978, A18; 15 July 1979, B6; *Washington Star*, 6 July 1960; 8 July 1960; 23 April 1961; Eighty-Seventh Congress, First Session, *Congressional Record*, Volume 107, part 4, page 5493–94.

4. *Washington Post*, 19 November 1961, B1; 1 December 1961, C1; 5 December 1961, A1; 15 December 1961, B1; 30 May 1962, B1; 10 June 1962, 31 August 1962, B2; *Washington Star*, 2 June 1962; http://bioguide.congress.gov/scripts/biodisplay.pl?index=N000009; http://www.library.georgetown.edu/dept/speccoll/cl224.htm, 10/18/2007; Eighty-Eighth Congress, First Session, *Congressional Record*, v.109, part 7, page 9746–47; part 19, 24908; http://bioguide.congress.gov/scripts/biodisplay.pl?index=L000122, 10/18/2007; http://michaelmeckler.com/books/review_010906.html.

5. *Washington Post*, 15 September 1962, C8; 16 February 1963, D14; 5 November 1963, A19; 11 December 1963, D3; 20 December 1963, D1; 24 December 1963, A18; 25 August 1964, D4; 3 November 1964, B1; 4 November 1964, D1; 21 November 1964, B2.

6. Ron Powers, *Super Tube: The Rise of Television Sports* (New York: Coward-McCann, 1984), p. 93–98; Steven Barnett *Games and Sets: The Changing Face of Sport on Television* (London: BFI Pub., 1990), 36.

Robert McChesney, "Media Made Sport: A History of Sports Coverage in the United States," *Media, Sports and Society*, ed. Lawrence A. Wenner (Newbury Park, CA: Sage Publications, 1989), 61.

7. Ed Gruver, *The American Football League: A Year-By-Year History, 1960–1969* (Jefferson, North Carolina: McFarland & Company, 1997); Jeff Miller, *Going Long: The Wild Ten-Year Saga of the American Football League in the Words of Those Who Lived It* (New York: McGraw Hill, Inc., 2003); Sal Maiorana, *If You Can't Join 'Em, Beat 'Em: A Remembrance of the American Football League* (Bloomington, IN: Authorhouse, 2003).

8. http://bioguide.congress.gov/scripts/bibdisplay.pl?index=W000445, 11/15/2007; *Washington Star*, 11 September 1965, A13; 7 October 1965, A1; 14 October 1965, B1; 31 October 1965, B-1; 17 December 1965; 5 May 1966, B4; 5 October 1966, F3; 2 November 1966, C4; 10 November 1966, E1; *Washington Post*, 17 September 1965, B3; 22 September 1965, D3; 14 October 1965, C7; 27 May 1985, WB5. Hecht and two of his partners pursued a suit against the Armory Board. After nearly five years, the case received its hearing in the U.S. District Court. The court ruled that the lease was a governmental action and therefore immune from antitrust laws. The Court of Appeals overturned the ruling and returned the case to the District Court for trail. The city then unsuccessfully sought to have the Appeals Court decision overturned.

9. *Washington Star*, 5 May 1966, B4; 8 June 1966, A1; 9 June 1966, B6; 5 October 1966, F3; 10 November 1966, E1.

10. *Washington Star*, 22 March 1964; 25 March 1964; 29 March 1964; *Washington Post*, 27 March 1964; 25 July 1964.

11. Eighty-Eighth Congress, First Session, *Congressional Record*, v.109, part 7, page 9746–47; part 19, 24908; *Washington Post*, 11 October 1963, 1; 30 October 1963, A1; 6 November 1963, A1; 10 November 1963, A6; 17 November 1963, A1, E1; *New York Times*, 3 September 1964, 1; Carol E. Hoffecker, *Honest John Williams: U.S. Senator from Delaware* (Newark: University of Delaware Press, 2000), 183?185.

12. Hoffecker, 196–201.

13. Eighty-Eighth Congress, Second Ses-

sion, *Congressional Record*, Volume 110, Part 5, page 5674–75; part 10, 10449; part 11, 21465–66; http://bioguide.congress.gov/scripts/biodisplay.pl?index=H000049, 12/10/2007; http://en.wikipedia.org/wiki/Durward_Gorham_Hall, 12/15/2007; *Christian Science Monitor*, 25 January 1964, 1; *Washington Post*, 3 September 1964; "That Lingering Aroma," *Time*, 11 September 1964.

14. http://www.answers.com/topic/john-little-mcclellan, 12/15/2007; Eighty-Eighth Congress, Second Session, *Congressional Record*, v.110, part 17, page 21904–21915.

15. http://clerk.house.gov/art_history/house_history/Session_Dates/sessionsAll.html.

16. *Los Angeles Times*, 15 December 1964, A8; 9 January 1966, F4; *Chicago Daily Tribune*, 3 February 1965, 1.

17. General Accounting Office, "Review of Change Orders and Other Matters Relating to the Construction of District of Columbia Stadium" (Washington, D.C.: Government Printing Office, August 1966); Eighty-Ninth Congress, Second Session, *Congressional Record*, Volume 112, Part 17, page 22418–11419; *Washington Post*, 13 September 1966, C1.

Conclusion

1. Simon Martin, *Football and Fascism: Local Identities and National Integration in Mussolini's Italy* (London: Berg Publishers, 2004); University of Michigan News Service, "Municipalities thinking of funding a new sports stadium should make a crucial demand: 'Show me the money!'" 2 April 1997.

2. http://www.britishdesign.co.uk/index.php?page=newsservice/view&news_id=3664, 12/13/2007; http://www.washingtonpost.com/wp-dyn/content/article/2003/06/22/AR2005041501384.html.

3. Sean McAdam, "Winning is the best way to boost revenue," 19 May 2006, at http://sports.espn.go.com/mlb/columns/story?id=2450555, 12/13/2007.

4. www.mikrooekonomie.rwth-aachen.de/workingpaper/DP_0512.pdf, 12/13/2007; http://football.calsci.com/SalaryCap.html; CNNSI, "It's only money," 21 July 2003; "Luxury Tax Breakdown," 30 August 2002; http://mlb.mlb.com/mlb/y2005/m12/d21/c1286225.jsp; Ken Rosenthal, "Ahem! The Yankees are not evil," *The Sporting News*, 1 March 2004, 12/13/2007.

5. Jeffrey Scholes, "Professional Baseball and Fan Disillusionment: A Religious Ritual Analysis," *Journal of Religion and Popular Culture* (Summer 2004).

6. "Top 50 TV Markets Ranked by Household, 2004," Nielsen Media Research, Inc. Nielsen Station Index (NSI).

7. *Washington Post*, 6 January 2007, E1; 9 October 2007, B3; "New Stadium Project: Poplar Point," http:// web.mlsnet.com/t103/stadium/poplar_point Accessed 12/16/2007; Robert Wagman, "New D.C. soccer stadium faces many obstacles," *Soccer Times* 12 March 2006.

Bibliography

Primary Sources: Manuscript Collections

National Archives and Records Administration, Washington, D.C., and College Park, MD:
 Records of the District Courts of the United States (Record Group 21).
 Records of U.S. District and Other Courts in the District of Columbia, 1801–1993.
 Office of Public Buildings and Public Parks (Record Group 42):
 General Records, 1791–1924.
 Records of the Office of Public Buildings and Public Parks of the National Capital, 1900–1935.
 Records of the National Capital Planning Commission (Record Group 328):
 General Records, 1924–1990.
 Records of the National Park Service (Record Group 79):
 Records of the National Capital Region, 1924–1951.

Other Primary Sources

Annual Report of the Army Corps of Engineers
Baseball Reference.com
Congressional Biographical Dictionary
Congressional Record
District of Columbia Government, various locations, Washington, D.C.:
 Chief Financial Officer, Documents related to Baseball in the District
 D.C. Sports and Entertainment Commission, Documents related to Baseball in the District
 D.C. Armory Board
 Annual Reports
 Starplex
Historical Society of Washington, D.C.:
 Howard S. Fisk Bicycle Club Collection
 Ulysses S. Grant III Collection
 Palisades Folder
Library of Congress, Manuscript Division, Washington, D.C.:
 Senator Harold Hitz Burton Papers
 Olmsted Associates Papers
Library of Congress, Microfilm Room:
 Architectural Record
 Magazine of Art
 Time
 Sporting Life
 The Sporting News
Mary Teresa Norton Papers
Rutgers University, Alexander Library
Smithsonian Institution Archives:
 RU 46 Office of the Secretary Records

Washington, D.C., Public Library, Martin Luther King Jr. Library:
 District of Columbia Building Permits
 Sandborn Maps
 Washingtonia Room:
 Vertical Files

Secondary Sources

Abbott, Carl. *Political Terrain: Washington, D.C., from Tidewater Town to Global Metropolis.* Chapel Hill: University of North Carolina Press, 1999.

Ancestry in America. Millerton, NY: Grey House Publishing, 2003.

Bachin, Robin F. *Building the South Side: Urban Space and Civic Culture in Chicago, 1890–1919.* Chicago: University of Chicago Press, 2004.

Baltimore and Ohio Rail Road Company. *Guide to Washington.* Washington, D.C.: Charles O. Scull, Co., 1889.

Barnett, Steven. *Games and Sets: The Changing Face of Sport on Television.* London: BFI Pub., 1990.

Bealle, Morris A. *The Washington Senators.* Washington, D.C.: Columbia Publishing Co., 1947.

Ben, Michael. *Ballparks of North America.* Jefferson, NC: McFarland & Company, 1989.

Bowling, Kenneth R. "From 'Federal Town' to 'National Capital.'" *Washington History* (Spring/Summer 2002): 8–25.

Bromwell, Colonel Charles S. "Annual Report of the Office of Buildings and Grounds." *Annual Report of the Chief of Engineers United States Army 1906.* Washington, D.C.: Government Printing Office, 1906.

Bryan, Wilhelmus Bogart. *A History of the National Capital.* Vol. 2, *1815–1878.* New York: The Macmillan Company, 1915.

Burk, Robert F. *Never Just a Game: Players, Owners and American Baseball to 1920.* Chapel Hill: University of North Carolina, 1994.

Burns, James B. "The First Ten Years, Depression and War." *Government Standard* (September 2001).

Bushnell, George D. "When Chicago Was Wheel Crazy." *Chicago History* 4, no. 3 (Fall 1975): 167–174.

Casway, Jerold. *Ed Delahanty in the Emerald Age of Baseball.* Notre Dame, IN: University of Notre Dame, 2004.

Ceresi, Frank, and Carol McMains. "The Washington Nationals and the Development of America's National Pastime." *Washington History* 15, no. 1 (Spring/Summer 2003): 26–41.

Clarke, Jeanne Nienaber. *Roosevelt's Warrior: Harold L. Ickes and the New Deal.* Baltimore, MD: Johns Hopkins University Press, 1996.

Commission on the Bicentenary of the U.S. House of Representatives by the Office of the Historian, U.S. House of Representatives. *Women in Congress, 1917–1990.* Washington, D.C.: U.S. Government Printing Office, 1991.

Congressional Budget Office. "Changes in Federal Employment: An Update." May 2001.

Cowdrey, Albert E. *A City for the Nation: The Army Engineers and the Building of Washington, D.C., 1790–1967.* Washington, D.C.: Army Corps of Engineers, 1978.

Derthick, Martha. *City Politics in Washington, D.C.* Cambridge: MIT Press, 1962.

Deveaux, Tom. *The Washington Senators, 1901–1971.* Jefferson, NC: McFarland & Co., 2001.

Doheny, David A. *David Finley: Quiet Force for America's Arts.* Charlottesville: University of Virginia Press, 2006.

Dyreson, Mark. "Selling American Civilization: The Olympic Games of 1920 and American Culture." *Olympika: The International Journal of Olympic Studies* 8 (1999).

Elfenbein, Jessica Ivy. *Civics, Commerce, and Community: The History of the Greater Washington Board of Trade, 1889–1989.* Dubuque, IA: Kendall-Hunt Publishing Co., 1990.

Fitzpatrick, Sandra, and Maria R. Goodwin. *The Guide to Black Washington: Place and Events of Historical and Cultural Significance in the Nation's Capital.* Washington, D.C.: Hippocrene Books, 2001.

Gems, Gerald R. *Windy City Wars: Labor, Leisure, and Sport in the Making of Chicago.* Lanham, MD: Scarecrow Press, 1997.

Gerrety, Donald E. "Palisades: An Early Suburb of Washington." University of Maryland history course paper (1979) in vertical file at Washingtonia Room of MLK Jr. Library.

Gillette, Howard. *Between Justice and Beauty: Race, Planning and the Failure of Urban Policy in Washington, D.C.* Baltimore, MD: Johns Hopkins University Press, 1995.

Gillette, Howard, Jr., and Alan M. Kraut, "The Evolution of Washington's Italian American Community." In *Urban Odyssey: A Multicultural History of Washington, D.C.*, ed. Francine Curro Cary. Washington, D.C.: Smithsonian Institution Press, 1995.

Goode, James M. *Capital Losses: Cultural History of Washington's Destroyed Buildings.* Washington, D.C.: Smithsonian Institution Press, 1979.

Green, Constance McLaughlin. *Washington Capital City, 1879–1950.* Princeton, NJ: Princeton University Press, 1963.

_____. *Washington Village and Capital, 1800–1878.* Princeton, NJ: Princeton University Press, 1962.

Gruver, Ed. *The American Football League: A Year-By-Year History, 1960–1969.* Jefferson, NC: McFarland & Company, 1997.

Guarinello, Elena. "The Promise of the Games: Imagination and the Washington, D.C., 2012 Olympic Bid." Senior thesis, Bryn Mawr College, 2001.

Hage, George S. "Games People Played: Sports in Minnesota Daily Newspapers 1860–1890." *Minnesota History* (Winter 1981): 321–328.

Harpers Ferry Center of the National Park Service. *The National Parks: Shaping the System.* Washington, D.C.: Department of the Interior: 1991.

Harris, C.M. "Washington's 'Federal City,' Jefferson's 'federal town.'" *Washington History* 12 (2000).

Harrison, Michael R. "The 'Evil of the Misfit Subdivisions': Creating the Permanent System of Highways of the District of Columbia." *Washington History* (Spring/Summer 2002): 26–55.

Hatcher, Ed. "Washington's Nineteenth-Century Citizens' Associations and the Senate Park Commission Plan." *Washington History* (Fall/Winter 2002): 70–95.

Hoffecker, Carol E. *Honest John Williams: U.S. Senator from Delaware.* Newark, DE: University of Delaware Press, 2000.

Holcombe, Randall G. "Federal Government Growth Before The New Deal." *The Freeman* (September 1, 1997).

Holroyd, Steve. "The First Professional Soccer League in the United States: The American League of Professional Football (1894)." www.sover.net/~spectrum/alpf.html (accessed January 15, 2007).

Jacobs, Kathyn Allamong. *Capital Elites: High Society in Washington, D.C., After the Civil War.* Washington: Smithsonian Institution Press, 1995.

Johnson, Ronald M. "From Romantic Suburb to Racial Enclave: Le Droit Park, Washington, D.C., 1880–1920." *Phylon* 45, no. 4 (1984): 264–270.

Jones, David, ed. *Deadball Stars of the American League.* Dulles, VA: Potomac Books, Inc., 2006.

Kerr, Audrey Elisa. *The Paper Bag Principle: Class, Colorism, and Rumor and the Case of Black Washington, D.C.* Knoxville: University of Tennessee Press, 2006.

King, LeRoy O., Jr. *One Hundred Years of Capital Traction: The Story of Streetcars in the Nation's Capital.* Washington, D.C.: Taylor Publishing Company, 1972.

Kohler, Sue A. *Commission of Fine Arts: A Brief History, 1910–1995.* Washington, D.C.: U.S. Commission of Fine Arts, 1996.

Kuklick, Bruce. *To Every Thing a Season: Shibe Park and Urban Philadelphia, 1909–1976.* Princeton, NJ: Princeton University Press, 1991.

Lessoff, Alan. *The Nation and Its City: Politics, "Corruption," and Progress in Washington, D.C., 1861–1902.* Baltimore: Johns Hopkins University Press, 1994.

Light, Paul C. "The True Size of Government." *Government Executive* (January 1, 1999).

Lowenfish, Lee. *Branch Rickey: Baseball's Ferocious Gentleman.* Omaha: University of Nebraska Press, 2007.

Maiorana, Sal. *If You Can't Join 'Em, Beat 'Em: A Remembrance of the American Football League.* Bloomington, IN: Authorhouse, 2003.

Martin, Simon. *Football and Fascism: Local Identities and National Integration in Mussolini's Italy.* London: Berg Publishers, 2004.

McAleer, Margaret H. "The Green Streets of Washington: The Experience of Irish Mechanics in Antebellum Washington." In *Urban Odyssey: A Multicultural History of Washington, D.C.*, ed. Francine Curro Cary. Washington, D.C.: Smithsonian Institution Press, 1995.

McChesney, Robert. "Media Made Sport: A History of Sports Coverage in the United States." In *Media, Sports and Society.* Ed. Lawrence A. Wenner. Newbury Park, CA: Sage Publications, 1989.

Miller, Jeff. *Going Long: The Wild Ten-Year Saga of the American Football League in the Words of Those Who Lived It.* New York: McGraw Hill, Inc., 2003.

Morrison's Strangers Guide for Washington City, D.C., 1891. Washington: William H. Morrison, 1891.

Muller, Martin. *AIA Guide to the Architecture of Washington, D.C.* Washington Chapter of the American Institute of Architects, 2005.

Nye, Peter. *Hearts of Lions: The History of American Bicycle Racing.* New York: W.W. Norton & Co., 1988.

Okkonen, Marc. *Baseball Memories, 1900–1909: An Illustrated Chronicle of the Big League's First Decade, All The Players, Managers, Cities and Ballparks.* New York: Sterling Publishing, 1992.

Olszewski, George J. *A History of the Washington Monument, 1844–1968.* Washington, D.C.: National Park Service, 1971.

Passonneau, Joseph R. *Washington Through Two Centuries: A History in Maps and Images.* New York: The Monacelli Press, 2004.

Povich, Shirley. *The Washington Senators.* New York: G.P. Putnam's Sons, 1954.

Powers, Ron. *Super Tube: The Rise of Television Sports.* New York: Coward-McCann, 1984.

Richardson, John P. "Alexander R. Shepard_His Time and Ours." 34th Annual Washington Studies Conference, November 2007.

Ritter, Lawrence S. *Lost Ballparks: A Celebration of Baseball's Legendary Fields.* New York: Penguin Books, 1994.

Rosentraub, Mark S. *Major League Losers: The Real Cost of Sports and Who's Paying For It.* New York: Basic Books, 1997.

Schoenebaum, Eleanora W., ed. *Political Profiles: The Truman Years.* New York: Facts on File, 1978.

Scholes, Jeffrey. "Professional Baseball and Fan Disillusionment: A Religious Ritual Analysis." *Journal of Religion and Popular Culture* (Summer 2004).

Sherwood, Suzanne. *Foggy Bottom, 1800–1975: A Study in the Uses of an Urban Neighborhood.* Washington, D.C.: George Washington University, 1978.

Siracusa, Joseph M., ed. *Political Profiles: The Kennedy Years.* New York: Facts on File, 2004.

Smith, Kathryn Schneider. *Port Town to Urban Neighborhood: The Georgetown Waterfront of Washington, D.C., 1880–1920.* Washington, D.C.: George Washington University, 1989.

Smith, Ron. *The Ballpark Book.* St. Louis, MO: Sporting News Books, 2003.

Snyder, Alice Ivey. Washington's Bid for the 2012 Olympic Games, 20 October 2002. apmpnca.org/library/oct_20_Alice_Snyder/index.htm (accessed February 13, 2007).

Spreng, Ron. "The 1890s Bicycling Craze In The Red River Valley." *Minnesota History* (Summer 1995): 269–282.

Stefanelli, Dana. "A Capital Investment: Real Estate Speculation in the District of Columbia, 1790–1840." 34th Annual Washington Studies Conference, November 2007.

Stimpson, Miriam F. *A Field Guide to Landmarks of Modern Architecture in the United States.* Englewood Cliffs, NJ: Prentice Hall, Inc., 1985.

Sullivan, Neil J. *The Diamond in the Bronx: Yankee Stadium and Politics of New York.* New York: Oxford University Press, 2001.

_____. *The Dodgers Move West.* New York: Oxford University Press, 1987.

Tu, Charles C. "How Does a New Sports Stadium Affect Housing Values? The Case of FedEx Field." *Land Economics* (August 2005).

Ward, Richard F. *South and West of the Capitol Dome.* New York: Vantage Press, 1978.

White, Edward G. *Creating the National Pastime: Baseball Transforms Itself, 1903–1953.* Princeton, NJ: Princeton University Press, 1996.

White, Graham, and John Maize. *Harold Ickes of the New Deal: His Private Life and Public Career.* Cambridge, MA: Harvard University Press, 1985.

Whittingham, Richard. *The Washington Redskins: An Illustrated History.* New York: Simon and Schuster, 1990.

Index

Page numbers in **bold italics** indicate photographs and illustrations.

277